**Technocrats of the Imagination**

# Art, Technology, and the Military-Industrial Avant-Garde

John Beck and Ryan Bishop

A Cultural Politics Book  Edited by John Armitage, Ryan Bishop, and Douglas Kellner

Duke University Press   Durham and London   2020

# TECHNOCRATS OF THE IMAGINATION

© 2020 Duke University Press
All rights reserved

Designed by Aimee C. Harrison & Drew Sisk
Typeset in Garamond Premier Pro by Westchester Publishing Services

Library of Congress Cataloging-in-Publication Data
Names: Beck, John, [date] author. | Bishop, Ryan, [date] author.
Title: Technocrats of the imagination : art, technology, and the military-industrial
  avant-garde / John Beck, Ryan Bishop.
Description: Durham : Duke University Press, 2020 | "A cultural politics book." |
  Includes bibliographical references and index.
Identifiers: LCCN 2019023962 (print) | LCCN 2019023963 (ebook)
ISBN 9781478005957 (hardcover)
ISBN 9781478006602 (paperback)
ISBN 9781478007326 (ebook)
Subjects: LCSH: Technology and the arts—History—20th century. | Arts—United
  States—Experimental methods. | Military-industrial complex—United States.
Classification: LCC NX180.T4 B43 2020 (print) | LCC NX180.T4 (ebook) |
  DDC 700.1/050973—dc23
LC record available at https://lccn.loc.gov/2019023962
LC ebook record available at https://lccn.loc.gov/2019023963

Cover art: Pantelis Xagoraris, untitled (1974). Created during a fellowship
at the MIT Center for Advanced Visual Studies. Reprinted by permission
of MIT.

**Contents**

Acknowledgments   vii
Introduction   1

Chapter 1   Science, Art, Democracy   17
Chapter 2   A Laboratory of Form and Movement: Institutionalizing Emancipatory Technicity at MIT   46
Chapter 3   The Hands-On Process: Engineering Collaboration at E.A.T.   77
Chapter 4   Feedback: Expertise, LACMA, and the Think Tank   107
Chapter 5   How to Make the World Work   133
Chapter 6   Heritage of Our Times   164

Notes   193
References   201
Index   221

## Acknowledgments

This book grew out of an earlier project of ours entitled *Cold War Legacies: Systems, Theory, Aesthetics* (2016). As we were writing the introduction to that volume, it became clear that the issues addressed there needed more space. The present book is an attempt to find that space. So in the first instance, we wish to thank all the contributors to that collection for their help in shaping the ideas that emerged here: Ele Carpenter, Fabienne Collingnon, Mark Coté, Dan Grausam, Ken Hollings, Adrian Mackenzie, Jussi Parikka, John Phillips, Adam Piette, James Purdon, Aura Satz, and Neal White. We would also like to thank our respective institutions and research centers for support to visit archives at the Getty Research Institute and the Buckminster Fuller archive at Stanford University. We owe a special thanks to Jussi Parikka, Lori Emerson, and Darren Wershler, who are currently writing a book on media and technology labs and have been in dialog with us about the many overlapping issues and materials. Courtney Berger, our excellent editor at Duke University Press, the excellent and insightful reviewers, and everyone at the press involved in realizing this book, as well as those who constantly provide support and steerage for the Cultural Politics book series and journal, deserve our most profound appreciation.

John would like to thank the Department of English, Linguistics and Cultural Studies at the University of Westminster for financial and logistical support, with a special mention to Sharon Sinclair for her patient navigation of all manner of administrative knots. John is grateful for the award of a Library Research Grant from the Getty Research Institute, which made it possible to consult the Experiments in Art and Technology archives. Thanks also to the Balch Art Research Library of the Los Angeles County Museum of Art for making archival materials available at short notice. The warmth and efficiency of the staff at the Getty and the Balch are much appreciated. Many thanks to Douglas Kahn for sending over, unsolicited, some marvelous audio material. For their continued support and friendship, thanks to Matthew Cornford,

Mark Dorrian, and Neal White, and for providing deep context, thanks to Lucy Bond, Georgina Colby, David Cunningham, Rob La Frenais, Alex Warwick, and Leigh Wilson. To Paula and Ed, the ultimate combination of art and tech.

Ryan would like to thank the Winchester School of Art, University of Southampton, for its continued intellectual support for this project. Many colleagues contributed directly to the shape of this book, including Ed d'Souza, Jussi Parikka, Sunil Manghani, Victor Burgin, John Armitage, Joanne Roberts, Jonathan Faiers, Seth Giddings, Mihaela Brebenel, Jo Turney, Alessandro Ludovico, Daniel Cid, Dan Ashton, and Valentina Cardo. Others whose input and friendship found its way into this volume include, in no specific order, John Phillips, Sean Cubitt, Mike Featherstone, Couze Venn, Kristoffer Gansing, Daphne Dragona, Tania Roy, Tiziana Terranova, Ben Bratton, Jordan Crandall, Ed Keller, Geoff Winthrop-Young, T'ai Smith, Ken Wark, and Elena Lamberti among many others. Finally Ryan would like to extend infinite gratitude to his dearest collaborator, Adeline Hoe.

# Introduction

This is the story of two avant-gardes and their brief moment of asymmetric convergence. Each emerges out of the American experience of World War II and each is international in scope, including a contingent of Germans, and responsive to the altered economic, political, and technological circumstances of the world after 1945. Each has its roots in an earlier encounter with modernity and each, in different ways, seeks a purchase on the future. The first is the postwar American artistic avant-garde, infused with the legacy of radical experimentation brought from Europe by those able to extract themselves from the conflagration. The second is the so-called military-industrial complex, the network of private and government institutions held together with Federal dollars and fortified, again, with European brains in flight from, or smuggled out of, tyrannous regimes and their defeated remnants.

The point of convergence is the late 1960s, when a loose confederacy of artists now referred to as the neo-avant-garde (a term we will have cause to return to toward the end of this book), including, most prominently and influentially, John Cage and Robert Rauschenberg, participated in a number of collaborative, interdisciplinary projects aimed at plugging American art into the power grid driving US scientific, technological, and industrial innovation. At leading universities, corporations, and museums, finding ways of bringing advanced art and cutting-edge technology together was conceived of as a way of unleashing the creative capacities of artists, scientists, and engineers, of sparking as-yet unimagined inventions of form and function, and of initiating new modes of inquiry unfettered by conventional distinctions based on professional loyalties, prejudices, or habits of mind. For the artists, informed by an ongoing investigation of the unfinished projects of Dada, Surrealism, Constructivism and other aspects of early twentieth-century avant-garde, the fusion of art and technology was not only an intrinsic aspect of contemporary practice but was bound up with the avant-garde's broader utopian challenge to the compartmentalized

and administered lifeworld of modernity. For Cage and Rauschenberg, designers and educators like R. Buckminster Fuller and the Eames Office, and artists working closely with emerging computational and audiovisual technologies such as György Kepes, Jack Burnham, and Stan VanDerBeek, experiments in art, technology, and science presaged not merely a new aesthetic but a new social order based on collective experimentation within the richest and most advanced science and tech infrastructure the world had ever seen. Imagine Marcel Duchamp, Vladimir Tatlin, or El Lissitzky supported by IBM and MIT. What happens when the possibility of such improbable pairings is taken seriously is the subject of this book.

The collectivist dimension of art-and-technology collaborations is a vital part of their utopian promise since it represents an attempt by many artists and organizers to instantiate radical democratic practices, or at least to start to imagine what such practices might be, within the ostensibly hierarchical and corporate environment of the mid-twentieth-century university or business. The dilation of the coterie to include the spectator and passers-by, so central to the performative happenings, processes, and interventions of artists like George Maciunas, Claes Oldenburg, and Otto Piene, and enlarged further in the multimedia broadcast experiments of Cage, VanDerBeek, James Lee Byars, and many others, posits the redistribution of artistic agency and a redefinition of what the aesthetic might be and do. The pursuit of common ground and a sense of the public good are key aspects of 1960s art-and-technology projects that are easily overlooked amid the (sometimes literal) smoke-and-mirrors spectacle of much of the activity. Without the prospect of social, as well as artistic, transformation, an ambition shared, though manifest in different forms, by the historical avant-garde and aspects of progressive pedagogy reintroduced to the US through Bauhaus émigré artists and educators, the art-and-technology projects are largely just experiments in doing things with lasers. Taking the avant-garde credentials of the project leaders seriously means that these otherwise ephemeral enterprises ought to be situated within a longer temporality that includes both the politics of the early twentieth-century avant-garde and the early twenty-first century reclamation of some of the key 1960s projects. Furthermore, if there are political considerations at play in the art-and-technology projects, which we believe there are, an understanding of how the avant-garde aspirations of American artists might be situated within the broader cultural climate of mid-century corporate liberalism is necessary, for it is this climate that spawns and then destroys them.

World War II drew the United States into international affairs, and postwar global geopolitics was redefined largely according to US interests. With much of Europe and the Soviet Union devastated by war and economically depleted, the Pax Americana was predicated on the superiority of democracy as a system of government capable of restoring ruined nations and maintaining peace. This notion of the US as the modernizing guardian of freedom was especially compelling given the extended Soviet influence across Eastern Europe.

The new global responsibilities facing the US were inevitably colored by anxieties produced by evidence of the extent to which political extremism in Europe had gripped entire populations. The massive mobilization of US resources during the war had radically extended the role of government in American life far beyond anything imagined by the architects of the New Deal. The scale of the challenges facing the postwar world left little room for a rollback of government intervention; indeed, the Federal management of domestic affairs, not to mention foreign policy, came to be seen as entirely commensurate with the successful organization of a complex modern society. The effectiveness of wartime mobilization, not least through the coordination of scientific, technological and military institutions and personnel, suggested that the continuation of support for research across the human and physical sciences should be maintained and developed during peacetime, not only for the purposes of national security but also to enhance the health and prosperity of the American people. To the extent that American democracy was normalized as the natural order of things, structured according to the value-neutral terms of a scientific rationality free from theological or ideological influence, then the application of reason, in its managerial and organizational modes, could be understood as entirely in keeping with the democratic spirit.

Certainly, the prosperity enjoyed by many Americans during the 1950s and early 1960s appeared to confirm the sense that science and technology were delivering unprecedented rewards in the form of the new consumer goods and improved infrastructure that transformed cities, created suburbs, provided jobs, and delivered mobility, opportunity, security, comfort, and, indeed, pleasure. Organizational efficiency and design innovation elevated the status of scientists, engineers, and planners, despite growing concerns regarding the increasing conformism of American life. To an extent, the collective labor of corporate America and its potentially flattening social effects could be offset by a celebration of cultural ingenuity and novelty. The multiplication of consumer goods and services, along with the emergence and promotion of a distinctive American culture able to embrace popular forms yet serious enough to supplant European predecessors, suggested that fears of bland uniformity could

be outweighed by the energy and inventiveness of a people unfettered by old-world ideological limitations.

The American postwar embrace of the modern, then, meant holding in abeyance a number of contradictions. Even as contemporary science became too difficult for the uninitiated to understand, science and the scientific method were conceived of as foundational to modern democracy, guarantors of impartiality and objectivity. At the same time, it was the scientists who continued to invent the ever more destructive means by which the world might be destroyed. The same ambivalence marks the extension of new technologies into every aspect of life. Technology was self-evidently an engine of social change and emancipatory potential, yet technology also injected into everyday life a nonhuman world of efficiency and alienation. Similarly, while individual freedom remained the bedrock of democratic virtue, the complexity of modern society increasingly required expert organization and management according to rational principles. This reliance on expertise extended into the arts which, despite their purported achievements, had become, like much modern science, increasingly abstruse and incomprehensible to the untutored.

The percolating anxieties during the 1950s surrounding unwelcome levels of conformity and social control, not to mention the existential dread fostered by an awareness of the atomic bomb, sat alongside the widespread celebration of mastery and expertise that also characterizes the era. The response to this unease was, in many areas of life, a commitment to more integration and more effective management, wider collaboration, and deeper investigation of the psychosocial dimensions of the modern world. The wartime emergence of cybernetics and systems thinking found new converts far beyond their military applications and converged with other approaches to conceptualizing totality, such as Gestalt theory.[1] The sense that the complexity of any given situation required the combined understanding of numerous perspectives had become established during wartime but, by the 1960s, was a commonplace of American institutional life, from government to university, corporation to think tank. This embrace of interdisciplinarity was, at once, a recognition of the necessary fluidity required to solve complex problems but also, in keeping with the confused rhetoric of American mid-century democracy, an acceptance of the role of the expert and of the necessity of collaboration. As such, the rise of interdisciplinarity as a virtue combined a commitment to collective enterprise among equals with acknowledgement of the distinctiveness of some individuals by dint of their expert knowledge. Interdisciplinary networks provided a context within which individual capacities might be recognized while rejecting the idea that any one individual might be enough. Interdisciplinarity allowed

for expertise but rejected the notion of individual genius. Part of the attractiveness of interdisciplinarity during the Cold War across a wide spectrum of fields was that it appeared to capture something of the spirit of what a properly functioning democracy might look like. It is within this context that the transfer of avant-garde artistic energies from Europe to the US was able to find a plausible place within the burgeoning military-industrial organization of Cold War America.

The postwar emphasis on interdisciplinary collaboration and creativity in the human and physical sciences chimed with the broad contours of the historical avant-garde's challenge to bourgeois art, namely through a rejection of individual genius and a stress on collective practice; a commitment to experimentation and process over outcome; a dismissal of medium specificity and a dismantling of the distinction between art and non-art, or, in other words, between art and life. While it is clearly a stretch to draw analogies between Dada or the Bauhaus and the RAND Corporation or the Macy conferences, a general sympathy toward the collaborative and the innovative increasingly attracted, during the 1960s, the seemingly incommensurable worlds of advanced Cold War technoscience and advanced art. It is a convergence that is made possible by the heightened status of scientists and engineers during the early Cold War, who came to serve as models of a new creative class, and the expanded ambitions of artists seeking access to new materials and methods of fabrication made possible by technical advances as well as a revivified sense of art's social remit as the high formalist moment of American abstraction came under increasing pressure from the neo-avant-garde.

The purpose here is not to smooth out the profound differences in mission and function among technologists, scientists, and artists, nor to suggest that these constituencies necessarily shared the same broad vision and subscribed to the same values. In many ways the converging paths of technology and art during the 1960s was as much a clash as it was a meeting, and the often fractious and slender common ground between them will be the subject of a good deal of what follows. What scientists, engineers, defense intellectuals, and artists did share, nevertheless, was a common sense, distributed widely in the culture not only in the US but strongly registered overseas as well, of the remarkably propulsive power of American modernity and its capacity to actualize new modes of experience and social organization on a grand scale. To no small degree this sense was a consequence of unprecedented and unrivaled access to financial and technological resources and the organizational structures with which to deploy them. Yet beyond the simple fact of wealth and power, the compelling narrative the US was able to establish for itself, as the sole legatee of

a European tradition of enlightenment only the US was capable of protecting, lent a powerful moral charge to the stewardship of a world yet to attain the state of immanent utopia America already enjoyed. This sense of mission is there in the dream of a post-ideological liberal democracy run by a benign bureaucracy of experts, and it is there also in the post-disciplinary aspirations of art and technology collaborations that grew, in weird technocratic countercultural formations, out of Black Mountain College in North Carolina, Bell Laboratories in New Jersey, the Massachusetts Institute of Technology in Cambridge, Massachusetts, the Los Angeles County Museum of Art (LACMA), and elsewhere.

While Black Mountain was not explicitly geared to art-and-technology collaboration, the college was an important meeting point where the cross-disciplinary, thinking-by-doing ethos shared by the Bauhaus and American progressive education were synthesized. Many of the key participants in art-and-technology projects of the 1960s passed through Black Mountain either as visiting staff (John Cage, Buckminster Fuller) or as students (Robert Rauschenberg, Stan VanDerBeek). The Bauhaus influence also permeated MIT's Center for Advanced Visual Studies (CAVS), founded in 1967 by György Kepes, who had previously worked with László Moholy-Nagy at the New Bauhaus in Chicago. Unlike Black Mountain, which was a resolutely New Deal-era liberal arts college, MIT was at the heart of Cold War R&D, and the well-funded labs provided CAVS fellows like VanDerBeek and Jack Burnham with access to the most advanced technology.

If MIT was the paradigmatic Cold War university, Bell Labs, where scientist Billy Klüver launched Experiments in Art and Technology (E.A.T.) with Rauschenberg in late 1966, represents the other side of Cold War research. A private company whose labs were designed to replicate the flow of ideas and personnel more characteristic of a campus than a business, Klüver and others at Bell had, since the 1950s, facilitated an easy movement of artists, musicians, and composers from New York City and nearby Rutgers University and Douglass College through the Murray Hill complex. Envisaged as a clearing-house for art-and-technology collaboration, E.A.T. was at once an agency, lobbying organization, and think tank. More limited in scope but still capable of drawing on major resources, LACMA's Art & Technology Program (A&T), launched in 1967 by curator Maurice Tuchman, sought to hook up artists with organizations and businesses in Southern California's booming industrial and technology sectors. More focused on producing art than E.A.T., and culminating in an exhibition at the museum in 1971, A&T provided access to resources and expertise for a number of prominent artists, including Andy Warhol, Claes Oldenburg, R. B. Kitaj, and E.A.T. members Rauschenberg and Robert Whitman.

Some of these initiatives have become legendary, such as Black Mountain and E.A.T., even when, and sometimes because, their achievements were short-lived. In recent years, there has been revived interest in many of the 1960s projects as new technologies and new conceptions of art practice have sharpened a desire to locate, evaluate, and emulate predecessors' experiments. Yet the projects discussed here were all relative failures, if success is measured according to the pronouncements of the project leaders, and they often sustained heavy critical fire during their brief life spans. The demise of these experiments in collaborative, interdisciplinary exploration can be easily summarized in local terms—lack of funds, lack of shared agenda, inability to engage or persuade relevant constituencies, withdrawal of institutional support—but the larger failure lies in the breathtaking collapse of confidence, during the latter half of the 1960s, in the US as a legitimate world power and the rapid reversal of fortunes, and withdrawal of trust, experienced by the institutions that authorized that power. The complexity of modern society was, by 1968, no longer a marvel to behold for many Americans; indeed, complexity came to be seen as a function of power, and expertise its instrument. In retrospect, it is hard to imagine a worse time to launch an art-and-technology initiative than 1967, the moment at which technology was no longer seen as an open invitation to build the future but increasingly perceived simply as a weapon.

One measure of the shifting political assessment of technology was the publication in the *New York Review of Books* in 1969 of sociologist John McDermott's withering response to the techno-optimism promoted by Emmanuel Mesthene, director of the IBM-sponsored Harvard Program on Technology and Society, which had just released its fourth annual report. By the time sculptor Richard Serra wrote, two years later, in response to the Los Angeles A&T exhibit, that technology is neither art nor invention but "what we do to the Black Panthers and the Vietnamese under the guise of advancement in a materialistic theology" (Serra and Serra 1980, 40), McDermott's association of technology with a managerial elite blind or indifferent to its catastrophic effects had become a widespread concern.[2] Perhaps the worst critical battering among the prominent art-and-technology projects of the later 1960s was meted out to A&T, but it was merely the most visible casualty of the renunciation of the utopian promise of a marriage of art and technology. Ambitious projects in the early 1970s saw E.A.T. developing satellite broadcasting and communications technology in developing countries, but these were hampered by lack of funds. Kepes retired in 1974.

The restructuring and realignment of defense R&D funding according to a more entrepreneurial and commercial model after the legitimation crisis of

the late 1960s is part of the broader neoliberal deployment of marketization as a means of redistributing responsibility and accountability from the late 1970s onward. In the arts, by the early 1980s the institutional critique posed by post-minimalist, often politically radical, forms of practice (the kind of critique targeted at the 1960s art-and-technology projects discussed here) was supplanted by a revival of interest in painting (including such US artists as Keith Haring, Jean-Michel Basquiat, and Ross Bleckner, along with influential German painters like Anselm Keifer, Georg Baselitz, and Gerhard Richter) and the ironic distance of the so-called Pictures Generation (including Barbara Kruger, Cindy Sherman, and Richard Prince), both tendencies capable of delivering gallery- and market-ready product relieved of the broader conceptual and political burdens posed by the neo-avant-garde. As the art world became increasingly financialized and globalized as a luxury dry-goods market, and as New York became merely a node in the global supply chain rather than the pacesetter, the kind of artists engaged in the explorative interdisciplinary work characteristic of the art-and-technology projects of the 1960s were more likely to find a welcome home in Silicon Valley, where the Stewart Brand mode of techno-futurist pioneer-consultancy, of the kind prototyped by Buckminster Fuller, had become the orthodox workplace model. Brand's celebration of MIT's Media Lab in a 1987 book that claimed, in its subtitle, that MIT was "inventing the future" there, is emblematic of the shift away from art as such and toward a more fluid conception of innovation as world-building. To an extent, this had been the ambition of art-and-tech projects from the outset, from the Bauhaus and Black Mountain through to E.A.T. and CAVS, and had undergirded the utopianism of the avant-garde project since the early twentieth century. Yet the integration of art and life achieved at Media Lab and in Silicon Valley, as much as it appeared to realize the erasure of distinctions between art and technology, work and leisure, that had been central to the historical avant-garde's political ambitions, speaks more directly to the restructuring of capitalist relations of production after the 1970s than it does the eradication of bourgeois values.

The early twenty-first century has seen a surge of interest in art-and-technology collaborations that is at once future oriented and backward looking.[3] The reputations of the main 1960s projects considered here, summarily dismissed at the end of that decade as the worst kind of complicit corporate art, have all recently found themselves positioned as illustrious predecessors. In 2013, LACMA launched the Art + Technology Lab (A + T), explicitly inspired by the museum's 1960s project and designed to support artists seeking to develop work with emerging technology. In 2015, MIT's Center for Art, Science, and Technology (CAST), the descendent of Kepes's CAVS, received a $1.5

million Mellon Foundation grant to further promote and enable the center's mission to inspire teaching, research, and programming that operate at the experimental intersections of art, science, and engineering. In 2016, marking the fiftieth anniversary of Klüver's celebrated 9 Evenings: Theatre and Engineering, the project that kick-started E.A.T., Nokia Bell Labs launched the E.A.T. Salon, another self-consciously retro-futurist collaborative venture intended to foster innovation across the arts and technology sectors. All at once, it seems, the present has caught up with, or at least caught on to, the lost futures canceled by the most egregious excesses of Cold War militarism.

The revival of interest in art-and-technology collaboration in the early twenty-first century, not least in the retrieval of the earlier projects as proudly displayed precursors, is, we argue here, not only a consequence of the massive transformations brought about by ubiquitous computation, but also due to the permeation of contemporary life by the time-limited, project-based, collaborative-labor model that has restructured society according to the demands of the neoliberal market. The buzzwords of the entrepreneurial ethos are in many cases the same terms circulating in the jargon of Cold War corporate liberalism, yet what has been evacuated from notions of creativity, collaboration, and interdisciplinarity in their contemporary iterations is the sense that they were of value to the extent that they served a public good. It is true enough that the conception of what constituted the public, as understood through the scientism of the Cold War corporate state, might have been severely delimited and exclusionary, yet the realpolitik driving the need to improve creative and productive capacity in science and industry, and in society more broadly, nevertheless carried a utopian charge largely missing from the atomized, Hobbesian revanchism typical of twenty-first-century enterprise. The contemporary art-and-technology lab is reliant on the precarity of the contemporary labor market in the culture industries as much as it is the beneficiary of tech largesse. In this regard, as in others, the history of art-and-technology collaborations since the postwar period is part of the narrative outlined by Philip Mirowski in his series of books that track the mutually supportive energies among neoclassical economics, physics, and the military as they produce neoliberal thought out of Cold War computation (Mirowski 1989, 2002, 2011, 2013; Mirowski and Plehwe 2015).

Recent scholarly and curatorial interest in the 1960s art-and-tech projects has identified them as influential in facilitating the use of computation and other new technologies in contemporary art (see, e.g., Blakinger 2016; Blauvelt 2015; Lee 2004; Wisnioski 2012). To a significant degree, what was once seen as somewhat marginal to art history has acquired a prominent place.[4] The political ramifications of these projects, however, and their relation to the wider

military-industrial agenda of the Cold War US, remains under-examined and is often positioned as a background concern in the context of a predominantly art-historical narrative. On the other hand, recent work in the history of the social sciences, science and technology studies, and related fields, has explored the extent to which Cold War thinking, especially in relation to systems analysis and rational choice theory, came to permeate American social organization and embedded itself into the deep structure of economic, political and social life (see, e.g., Amadae 2003, 2015; Cohen-Cole 2014; Erickson et al 2013; Isaac 2007, 2011; Oreskes 2014; Rohde 2013; Solovey and Cravens 2012). Our aim, here, in part, is to draw together the strands of these two histories in order to contextualize art-and-technology projects within a broader narrative about the changing fortunes of American liberalism, and to understand how the progressive ethos realized, fleetingly, at institutions like Black Mountain and, less expectedly, commercial concerns like Bell Labs, was metabolized by the military-industrial state into neoliberal orthodoxy.

In his book on artistic labor, *Dark Matter*, artist and activist Gregory Sholette wonders whether it is not "the alleged radicalism of art, but its demonstrated capacity to mobilize excess, even redundant productivity, that makes it an attractive model to the priests and priestesses of the new networked economy" (Sholette 2011, 43). Perhaps, he goes on, it is "not the artist's seemingly transgressive, risk-taking nonconformity, but exactly a mode of distributed risk and social cooperation denied by neoliberalism that leads certain CEOs and business thinkers to see artistic methods as near-miraculous models of 'just-in-time creativity'" (43). The impetus for art-and-technology collaborations during the 1960s largely came from those with an interest in realizing the potential of art, whether it was curators like Maurice Tuchman and Jane Livingston at LACMA or committed art-loving engineers like Billy Klüver. The traffic was mostly in one direction, with Tuchman, Klüver, and Kepes, among others, working to persuade an indifferent or openly hostile science and tech establishment to accommodate the unusual interests and demands of artists. To a significant degree, as James Conant's Cold War model of general education, discussed below, suggests, the predominant notion of the arts through the Cold War period was that of civilizing influence, necessary for social cohesion and the inculcation of values but distinct from the serious, albeit creative work of research, design, and manufacture. When collaboration between arts and engineers did happen, the resulting work retained the imprimatur of the artist's signature, despite the efforts of some, like Klüver, to credit participating engineers.

To a considerable extent, then, the notional two-cultures model that dominated the debate in the early 1960s remained largely untroubled by the

incursion of artists into laboratories, workshops, and factories. The situation outlined by Sholette, however, suggests a significant shift in the perceived value of art and artists among corporate and business leaders, thanks in no small part to the successes of the tech sector and the restructuring of the economy since the 1970s, to which the rise of Silicon Valley substantially contributed. From a twenty-first-century vantage point, the claims made for creativity, innovation, and interdisciplinary collaboration during the 1950s and 1960s by scientists and artists seem unremarkable indeed, given the extent to which these virtues have become normative. Yet the mainstreaming of the idea of the creative economy enabled by the absorption of countercultural rhetoric into tech business strategy has not resulted in the kind of revolution of everyday life envisaged by the historical avant-garde or its mid-century descendants. Instead, a deregulated and dematerialized economy no longer beholden to any national interest or labor force has found it extremely easy to accommodate the revolutionary ambitions of the avant-garde. A successful enterprise is now one that is nimble, creative, innovative, and disruptive, its workers contributing as outsourced entrepreneurs on temporary or time- or project-based contracts. The ability and willingness to collaborate is a given.

As university research has also become increasingly marketized, not only in the commercialization of military-related R&D, but also through the competition for funding, faculty, and students, the distinction Cold War technocrats defended between so-called basic (or non-instrumentalized) and applied research has become less relevant. In such a climate, the arts and humanities have repositioned themselves as players in the new creative economy, the virtues associated with these fields, such as critical and analytical inventiveness and the production of conceptual and formal novelty, now valued as a necessary component of an interdisciplinary business environment. The reconfiguration of art practice as research under these conditions, though it is often explained as a means of securing equal status across disciplines and as a recognition of practice as a mode of rigorous inquiry, nonetheless normalizes and regulates the antinomian energies still associated with the arts as another branch of the knowledge economy.

It is, then, artists (and the folk history of their creatively disruptive force), if not art itself, that have been celebrated, and vilified, as the primary agents of urban gentrification and the source of creative juice powering all manner of start-ups and entrepreneurial adventures. Sholette's point that it is not their radicalism but their capacity for adaptation and cooperation that makes artists valuable for business is an argument Klüver or Kepes would have been unlikely to contest. What they would have challenged, however, is the degraded status,

if not the complete erasure, of the notion of a public good that counted for more than economic gain. Despite the nonideological ideology of much US Cold War thinking, where American democracy operated unproblematically as code for human nature, and despite the strategic value placed on celebrations of individual creative freedom within the context of a set of tacitly accepted, shared normative values, the grand talk of "civilization" or "Western man" did presuppose a model of human community and the collective good.[5] The extent to which this model also contributed to the deployment of science and technology in the engineering of consent and the suppression of dissent cannot be denied, but the atomized, economistic regime that emerged out of and supplanted Cold War-era consensus culture has left little of the utopian capacities of that era uncontaminated.

The revival of CAVS as CAST, of A&T as A+T, and E.A.T. as the E.A.T. Salon is part of a broader reassessment of midcentury art-and-technology collaborations that identifies, correctly, the germ of many present preoccupations in those initiatives. Yet the conditions under which these projects are revived or reimagined must be attended to, just as the military-industrial context of the original projects must be understood as integral to their formation and, significantly, to their demise. The new art-and-tech projects are often sponsored by the tech sector and encourage work in areas such as machine learning, augmented reality, and robotics that are already the mainstays of contemporary technological R&D. The artists participating in these ventures are less likely than in the 1960s to be art "stars" and less likely to produce works for exhibition. Instead, they are the art professionals contracted in or winners of funding or residency competitions tasked with realizing projects that fall within the purview of the host institution. In a society where art's emancipatory capacity has been codified as its contribution to a culture of competition-driven entrepreneurial dynamism and precarious labor, computationally mediated information flows and privatized spatiotemporal capacities, it is unsurprising that it is these elements latent in the 1960s projects that have been pulled out for use while the radical potential embedded therein—the incubated though often dormant revolutionary energies of the historical avant-garde—lay undisturbed.

The aim of this book is to disturb these energies and to address the 1960s art-and-tech ventures within a context that extends backward and forward. We return to the early twentieth century in order to understand how the complex coupling of American progressive liberalism and the European and Russian avant-garde produced a distinctive mid-century US art-technology utopianism even as it was invariably nested within the growing military-industrial infrastructure of the corporate state. Chapter 1 seeks to position the 1960s art-

and-technology projects as the product of a particular way of thinking about the relation between science and democracy that has its roots in John Dewey's pragmatism. It is Dewey's conception of the scientific method as a generalized mode of active engagement with the world that enables him to conceive of science, technology, education, and art as aspects of a dynamic and transformative collective project capable of actualizing a democracy commensurate with American modernity. The influence of Dewey's ideas in Germany contributed to the design philosophy of prominent schools like the Bauhaus, many of whose leading figures emigrated to the US during the 1930s. Bauhaus émigrés like Josef Albers and György Kepes, among others, brought an understanding of the European modernist avant-garde synthesized with a Deweyan model of scientific democracy that provided a compelling model for collaborative, interdisciplinary art-and-technology research for US artists and designers during the 1950s and 1960s.

World War II and the early years of the Cold War, however, also saw a realignment of priorities in education and the conception of the democratic citizen toward specialization and expertise and away from Dewey's participatory collectivism. The massive surge in federal funding of scientific research and the exalted position of the scientist provided a plausible context for art-and-technology collaboration, but the social ambitions driving the Bauhaus-Dewey model were increasingly downplayed, challenged, or distorted by the corporate liberalism that developed to fight the Cold War. The following three chapters consider key 1960s art-and-technology initiatives—CAVS, E.A.T. and LACMA's A&T—as they attempt to work through the implications of what is essentially a progressive conception of participatory democracy within distinctive but related institutional contexts. We read the main 1960s art-and-tech projects as engaged, in various and challenging ways, with the prevailing ethos of the postwar institutions that supported them; that is, the research university, the military-funded corporation, and the modern art gallery based in a region booming on defense-industry growth. It is here that the radical legacies of the artistic avant-garde collide with the normalized corporate liberalism of the Cold War.

In chapter 2, we focus on MIT as the site of Kepes's attempts to redeem the Cold War university through the arts. Chapter 3 considers E.A.T.'s collaborative model as an extrapolation of Bell Labs' innovative and longstanding support of interdisciplinary working within the private sector, though Billy Klüver's stress on practical problem-solving remained loyal to the notion of the artist as the center of gravity underpinning any art and science collaboration. The strategy of LACMA's Art & Technology program, explored in chapter 4,

was perhaps less ambitious than those of either Klüver or Kepes in terms of broader social outlook, but the attempt to link Los Angeles's new museum into the Southern California business environment nonetheless grasped the sense that art constituted a field of expertise on a par with technology and science. By focusing on collaborations LACMA established between individual artists and two of the most influential think tanks of the era, the RAND Corporation and the Hudson Institute, we consider how notions of expertise and specialist knowledge proved more resistant to collaborative enterprise than Klüver and Kepes might have hoped.

The art-and-tech programs were never reductively complicit with military-industrial interests, however much their contemporary critics labored to make the charge stick. Instead, they operated within a broader cultural climate where the imbrication of technological innovation and social progress were largely unchallenged and where the perceived nonideological virtues of creativity and collaboration could do real work toward the preservation and protection of the public good. Chapter 5 takes a wider view of the ways in which art-and-technology projects of the 1960s attempted to erase distinctions across media, disciplines, and subject specialization in order to grasp the totality of American modernity. In a variety of ways, E.A.T., CAVS, and LACMA were all involved in international expositions aimed at promoting American technology and American values. Through examination of some of the ambitious work undertaken by, among others, Charles and Ray Eames and Buckminster Fuller, we address the cybernetically influenced desire to capture, and to an extent account for, the dynamic, fluid capacities of the modern world. Bolstered by the post-ideological imaginary fostered by US corporate liberalism, the "everything is connected" ethos allowed designers like the Eameses and Fuller to imagine a benevolent generalized technology fully commensurate with the natural order and capable of awakening untapped human capacities. Though there remains more than a trace of Dewey's anti-dualistic thinking in projects like Fuller's, and their techno-utopianism found a ready audience among a counterculture suspicious of Cold War politics, the post-ideological notion of a value-free technology deployed by the unprecedented creative capacities of an affluent and benevolent democracy failed to account for the Vietnam War.

Finally, in chapter 6 we look forward from the 1960s to consider the complex legacy of the era's projects as it is manifest in twenty-first-century iterations. The limits of the 1960s art-and-technology projects were largely set by the realities, rather than the rhetorical claims, of Cold War corporate liberalism, and the escalation of the war in Vietnam rapidly undermined the utopianism that promised the solution to social problems through the application of

scientific rationality. The projects discussed here did not survive the erosion of confidence in the American government of the late 1960s and early 1970s. Chapter 6 reflects on the reasons for the turn away from art-and-technology projects. It also explores how the funding of defense research and development after Vietnam served to reshape the relation among universities, the private sector, and the defense establishment, contributing to the growth of new technologies such as computing and biotechnology. The twenty-first-century tech sector, in its turn, has prepared the ground for the reemergence of art-and-technology initiatives, and this chapter examines the revival of our three core projects from the 1960s.

Part of the story here, as will hopefully become clear, is the way in which the Cold War generated the conditions and the modes of thinking that enabled neoliberalism to take root as the latest nonideological ideology. The work on probability that made possible the innovations of the Manhattan Project and migrated, postwar, to think tanks like the RAND Corporation, where game theory underpinned nuclear strategy before finding widespread applications in economics and the social sciences, is a narrative that runs alongside, and periodically intersects with, the history of the artistic avant-garde. This dual track, crisscrossing series of knots and loops binds the history of art and the history of science and technology in the US during the twentieth century. Together, these entwined strands reveal much about the assumptions and legacy of the American Century, its cultural, economic, and military reach, and the ways in which those assumptions continue to shape our sense of the limits of the possible.[6]

# 01

## Science, Art, Democracy

The danger is in the neatness of identifications.
—Samuel Beckett, "Dante...Bruno. Vico...Joyce"

The art-and-technology projects of the 1960s mark the meeting point of the post-formalist experimentalists of an ascendant American art and the federally funded military-industrial university R&D machinery of the Cold War superpower. What these very different constituencies share is a commitment to continuous innovation in the design and application of technology, an understanding that this process requires collaborative experimentation, and that such a process is, broadly speaking, a social good, whether that means enhanced national security and an improved standard of living, or new modes of experience and understanding. Without this broadly sympathetic outlook, it is hard to imagine organizations like Bell Labs or the companies involved in LACMA's Art & Technology Program (A&T) allowing artists, however grudgingly, on-site. Nor is it likely that artists would have participated so willingly without some inkling that science and industry offered, beyond merely technical expertise and access to materials, opportunities to explore new modes of working. It is true that in some cases the main draw for artists was the prospect of being able to scale up their work using skills and resources otherwise unavailable to them. It is equally the case that the presence of artists in some companies and institutions was seen as a burdensome interference with business as usual. Nevertheless, a

general faith in the powerful capacities of technological innovation to further the interests of American society, a widely shared sense that American ingenuity and energy were inventing the future, largely outweighed local challenges to the view that art and technology were operating according to the same aspirational values.

The shared virtues of creativity, collaboration, and experimentation that underpinned interactions between art and technology, however, mask profoundly different ideas of what those terms might mean and how they might be achieved. The conception of experimental collaboration in the arts largely derived from the process-oriented practice developed during the Progressive Era's engagement with educational reform, coupled with the integrated design practices characterized by European schools like the Bauhaus. By contrast, by the end of World War II, innovation and collaboration, as understood by institutions training and employing American scientists and engineers, were aspects of an expertise-driven intellectual economy made possible through a system of education based on competition and specialization. Both views of creativity, collaboration, and experimentation were predicated on an understanding of a necessary interdependency between science and democracy, yet the nature of that relationship depended on very different notions of what each of those terms might mean. The art-and-technology projects of the 1960s, then, mark the collision of two versions of what an American scientific democracy might look like.

A commitment to the belief that a scientific culture, broadly conceived, could support and enlarge American democracy is present at least as far back as the post–Civil War period, when a scientific approach to understanding the physical and social worlds provided, it was thought by advocates of science, a regulatory ethical check on religious and corporate interests (see Jewett 2012, 28-54). Exposure to the principles and methods of science was considered crucial to the formation of citizens capable of disinterested observation, empirical inquiry, and the rational pursuit of knowledge uncontaminated by ideology, dogma, or narrow self-interest. To be sure, the promotion of science as a value-free model of social reproduction also contributed to the scientism that legitimated corporate managerialism and the engineering of consent, perhaps most vividly illustrated by the rise of Fordism. Nonetheless, the social liberalism of the Progressive Era was grounded by the sense that science provided the framework through which a modern democratic society could most effectively organize itself in a secular fashion for the purposeful well-being of all citizens and that effective intervention could mitigate the inequalities produced by unregulated individualism.

This was certainly the position of philosopher John Dewey who, during the first third of the twentieth century, emerged as America's foremost pub-

lic intellectual and, more than perhaps any other single figure, shaped and influenced debate on the relations between science, politics, and society in the United States. It is Dewey's argument for a ground-up rebuilding of American democracy through an education system informed by the experimentalism of the scientific method that dominated the strain of art-and-technology collectivism that runs from the Bauhaus through Black Mountain College and, through shared personnel, into projects like MIT's Center for Advanced Visual Studies (CAVS) and Bell Labs' Experiments in Art and Technology (E.A.T.). It was, however, precisely in opposition to Dewey's model of scientific democracy that the military-industrial management of US science and tech research culture conceived of itself after World War II, even though the fundamental commitment to an imbricated science and democracy remained its core principle. The contest over the meaning of the relations between science, democracy, and education is at the heart of art-and-technology collaborations between the artistic and military-industrial avant-gardes, and Dewey is the pivot.

**Democracy and Education**

Dewey's thinking on democracy was forged in the pre–Progressive Era in Chicago in opposition to the dominant laissez-faire interpretation of Darwinism, popularized by Herbert Spencer's phrase "the survival of the fittest," and the atomistic conception of individualism that accompanied it.[1] Exposed to the settlement house movement's attempt to bridge class and cultural divisions through his involvement with Jane Addams's Hull House and that organization's participation in campaigns for factory legislation and improved services, Dewey's commitment to Chicago's reform movements resulted in the opening of the Laboratory School of the University of Chicago in 1896. The purpose of the so-called Dewey School was to test the proposition that the social reproduction of democracy required a properly democratic education.[2] The most effective means of achieving this, for Dewey, was to emphasize collective problem-solving over the top-down delivery of information. As such, at the center of the curriculum was what Dewey called, in his 1899 book *The School and Society*, the "occupation," by which he meant "a mode of activity on the part of the child which reproduces, or runs parallel to, some form of work carried on in social life" (Dewey 1983, 92). By engaging in occupational activities, students were expected to learn practical skills as well as gain an appropriate knowledge of all the subjects, from history through mathematics, physics, biology, reading, writing, and art and music, required to fulfill the task. The acquisition of knowledge was driven by a need to develop the skills and use the tools necessary

to undertake an occupation. For Dewey, "until the emphasis changes to the conditions which make it necessary for the child to take an active share in the personal building up of his own problems and to participate in methods of solving them (even at the expense of experimentation and error) mind is not really freed" (quoted in Westbrook 1991, 103).

Among the common misrepresentations of Dewey's pedagogy is that it is a model of child-centered learning and that it is mainly an argument for vocational training at the expense of intellectual inquiry, neither of which is accurate. The construction of an environment within which learning could be shaped was a key component of Dewey's sense of the teacher as a tireless agent in the development of character, and Dewey was a vocal critic of the child-centered education advocated by some Chicago reformers. On vocational training, Dewey likewise was at odds with the growing demands for the inculcation of "industrial intelligence" in schools made by business leaders. Dewey's problem-solving, occupation-based learning was conceived as a means of removing the distinction between culture and utility, not training for the workplace, and he was contemptuous of those who claimed vocational education was more democratic than traditional learning. "Nothing in the history of education is more touching," wrote Dewey, "than to hear some successful leaders denounce as undemocratic the attempts to give all the children at public expense the fuller education which their own children enjoy as a matter of course" (quoted in Westbrook 1991, 178). A reductive reading of Dewey's educational philosophy that sees only free play or instrumental training is possible only if the operating principles underpinning Dewey's thinking—that is, the overlapping virtues of science and democracy—are ignored.

Dewey claimed that Hegel had left a "permanent deposit" in his thinking, and the notion of *Bildung* shapes Dewey's understanding of education as a process of growth through experience.[3] The German *Bildung* tradition's insistence on the social nature of the self is crucial for Dewey, as is Hegel's expansion of *Bildung* to include a challenge to superstition and tradition. While Dewey rejected the transcendental impulse in Hegel, the stress on conflict and struggle—the perpetual encounter between consciousness and the world—is central to Dewey's understanding of inquiry as embodied, dynamic, and prospective. Dewey's combative resistance to binary thinking means that, for him, there is no separation between theory and practice, knowing and doing. The difficulty with this holism, however, is that it becomes hard to make any kind of distinction at all between one mode of operation and another. Science, democracy, ethics, education, aesthetics: for Dewey, these are mutually supportive terms underpinned by a commitment to open-ended experiment grounded in "expe-

rience," the everyday interaction of the human subject with the environment. One of the reasons Dewey has been misrepresented or misunderstood so often is that his preference for ordinary language over technical philosophical terminology, not to mention his infamously longwinded style, means that his arguments lack the kind of precision that might inoculate them against reductive or inaccurate interpretations. Yet the fluidity with which Dewey moves between science and democracy, experience and aesthetics, however imprecise, is entirely in keeping with his rejection of hard edges that might wall off one term from another.

A Darwinian commitment to growth and change is never far from Dewey's thought, while scientific method, as an active means of advancing knowledge, is conceived of as a social instrument capable of emancipatory transformation (see, e.g., Metz 1969). What Darwin gave Dewey was a means of preserving Hegel's notion of progress while ditching any sense that progress is inevitable. The struggle in Darwin, for Dewey, is about finding ways to survive current conditions. This extends to philosophy and the overthrowing of outmoded ideas. Old ideas, for Dewey, are more than just abstract forms; they are "habits, predispositions, deeply engrained attitudes of aversion and preference" (Dewey 1910b, 19) that "give way slowly" since the questions and alternative answers are already anticipated by the framing of the idea. In fact, Dewey claims, "intellectual progress usually occurs through sheer abandonment of questions together with both of the alternatives they assume—an abandonment that results from their decreasing vitality and a change of urgent interest" (19). Old questions are not solved, Dewey concludes; "we get over them" (19).

Among the challenges posed in getting over the old questions is how to give proper weight to ideas and categories that have become narrowly instrumental. If education, for Dewey, is more than the acquisition of facts and skills, science is more than accumulated scientific knowledge and democracy is more than a system of government. For Dewey, it must be the job of inquiry to resist the limitations of current definitions—an abandonment of the dominant paradigms framing the limits of the possible. Dewey is clear that the current understanding of science is no less limited and problematic than already existing democracy. Terms like "science" and "democracy," for Dewey, have been degraded by their association with the inequalities produced by capitalism and must be reconstructed, along with philosophy, as functions of a dynamic liberal polity. Science, so conceived, is not a body of knowledge but a method of inquiry tethered intrinsically to the needs and desires of everyday life. In its most general form, Dewey divides inquiry into five steps: "(i) a felt difficulty, (ii) its location and definition, (iii) suggestion of a possible solution, (iv) development

by reasoning of the bearing of the suggestions, (v) further observation and experiment leading to its acceptance or rejection" (Dewey 1910a, 72). The stress here is on the experiential and material: difficulties are "felt," located, and defined; reasoning is not abstract but emerges in response to a concrete situation and leads to relays of experiment and observation. What is also striking is the resistance to any conclusive end to the process. Indeed, for Dewey, reflective thinking "involves a willingness to endure a condition of mental unrest and disturbance" that is not likely to abate: "To maintain the state of doubt and to carry on systematic and protracted inquiry—these are the essentials of thinking" (13). This notion of science as a perpetual process of self-correcting inquiry underpins Dewey's thinking on philosophy, education, politics, and art.

The influence of Dewey's educational ideas extended beyond the US, notably among German educational reformers, and his notion of "learning by doing" (Dewey 1916, 217) found its way into Bauhaus philosophy through Georg Kerschensteiner's concept of *Produktiver Arbeit* and the Deutscher Werkbund industrial-design movement (see Díaz 2015, 46). In his Bauhaus-era writing, Josef Albers echoes Dewey's critique of knowledge as the transmission of the accumulated opinions, methods, and rules of the past; as Eva Díaz comments, for Albers, like Dewey, "*change* was a privileged term" (47, original emphasis). Walter Gropius also sounds a distinctly Deweyan note in his 1923 essay "The Theory and Organization of the Bauhaus," where he rejects the "old dualistic world-concept which envisaged the ego in opposition to the universe" and notes the "dawning recognition of the essential oneness of all things and their appearances" (Gropius 1938, 22). Gropius shares Dewey's negative assessment of the distortions produced by a narrow ends-oriented industrial economy, and argues that the solution depends on "a change in the individual's attitude toward his work" so that "machine-economy" is reconceived as "a means of freeing the intellect from the burden of mechanical labor" (22). What the Bauhaus offered was an integration of art and craft with trade and industry that would end the reactionary partitioning of creativity, skill, and efficient production, eliminating the rarefied enclosure that cultivated a useless, out-of-touch aestheticism divorced from experience and opening industry to the creative possibilities latent in technological modernity.

### The Torpedo

Alfred Barr only spent four days in Dessau, but his 1927 visit to the Bauhaus school of art had a decisive impact on the future director of the New York Museum of Modern Art (MoMA). Two years before his trip to Germany and

before completing his doctorate at Harvard, Barr was hired to teach art history at Wellesley College, where he offered the first-ever undergraduate course on modern art. While the course focused on painting, Barr introduced the study of design, architecture, film, sculpture, and photography to the class, expected students to read *Vanity Fair*, the *New Yorker* and the *New Masses*, and encouraged appreciation of factory buildings over museum visits.[4] The Bauhaus visit did not make Barr a modernist but it confirmed his pedagogical practices. At Harvard, Barr had worked under Paul J. Sachs, associate director of the Fogg Art Museum, an institution Sachs described as "a laboratory of the fine arts" (Kantor 2002, 56) due to the Fogg's commitment to technical research and experimentation with new methods for the conservation and scrutiny of art works. An understanding of art as institutionally situated and produced through the mediation of a cadre of expert professionals primed Barr for the Bauhaus model of the arts as structurally unified and conversant with the methods and practices of the modern industrial world.

It was Sachs who recommended Barr as the first director of MoMA, though Barr's vision of a multi-departmental museum devoted to, in addition to painting and sculpture, architecture, film, design, photography, commercial, and industrial art far exceeded what the original founders had envisaged. Barr's classificatory tendency, not to mention his teleological sense of the direction of modern art history, is captured in his famous "torpedo" diagrams of the "ideal permanent collection" (figure 1.1). In the first of these, presented in 1933 as part of a long-range plan for building a collection, the torpedo's propeller represents European and non-European "prototypes and sources." Read chronologically from left to right, with the nose of the torpedo facing right, Barr's timeline moves from 1850 to 1950, with significant artists and movements mapped across the body of the projectile. There is still, in the 1933 drawing, plenty of space for the Europeans alongside American and Mexican art at the 1950 nose. A new version of the diagram drafted in 1941, however, is more pared back in terms of notation and now the presence of the US and Mexico expands along a widening axis from just before the 1925 mark until these two countries occupy the entire front section of the torpedo. By 1950, according to the diagram, modern art (at least as far as MoMA is concerned) will be exclusively represented by American (and Mexican) work. Modern art is a moving object, propelled by European energy but charged with an American payload.

The historical trajectory in Barr's 1930s and 1940s projections is accurate enough in its expectation that American modernist art will, by the 1950s, dominate the field. Barr's teleology, as well as his military-industrial trope of American art as the sharp end of US cultural hegemony, with MoMA as its institutional

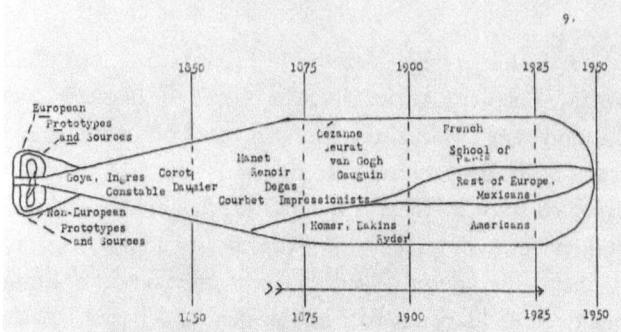

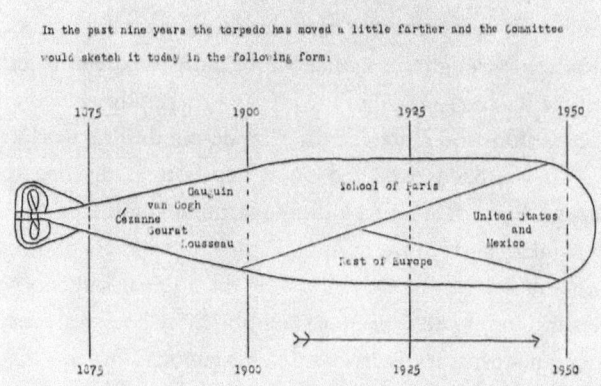

Figure 1.1. Alfred Hamilton Barr's "torpedo" diagrams of the ideal permanent collection of the Museum of Modern Art, as advanced in 1933 (*top*) and in 1941 (*bottom*). Prepared by Alfred H. Barr Jr. for the "Advisory Committee Report on Museum Collections," 1941. Offset, printed in black, 8½×11 in. (20.3×29.2 cm). Alfred H. Barr Jr. Papers, 9a.15, Museum of Modern Art Archives, New York. MA70. © 2019. Digital image, Museum of Modern Art, New York/ Scala, Florence.

centerpiece, are achieved facts soon enough. By this point, thanks in no small part to Barr's advocacy, the Bauhaus had entered the American bloodstream and, alongside other selected strains of the European avant-garde, become a defining influence on some of the most adventurous and utopian aspects of Cold War US culture. As a weaponized avant-garde, front-loaded with a US modernism synthesized out of the thwarted experiments of the recent past and packed into a sleek projectile, Barr's torpedo foreshadows what will become a familiar postwar US narrative: the inheritor and guardian of the best of European inventiveness has reengineered its components and rendered them battle ready.

The movement Barr makes from the "laboratory" of Harvard's Fogg Museum to the Dessau Bauhaus and then on to establish MoMA as a prime disseminator of European, and then American, modernism is in many ways a capsule lesson in how the European avant-garde found an institutional and cultural place in the postwar United States. The stress on an expanded defini-

tion of art along scientific lines in US institutions in the early twentieth century is catalyzed through an encounter with the utopian modernist energies of the European avant-garde just as they are about to be canceled by the rise of fascism. Backed by American finance (Paul Sachs, as well as working for the Fogg, was a partner in Goldman Sachs, and the other MoMA founders included Abby Aldrich Rockefeller, wife of John D. Rockefeller Jr.), and seeded with émigré talent, modern art in the US is assimilated and distributed through elite institutions that, by the end of World War II, are able to serve as beacons of creative liberty and inheritors of the tradition of the new. The postwar expansion of higher education in the US embeds the history of the avant-garde, as it has passed through the interpretive curatorial filter of institutions like MoMA, into American universities, reactivating the unfinished utopian project in the Cold War US.

There is much, then, in the Bauhaus philosophy that chimes with Dewey's anti-dualistic thinking, not only in the shared critique of the deadening effects of industrial labor but in the broadly utopian conception of inquiry free from disciplinary constraints as the agent of transformation. When John Andrew Rice founded Black Mountain College in 1933 following his dismissal from Rollins College in Winter Park, Florida, it was Dewey that provided the theoretical backbone, and Bauhaus émigrés who brought the labor. The new college was modeled on Rice's Deweyan commitment to an education stripped of constraining bureaucracy and artificial disciplinary boundaries. Louis Adamic captured the spirit of the enterprise in a 1936 article for *Harper's* when he wrote, in full Deweyan flow, that at Black Mountain, "education is *experience* that involves in action the whole person" (Adamic 1936, 519, original emphasis). Rice underscores the point in his autobiography: "Black Mountain was to be education for democracy" (Rice 1942, 327). Through connections at MoMA, Rice was able to recruit Josef and Anni Albers just as the Berlin Bauhaus closed. The Gestapo shut down the Bauhaus on April 11, 1933; the Albers arrived in New York on November 24 (Danilowitz 2006). The fact that it was uncertain how the Black Mountain venture would work out actually appealed to the Albers, who were encouraged by the description of the college in a letter of introduction from Theodore Dreier (another Rollins defector whose aunt Katherine was a patron of the avant-garde) as "pioneering" (Danilowitz 2006).[5] The open-ended, unformulated character of Black Mountain met both Deweyan and Bauhaus standards: an improvisatory, experimental environment unencumbered by conventional institutional or disciplinary hierarchies was the perfect site for the emergence of as yet undetermined forms of creative experience.[6]

### Experience as Experimentation

The core element of Dewey's thinking that animated Bauhaus and Black Mountain pedagogy was thinking by doing, or what he called in *Democracy and Education*, "experience as experimentation" (1916, 317). While the "analysis and rearrangement of facts ... is indispensable to the growth of knowledge and power of explanation and right classification," it cannot, for Dewey, "be attained purely mentally—just inside the head" (321). To find something out, something has to be done, conditions have to be altered. This, claimed Dewey, "is the lesson of the laboratory method, and the lesson which all education has to learn" (321–322). The laboratory, he goes on, "is the discovery of the conditions under which *labor* may become intellectually fruitful and not merely externally productive" (322, original emphasis). Under Rice and Albers, Black Mountain modeled itself, in Deweyan fashion, as a laboratory in this sense, providing the conditions under which experimentation might take place.[7]

As Eva Díaz explains, by the mid-1940s, the college "held experimentation to be a practice of changing ingrained habits of perception by testing the contingency of form in controlled situations" (2015, 53). The precise nature, however, of what is meant by "experiment," a term which comes to function in Dewey and others as a code word for freedom, and as such, as intrinsically virtuous, is not always clear. There is a difference, for example, between an experiment as a testing of previously formulated hypotheses and experiment as an innovative procedure, and Díaz identifies three models of experiment undertaken at Black Mountain: "the methodical testing of the appearance and construction of form in the interest of designing new, though ever-contingent, visual experiences (Albers); the organization of aleatory (chance-generated) processes and the anarchical acceptance of indeterminacy (Cage); and 'comprehensive, anticipatory design science' that tests traditional artistic and architectural forms, and embraces temporary failures, in order to teleologically progress toward a utopia of efficiently managed resources (Fuller)" (9). Though these procedures are distinct in aims, methods, and outcomes, the exploratory, non-predetermined status of such activity is firmly within the bounds of Dewey's understanding of the experiment, which did not mean, as Philip Mirowski reminds us, "mimicking the actual quotidian procedures of the physical scientists" (Mirowski 2004, 296) but referred to what Dewey understood as "a certain logic of method" (Dewey 2016, 202).

There is a shared embrace of contingency in these methods and a prospective outlook that underpins the stress on process. There are, however, differences in relation to purpose. Albers and Fuller are committed to testing the

limits of conventional understanding; the experiment is simply the means of doing so. They remain wedded to matters of evaluation and improvement in way that Cage was not. For Cage, by contrast, the experiment is the work itself, with chance as the medium that determines the form the work takes. For Albers, experiment is a return to the study of materials in order to arrive at an understanding of what is possible outside the constraints of established processes. In a Bauhaus-era text called "Concerning Fundamental Design" that reveals the influence of Dewey, Albers writes that "To experiment is at first more valuable than to produce: free play in the beginning develops courage ... Our aim is not so much to work differently as to work without copying or repeating others. We try to experiment, to train ourselves in 'constructive thinking'" (1938, 116). For Albers, the purpose of experiment is not innovation as such but the direct acquisition of understanding through action unhindered by precedent. While experiments may yield innovations in application or treatment, or may result in methods already in use, the main thing is that "we have arrived at them independently, through direct experience and they are our own because they have been re-discovered rather than taught" (116).

Dewey's major statement on aesthetics came surprisingly late in his career. Initially delivered as a series of lectures at Harvard in 1932 and published in 1934, *Art as Experience* rejects the compartmentalization of art as a distinct and separate sphere and charges philosophies of art as complicit in locating art "in a region inhabited by no other creature, and that emphasize beyond all reason the merely contemplative character of the esthetic" (Dewey 1980, 10).[8] For Dewey, art is an intrinsic aspect of everyday experience; the work of art "develops and accentuates what is characteristically valuable in things of everyday enjoyment" (11). This is not to say that Dewey dissolves the category of art entirely into a generic notion of experience. Rather, it is the forms given to experience through interaction with the world that produces art. Here, Dewey returns to a Darwinian notion of transformation: "There is in nature, even below the level of life, something more than mere flux and change. Form is arrived at whenever a stable, even though moving, equilibrium is reached. Changes interlock and sustain one another" (14). The "rhythm" of discord and equilibrium experienced by the "live creature" in relation to the environment provides the conditions under which the artist works. The artist, Dewey explains, "does not shun moments of resistance and tension. He rather cultivates them, not for their own sake but because of their potentialities, bringing to living consciousness an experience that is unified and total" (15). The sense of completeness described here, a unity and distinctiveness that constitutes the production of art out of experience, Dewey calls "*an* experience" (35, original

emphasis). Such *an* experience is distinguished by "a single *quality* that pervades the entire experience in spite of the variation of its constituent parts" (37, original emphasis). The kind of integral experience Dewey describes here emerges out of the doings and sufferings of everyday experience but is distinctive within ordinary experience by virtue that it is somehow "finished in a way that is satisfactory"—it is a situation "so rounded out that its close is a consummation and not a cessation" (35).

There is not much discussion of art works in *Art as Experience*, which is more concerned with enlarging the field of the aesthetic to include everyday life than it is with addressing the narrow field of actual works of art. This is a typical Dewey strategy, whereby the frame that defines the dualistic relation between two categories—in this case, art and non-art—is removed so that the properties of one are allowed to articulate the other. Art is repositioned so that it becomes experience, the artwork merely functioning as evidence of how the process of experience is able to reach a consummatory stage. Though the influence of *Art as Experience*, in all its vagueness, is probably due as much to its role in providing an intellectual foundation of the Federal Arts Project of the Works Progress Administration (WPA) under director Holger Cahill as it is to its persuasiveness as aesthetic theory, Dewey's account of the process of experience as a kind of supercharged ordinariness nevertheless found a receptive readership among American artists. The WPA exposed *Art as Experience* to an entire generation of artists, and it became a key text for some Abstract Expressionists, including Robert Motherwell, who briefly taught painting at Black Mountain in the 1940s and referred to *Art as Experience* as one of his "early bibles" (see Berube 1998; Buettner 1975). Albers, as we have already noted, was familiar with Dewey before he arrived in the US; a short article in English published in 1935, also called "Art as Experience," underscored the influence of Dewey's ideas on Albers's thinking (Albers 1935).

### Expertise and the Redefinition of Freedom

By the 1930s, then, Dewey's influence extends across debates concerned, in terms of matters of education policy, university curricula, and the public support of scientific research, with the relation between science and democracy, and, in the arts, with the broad relation between ordinary experience and the aesthetic. In this regard, Dewey's thinking comes to shape the key preoccupations of the emerging military-industrial and artistic avant-gardes in the decades preceding World War II. By the end of the 1940s, however, Dewey's conception of scientific democracy has been modified, eroded, and reformed

as corporate managerial liberalism, and his processual understanding of art as experience is overtaken by the ascendancy of formalism in art criticism as the dominant mode of articulating the distinctiveness of American art. This is not to say that Dewey's liberalism is entirely snuffed out, since its influence on Black Mountain continues to inform the work of John Cage, among others. But the broad communitarianism of Dewey's conception of democracy and the fluidity with which he imagines the interplay of science, technology, art, and everyday life in a free society is increasingly reconceptualized within the remit of a diminished public sphere overseen by specialized expertise. The holism of Dewey's philosophy is traceable, perhaps, in the rise of systems theory and cybernetics, and also in the growing popularity of Gestalt philosophy in the arts and social sciences. Yet it was not until the 1960s that radical educationalists and others retrieved Dewey's thinking. By this point, the kind of progressivism imagined by Dewey during the 1920s and 1930s, a mode of social democracy to the left of the New Deal and targeted at the power of American corporate wealth and influence, had access only to the fringes of mainstream debate. Despite the various Dewey revivals of the latter half of the twentieth century, the center of gravity in American politics had moved decisively to the right, and Dewey's reputation as a radical philosopher never properly recovered from the distortions and misunderstandings his work engendered.

Part of the problem with Dewey's position is that his language of cooperation, adjustment, and problem-solving can easily be construed to suggest compliance, adaptation, and narrow functionalism. While Dewey's arguments are often explicitly targeted against the iniquities of emerging corporatism and stress the reimagining, as opposed to the reinforcement, of social habits and practices, Dewey's commitment to democracy as an essentially optimistic mode of emancipatory creativity and inquiry often fails to account for the structural intractability of vested interests and inequalities. For Dewey there is no injustice that cannot be overcome through the application of the ideologically neutral scientific method, broadly conceived as the on-the-ground testing of possibilities. Dewey's notion of science as a particular stance toward the world bears little relation to the instrumentalized science of the Cold War, yet the adventurous US techno-utopianism of the 1950s and 1960s can often look remarkably similar to Dewey's democratic spirit of invention. The promise of a great community, uninhibited by old ideas, experimenting its way into the future, could just as easily capture the spirit of postwar corporate liberalism as it does the ethos of Black Mountain College. Among the dangers of Dewey's loose-limbed sense of experience as a progressive, experimental practice is the way in which it can also be construed as an articulation of technocratic

individualism. While the democratic socialist position Dewey developed during the 1920s and 1930s (he was critical of the New Deal as insufficiently radical and designed mainly to prop up capitalism) advocated public control of major industries and government oversight of the economy for the general welfare of the population, Dewey's faith in science is often understood as scientistic and his politics merely weakly reformist. What Dewey was surprisingly unprepared to acknowledge, given his deep understanding of the social basis of education, was that the form that science takes is also determined by the historical circumstances within which it is articulated. Here he might have learned from Thorstein Veblen, who noted in 1918 that, as with historical phases of civilization, even "the latest, and in the mind of its keepers the most mature, system of knowledge" will derive "its character and its scope and method from the habits of life of the group, from the institutions with which it is bound in a web of give and take" (Veblen 1918, 2).

By the mid-1940s, as Mirowski observes, Dewey's model of science as democracy was not only untenable but "unintentionally provided the major resource for certain more pointed and virulent doctrines on the social relations of science" that developed during the Cold War (2004, 297). Black Mountain managed, briefly, to capture something of the emancipatory promise encoded in Dewey's conception of a post-disciplinary, free inquiry–driven, collectivist education as the platform for a thoroughgoing reconstruction of democracy. At the same time, however, the Black Mountain model reproduced some of the challenges that trouble Dewey's ideas. Among these was the absence of a critical perspective from which to approach science and technology as they were constituted in the mid-twentieth-century US and, not unrelated, the question of expertise and hierarchy. In many ways, Black Mountain College reproduced, admittedly in an idiosyncratic form, the institutional formations characteristic of the emergent research universities in the period following World War II. The notions of collective investigation, unimpeded freedom of inquiry, and the cultivation of elite expertise within a protected, self-legitimating environment, are attributes the science lab and the liberal arts college shared.[9] Charismatic figures like Josef Albers, Buckminster Fuller, and Charles Olson are likewise versions of the elite research scientist and prone to cultish discipleship. While the collaborative spirit at Black Mountain drew upon the radical critique of individual genius derived from the original Bauhaus and the communitarian outlook of Dewey's repurposed, socially responsive individualism, the presiding model of collective endeavor dominant throughout most of Black Mountain's lifetime, shaped by the New Deal but forged in World War II, remained prone to the hierarchical, patriarchal tendencies of its military-industrial

counterparts. It is in the context of an emerging corporate sense of collective enterprise—the prime example here would be the hot house of the Manhattan Project—that Black Mountain reveals itself to be, at the same time, radically at odds with, yet remarkably close to, the group dynamic characteristic of the Cold War lab.[10]

The self-segregating laboratory of experts is far away from Dewey's notion of scientific democracy as the great collective experiment in freedom, and the kind of interdisciplinary collaboration envisaged by 1945 was as much about protecting the autonomy of advanced inquiry from the predilections of an ill-informed public. Part of the problem here is that Dewey's notion of a scientific democracy had little to do with the scientific community as it was actually constituted and served more as a projected model of what a generalized scientific method might mean for social organization. As Andrew Jewett notes, "the core assumption that citizens could harmonize modern economic and social forms with democratic political control by drawing on scientific resources was not a logical deduction from scientific practice, but rather a political tenet," as was the notion that the community of scientists might serve "as a model for democratic deliberation" (2012, 371). While the identification of science with democracy did not disappear, and was central to, for example, Robert Merton's 1942 outline of the four core values of the scientific ethos (universalism, communism, disinterestedness, and organized skepticism), the general distribution of creative agency in Dewey's expansive model of science (and democracy) was significantly pared back (Merton 1973; see also Allen and Hecht 2001, 6–7; Hollinger 1983; Wang 1999b, 2002). James Conant's meritocratic model of general education is one example, where the pool of college entrants was expanded beyond narrow class interests by the introduction of standardized testing, thereby making access to elite institutions notionally more democratic while preserving the institution's exclusive status.

Conant was skeptical of what he saw as the inflated claims made for the scientific method as it had come to be understood by the 1940s, thanks in no small part to Dewey. Rather than a description of professional practice, Conant complained, the scientific method had come to be seen "as a way of looking at life; at times it seems almost a panacea for social problems" (quoted in McGrath 2002, 106–107). For Conant, it was the institutions of science and not its methods that were important, since it was through institutions that ideas were generated and circulated. Like Vannevar Bush, Conant wanted the public to understand enough science to be deferential toward the experts and institutions that practiced it.[11] The uncoupling of science from the public, the union of which was so central to Dewey's understanding of a scientific democracy,

in effect produces the notion of the "scientific community," a notion David Hollinger argues only came into everyday use during the 1960s, despite the long history of science as a collective enterprise. The reason for this new public awareness of the scientific community, claims Hollinger, is that after World War II, scientists "found themselves enmeshed in a system of capital-intensive research funded by a government responsive to popular political pressures and preoccupied with military priorities" (Hollinger 1990, 900; see also Hollinger 1995). Because science was economically dependent upon the public and wary of military encroachment upon academic freedom, scientists increasingly saw themselves as a political constituency. As a clearly identified "community," however, scientists could now be perceived as an untouchable elite (by a public suspicious of the consequences of scientific inquiry and its technological applications) and, simultaneously, as a collectivity constituted by a purported academic freedom that was also increasingly threatened by the demands placed upon it by its paymasters.

It is this latter position, of the scientific community as endangered by the instrumentalizing claims made upon it by its political and military backers, that prompted Vannevar Bush's 1945 defense of scientific freedom in *Science—The Endless Frontier*. Bush was director of the wartime Office of Scientific Research and Development (OSRD) and, postwar, understood the need for science to be organized for the purposes of peace. To some degree, Bush shared with Dewey a belief in a planning society, though the conservative Bush's call for the organization of science was less interested in socialism than Roosevelt's New Deal had been.[12] Nonetheless, Bush was invited by the president in 1944 to present recommendations on how to organize science with a view to "advance the general welfare," including a program of medical research, aid to public and private institutions, and a plan to develop scientific talent in American youth (quoted in Kevles 1977, 17). *Science—The Endless Frontier,* based on the findings of four committees charged with developing Roosevelt's request, is Bush's response.

The instrumentalism of Bush's defense of science was predicated on freedom but the argument in *Science—The Endless Frontier* is hardly comparable to Dewey's Hegelian conception of the development of self through dynamic inquiry, though Bush's argument in favor of academic freedom remained underpinned by an appeal to democratic virtues. So long, wrote Bush, "as scientists are free to pursue the truth wherever it may lead, there will be a flow of new scientific knowledge to those who can apply it to practical problems in Government, in industry, or elsewhere" (Bush 1960, 12). The dependence of those who pursue truth on the protection of government guarantees the flow of knowledge to those most able to apply it, but the pursuit of truth itself must

be beyond the control of government. As such, scientific research becomes not only a resource but an embodiment of the values of democratic freedom: the pursuit of truth is, in a sense, ungovernable even as it remains the primary responsibility of government. "Scientific progress," Bush made clear, "results from the free play of free intellects, working on subjects of their own choice, in the manner dictated by their curiosity for exploration of the unknown" (12). The instrumental benefits of scientific research, then, are underwritten by a resolutely non-instrumentalized conception of the conditions that make research possible. Bush's notion of the "free play of free intellects" driven by curiosity could serve as a description of Dewey's notion of progressive education or a shorthand for the ethos of Black Mountain College, but it is a conception of freedom evacuated of the promise of public distribution. While the general population was at liberty to consume the practical applications that might spin out of scientific research, the activity of science itself must remain out of bounds.

The redefinition of freedom, by technocrats like Bush, as the fenced-off space of privilege for experts bears comparison with the reorientation of American art in the early postwar period. The investigative, experimental model of the aesthetic outlined by Dewey in *Art and Experience* was not bound by a conception of art predetermined by the activity of artists. Although their circumstances and aims may have differed, at both the Bauhaus and at Black Mountain, the stress was placed on a relational, comparative approach to materials that did not favor one medium or skill set over another. Yet, as Jeffrey Saletnik argues, the "sensory-integrated practices of Bauhaus preliminary instruction, although still essential to the training of artists and designers, were denuded of value in their American context due in part to the specialized tendencies that came to dominate American art criticism following World War II" (2009, 83). Clement Greenberg's stress on the autonomous art object, the importance of medium specificity, and the priority of painting and of the optical, set formalism at odds with the processual interdisciplinarity and haptic performativity that characterized activity at Black Mountain. "Not much art came out of Black Mountain," Greenberg noted (quoted in Díaz 2015, 56), only some famous names, and though he taught there briefly in 1950 on Willem de Kooning's recommendation, Greenberg soon left. He was not wrong, though, since "art" as Greenberg understood it was not really the point of Black Mountain. The parameters of what constituted art under Greenberg's formalism suggests, like Bush's or Conant's model of science, a protective containment of specialist knowledge within the walled garden, the only site where free play is permitted.[13] The definition of freedom, on these terms, is self-authenticated.

### High Civilization

The National Security Act of 1947 expanded and centralized the federal government's civilian authority over defense and intelligence operations, with the president as commander-in-chief. The army, navy, and air force were unified under the authority of the National Military Establishment (replaced by the Department of Defense [DoD] in 1949), headed by a civilian secretary of defense. Inside the DoD, President Truman also united all signals intelligence under the National Security Agency (NSA). All aspects of the national security state—DoD, NSA, CIA, and the National Security Council—were now routed through the Oval Office, and the president was positioned to be able to coordinate technology policy in relation to these institutions.

By the outbreak of the Korean War in 1950, following the Soviet blockade of Berlin, the "fall" of China, and the first successful Soviet nuclear test, communism was no longer merely perceived as a subversive danger but a direct military threat. In response, the top secret "National Security Council Report 68" (also known as NSC-68) outlined plans for a rapid and massive American military buildup, plans President Eisenhower pursued during the 1950s through developing a decentralized procurement policy, based in part on the wartime system of contracting out, in alliance with the private sector. The aim, for Eisenhower, was to build on the integration of civilian and military expertise that won World War II and allow each sector to more properly understand the needs and capabilities of the other. It was the job of the government, as Eisenhower saw it, to take the initiative in promoting development and, he explained, "our duty to support broad research programs in educational institutions, in industry, and in whatever field might be of importance to the Army" (quoted in Weiss 2014 28–29; see also Melman 1970). It was now the state's job, as Linda Weiss puts it, "to guarantee U.S. technological leadership"; the national-security-state vision of innovation enterprise was "permanent preparedness in pursuit of perpetual innovation" (2014, 29). Defense-led R&D was now embedded in the civilian economy, transforming the role of companies and universities. Though Eisenhower famously had cause to doubt the wisdom of this thoroughgoing integration of civilian and military enterprise, as his farewell address in 1961 attests, it is largely through his encouragement of public-private partnership that universities like MIT and Stanford were able to develop into R&D powerhouses.

When Eisenhower warned, in 1961, that under the conditions established by the military-industrial complex, "government contract becomes virtually a substitute for intellectual curiosity," he was, somewhat belatedly, expressing a

concern for academic freedom that had been at the heart of Vannevar Bush's writings during the 1940s. Bush accepted the militarization of society and the need for federal funding of science, but he was clear in his defense of the need for intellectual freedom for scientists. In *Modern Arms and Free Men* (1949), a book aimed at making the case for public support for free scientific inquiry funded by the state, Bush began by raising the threat of another war. Outlining the new technologies of war and the possibility of as yet unimaginable future developments, Bush admitted that the prospect of grasping the implications could be overwhelming. Yet, he wrote, it is not acceptable to "take refuge in the assertion that these matters are for specialists" (Bush 1949, 3); as a democracy, it behooves the public to grasp the seriousness of the situation and choose responsible leaders capable of sound judgment. Amid the swirl of opinion and argument, for Bush there were two key points of focus: science and democracy. The two, wrote Bush, "are intimately entwined, for science does not operate in a vacuum, but is conditioned by the political system that controls its operations and applications" (5). For America to prevail, Bush argued, it is imperative that the public has confidence in the virtue of scientific endeavor and its necessity in preserving the democratic way of life. World War II demonstrated, Bush claimed, that the collective will could support and harness science and technology in pursuit of victory from tyranny. The postwar world, he insisted, must continue to trust in science as an intrinsic function of democracy. While, unlike Dewey, Bush did not claim that all citizens ought to become scientists (according to Dewey's broad understanding of science as a stance toward the world), he did insist upon the necessity for education as the engine of progress in science—we may not all become experts but we must embrace the collective responsibility to nurture expertise among us.

*Modern Arms and Free Men* was part of a broader postwar push to foster public support for science as a matter of urgent national security, to explain why advanced scientific research was now in the public interest and warranted government expenditure. Bush's argument that the triumph of American productive capacity during World War II could be continued in peacetime, and his assurance that "the hopeful aspects of modern applied science outweigh by a heavy margin the threat to our civilization" (Bush 1949, 2), would become the standard US Cold War consensus narrative, the backbone of postwar consumer culture's techno-futurism, and the primary evidence of America's virtuous place in the global order as the beacon of liberty and benign police presence. Bush made the federal funding of science and technology R&D for the military-industrial state seem reasonable and necessary. He also carved out a special place for scientists as those whose freedom must be protected and trusted.

At least until the mid-1960s, Bush's view of what the public's position on science should be held firm, though it was not public opinion that threatened "intellectual curiosity" for Eisenhower but business interests skewing innovation away from the common good and toward corporate profit. Bush's concern for scientific freedom spoke mostly in defense of "basic science" and, at least for physicists and mathematicians (the postwar scientific elite least willing to give up the status and authority they had acquired saving the world from fascism), this special dispensation was granted, according to Mirowski, through the invention of "operational research" (OR) as "the empirical template for the idea of a free-floating 'scientific community,' distinguished by its possession of a special expertise rooted in a generic 'scientific method,' subsisting with a fair degree of autonomy within but apart from a larger social community" (2004, 301).

For Mirowski, it is OR that secured the relationship between scientists and the state, providing the "intellectual firepower" with which to engineer a new society comfortable with the entwined relationship between science and the military (302). It is this "scientific community" of experts that framed the Cold War's logical positivist philosophy of science and provided the context within which social science, driven to find a respectable home among the hard scientists, constructed a new articulation of modern democracy out of neoclassical economics and theories of decision-making, rational choice, organization, and management. Eisenhower's facilitation of university-based defense contract work, despite his farewell worries, made conditions favorable for scientists to position themselves as separate from the sharp-end of military affairs while drawing on the considerable funds defense R&D made available. Already implicit in Bush's defense of "basic" science was the notion of a far-from-democratic priesthood detached from ordinary affairs and beyond oversight.

The proliferation of federally funded research and development centers (FFRDCs), including research labs, test sites, and think tanks, was, as Bush envisioned in his defense of free inquiry, driven by a commitment to speculative thinking and experimentation—this was a genuine interdisciplinary, hi-tech avant-garde. As Stuart Leslie explains, "The 'golden triangle' of military agencies, the high technology industry, and research universities created a new kind of postwar science, one that blurred traditional distinctions between theory and practice, science and engineering, civilian and military, and classified and unclassified, one that owed its character as well as its contracts to the national security state" (1993, 2). The synergies among government, corporate, and education institutions were well-established by the 1960s, producing an interlocking network of organizations through which resources, personnel, and ideas could circulate. After his landslide victory of 1964, President Johnson confi-

dently aimed to extend the rational methods of corporate planning to fixing America's social problems. Think tanks like RAND turned their attention to social issues, and the National Foundation on the Arts and the Humanities Act of 1965 created new federal agencies to support research, education, and public programs in the US.

The National Endowment for the Humanities (NEH) and the National Endowment for the Arts (NEA) were intended to fulfill the declared findings of Congress, stated in the act, that "a high civilization must not limit its efforts to science and technology alone but must give full value and support to the other great branches of man's scholarly and cultural activity" (sec. 2). Furthermore, the act announced that "democracy demands wisdom and vision in its citizens and that it must therefore foster and support a form of education designed to make men masters of their technology and not its unthinking servant" (sec. 2). Though the act conceded that while "no government can call a great artist or scholar into existence," it is "necessary and appropriate" for the government "to help create and sustain not only a climate encouraging freedom of thought, imagination, and inquiry but also the material conditions facilitating the release of this creative talent" (sec. 2). Finally, just to make sure that the message is properly underscored, the act reminds the reader that "the world leadership which has come to the United States cannot rest solely upon superior power, wealth, and technology, but must be solidly founded upon worldwide respect and admiration for the Nation's high qualities as a leader in the realm of ideas and of the spirit" (sec. 2). This is powerful rhetoric and, from an early twenty-first century standpoint, remarkable in its acknowledgement that the necessary health of the arts and humanities for "a high civilization" requires government support. While the general spirit of the National Foundation on the Arts and the Humanities Act is in keeping with Conant's (rather than Dewey's) conception of the arts as a civilizing counterweight to science and technology, it nevertheless radiates democratic benevolence, right through to the desire to lead in the realms of ideas and spirit.

US techno-optimism and the country's confident global outlook crested sometime around the creation of the NEA in September 1965. The trough was to be steep. Johnson began the systematic bombing of North Vietnam, called Operation Rolling Thunder, in February 1965, and ground forces were increased by 150 percent by the end of June. Two months later, the African-American neighborhood of Watts in Los Angeles exploded in rebellion on August 11, five days after Johnson signed the Voting Rights Act into law. "To be an American engineer in the aftermath of World War II," writes Matthew Wisnioski, "had been to look upon a seemingly limitless future," and in the name of democracy "engineers

found government patronage on the frontiers of electronics, aeronautics, and nuclear power that swelled the profession's ranks" (2012, 3). By 1968, however, science and technology had come to be seen by many as sinister, nihilistic, and death-driven. "Never before," Wisnioski notes, "had technological power appeared simultaneously so autonomous and so inextricable from political power, and not since the machine-breaking uprisings of the early nineteenth century had so many citizens perceived technology as a force to be resisted" (4).

**Creativity contra Conformity**

At the heart of all the art-and-technology initiatives discussed here is a conception of creativity as an intrinsic good. This sense is shared not only among artists but by the scientists, engineers, executives, and administrators prepared to develop relations across what C. P. Snow (1965) infamously called the "two cultures." Certainly, Snow's timely contribution to the discussion of what modern society might consider to be of shared value, delivered two years after the launch of Sputnik triggered a wave of soul-searching and government spending aimed at closing the tech gap with the Soviets, provided part of the context within which artists, scientists, and engineers sought common ground. Creativity, a suitably nebulous term with little in the way of negative baggage, serves all comers.

In the context of the early postwar period, democracies like the US were faced with the seemingly contradictory challenges of maintaining unity and protecting individual autonomy. Modern mass society was evidently capable of producing a dangerously conformist, de-individuated culture, as European fascism and Soviet communism demonstrated. The main distinction Americans usually made between the United States and the Soviet Union was that the former encouraged individual autonomy. Anxieties surrounding the creeping conformism of contemporary life therefore did not sit well with the notion of the US as a dynamic society of free agents. On the other hand, the increased complexity of modern life was often associated with the heterogeneity of the American population in terms not only of race, religion, and ethnicity but also with regard to ways of life and forms of knowledge. The fragmentary nature of American society posed a serious challenge to the cultivation of a coherent set of shared values. The US was, it seemed, at the same time a society of fragmentary and mobile constituencies and of powerful conformist tendencies. For many intellectuals, educationalists, social scientists and policy-makers it was clear that authoritarianism fed on the isolation and lack of shared purpose experienced by a disunited people.

While the complexity of modern life required, as had fighting the war, the expert and specialized management of resources and populations, the growth of bureaucracy and homogeneity that came with good management threatened to flatten out long-cherished American democratic virtues, including the pioneering spirit exemplified in individual enterprise. During the 1950s, conformity in its corporate and suburban forms became a widespread concern that turned sociological studies such as David Riesman's *The Lonely Crowd* (1950), C. Wright Mills's *White Collar* (1951), and William H. Whyte Jr.'s *The Organization Man* (1956) into bestsellers, along with Sloan Wilson's novel *The Man in the Gray Flannel Suit* (1955), which became a successful film the following year starring Gregory Peck.

In order to counter modern society's conformist tendencies and the modern individual's vulnerability toward acquiescence, what was required was the development of qualities that resisted unthinking obedience to authority while remaining grounded in the sense of a common goal. The work undertaken by psychologists concerned with what the most influential study of its kind called the "authoritarian personality" (Adorno et al. 1950) developed a set of tools designed to identify character traits associated with authoritarian sympathies. Authoritarian types, Adorno and his co-authors claimed in *The Authoritarian Personality*, were similar to one another, uncritical of and unreflectively obedient to authority, prone to stereotyped and prejudiced thinking, rigid, intolerant of ambiguity, and narrow-minded to the point of irrationality. By contrast, and here the emergence of a healthy antithesis to the pathological authoritarian seems to arrive almost as a relief, the democratic character is characterized as diverse in attitudes and background, autonomous and reflective, and capable of exercising reason when confronted with complex and ambiguous ideas. In short, as Jamie Cohen-Cole explains, *The Authoritarian Personality* "concluded that autonomy allowed individuals not only to be true to themselves but also to maintain a connection with truth and reality. Conformity, on the other hand, produced only lies and errors in vision, memory, or logic" (2014, 43).

In a particularly florid articulation of the dangers of conformity, Illinois governor and two-time Democratic presidential candidate Adlai Stevenson charged the female students of Smith College, in his commencement address of June 6, 1955, with the duty to nurture, in their future roles as housewives and mothers, "not just 'well-adjusted,' 'well-balanced' personalities" or "better groupers and conformers" but "more idiosyncratic, unpredictable characters (that rugged frontier word 'ornery' occurs to me); people who take open eyes and open minds out with them into the society which they will share and help to transform" (Stevenson 1955a, 196). Framing domestic life as the frontline in the

battle between collectivism and individualism, as well as reviving nineteenth-century notions of female moral guardianship that would make Stevenson's commencement speech a target in Betty Friedan's *The Feminine Mystique* (first published in 1963), Stevenson reached back to antiquity in order to track the swings of the historical pendulum as it arcs back and forth between freedom and bondage.[14]

Since "tribal life" gave way to the emergence of the individual in Greek and Judaic thought (the "origins of Western civilization"), the struggle to achieve a free society, claimed Stevenson, had been "at all times a precarious and audacious experiment." Out of "medieval bondage" rose science, reason, and the rebirth of individualism in the Reformation and the Renaissance, he went on, producing "an almost explosive expansion of mental horizons" (Stevenson 1955a, 195). But, "as always," the pendulum swung too far and produced, in the twentieth century, extreme "social fragmentation" and "abstract intellectualism" that developed into a "powerful drive" toward "totalitarian collectivism" (195). As broad and reductively teleological as Stevenson's diagnosis was in the speech, his suspicion of narrow specialization as the corrosive agent of atomizing alienation and the redemptive power he identified in "the cultivation of more mature values" articulated a widely held sense that creativity should operate as the defining virtue of a free society: "we will defeat totalitarian, authoritarian ideas only by better ideas; we will frustrate the evils of vocational specialization only by the virtues of intellectual generalities" (196). In his appeal to open eyes, open minds, and intellectual generalities, Stevenson was in line with the psychological studies of creativity conducted since World War II that stressed open-mindedness, independence of thought, and tolerance of ambiguity as indicators of good character and robust mental health.

The same principles motivated Harvard University, under its president James Conant, to draft *General Education in a Free Society* (often known as the "Red Book"), published in 1945 and intended as a template for a democratic education in a time of increased bureaucratic expertise. A chemist who also worked on the Manhattan Project, Conant understood that the comprehension of modern science was beyond the reach of many people and that a basic scientific knowledge, fortified by the cultivation of morality through the humanities, was the best means of nurturing a pro-science democratic society. Specialization might be a necessary aspect of a complex society, and Conant was a firm defender of expertise, but the Red Book insists that education "must look to the whole man" (HUC 1950, 74) and include the cultivation of "instincts and sentiments as well as the intellect" (75). The challenge of combining an "alert and aggressive individualism" with the willingness of citizens "to sub-

ordinate their individual good to the common good," the Red Book continues, "is one of the hardest tasks facing our society" (77). A free society requires the toleration that comes from "openness of mind" and also conviction stemming from belief and principle, yet, as the Red Book concedes, toleration and conviction "seem incompatible" (77). "How far," the reader is asked to consider, "should we go in the direction of the open mind?" (78). The proposed answer is to acknowledge a dialectical—though the word itself is not used—relation between tolerance and conviction: "each must have something of the other" if toleration is not to become nihilism and thus prevent conviction turning into dogmatism (78).

The challenge of modulating the extremes of tolerance and conviction is the task Stevenson charged the future wives and mothers of Smith College to undertake in their cultivation of the next generation of "ornery" Americans. The successful negotiation of individual and collective needs required a mode of socialization that produced well-adjusted yet idiosyncratic citizens capable of challenging authority, but also willing to subordinate individual will to the common good. Furthermore, while modern life necessitated the acquisition of specialized, expert knowledge, this must be moderated through the cultivation of a general moral sense. As difficult as this task sounds, what is clear from the Red Book's model of general education and Stevenson's view of the housewife's duties is that creativity is not innate but is socially produced. If creativity was a sign of good health that was derived through interaction with others, it was in contrast to the idea of genius, with its associations with mental disorder and social isolation.

The antidote to conformity lay, for many, in the preservation of individual freedom made possible by American democracy. For psychologist and president of the Carnegie Corporation of New York, John W. Gardner, so long as individuals were able to pursue their natural curiosity, American society and its institutions would remain capable of "self-renewal" and avoid blind obedience to stultifying habit and outmoded tradition. "When we speak of the individual as a source of renewal," wrote Gardner, "we call to mind the magic word *creativity*—a word of dizzying popularity at the moment. It is more than a word today; it is an incantation" (1965, 32). Despite the "national vice" that tends to "corrupt and vulgarize" fresh or relevant new ideas, creativity "is more than a fad" for Gardner since it represents "part of a growing resistance to the tyranny of the formula, a new respect for individuality, a dawning recognition of the potentialities of the liberated mind" (32). Delivered in the year he became secretary of health, education, and welfare in the Johnson administration, Gardner's defense of creativity insisted that the attribute was not the preserve of a small

minority, nor was creativity coterminous with intelligence. "Each of us knows at least one bright person," he reassures the reader, "who is essentially no more original or innovative than one of the more accomplished computers" (33). Gardner is convinced, however, that many people "could achieve fairly impressive levels of creativity under favorable circumstances" (33) since creativity is "possible in most forms of human activity" (34). The confidence Gardner was able to place in the virtues of creativity in 1965 was backed up by twenty years of intensive research into creativity by American psychologists that sought to understand and access the untapped natural resource that appeared to stand in opposition to the narrow and rigid obedience characteristic of the authoritarian personality.

Work on the psychology of creativity grew in the years following World War II as agencies like the Atomic Energy Commission and the National Science Foundation sought to identify the most promising future nuclear scientists. The Institute of Personality Assessment and Research (IPAR) at Berkeley began a major research project aimed at developing standards for evaluating creativity in 1949 with support from the Carnegie Corporation and the Rockefeller Foundation (Cohen-Cole 2014, 44). By the mid-1950s, J. P. Guilford, who had worked on assessing the intellectual abilities of aircrew trainees during World War II, had developed what he called the structure-of-intellect model of human aptitudes, which went beyond conventional intelligence tests in order to map a three-dimensional structure of 120 different intellectual abilities (Ogata 2013, 16). Twenty-four of Guilford's personality traits were components of what he influentially called "divergent thinking," or the capacity to come up with many potential solutions to a problem, in contrast to the "convergent thinking," or one correct answer, typical of what is thought of as intelligence. Guilford's work prompted an expansion of research into creativity during the late 1950s and 1960s, including the development by E. Paul Torrance at the University of Minnesota of what became known as the Torrance Tests of Creative Thinking, and a series of studies by Jacob W. Getzles and Philip W. Jackson, at what was originally the Dewey Laboratory School at the University of Chicago, into creativity and intelligence.

What emerged from this research was a growing consensus that the encouragement of creativity in early life could have a significant impact on long-term professional success and a capacity for problem-solving that was not necessarily tied to conventional measures of what constituted high intelligence. Faced with the recent memory of authoritarian, ultra-conformist regimes and the prospect of a future conflict with another that might bring about unprecedented global destruction, creativity research was far from an experiment in progressive education and driven instead by the imperative to find in American

democratic society a decisive edge. Psychologist Carl Rogers claimed in 1954 that "international annihilation will be the price we pay for a lack of creativity" (quoted in Sawyer 2006, 41), and the sense of high stakes remained a staple of pronouncements made by creativity researchers, not least after the successful launch of Sputnik by the Soviet Union in 1957. A *Look* magazine article on creativity from 1961, for example, quoted Torrence's claim: "The future of our civilization—our very survival—depends upon the creative thinking of our next generation" (quoted in Ogata 2013, 18). The danger with such pronouncements, as Gardner would note in his comments on the "dizzying popularity" of creativity four years later, was that they promised much but delivered little. Despite the research, locating and cultivating creativity remained elusive. The tendency, explains Jamie Cohen-Cole, was for psychologists to define and measure creativity according to their own preexisting definition of what creativity was (2014, 44–45). The IPAR study, for instance, included canvassing experts for names of creative people in their field, who were then invited to Berkeley to complete a range of tests (Sawyer 2006, 46). The possibility that conventional notions of what constitutes creativity might be replicated through such peer-selection did not seem to arise as a perceived problem.[15]

## Collaboration

In its capacity for adaptability, creativity allowed for a responsiveness to change, and as a socially derived virtue, creativity was most meaningfully developed in collaboration with others. Indeed, working with people with different expertise and experience offered a response to Stevenson's widely shared concern regarding overspecialization and its alienating effects. While the pragmatic interdisciplinary labors of wartime scientists and engineers required little philosophical justification so long as the task was met, the enthusiasm among many for such collaborative work extended further than the commonsense understanding that a complex problem requires group effort. Collaboration seemed to confirm the sense of creativity as the outcome of interaction, where an open mind was the precondition for a shared collective effort that also served to break down rigid personal loyalties. Working together promised to deliver the kind of environment conducive to Conant's dialectical conception of tolerance and conviction. Within such an environment individual expertise could be respected even as it was creatively adapted to the group situation. Such a model of collaboration did not preclude antagonism and disagreement, which was to be expected among ornery individualists, but the moderating factor of shared purpose would allow such friction to become part of the creative process.

Interdisciplinary collaboration did not begin with the war, but mobilization radically accelerated the application of shared expertise across the physical and social sciences. Otto Neurath's unity of science movement, intended to establish a common language for science, had its origins in the Vienna Circle of the 1920s, while private foundations like the Laura Spelman Rockefeller Memorial in the US had been supporting collaborative social scientific research since World War I.[16] The Macy conferences, perhaps the best known interdisciplinary scientific gatherings of the postwar period, notably for their work on cybernetics, were initiated in 1941 in the first instance to facilitate communication across the sciences. The war, especially through the successes in physics, catalyzed this trend toward the pursuit of a unified scientific discourse. In fact, advances in physics, it was argued, notably by Frank Fremont-Smith of the Macy Foundation, pressed the case for increased interdisciplinary communication as a matter of urgency since the "physical sciences have developed to such a point and have gotten so far ahead of the social sciences that there is grave possibility that social misuse of the physical sciences may block or greatly delay any further progress in civilization" (quoted in Kline 2015, 39). The threat of narrow specialization looms large here, and the need for an integration of the physical and social sciences, like so much of the rhetoric of the early Cold War period, is framed, not as a question of method but as a matter of civilizational survival.[17]

A differently inflected argument for collaboration in the arts nonetheless maintained a connection between collective creativity and social organization, if not progress as such. The avant-gardes of Paris, Weimar Germany and the postrevolutionary Soviet Union variously challenged the singular status of art as a set of discrete objects, the artisanal skill set of the artist, the conventional modes of display and distribution of art, and the function of art and the artist within bourgeois society. In different ways, Russian Constructivism, Dada, and Surrealism reconfigured artistic practice as a mode of investigation aimed at the reconstruction of everyday life. As such, as John Roberts suggests, these tendencies ought to be seen less as "movements" in the art historical sense and more as "loose confederations of collaborators and co-researchers, which in some instances, for short periods of time, conjoin to form units of group production" (Roberts 2015, 122). It is this collective spirit, pitched toward a broad transvaluation of the categories of labor, discipline, skill, and function, that characterized the structure and practice of Black Mountain College, where the communitarian aspects of American progressive liberalism and the Bauhaus fusion of craft and industrial modernity combined to carve out a utopian collaborative space that blurred the distinctions between art, labor, and living. George Maciunas, the driving force behind much of the Fluxus activity of the

1960s, was one of the few American-based artists with a working knowledge of Russian Constructivism and Productivism, and the 1920s Russian journal *LEF*. In New Jersey, both Rutgers University and Douglass College provided a base for a lot of Fluxus work, often in dialog with engineers and visiting artists at nearby Bell Labs. It is through networks such as these that linked universities, corporations, galleries, and artist groups that information about the historical avant-garde, its ideas and methods found a plausible context within the nascent interdisciplinary ethos of the science-and-technology sector. It is hard to imagine E.A.T., CAVS, and A&T without the conceptual backbone of the historical avant-garde, though the political energies of those prior tendencies were undeniably suppressed or stripped out in favor of a more functionalist model in keeping with the de- or post-ideological mood of the times.

It is, however, precisely the political ramifications of the avant-garde project that so decisively challenged the 1960s art-and-technology organizations at the end of the decade, as the adversarial capacities of the avant-garde met with the revolutionary ambitions of aspects of the US counterculture. If radical collectivism is implicit yet muted in art-and-technology collaborations like E.A.T. and CAVS, the broader tendencies across American science and technology toward interdisciplinary collaboration were no less rooted in a conception of how a free society should operate. Like creativity, collaboration was figured as an intrinsic good, in keeping with democratic values, and among the distinctive features both necessary and desirable for the progressive development of a modern industrial state. The very features of the interdisciplinary model that allowed for its acceptance as a nonideological, commonsense approach to rational problem-solving, however, are also among the attributes that have shaped contemporary neoliberal notions of the social organization of labor and the reconceptualization of practice in the arts and humanities as a mode of research.

## A Laboratory of Form and Movement
### Institutionalizing Emancipatory Technicity at MIT

The Bauhaus became the focal point of new creative forces accepting the challenges of technical progress with its recognition of social responsibility. It became the experimental shop, the laboratory of the new movement.
—László Moholy-Nagy, *The New Vision*

The task of the contemporary artist is to release and bring into social action the dynamic forces of visual imagery. As contemporary scientists are struggling to liberate the arrested energy of the atom, painters of our day must liberate the inexhaustible energy reservoir of the visual associations. To accomplish this, they need a clear grasp of the social field, intellectual honesty, and creative powers capable of integrating experiences into a plastic form. This goal will be reached only when art once more lives in inseparable unity with human life.
—György Kepes, *Language of Vision*

In his introduction to a special issue of the journal *Daedalus* published in 1960 and devoted to the "visual arts today," Hungarian émigré and Bauhaus veteran György Kepes explained how his early enthusiasm for the formal properties of painting came to seem "anemic" in a world characterized by "mass poverty, depression, and social unrest" (1960, 5). Turning his back on painting and redirecting his interests toward "man-made images" and their impact, Kepes sought in the mass "visual communication of ideas" (5) a means of making lives better, only to find that the suffering brought about by World War II rendered his ideas

"shallow"(5). Kepes decided to go in search of "values" rather than tools and found them in modern science. "Basically," he writes, "the world made newly visible by science contained the essential symbols for our reconstruction of physical surroundings and for the restructuring of the world of sense, feeling, and thought within us" (5). Kepes became convinced that a purposeful union of the visual arts and science provided the most compelling means of realizing the profound social reconstruction he had so long pursued, and he returned to the pages of *Daedalus* five years later to make a pitch for the kind of collaboration he had in mind. Central to his vision for combining the arts and science was the stimulation of discourse between artists interested in technical developments and generating interaction among artists, scientists, and technologists. "Fully aware of the considerable difficulties" involved in engineering such interaction, Kepes writes, with only the merest Swiftian irony, "I wish to put forward a modest proposal":

> I propose the formation of a closely knit work community of eight to ten promising young artists and designers, each committed to some specific goals. The group, located in an academic institution with a strong scientific tradition, would include painters, sculptors, film-makers, photographers, stage designers, illumination engineers, and graphic designers. They would be chosen for their demonstrated interest and alertness to certain common tasks. It is assumed that close and continuous work contact with one another and with the academic community of architects, city planners, scientists, and engineers would lead to a climate more conducive to the development of new ideas than could be achieved by individuals working alone, exposed only to random stimulations and subjected to the pressures of professional competition and the caprices of the art market. (1965, 122)

Two years later, Kepes would realize his ambition with the opening of the Center for Advanced Visual Studies (CAVS) at MIT, nearly thirty years after the center's core values were first articulated in the US by Kepes and his Bauhaus colleagues.

Shortly after the collapse of the New Bauhaus in Chicago after only one year, its director László Moholy-Nagy rallied his teachers, friends, and advocates to reestablish the school and its progressive curriculum. In late 1938, Moholy-Nagy launched the School of Design in Chicago with a statement of intention "to form a new nucleus for an independent reliable education center, where art, science and technology will be united into a creative pattern" (quoted in S. Moholy-Nagy 1969, 166). Eschewing a traditional board of

trustees, Moholy-Nagy enlisted the moral support of like-minded educators whom he believed understood the nature and ambition of his project, including Julian Huxley, who had worked with Moholy-Nagy on a film about architecture at the London Zoo and who was an advocate of the "unity of science" school; W. W. Norton, the US publisher of Moholy-Nagy's *The New Vision;* Alfred H. Barr, who sponsored the Bauhaus exhibition at MoMA in 1938; and John Dewey. With Europe perched at the edge of the abyss, the luminaries Moholy-Nagy assembled to back his new iteration of the American Bauhaus represented the combined authority of the US progressive tradition and the remnants of the European design avant-garde. After Barr's important MoMA Bauhaus exhibition closed in New York, it toured the West and East coasts for fourteen months, with other Bauhaus shows and events taking place across the country through 1939 and 1940. By the time the US entered the war in late 1941, Barr's promotion of Moholy-Nagy's synthesis of US pragmatism and European discipline had embedded itself decisively into American cultural life as a vision of the future. When asked why he felt the Bauhaus important enough to warrant a show at MoMA, Barr's response captured the extent to which US modernity and old-world vanguardism had found a common language: the Bauhaus, Barr explained, had "accepted the machine as an instrument worthy of the artist," removing the gap between "the artist and the industrial system" and between "fine" and "applied arts" (quoted in S. Moholy-Nagy 1969, 168).

Kepes had worked with Moholy-Nagy in Berlin and Chicago, and now joined him on his staff at the School of Design, where he adapted the influential program of study on light and color that would lead to his appointment at MIT in 1947. The vision for socially transformative arts-science collaboration Kepes articulated in the mid-1960s is unthinkable without the Bauhaus, but it was probably unachievable without the postwar clout of a heavyweight research university like MIT. Nevertheless, despite the long germination process, CAVS would last only seven years under Kepes's directorship. As with Moholy-Nagy's New Bauhaus and School of Design, the American context proved welcoming in theory but resistant in practice. As the intellectual, academic, and institutional climate in the US during World War II and the early Cold War shifted, as we saw in the previous chapter, away from the collectivist spirit of the New Deal era and toward a more competitive, meritocratic, and hierarchical model of ends-oriented corporatism, the kind of exploratory and, indeed, often emancipatory tendencies of projects like CAVS, with their roots deep in early twentieth-century European radicalism, meant that although they might be supported rhetorically (as evidence of creative freedom), they were often financially and politically vulnerable.

Nevertheless, CAVS caught the wave of speculative techno-utopianism that rose in the early 1960s to become the first of MIT's art-and-tech labs. Kepes was able, in his influential post-Macy conference interdisciplinary studies series of publications Vision + Value, to set the tone and the terms for what an integrated and institutionalized US art-science program might look like. Drawing in important artists and thinkers, including Buckminster Fuller, Norbert Wiener, Walter Gropius, John Cage, Robert Smithson, and Jack Burnham, CAVS laid the groundwork for subsequent MIT ventures such as the influential Media Lab, under Nicholas Negroponte, and the Center for Art, Science, and Technology (CAST). Situated within a prestigious and influential university flush with Cold War military R&D dollars, CAVS was able to mobilize Kepes's thirty-years-in-the-making vision of a studio-lab fusion that might, as he hoped in 1960, be capable of restructuring the physical and spiritual worlds—of inventing the future.

**Light, Vision, *Kunst und Technik*: The Bauhaus in America**

László Moholy-Nagy joined the Bauhaus in Weimar at the invitation of Walter Gropius in 1923 and developed the foundation course for the school in that year. After emigrating from Germany initially to Amsterdam and later London, he landed in Chicago and became the first director of the New Bauhaus. *The New Vision*, first published in 1929 and translated into English for a US edition in 1935, helped broaden Moholy-Nagy's reception while cementing a Bauhaus continuity with Europe. The work chimed with that undertaken by Gropius at Harvard and Albers at Black Mountain as émigré scholars, artists, and theorists returned elements of Dewey's pedagogical philosophy to the US. The centrality of arts-and-design education, as well as aspects of the pragmatic application of new industrial materials, for building an emergent and semi-utopian social urbanism proved a key feature of this experimental educational practice—"the laboratory of [a] new movement" as Moholy-Nagy (1946a, 21) called it—and the grand ambition undergirding the design program was no less than the transvaluation of everyday life. "We shall give you a laboratory of form and movement," László Moholy-Nagy promised a Chicago audience in September 1937, "a place where all you've swallowed down inside of you during office hours and in factories gets liberated by experience and coordination. When you have been with us, your hobby will be your real work" (quoted in S. Moholy-Nagy 1969, 149).

The shared commitment of the Bauhaus and Deweyan pragmatism to a socially emancipatory "learning by doing" philosophy runs through Kepes's

writing. In *The New Landscape in Art and Science*, for example, Kepes cites a 1919 speech by Dewey delivered in Tokyo in which Dewey claims that "there is no more significant question before the world" than the challenge of reconciling "practical science and contemplative esthetic appreciation." Without science, Dewey goes on, "man will be the sport and victim of natural forces which he cannot use or control," while without art "mankind might become a race of economic monsters, restlessly driving hard bargains with nature and one another, bored with leisure or capable of putting it to use only in ostentatious display and extravagant dissipation" (cited in Kepes 1956, 28). For Kepes, tasked at MIT with directing a revamped drawing program intended to run through all levels of the university, the visual image could function as an "act of creative integration" able to "mobilize the creative imagination for positive social action, and direct it toward positive social goals" (13–14). This required, at the individual level, retraining the eye of the perceiver, but also, more broadly, reshaping social perception. The purpose of books like *The New Landscape*, with their carefully designed interplay of image and text, was to assist in the reorganization of visual literacy. This was the pedagogical basis for Kepes's new "Visual Fundamentals" course at MIT.

In a fresh edition of *The New Vision* published in 1945, Moholy-Nagy includes a short introduction that underscores the importance of fundamentals in Bauhaus thinking. Aimed precisely at the nonspecialist, the postwar version of *The New Vision* set out to explain how the Bauhaus merger of theory and practice amounted to no less than the groundwork for a new society. The National Socialists closed the Bauhaus in Germany, Moholy-Nagy reminds his readers, but in the US it was possible for the Bauhaus to aid "America as the bearer of a new civilization" that had to "simultaneously cultivate and industrialize a continent." The US is the "ideal ground," he continues, "on which to work out an educational principle which strives for the closest connection between art, science, and technology" (Moholy-Nagy 1946a, 10). Explaining Gropius's first Bauhaus of 1919 as "a community of workers" that resulted in "the powers latent in each individual [being] welded into a free collective body," Moholy-Nagy highlighted the practical dimensions of art as experience (19). What this means for Moholy-Nagy is that art is always historically contingent, and he gives an account of how the German iteration of the school arose in response to industrialization and the redundancy of traditional forms of design and manufacture. "The Bauhaus," he explains, "became the focal point of new creative forces accepting the challenge of technical progress with its recognition of social responsibility." Conceiving of a design school as "the experimental shop, the laboratory of the new movement" (20–21) situates education

at the center of innovative social and cultural production, much as Dewey had conceived of the school as the engine of democracy.

Moholy-Nagy recruited a heavyweight team of supporters to launch the Chicago Bauhaus, just as he was to do with the launch of the School of Design. Gathered from different universities, some even working gratis, sympathetic researchers included "unity of science" members from the University of Chicago such as Charles W. Morris, Carl Eckart, and Ralph W. Gerard, the latter an important neurophysiologist who became a founding participant in the Macy conferences on cybernetics. Morris and Gerard would provide pieces for Kepes's later book *The New Landscape in Art and Science*, and the holistic sensibility shared by voguish intellectual trends like Gestalt psychology, organicist biology, and cybernetics became integrated into the utopian Bauhaus ethos of crafting form from fragmentation and of creating whole sociobiological humans through aesthetic and visual training.

This loosely defined mix of information theory, Eastern-inflected, process-oriented investigation, and Hungarian aesthetic rigor would come to shape a range of artistic preoccupations through the 1950s and 1960s, so it is not surprising that someone like John Cage felt at home among the Bauhaus crowd. Cage, who would later collaborate with Kepes on numerous projects, met Kepes and Moholy-Nagy at Mills College when they were all teaching a summer institute there. The conversations were such that Moholy-Nagy invited Cage to teach a course called "Sound Experiments" at the School of Design in 1941. Such was the sympathetic engagement on all sides that Cage occasionally described his work as "a counterpart in music of the work in visual arts conducted at the School of Design, which is the American Bauhaus" (cited in F. Turner 2013, 121).

In 1945, as Moholy-Nagy typed out the introduction to the third edition of *The New Vision*, the short-lived Chicago Bauhaus had metamorphosed into the School of Design, and then the Institute of Design. American soil was perhaps thinner than he had hoped, and unable, or unwilling, to allow the luxuriant foliage of the Bauhaus vision to prosper. Yet the republication of the book, as well as the extended work documenting the results of the experiment in Chicago in his posthumous volume *Vision in Motion*, attest to Moholy-Nagy's unchecked determination. Signs of a larger economic shift away from progressive values in the US can be found in Sibyl Moholy-Nagy's account of her husband's tenure at the School of Design and its restructuring as the Institute of Design, complete with an administrative board. When László engaged in fundraising activities, he offered donors "a stake in the future," not in the kind of intellectual influence that can be achieved in a lifetime but rather that

attained "in the lifetime of generations." The newly appointed professional fundraiser for the Institute, on the other hand, offered donors "an income tax deduction" (S. Moholy-Nagy 1969, 217). With the new fundraiser's appeal to the rational motivations of individual actors, a different economic context for arts-and-design education becomes apparent. That Moholy-Nagy could not sustain the School of Design with his dedicated community of internally regulated artists and teachers, and needed the infusion of business expertise to survive, marks the changing values emergent in the shift from the school's founding in 1938 to the institute's in 1944. The postwar world of expertise and individual action entered the experimental lab and classroom of the Bauhaus in Chicago and converted it into another office.

The dissolution of the Chicago Bauhaus scattered its influential artists and educators across the US. Kepes wound up in north Texas, where he finished *Language of Vision*, his own version of Moholy-Nagy's *The New Vision*, which would bring him to larger prominence. Here Kepes revealed the same tenacious idealism toward social progress and modernist belief in arts education that drove Moholy-Nagy. The introduction to *Language of Vision* is a paean to Deweyan pedagogy, with its desire for the perceiving subject to interpret and reconstitute the chaos of the world into forms capable of fully realizing the human capacity of each individual. Looking beyond the catastrophes of the twentieth century, Kepes maintained a vision of humanity as a transcendental good, following in the utopian steps of nineteenth-century forebears such as William Morris, Thomas Carlyle, and John Ruskin. *Language of Vision* led him to the heart of technoscientific research in the postwar US: MIT.

### *Language of Vision*: Kepes in Print

As an educational institution, MIT has a unique R&D history, with shifting relations between industry and government, especially defense spending. As Anna Vallye notes, Kepes's arrival at MIT followed an extensive institutional reconstitution of MIT in the 1930s from an applied sciences extension of industry to a full research-based science university interested in basic scientific research (2013, 146–147). The shift was somewhat prescient because Vannevar Bush makes the same case in his influential apologia for basic research, *Science: The Endless Frontier*, just after World War II. Writing for a general audience, Bush defends the long-term instrumentality of basic scientific research on the basis that "blue sky" investigations eventually translate into applications initially unforeseen. Technological process as such is therefore a consequence of untrammeled scientific curiosity. In many ways, Kepes's tenure at MIT between

1946 and 1977 was characterized by a similar commitment to basic research and a trust in the virtues of the unintended consequence of a genuinely de-instrumentalized experimentalism. In Vallye's assessment, Kepes was "directed toward inventing a discourse of the aesthetic image as both analog and catalyst for communities of knowledge—tentative, exploratory and allusive structures dedicated to the production of the ultimate postwar desideratum: social potential, aleatory and opportunistic" (146). His educational ideals, in other words, embodied the elements that constitute a lab. And MIT knows labs.

••••••••••••••••••••••••••••••••••••••••••••••••••

The MIT motto *mens et manus* ("mind and hand") chimes perfectly with core Bauhaus pedagogical principles. The two institutions, however, could not have been more different when it came to financial stability and relevance within the national research agenda. In 1943, in the midst of World War II, MIT handled $25 million worth of government contracts. The president of the university at the time, Karl Taylor Compton, wrote a report to his trustees that said: "The value to our country of this type of institution in a time of emergency [is enormous]. Its war value is parallel to that of a fleet or an army . . . I submit that its value to our country justifies it maintenance on the highest possible plane of effectiveness" (quoted in Schweber 1992, 152). After the war, Department of Defense funding continued to rise. Flashpoint events such as the Czech coup and the blockade of Berlin in 1948/9 proved pivotal, but the Korean conflict "cemented" the postwar partnership (152). The volume of sponsored research at MIT doubled every six years during the immediate postwar period, and from 1948 to 1968 accounted for 80 percent of the university's total operating budget (Kaiser 2011, 105). These were the years of Kepes's most fervent activity at MIT, activity that helped contribute to a momentum of institutional alliances, geopolitical demands, total war mentality, and a shared belief in technological solutions to military/political problems that can be found in the technicity the university established with the government prior to World War II.

Vannevar Bush argued that although a continuity existed in the pre-war and wartime alliance between MIT (as an example of, and metonym for, university-based research), the military, and technological development, a fundamental change occurred within the momentum of the trajectory during the war and into the Cold War. The fact that "World War II was the first war in human history to be affected decisively by weapons unknown at the outbreak of hostilities," he wrote, created "a situation that demanded closer linkage among military men, scientists, and industrialists than had ever been required" (quoted in Schweber 1992, 156). This is the context in which the expanding

scale of scientific research moved toward so-called Big Science. During the decades after the war, with the momentum of large-scale projects aimed at solving large-scale problems, the sciences, physics especially, moved from individual and small-team labs to huge factory or multi-sited projects involving large numbers and many teams, as Peter Galison (1992) explains. The teams included not just scientists but engineers, administrators, and technicians with university research entering the industrial factory floor and scientists becoming project managers more than experimenters.

In the immediate postwar moment, Kepes helped overhaul MIT's curriculum shift toward general education and basic science with a set of courses structured around vision, techniques, and their social implications. Much of this was articulated in *Language of Vision* (1944), in which Kepes generates "a philosophy of the image as both index and instrument of a visual technology of knowledge" (Vallye 2013, 154). Kepes charts the demise of traditional perspective due to visual technologies that have freed the biological eye to see otherwise. The section titles indicate a dramatic, dynamic narrative movement in which perspective expands, proliferates, fragments, and converges in kaleidoscopic sequence: "Amplified Perspective," "Multiple, Simultaneous Perspectives," "Breakdown of Fixed Perspective," "Integration of the Plastic Forces," "Compression, Interpenetration," "Final Elimination of the Fixed Perspective Order," and "Ultimate Opening of the Picture Surface." As is the case in some aspects of cybernetic theory, the centrality of the human in a given process (in this case, image-making) disappears.

The interdisciplinary influence of Kepes' book is indicated by the inclusion of an introduction (in the first edition) by Sigfried Giedion, a cultural historian of automation and of architecture, and the addition, in the 1969 reprint, of a new introduction by universal grammar advocate S. I. Hayakawa. That thinkers working in advanced technology and information theory were considered suitable advocates for a volume by a designer, artist, and educator is a measure of the extent to which Kepes perhaps achieved his aim of dissolving disciplinary barriers. Hayakawa highlights Kepes's emphasis on the relatedness between viewer and viewed as a revolutionary call to move beyond "the deluded self-importance of absolute 'individualism' in favor of social relatedness and interdependence" (1969, 10). The emphasis on process and connections, of mediations and interactions between things, spoke to the general impulse toward systems art at MIT and the new Center for Advanced Visual Studies (CAVS). But as Donna Haraway reminds us, "it matters which figures figure figures, which systems systematize systems" (2016, 101). For Kepes, the systems

with which he wished to systematize his own visual systems emerged from the sciences through a belief that the arts could positively and effectively engage with the challenges of contemporary society. The sciences were the ultimate *pharmakon*: poison and medicine. Just as the only solution for nuclear proliferation appeared, paradoxically, to be more nuclear proliferation, for Kepes the only solution to technological turmoil was more technology and science, *but* funneled through and tempered by visual communication obtained in arts training. Learning to see differently in a literal sense would, for Kepes, engender a transformation of vision in a figurative sense: the perspective wrought by perspective, in other words, held the key to social healing, if only it could be envisioned—seen—as such. "To perceive a visual perception implies the beholder's participation in a process of organization," Kepes claims in the introduction to the second edition; "the experience of an image is thus a creative act of integration" (1969, 13). Such acts were essential for imposing structure on an exponentially chaotic social sphere, leading to his conclusion that the plastic arts, therefore, are "an invaluable educational medium" (13). The language of integration, important to visual communication, found institutional fit at MIT in defense-related research in the post–World War II environment that demanded interdisciplinary cooperation (Vallye 2013, 162). CAVS emerged out of such efforts.

Both Reinhold Martin and Anna Vallye separately argue that Kepes's *The New Landscape in Art and Science* (1956) lays out the philosophical vision for CAVS. A similar argument could also be made for his foundational work *Language of Vision*, and, more pertinently, for the Vision + Value series and its Macy conference-inflected gathering of interdisciplinary scholars. In the years between *Language of Vision* and *The New Landscape*, an explosion of technological expansion of the human sensorium and its capacities materialized. Kepes, as did Moholy-Nagy, had an interest in scientific or technologically generated images that dated back to their days in Weimar Berlin, something they carried onward to their London and Chicago activities. Further, the opportunities, challenges, and problems such images posed to traditional modes of image production figured strongly in their artistic production, course design, and critical writings. The capacity of technological tools to alter spatio-temporal relations provided visual access to elements of nature not otherwise detectable and transformed the field of the visible. Just as Ètienne-Jules Marey and Eadweard Muybridge had done with motion studies in the previous century, and Marey had done with electrocardiograms, labs at MIT and elsewhere at the time Kepes was writing *Language of Vision* were busy capturing the splash-back from drops of

water (Berenice Abbott) and spark photographs of objects in flight. "The products of the oscilloscope, stroboscope, and interferometer," Vallye writes, and "the images on radar screens, radiographs, and spectrographs, were diagrams of *events,* rather than descriptions of 'things' or 'properties'" (2013, 163–165). Just as systems theory moved from object-centered research to processual investigations, representations of natural events previously undetectable by unaided senses provided graphic representations that challenged artistic mimetic forms. Rendering the invisible visible held fascination for Kepes and others.

In "Toward a Dynamic Iconography," the final section of *Language of Vision,* Kepes writes about the non-artist role in Dada and Surrealism in a way that evokes the scientist in the lab (1967, 194–196). Both work to deliver through specific techniques a form from nature in spite of the fact that it is the artist/scientist who provides and applies these techniques. Sounding like an early incarnation of John Cage and his experiments with chance, Kepes writes that the earlier generation of avant-garde artists had telescoped their role in artistic production "only to a sheer assistance of chance happenings" (194). It is but a small step from the artist as scientist setting up an experiment in a lab to the systems art that would preoccupy CAVS from Jack Burnham's fellowship there into the end of the 1960s.

The Vision + Value series of publications resulted from an interdisciplinary set of seminars and editorial commissions by Kepes intended to foment further exploration of a visual field capable of synthesizing technological change while also taking into account the shift marked by cybernetics toward systems and information as leading the age toward, in Kepes's words, "communication and control" (quoted in R. Martin 2003, 67). Kepes attended some of the Macy conferences and had been inspired by the cross-disciplinary goal of pursuing cybernetic theory as a means for thinking the entire biosocial domain of human and nonhuman action, whether in the form of nature or machines. The echoes with Bauhaus ideals struck him as obvious, though certainly in the repetition of these goals the stakes had been raised significantly. And the role of the Vision + Value books in laying the groundwork for CAVS is significant, emerging as they did in 1965 and 1966 and reflecting overlapping interests found in Gestalt psychology, physiology, biology, systems theory, logical positivism, linguistics, architecture, art, design, music, and perception theory. Attending the events that Kepes organized were friends from the New Bauhaus days, the University of Chicago scholars Charles Morris and Ralph Gerard. The impressive array of contributors also included Christopher Alexander, Rudolf Arnheim, Saul Bass, John Cage, Buckminster Fuller, Sigfried Giedion,

Marshall McLuhan, George Nelson, I. A. Richards, Lancelot H. Whyte, and Ludwig von Bertalanffy. The range of disciplines huddled under titles such as *Structure in Art and Science, The Nature of Art and Motion, Education of Vision,* and *Sign, Image, Symbol* that reveal the scope and ambitions of Kepes's vision of a lab that could bring the arts and sciences harmoniously together as avant-garde composers and artists argued ideas with mathematicians, physicists, microbiologists, psychologists, architects, systems theorists, literary theorists, sociologists, art historians, and media theorists.

These seminars and their resultant publications displayed an ongoing concern with the scale of visual and intellectual inquiry that underpinned much of the impetus behind Bauhaus-influenced education, making, and theory. The import of scale is markedly evidenced across the decades, for example in Kepes's *New Landscape*, in which patterns of nature become scaled and technologically envisioned; and in Moholy-Nagy's *Vision in Motion*, where he discusses the Industrial Revolution's transformation of the world through "mass production, mass distribution and mass communication" resulting in the need to think in global terms (1946b, 13). The latter understood art as a means to bridge the biological and the social, the individual and society, the intellect and emotions. The role of the artist in society, he writes, is "to penetrate yet-unseen ranges of the biological functions, to search the new dimension of the industrial society and to translate the new findings into emotional orientation" (11). The arts for Moholy-Nagy are essential for a healthy society, and it is incumbent on artists and designers to solve the problems wrought by technology and industrialization. The exhibition *The New Landscape* that Kepes curated at MIT in 1951 displayed images from microscopic photography and the edges of telescopic imagery of outer space. The exhibition of images suspended in air essentially embodied a three-dimensional still version of the Eameses' massively influential film *Powers of Ten* (1968), which placed micro and macro technologically enhanced scientific photography within an art-centric context.[1] The title of the book that Kepes published five years after the exhibition, *The New Landscape in Art and Science*, suggests that the visual essay and collage format of the text provides "a kind of laboratory experiment" in which the "visual images" provide "the content" and the "verbal statements—comments and documents—are illustrations" (1956, 17). The simplistic inversion of the standard power relationship between image and text in scientific publications belies the larger agenda of subverting science as a privileged site for knowledge production. Offering the verbal texts as supplements for a visual story told through images, Kepes reveals the necessity of the supplement for the foundation of the main text—in

Figure 2.1. Layout design of György Kepes's *The New Landscape in Art and Science* (Chicago: Paul Theobald and Co., 1956).

this case, one composed of a "poetic vision" for the "new landscape" the book invoked, evoked, and embodied (17).

*****************************************************

The organization, layout, and textual strategies of *The New Landscape*, according to Vallye, operate as "a collage of instruments and agents, a subjects-objects collectivity within which 'pattern-seeing' would spring forth" (2013, 171). The book—as did the Vision + Value series, though to a lesser extent—offers a dynamic juxtaposition of images, quotations, text, and image captions resulting in an Eisenstein montage effect of images propelling textual exegesis (see figure 2.1). The historical arc depicted in the book is long and intercultural, drawing on examples from ancient and early civilizations in a synchronic though historically framed manner. The pattern-seeking agenda that scales from micro to macro levels of visibility and skipping through chronotopes of world history offers a reading of nature and culture in visual dialog that expands the struc-

turalist interests of the moment. The experimental design deployed in Kepes's and Moholy-Nagy's books show the sustained interest in graphic design for Bauhaus educators, working as they did across advertising and numerous other design applications. Graphic design, back in the Weimar Republic, offered an early instance of industrial reproduction capable of appropriation for artistic production. The enthusiasm never left them, as *The New Landscape* exemplifies. Reinhold Martin, however, finds in the book a sense of "exhaustion," of the Kepes project for sociobiological training and control running into a technological momentum no longer containable (if it ever was) (2003, 72–75). It is difficult to follow Martin on this one given that in 1956 Kepes leapt straight into the seminar series that became Vision + Value, and thus constituted the immediate interdisciplinary precursor to CAVS. Perhaps this exhaustion can be noted in the almost immediate collapse of CAVS projects as they ran into a sociopolitical and institutional context that made the avant-garde art and science/technology lab an untimely intervention in US academia. Nonetheless, Kepes forged ahead and his first group of CAVS artists included Jack Burnham, Stan VanDerBeek, and Otto Piene.

At the university level at MIT, the late 1960s anti-war backlash registered loudly, as it had at many universities across the US. Given the institution's heavy reliance on government-funded research, MIT acutely felt the change. The Hoffman Committee's 1970 report *Creative Renewal in a Time of Crisis* addressed a host of problems facing the university, including the drying up of government-sponsored research and the failure of the school of Humanities and Social Sciences to deliver on its mandate of creative, interdisciplinary thinking for all MIT students (Kaiser 2011, 115–117). It was within such a context of institutional self-reflection and examination that Kepes's CAVS emerged. The report also argued that the institution had a burgeoning PR problem in the midst of Vietnam War controversies due to the institution's close association with weapons of war, an image unlikely to help recruit students or serve the university well in the long run (much as IBM had made its own public-facing pivot from military computation to universal computation). Again, CAVS could help with this problem.

### The Totality of Patterns

"Experiment in Totality" is the subtitle of Sibyl Moholy-Nagy's detailed, critical memoir of her husband's life and work (1950, 1969), and it neatly articulates the consistency of Bauhaus ideals, at least as espoused by Kepes, from 1919 until the 1970s. The consistency of the ideals proves especially marked in each postwar

moment. The subtitle could well be applied as easily to the Macy conferences, cybernetics, systems theory, and systems aesthetics. The history of the Macy conferences as the fount of cybernetics is well documented.[2] Once Norbert Wiener and Johann von Neumann had become increasingly convinced during their World War II research that inquiry into neurology and engineering (biology and machines) had essentially joined up as a single subject, they attempted to form a research center at MIT to pursue this path. Although their institutional efforts ultimately failed, the Macy conferences became their lab for scientific and social scientific interdisciplinary debate and experimentation with cybernetic models and processes (Dupuy 1994, 70–89). Designed as a forum for discussion and debate, not a site for the presentation of final thoughts and findings, the informal laboratory nature of the conferences allowed for experimentation with shared problems and interests across disciplines.

The primary driving force behind the Macy conferences was not Wiener or von Neumann but the University of Chicago physiologist Warren McCulloch, who initiated the interdisciplinary examination into "cerebral inhibition" in 1942, an event funded by the Josiah Macy Jr. Foundation. At that event, Wiener and Julian Bigelow presented some of the research they were conducting for the military on the theoretical problems posed by antiaircraft defense, research that found unexpected resonance with that pursued by Mexican physiologist Arturo Rosenblueth. The paper presented at the initial Macy conference, and published in 1943 under the title "Behavior, Purpose and Teleology," found analogy between antiaircraft targeting systems and the movements of patients suffering from brain damage: essentially self-correcting mechanisms or systems. An obvious difference between the two examples is that one system is mechanical and the other organic, with the self-correcting behavior of each overriding the difference. The paper contained nascent elements of cybernetics, including feedback loops and the difference between how a system (human, machine, or human-machine) actually behaved, and its stated or intended results. After the war ended, a series of ten additional conferences took place leading to the establishment of cybernetics, information theory, systems theory, and artificial intelligence as important interdisciplinary areas of academic study.

Kepes, along with many artists and art theorists, was drawn to these theories as a means of articulating, according to the latest jargon, the convergence of mechanical and organic energies that had preoccupied his work since the 1930s. As "interpretive syntheses" (Shanken 2013, 83–86) of systems theory and cybernetics, Kepes's applications and inspirations, as with many of the art world's adaptations of cybernetics research, were a less than rigorous deployment of new scientific models and, as Jones suggests, more of an "ameliorative

project" to keep art and science together through "analogy and translation" (Jones 2013, 517).

Systems theory in biology predates by a decade the cybernetic inklings articulated by Wiener et al. in 1943. Posited by von Bertalanffy in the 1930s, systems theory concentrates on processes over objects, relationships between parts, organic teleology over mechanical function, and the organization of an entity in relativistic terms. In a manner of speaking, cybernetics provided mathematical and engineering underpinning for the insights laid in biological systems theory, and hence their frequently linked status. The developments offered by cybernetics to the emergence of information theory by Shannon and Weaver, again initially offered at the Macy conferences, added ideas of control and communication to the potent mix of theories available to the artistic avant-garde. Some members of the Macy conferences were also prone to a kind of metaphorization and interpretive synthesis, though of a stripe more scientifically grounded and informed than that which filtered out into the art world. Pushing back against the then-dominant positivists and behaviorists, many of whom occasionally antagonistically attended the conferences, Wiener, along with the anthropologists Gregory Bateson and Margaret Mead, and philosopher Filmer S. C. Northrop, also gravitated toward using elements of their theoretical insights as a means to generate knowledge about the world (Heims 1991, 248–272). Wiener easily traversed a vast terrain of social and political issues using the language and conceptual apparatus of cybernetics as a discursive heuristic to consider communication's similarities in nature, machines, and society—rendering cybernetics, in his work for a general reading public, more moral philosophy than mathematics. Bateson too later attempted rather vast experiments in totality that made him a leading light in the emergent counterculture of the 1960s. These grand visions spoke to Kepes's own desires.

*******************************************************

Nonetheless, Kepes's selective engagement did not deter the scientists themselves from speaking to or collaborating with him and others in the arts; nor did these dialogs dampen the impulse to experiment with totality in any and all domains that Kepes kept alive. Wiener, for example, responded to Kepes's brief for the expanded book version of the exhibition *The New Landscape* with a contribution entitled "Pure Patterns in a Natural World" (1956). In the chapter, Wiener outlines three approaches to abstract patterns in the world from the point of view of science and mathematics: one is the approach constructed through axioms or postulates that describe "intellectually or emotionally satisfying arrangements in the world" (274); the second approach works to

disentangle neat axioms; while the third approach, where Wiener sees mathematics and artists coming together, observes "specific patterns of intrinsic interest" and then offers "a free composition as an essay of the patterns observed" (274). This is the affinity he feels for Kepes's agenda predicated on six images the artist has sent him. Wiener asserts that his brief contribution intends to illustrate that the patterns in these images not only "excite a sensory interest in the eye of the observer," but do so precisely because "they have a specific mathematical structure" (274). Wiener then briefly analyzes the images by dividing them into mathematically sound patterns made available through telescopic and other prosthetically enhanced visual technologies and those that are mere "emotional puns"—that is, accidents of morphological analogy. Some of the latter are produced through the operation of visual technologies rather than from a mathematical standpoint. One of the more interesting of the former, for Wiener, and here echoing Kepes's overriding agenda, depicts "dielectric breakdown," which leads to a few lines from Wiener on the import of understanding and theorizing the phenomenon of "breakdown" for physics, mathematics, and indeed society (274). Wiener's ongoing interest in noise and entropy finds its way into his comments and offers Kepes a real nugget to work with, while his critique of "emotional puns" flags up the problems inherent in wishing to find analogies and wholes at every turn. For Kepes's part, though, he was under no illusion that his agenda would occasionally teeter on the vagaries of chance, happenstance, and mistaken analogs.

Ralph Gerard (1956), also fresh from Macy conference engagements and recalling his days as Kepes's colleague in Chicago, follows Wiener's contribution with a piece entitled "Design and Function in the Living," which argues that while beauty might be in the eye of the beholder, it might also reside in "the object beheld" (277) as well. Gerard's brief but wide-ranging and variously scaled reading of structure and patterning in living organisms chimes with the *New Landscape* remit beautifully. Citing evidence available through X-ray and electron microscopes, Gerard explains "chemistry, the structure and behavior of molecules and molecule aggregates, thus grades insensibly into biology, the structure and behavior of cells and cell aggregates" (279). Just as Kepes's selection of technoscientific images for the exhibition and the book scale from micro to macro, so too does Gerard's argument that "nature has an anatomy at all levels" (279). In the end, though, Gerard concludes that the most complex of organisms yield the most beauty, with a kind of evolutionary progress and bias smuggled into his nuanced overview of form, function, structure, and biology.

Despite Kepes's efforts to keep Bauhaus principles of experimentation and wholeness operative through the 1970s, Moholy-Nagy's wife and collaborator

thought the spirit of the endeavor ended quite a bit earlier than her friend's efforts would indicate. Writing in the second edition of her memoir in 1969, Sibyl Moholy-Nagy states that the first experiment in totality ran from 1919 to 1945, dying the year her husband did. Nevertheless, she notes a renewed interest in his work among a younger group of artists, thinkers, and scholars who distanced themselves from the "Art and Technology foundations whose aim is 'the esthetic contribution to technology, the upgrading of the new world of automation science through art'" (S. Moholy-Nagy 1969, xviii). Such foundations, she claims, have nothing to say to this new generation who fully understand in "Moholy's bio-technical matter the message of an inexhaustible cosmic energy he tried to decode" (xviii). Sibyl Moholy-Nagy captured important strands of the emergent consciousness-raising next iteration of Bauhaus experimentation with holistic visions found in the work by Gregory Bateson, Buckminster Fuller, Gene Youngblood, Stewart Brand and others.

Following in Moholy-Nagy's footsteps in his attempt to rethink design pedagogy from the ground up, Fuller published a curriculum of "design science" that includes "general systems theory," "theory of games (von Neumann)," and "cybernetics" alongside more traditional areas of scientific inquiry such as meteorology, geology, biology, and sciences of energy (Fuller 2008). The list also includes an area of scientific inquiry he calls "synergetics," which examines "the behavior of whole systems as unpredicted by the behavior of their separate parts" (78). The examples that he provides link the effects of the moon and sun on the earth within the solar system, as well as the exchange of gases by mammals necessary for plants and vice versa within the ecosystem. Each part requires the others within the system, but the behavior of each separate part does not predict the behavior of the others nor that of the system as a whole (78). This curriculum appears in the first volume of Steward Brand's *Whole Earth Catalog* (1968), which explicitly describes the project instantiated by the catalog as one initiated by the writing, thinking, and strategies of Fuller. The curriculum Fuller proposes, as Sibyl Moholy-Nagy states when scanning the intellectual horizon, reiterates Bauhaus biosocial concerns for the study of design writ large but does so in a manner that raises the stakes and scale exponentially.

Systems theory, as we have seen with Kepes's *New Landscape*, always addresses concerns of scale and complexity. And a problem with systems, as noted by von Bertalanffy (1950), is that open social systems are much more complex and difficult to circumscribe than closed physical ones. For Moholy-Nagy's and Kepes's borrowing of systems theory, and indeed going back to Wiener's writings, there is a continuum of systems that scale across those domains found in their sociobiological concerns about technology and materiality. But this is

taken to even greater lengths by Buckminster Fuller in his musings on "general systems theory" in *Operating Manual for Spaceship Earth*—a title inviting contemplation of scale if ever there was one (2008, 65–82). Fuller claims that the challenge to systems theory is to think the biggest systems possible: the planet within the solar system. Using his newly established field of "synergetics," Fuller approaches the behavior of large-scale systems (in this case, the largest we have) and their constituent parts, including Earth, all life upon it, and the ecosystem in which that life functions. Fuller's sci-fi imaginary positions humans as astronauts who must learn how to live in the closed system Spaceship Earth affords while understanding fully the rapidly changing nature of the elements in the systems. A year later, Fuller wrote his famous introduction to Gene Youngblood's influential study, *Expanded Cinema*, where holistic design and thinking, as it is in *Spaceship Earth*, is in its fullest glory, helping establish him as a key countercultural futurist, and doing so within an experimental visual arts context. Fuller enters the text in speculative fiction mode, positing telepathic communication between all unborn children *in utero*, so-called womblanders that constitute, at the time of his writing, a quarter of the population of Africa (1970, 16). To protest against the conditions into which they would be born, in a kind of reverse or sideways Lysistrata revolt, an allusion one of them invokes telepathically to the others, the womblanders in collective social resistance refuse to leave their individual amniotic worlds (17). Fuller's account becomes a springboard for thinking about long stretches of human history, travel, and cross-cultural interaction to comment on current globalization and real-time telecommunication technologies for reshaping the future of human life on the earth.

One of Fuller's primary targets is the false geometry of Cold War planetary divisions, without considering the liberatory potentialities of emergent communication technologies. The visualizing technologies that Youngblood's book (1970) discusses at length, the realm of expanded media, holds the potential for "Space Vehicle Earth" to awaken our sense of interconnected fragility within the biosphere of our benevolent, isolated sphere (Fuller 1970, 30–31). These technologies, as theorized by Youngblood, can correct our "misorientations" of terrestrial power and control, Fuller claims, toward the "forward, omnihumanity educating function of man's total communication system" (34). Fuller closes by stating that Youngblood's notion of the "Scenario-Universe principal" "must be employed to synchronize its senses and its knowledge" in order to ensure the survival of those installed on "Space Vehicle Earth" (35).

Telepathic fetuses and geometries of power, subjugation and financial gain might at first glance seem a far cry from the pedagogical trajectory of

Moholy-Nagy and Kepes. Yet the claims for what the "expanded cinema university" of the near future can provide through "a synchronizing of the senses" and an alignment of knowledge attendant upon their technologically enhanced operation are consonant with Bauhaus-era utopianism and the insistence on the control and utilization of the full range of human capabilities by Kepes and others. The techno-utopian moment perhaps has arrived, but Fuller has seen such possibilities squandered before; thus there is no breathless technophilic cheerleading here. Rather, Fuller's aim is a reckoning of human capacities and limitations, an understanding of human vulnerability in an ecosystem on a planet hurtling through inhospitable space. To recall the Bauhaus edict, he is looking for a biosocial perspective to emerge from technologies of visualization that expand human sensorial perspective.

Youngblood's own, rhetorically Fuller-fueled, analysis of the implications of telecommunication technologies for humanity manages to combine the Bauhaus, the Macy conferences and the Esalen Institute, filtered through Fuller, Wiener, and McLuhan, each of whom is cited as an influence (Youngblood 1970, 44). For Youngblood, the present is what he terms "the Paleocybernetic Age," a portmanteau phrase he claims fuses the "primitive potential associated with the Paleolithic and the transcendental integrities of 'practical utopianism' associated with Cybernetic [*sic*]" (41). For Youngblood, expanded cinema actually means "expanded consciousness" through technological innovations that will allow humanity "to be free enough to discover who we are" through a somewhat oxymoronic, unmediated capacity for externalizing to others our internal consciousness (41). The agenda is grand, but perhaps no grander than the other experiments in holistic theorizing examined here. The fractured visual environment reflecting a fractured sense of society's relationship to the individual and the world sounded by Fuller and Youngblood echoes the challenges to art and design in the early decades of the century as recounted by Moholy-Nagy and Kepes. *Expanded Cinema* reiterates and scales their agenda for new materials and immaterialities that look to the same technologies responsible for rending the biosocial order as containing the conditions of possibility for mending it. If the visual field is in crisis, then it is up to art and design to fix it. Youngblood claims to be writing at the end of cinema as we have known it, and an end to a mass media being expanded and decentralized with emergent technologies, with a new wave of cinemas and attendant worlds ready to emerge from the exponentially expanding visual field of humanity: worlds that Moholy-Nagy and Kepes might well have recursively beheld and embraced.

### *Mens et Manus*: MIT and Untimely Interventions

> The "Seminar on Technology and Culture at M.I.T." convened in 1964 by the Episcopalian chaplain, for example, became a model of cross-disciplinary reflection; its premise was that since society's problems are not generated in any single intellectual discipline, therefore one should not expect their resolution to lie in any one discipline, either. —MIT Arts, "White Paper"

> Those of us who have contributed to the new science of cybernetics thus stand in a moral position which is, to say the least, not very comfortable. We have contributed to the initiation of a new science which, as I have said, embraces technical developments with great possibilities for good and for evil. We can only hand it over into the world about us, and this is the world of Belsen and Hiroshima. We do not even have the choice of suppressing these technical developments. They belong to the age, and the most any of us can do by suppression is to put the development of the subject into the hands of the most irresponsible and venal engineers. The best we can do is to see that a large public understands the trend and the bearing of the present work, and to confine our personal efforts to those fields, such as physiology and psychology, most remote from war and exploitation. —Norbert Wiener, *Cybernetics*

Many of the scientists involved in the Macy conferences had returned to university life from war-related work, including Wiener, whose circular causality and its relation to computing for anti-aerial ballistics found purchase in many disciplines. The postwar hope was for a more unified scientific enterprise aimed at humane social progress and the benefit of humanity. Jones notes that Wiener's desire that cybernetics and systems theory would elude the fate of instrumental modernity found in the concentration camps was shared by Kepes and his work on CAVS (2013, 532–533). Kepes's first year running CAVS was devoted to projects that considered art and technology in relation to the "civic sphere" and the "total environment," works generated to make whole again the visual domain and human positioning within it. Others held similar ideas. The designer and frequent Eames Office collaborator George Nelson echoed Kepes with regard to the potentially healing power of design, art, and aesthetics aligned with science and technology. Nelson expressed these views in *Problems of Design* (1957), a book that led Kepes to invite Nelson to participate in the Vision + Value seminar. Such endeavors, as with the Macy conferences, would depend on collective rather than individual efforts, though CAVS was more geared toward outcomes than the Macy conferences' more discursive en-

vironment. Ragain describes the CAVS structure as "perhaps most reminiscent of the collaborative research teams popular in corporate and scientific settings; tangible outcomes were expected as well as a collectivist mindset" (2012). The collectivist mindset of research teams flourished at MIT and other sites. However, what kinds of expertise entered these labs was rapidly shifting in the postwar decades. For all the fears of fragmentation in a truly frightening world of atomic physics unleashed—used in violence and constitutive of a new geopolitical world order with potentially apocalyptic possibilities and certain ecological trauma—the general corporate, university, scientific, and artistic consensus seemed to cluster around a firm belief in the lab/studio project to "experiment" our way out of collective imperilment while feeding the democratic belief in collaboration as intrinsically beneficial to society. Even stripped of its progressive Deweyan basis, the collective endeavor of CAVS still fed into the larger but shifting vision of how to advance technology and the modern industrial state, a vision at odds with Kepes's own, but one that allowed him to establish his center at MIT.

If the Bauhaus in Germany developed a focus on tactility in design and art that drew some inspiration from Filippo Marinetti's 1921 manifesto on "tactilism," as well as from the wealth of new materials provided by the early part of the twentieth century (see Smith 2014), its later manifestation with Kepes at CAVS had to address the new dematerialized efforts of current technological explorations of processes and simulation. Kepes's own interests, though wide, almost always held an immaterial dimension in that he concentrated on vision and light, developing the basic course on light and color in Chicago that he brought to MIT. This movement to the apparently immaterial elements of contemporary technology attracted the attention of Jack Burnham, who, in the last chapter of his book *Beyond Modern Sculpture*, argued for a move toward systems and the dematerialization of art production (1968, 312–378). Burnham's and Kepes's interests had aligned for years before the two started working together at CAVS, and the issue of dematerialization was central to the critical practices of 1960s artists, as Lucy Lippard's (1967) influential chronicle of the period attests. At CAVS, Moholy-Nagy's core Bauhaus principle of "experience with the material" (25) refines and questions the constitution of empirical experience with the material and immaterial world when put through post-Macy conference MIT thinking, goals, and agendas.

Kepes wrote to Jack Burnham in 1967 to discuss the potential of CAVS, as well as to covertly gauge his possible interest in the center. Burnham responded enthusiastically and said the project was "already twenty years behind where it should be," asserting that the logical moment of such an endeavor was

immediately following World War II—that is, around the time of the Macy Conferences (Jones 2013, 528). In an important sense, Kepes's publications and exhibitions had indeed been pursuing collaborative interdisciplinary work all along, albeit without the institutional frame and imprimatur provided by the center. With CAVS, he secured his platform, at least for a moment. The establishment of the center—his "creative gestalt" (quoted in Vallye 2013, 178)—in many ways was the apotheosis of his entire career as an artist, teacher, and theorist. It also proved to be an untimely intervention.

The capacity to work collaboratively with other sectors of the university and other disciplines, as well as within a community of artists, was the primary criterion Kepes used for the selection of CAVS fellows. Joining VanDerBeek, Piene, and Burnham in 1967 were Vassilakis Takis, Harold Tovish, Ted Kraynik, and Wen-Ying Tsai. Piene collaborated with Kepes on major public art projects and would eventually take over directorship of the center. The experimental filmmaker VanDerBeek arrived at CAVS via Black Mountain College, where he had worked with Fuller, Cage, and Merce Cunningham—each of whom remained inspirations and collaborators for decades—before getting involved with Allan Kaprow's "happenings." Described by Gene Youngblood as a visionary investigation into the "cultural and psychological implications" for the "Paleocybernetic Age" (1970, 246), VanDerBeek's experimental "Movie-Drome" displayed inside a repurposed grain silo suggested his desire for an infinite screen and immersive environments. This project led him to computer-generated cinematic experiments with Poem Field, an early computer-animated set of films initiated at Bell Labs that he continued working on at CAVS.[3] VanDerBeek's work from the 1960s, as Gloria Sutton (2012, 313) argues, was in dialog with Kepes's *Language of Vision*, making him a splendid interlocutor for the center and its director.

In a short documentary about his work at CAVS punningly entitled *Stan VanDerBeek: The Computer Generation!!*, the filmmaker explains he has become "an itinerant technological fruit picker," or "a film plucker," working collaboratively in ways "involving lots of machines and other people," such as computer programmers, technology experts, scientific theorists, and other artists in a range of spaces.[4] Freed from the studio by the means of telecommunication (modems and so on) and software storage, VanDerBeek highlights negotiations between himself and others, different technologies, human-machine relations, different languages, and new tools for artistic production. In one short sequence, VanDerBeek and his programmer/collaborator at the MIT Architectural Machine ponder the possibilities of creating an "electronic paintbrush" to complement the electronic pen they use to demonstrate to viewers different

kinds of software for art—such as a haptic program for onscreen finger painting—as well as computer-generated imagery. Drinking from MIT's cybernetic well, he includes a futural meditation on the possibilities afforded by electronic art platforms, especially television and computers, that promise the creation of completely immersive environments capable of producing "homeostasis and balancing of our whole mind and body." The documentary concludes with a pitch for more labs like the one at MIT to provide increased opportunities for artists to shape communication systems and networks. Predicting that art schools will soon teach programming alongside life drawing, VanDerBeek claims that the challenge to the artist and "to society as a whole" is to make these tools accessible to all. Chanting the Kepes mantra, he says directly to camera: "we must reach out, communicate, balance our senses and live a good life."

Both the sculptor Wen-Ying Tsai and the sculptor and theorist Burnham explicitly wished to pursue systems, cybernetics, and "post-formalist" aesthetics while resident at the center. The Lincoln Laboratories at MIT especially drew Burnham's attention and found their way into several theoretical pieces he produced while a fellow at the center, including his highly influential 1968 article "Systems Esthetics" for *Artforum* (2015d). Burnham's interest in intelligent systems, artificial intelligence, and computer networks led him to seek out Marvin Minsky while at CAVS. Minsky helped pioneer AI research with chess-playing programs and robotics, and his theoretical work helped formulate Burnham's approaches to human-machine interactions. Burnham also was in regular contact with Nicholas Negroponte, then working at the Architecture Machine Group before it metamorphosed into the Media Lab, and which constituted the primary site for computing innovation at MIT at the time. Building on ideas that provided the conclusion of his book *Beyond Modern Sculpture*, which opted for a systems or process-oriented understanding of modern sculpture as opposed to an object-based one, and argued that a systems consciousness would replace the art object, Burnham published articles while at CAVS such as "The Aesthetics of Intelligent Systems" that, while not always explicitly socially progressive in the manner of Dewey, argued for an altogether different understanding of humanist assumptions, which in turn altered sociopolitical relations. Burnham also attempted to distance his own pedagogical approaches from those held dear by the Bauhaus ethos by basing his later teaching at Northwestern University on self-organizing models that he considered far removed from the earlier collaborative and communal approach offered by Moholy-Nagy.

One issue regarding the increased engagement between art and technology that concerned Burnham, who was generally favorable of such interactions,

concerned the scale of funds for cultural production that such projects entailed. He found an example of this issue played out in Billy Klüver and Robert Rauschenberg's 9 Evenings: Theatre and Engineering events, which he explored in some detail in the article entitled "The Future of Responsive Systems in Art" (Burnham 2015c). Although Burnham considers many of the elements of the 9 Evenings successful and laudatory—not least in the operating assumption that "a dehumanized scientific technology cannot help but destroy itself and the world around it," but with artists providing the massive "social need for a symbiotic fusion between art and technology" (91)—he argues that the rising costs of technologically informed systems-art will eventually lead to artists finding themselves as part of a "technological elite" in the same way "Nobel prize scientists" have (95). Their entire position and role will merge with that of big science: "rather than being humble experimenters in the laboratory," he writes, these scientists and future artists "are executives manipulating research money" and controlling the projects of those working under them (95). The critique, however, ends in a call for a Kantian moral imperative to understand the full ramifications of the integrated systems of nature yielding to the unavoidable responsibility society has toward the technological systems that increasingly determine human existence. In a move not unlike the Sartrean existential call placing morality in the hands of humanity because there is no recourse to a transcendental God, Burnham closes the essay by stating that as this new systems consciousness becomes visible and material, "we are beginning to accept responsibility for the well-being and continued existence of life upon the Earth" (98).

Pivoting between the possibilities of technological development and the ontological dread resultant from it in terms of socioeconomic and politico-ethical behavior of humans in relation to the natural and built environment, Burnham's texts challenge, extend, and occasionally overturn the more sanguine humanism and uncluttered progressivism of Kepes's books and theoretical positionings. In this way, Burnham's writings come closer to Wiener's sociophilosophical concerns than they do Kepes's written works. CAVS proved an excellent black box for Burnham to think with, and he pushed the social agenda in ways less overtly polite than VanDerBeek or Kepes managed while keeping the general revolutionary spirit firmly intact.

In an echo of the warnings about the power relations inherent in art and technological collaboration, such as with the 9 Evenings events, and where it could all too easily lead, especially with opportunities for instrumental and financial exploitation, Burnham reaches back to a historical example as a cautionary moment in his essay "Systems Esthetics" (2015d). Cozying up too

quickly and easily to engineering and technological thinking led, he notes, to artistic catastrophe for the Soviet Constructivists. A revolutionary movement embraced by Moholy-Nagy while in Berlin in the 1920s, the Soviet Constructivists were not much mentioned in the US at the time, except by Burnham and Fluxus CEO George Maciunas; as a group, they followed both "historical materialism and the scientific ethos" that quickly yielded to the "technological needs of Soviet Russia" (125). As artists, Burnham states, "they ceased to exist," yielding to "a utilitarian aesthetic" that allowed artists to be "crushed amid the Stalinist anti-intellectualism" that followed the movement's initial forays into socio-technical aesthetic exploration (125). Even though he provides a historical antecedent of warning, Burnham believes that the current moment of his writing offers ways to avoid the totalitarian impulses that destroyed the Constructivists due to an altogether different economic and material climate from that found in the US in the 1960s. While still clearly fraught with peril, making art in the age of systems means that artists are not engaged in "novel ways of rearranging surfaces and spaces," but rather they are enmeshed in a larger existential, perhaps even evolutionary, project (125). Burnham states that the combination of art and technology in the current moment shifts from *Homo faber*, "man the maker (of tools and images)" to *Homo arbiter formae*, "man the maker of aesthetic decisions" (125). The further he wishes to distance himself from Moholy-Nagy and Bauhaus influences, it seems, the closer he comes to closing the circle, for the pedagogical goal of Moholy-Nagy was clearly to produce students capable of making contemporary aesthetic decisions of import for the larger community. Concluding the article in a way very similar to the ending of "The Future of Responsive Systems in Art" (Burnham 2015c), he claims the decisions now facing artists, here serving as metonyms for all of humanity, "control the quality of all future life on the earth" (Burnham 2015d, 125).

Implied in this claim, operating in the long mushroom-shaped shadow of Hiroshima and Nagasaki while the Vietnam War raged in the jungles of Southeast Asia and the streets of the US, and again shot through with existentialist inspired ethics, is the intimation that these technological decisions will determine not only the quality of life on the earth but the very continuance of that life. Caroline A. Jones argues that Burnham's concluding paragraphs move rather quickly and elegantly from "the technocratic progressivism of Soviet Constructivism, the Bauhaus, and the Logical Positivists" implicated in some of the elements of systems theory to "Dewey-inflected pragmatism and Kepes' ambitious new unity-of-science" desires as articulated at CAVS, operating in what she calls "the crucible of cybernetics and systems that was MIT" (Jones 2013, 531). The stakes of artistic, technological, and aesthetic making at CAVS,

housed in this crucible, for Burnham, Kepes, Wiener, and others were consciously high. But it is worth noting that Burnham opens his article with a gesture toward Thomas Kuhn's theories of paradigm shifts in scientific revolutions: as he closes the article he pauses to state the time for aesthetic decision-making about the future of technology was evanescent, and once gone, perhaps gone for good, with a new paradigm waiting (out of structural necessity) to overturn the systems moment and its biosociological opportunities as he saw them.

Otto Piene became the director of CAVS after Kepes, at a time when that temporal window for proper aesthetic decisions about technology that Burnham mentioned at the end of "Systems Esthetics" seemed to be closing. Along with Burnham and VanDerBeek, Piene was a fellow at CAVS when it opened. He joined specifically to work on his "sky art" projects, and acquired helium for these massive constructions through the cryogenic lab at MIT (Wisnioski 2013, 776). Intended as art for public spaces, these works were not flying objects but aleatory, floating ones, and thus depended explicitly on environmental conditions without necessarily being environmental art. The ideas for Piene's "sky art" emerged initially from his days with Group Zero in Dusseldorf and his experiences during World War II. Piene co-founded Group Zero on principles and interests similar to those at CAVS, as Kepes noted, and his move to the center followed a logical trajectory.

While at MIT, Piene also worked with Harold Edgerton on strobe-lit sculpture and the development of "cybernetic sculptures," continuing his long-held interest in scientifically informed aesthetics (Bijvoet 1997, 46). Gene Youngblood, borrowing a phrase from Buckminster Fuller, called Piene a "design scientist" (Wisnioski 2013, 780). The son of a physicist, Piene claimed that the center under him was different from what it was under Kepes because he wished to foreground "making," the need for "dirt" studios and making new things by getting one's hands dirty. Kepes, he said, wrote "beautiful books" and had "wonderful ideas" that he felt bought the center more purchase in its early days (786). When Piene took over CAVS in 1974, he expanded its brief to include environmental arts, media arts, and events/happenings. This expanded the reach of CAVS across MIT and into the public realm. Piene's emphasis on environmental arts moved CAVS away from the criticisms leveled at Kepes' exhibits for supposedly glorifying the military-university-technology nexus. Nonetheless, Piene came under specific attack for his "sky art" projects as well as other CAVS initiatives even though the center under his directorship refused defense research funding (786).

With Kepes still at the head of the center, the 1970 CAVS-directed exhibition at the Smithsonian, *Explorations*, sought to bring the ethics of techno-

logical innovation directly into dialog with aesthetic production and artistic institutional display habits and priorities. Kepes's catalog for the show was entitled *Toward Civic Art* and stated the exhibition's goals were to get "art and the public to come together" through technological innovation and its potentials rather than have the civic sphere cleaved by them (1971, n.p.). But the civic space that the show directed its aims at was a polis torn asunder by war, economics, race, and the seemingly endless stream of technological innovation for military and governmental control of that same civic sphere. The exhibition featured several CAVS artists, such as Burnham, Piene, and VanDerBeek, who were invited to bring the ethos of the center to the country's political center through one of its most revered cultural institutions. It comes as no surprise that the exhibition was plagued by financial, technological, and critical problems. One highlight of the exhibition, though, was VanDerBeek's *Panels for the Walls of the World*, which deployed images, collages, drawings, and photos (often from the news) essentially streamed live from MIT by VanDerBeek through newly developed fax machines (by Xerox) for display on an ever-changing set of walls at the Smithsonian.[5] The dynamic and processual nature of the work spoke to the civic cybernetic goal of the exhibition stated in the catalog to place art and museumgoers in a "live audience feedback." VanDerBeek, drawing on his long-standing Black Mountain influences and friendships, as well as his continued engagement and dialog with Fuller and Marshall McLuhan, related this project to aspirations he had for his Movie-Drome: a site of real-time communications overcoming time-space constraints to bring people together to engage visual materials and produce communicational communities from them. Although the networked ideas underpinning the work relied still on broadcast technologies, in a sense the piece intimated an emergent decentralized means of communication and media that anticipated internet discursive idealism. However, grounded in the moment, the more immediate demand was one that Fuller articulated in 1965, to encourage artists, designers, engineers, and the general public to develop "a design revolution that would put an end to the basic causes of war" (quoted in Sutton 2015, 63). An attempt to heal the ongoing divisions of the Cold War, then red hot in Vietnam, but housed within the Smithsonian and sponsored by MIT, VanDerBeek's message was largely lost in ambient social noise.

And so the controversies continued and the new director of CAVS often found himself in the crosshairs. Piene's "sky art" was singled out by Sid Lewis of the Situationist-inspired group Council for Conscious Existence as being "the advanced guard of the cybernetic welfare state, the reconsecration of order, no longer with God as ruler, but with technology raised to myth in the perfect

order of zombies" (quoted in Wisnioski 2013, 188). The colorful pamphleteering in Lewis's rhetoric raises a central issue for arts investment at research universities, especially one so tethered to defense as MIT.

## The Media Lab: Experiment Yields to Opportunity

The institutional self-representation about art and science/technology experimentation at MIT, as indicated in its "Arts at MIT White Paper" (2011), might well have been instigated by CAVS, but the true center of how MIT is sensorially inventing the future is the Media Lab, the site for which Stewart Brand coined the phrase "inventing the future." The Media Lab has long been a shining star for MIT, and it is likely so for a number of reasons, most especially its digital championing of the individual rather than the social as its target audience. This championing complements and furthers the fundamental role that the digital has played in neoliberal reconfigurations of the general US economy. With the passing of the Bayh–Dole Act in 1980, the year that the Media Lab was launched, universities and small businesses could apply for patents based on research from federally funded projects, which spoke deeply to the coffers of university R&D centers. The Media Lab's co-founder Jerome Wiesner's pithy formulation that "if you look carefully, an awful lot of the media technology is art, and the art is technology" syntactically bestows technology and art positions of ontological equivalence through the grammatical leveling of the copula. Nonetheless, the Media Lab has not been much interested in art or the arts, or even full-bore experimentation for that matter, with its corporate-directed gaze. So it is of little surprise that the statements issued from the Media Lab and CAVS about each other should reveal a kind of antipodal set of institutional goals and values.

Wiesner was president of MIT when the Media Lab first opened its doors in 1980 after a massive capital-building campaign. He left the president's office to join Nicholas Negroponte as co-founder of the lab. More Negroponte's brain child than Wiesner's, the latter provided administrative and intellectual heft to the new endeavor. Wiesner, in many ways, perfectly embodied the lab's initial exploratory interests. Cultured and accomplished, Wiesner was friends with Picasso and Alexander Calder, and founded the Rad Lab, the most successful of MIT's World War II defense technology breakthroughs. Prior to working at MIT, he collected folk songs with Alan Lomax in the 1940s for the Smithsonian folk music project, and later that decade he attended the Macy conferences where he collaborated with fellow MIT scientist Norbert Wiener, whose thinking would guide Wiesner's own interdisciplinary lab in the 1950s.

The transition from Architecture Machine to the Media Lab in 1985, with the opening of the Wiesner Building (which had originally been called the Place for the Arts at MIT), meant a shift from primarily defense research to industry-funded research (Negroponte and Steenson 2013, 806–807).

The initial proposal for the lab argued for a new kind of education that would combine "two rapidly evolving and very different fields: information technologies and the human sciences" (quoted in Heims 1991, 279). The lab received funding from IBM, Nippon Telegraph and Telephone, Apple, and the Defense Advanced Research Projects Agency (DARPA), and these kinds of funding sources—corporate and military—proved a dividing line between Piene and Negroponte. The lab offered an explicitly promotional technophilic engagement with the digital, championing high tech's applications to all aspects of daily life. Such an ethos permeated the lab, and continues to do so (279). The Media Lab has become the primary precursor of contemporary art-technology labs operating with and through the digital because it is no longer concerned (and perhaps never was) with investigating problems, as was the case with the School of Design or CAVS, but rather with facilitating individual opportunity and monetizing new technologies for the market and consumption. A general vision of and belief that studio and lab can combine for the betterment (and increased profitability) of the US and indeed the world and its problems remains central to MIT and its many arts-based labs such as CAST and the Media Lab.

Negroponte would distance his pedagogy from that held dear by those who simplistically espouse Moholy-Nagy's famous dictum "everyone is talented," or perhaps merely modify it with the phrase "if aided with the proper technology." "The impact of computers on the arts," he says, "will be bringing out the artist in all of us. Much of it will be like hanging the child's paintings on the icebox. It doesn't have any meaning outside the family circle, but its very important to the local constituency. You'll see a return of the Sunday painter" (quoted in Brand 1987, 83). There are important differences though in the vision for art, technology, and aesthetic training that signal the shift from the biosocial commonweal of the 1930s and 1940s to that espoused in the 1980s. The goal beyond the individual has been circumscribed to the nuclear family as "a local constituency" of influence for the occasional artist. For Moholy-Nagy, Kepes, Piene, and others, of course, the aim is much grander and progressive—more of an experiment in techno-social aesthetic training than a consumer good and hobby that could be fun for the whole family but irrelevant beyond that tiny circle.

"The binding principle at the Media Lab, the primary theme," Negroponte revealed when addressing a group of potential Media Lab funders in

1986, "is personalization" (quoted in Brand 1987, 150). The external private funding and investment from corporations, coupled with occasional federal government monies, to further the personalization of computing and media technologies plays perfectly into a socioeconomic model that favors the individual actor who, in making rational choices for individual good, creates the collective good. Rather than having the social as the explicit goal of innovation, the model the Media Lab operates with has an assumption of the commonweal as a collateral, rather than a primary, result. Writing about Negroponte's position, though, Steward Brand reverts to his Buckminster Fuller-influenced communal techno-utopian ideals and contradicts Negroponte's assessment by stating that the primary theme of the Media Lab is not personalization but "conversation"—conversation "with and through computers" (151). Such a sentiment invokes more than a hint of Wiener's cybernetic ideals, ones with which Wiesner worked in the 1950s, using cybernetics as the foundation for the encompassing theme of communication at his Research Laboratory in Electronics (134). But how the Media Lab has evolved from the Architecture Machine and away from CAVS is succinctly stated by Negroponte and Piene respectively. Negroponte: "This is not an advanced art school" (quoted in Brand 1987, 83). Piene: "The offspring of the Media Lab are Media Lab type things and the offspring of the Center are mostly artistic things. And thank goodness. We never considered ourselves part of MIT doing what other people at MIT are doing very well" (quoted in Wisnioski 2013, 785).

## The Hands-On Process
### Engineering Collaboration at E.A.T.

Friction is as necessary to generate esthetic energy as it is to supply the energy that drives machinery.
—John Dewey, *Art as Experience*

Bell Telephone Laboratories, Incorporated was formed out of the engineering department of the Western Electric Company in 1925 and based on West Street in New York City, where the building complex extended back a full city block. Several facilities were based in New Jersey, including the radio research stations at Whippany, where the first experimental television broadcast in the US was conducted in 1927, and Holmdel, where radio astronomy was invented in 1932. It was south of Whippany, however, at Murray Hill that the expanding Bell Labs would make its New Jersey center of operations in 1941. Imagined from the start as a custom-built R&D facility, the purpose of the proposed new lab complex, Bell president Frank Baldwin Jewett told local residents in 1931, "is something along the lines of a miniature college or university" (quoted in Mozingo 2011, 56). The Great Depression held up the project, but the site, designed by landscape architects Olmstead Brothers and architects Voorhees, Walker, Foley, and Smith, was eventually completed in 1942, with additional buildings added in 1949 and 1958, by which time *Fortune* magazine was willing to name Bell Labs "The World's Greatest Industrial Laboratory" (Bello 1958).[1]

The pastoral surrounding was a key feature of the lab, and though the finished site had less of a campus feel than the original early 1930s design promised, the stress on intellectual and creative freedom remained. A 1954 feature in *Business Week* typically noted that the rural setting of Murray Hill gave the site a "university ambiance," while wondering how the "notoriously uncontrollable" scientists "can be kept working in such fruitful harmony without visible control" (quoted in Mozingo 2011, 62). The impression of freedom noted here was a powerful effect of the campus-like surroundings, marked by an apparent absence of corporate oversight and disinterest in commercial affairs. Such an effect was in part designed, as Louise Mozingo explains, "to attract, foster, separate, and elevate the research activities" of the Bell scientists, an intention which the success of the labs seemed to confirm (2011, 64).

While the conception of the Murray Hill campus preceded World War II, the site was completed amid the massive surge in government funding for new technologies that accompanied the war. In the first few years after Pearl Harbor, writes Jon Gertner, "Bell Labs took on nearly a thousand different projects for the military—everything from tank radio sets to communications systems for pilots wearing oxygen masks to enciphering machines for scrambling secret messages" (Gertner 2013, 62). Murray Hill was bigger and more prestigious than other industrial laboratories, and internationally recognized alongside Harvard and MIT (Knowles and Leslie 2001, 22). General research director Mervin J. Kelly had built up a strong solid-state physics group during the 1930s, including three future Nobel Prize winners, and Bell Labs, according to Knowles and Leslie, "beat other industrial and academic groups to the transistor largely because of the interdisciplinary collaboration and engineering resources unique to Murray Hill" (24).

It was with regard to disciplinarity that the Murray Hill lab self-consciously differed from the university model. There were no buildings for separate departments, and staff members with different expertise and roles were expected to work together (Gertner 2013, 56). When Kelly became executive vice president in 1945 he set about restructuring the organization by creating interdisciplinary groupings—"combining chemists, physicists, metallurgists, and engineers; combining theoreticians with experimentalists" (79)—to work on new electronic technologies. The attempt to cultivate free-ranging intellectual inquiry at Bell Labs was in keeping with the emerging consensus on the value of interdisciplinary collaboration. It was also a means of avoiding the kind of compartmentalization that, by the 1950s, was identified as one of the worrying hallmarks of American social conformism. The new, affluent research universities and laborato-

ries were driven less obviously by disinterested intellectual inquiry, despite the pleas of basic research advocates like Vannevar Bush, and more by the demands of the military and business. The everyday responsibilities of the government-sponsored scientific researcher was as likely to involve, in addition to research itself, managing contracts, projects, and staff, and committee and government agency work. The bureaucratic demands of the new order, increasingly set either on campus itself or in faux university environments like Murray Hill, produced a kind of R&D version of William H. Whyte's organization man (see Kaiser 2004).

Coupled with the demands that researchers comply with the patriotic ethos of cooperative loyalty to their project and their laboratory, the federally funded scientist's workload suggested that the pressures of research work left little room to be, as *Business Week* imagined scientists, "notoriously uncontrollable." Yet the article on Bell Labs' pastoral ambience had already half-answered its own question about how the work would get done in such luxurious surroundings when it recognized that, despite the expansiveness of the surroundings, "Partly the Freedom is illusory. The lab has firm plans and knows precisely what it wants.... Over the years men have been meticulously selected and precisely trained. Men chosen to fit the mold will fall into the desired pattern without any pressure from the mold itself" (quoted in Mozingo 2011, 62). The interdisciplinary openness, and the easy ambiance of the environment at Bell Labs, belied, according to this account, a more ingrained sense of discipline that required no compulsion. While it is unlikely that *Business Week* was developing a critique of the organization man in these comments, the grudging admiration of the Murray Hill campus is modified by the assumption that the rigor of the organization's selection and training processes has rendered such temptations redundant.

The *Business Week* assessment probably says more about how the business world imagined the lives of scientific researchers than about scientists themselves, but it is true that the challenge of protecting intellectual freedom amid an increasingly bureaucratized workplace environment remained a problem. As well as facilitating interdisciplinary movement across fields by avoiding discipline-specific buildings, Murray Hill further sought to engineer fluidity by making the laboratories themselves physically flexible. The buildings had no fixed partitions and rooms, and equipment and facilities could be assembled and taken apart at short notice. As depicted in a 1944 article in *Life* magazine, the impression of the magically appearing research lab stresses the capacity of the company to fit research around the needs of the scientist (see figure 3.1).

Figure 3.1. One of the pop-up laboratories at Bell Labs' Murray Hill campus, featured in *Life* magazine, September 18, 1944, p. 79.

The conception of the Cold War scientist, then, oscillated between the internalized discipline of the managerial class and the freewheeling inventiveness of the creative individual. Bell Labs, unhindered by the institutional and disciplinary loyalties of conventional university departments, managed to combine this mixture of conformity and free-thinking by cultivating inventiveness within, as *Business Week* suspected, a regime of rigorous selection and training. In this, Bell was able to harness something of the glamour and prestige associated with postwar scientific research while maintaining its business and military connections. Yet even within the innovative structure of Bell Labs, it is hard to see how such a corporate, managed environment might appeal to workers in the arts. Nevertheless, during the 1960s Bell became a focal point for arts-and-technology activity.

In part, the lure of the laboratory for non-scientists may be due to what used to be called cultural lag—the public celebration of physicists in particular, and scientists and technologists in general, during the 1950s created a perception of scientists as the true visionaries of the present, the avant-garde of the American century, powered by government largesse and public acclaim. While the pioneer phase of nuclear physics, with its eccentric European émigrés and charismatic leaders, was mostly over by the end of the 1950s, replaced by bureaucratic sprawl helmed by the big science organization men described by David Kaiser, the persistent aura of the scientist as a heroic innovator remained a persuasive prospect.[2] From a more practical point of view, the resources that research in science and technology had at its disposal were a more immediate source of attraction to artists. Many of the artists who became involved in art-and-technology projects during the 1960s thought mainly about how science and technology might be brought to bear on artistic problems—either practically and technically, in relation to materials and production, or theoretically through the introduction of new modes of expression (such as computers). In terms of prestige and resources, science and technology promised much for artists.

Less obvious, though no less important, is the question of how and why scientific and technological researchers might be interested in, and willing to become involved with, artists. If the allure of the laboratory for artists lay in the promise of otherwise inaccessible expertise and novel materials and methods, the attraction among science and technology professionals for art is less clear, especially now that the notion of the creative scientist had become a plausible framework within which to situate research. As we have seen, however, the possibility of the laboratory as a space for creative investigation and invention was more of an aspiration than a reality for most research scientists. The idea of the scientist as creator, though, fortified by Cold War social science's celebration

of creativity as the engine of liberty, remained as powerful a spur among scientists and engineers as it did for artists. The Bell Labs model of interdisciplinary collaboration appeared to offer a solution to the restricted demands of specialized and compartmentalized research that might be extrapolated to resolve the "two cultures" problem that notionally continued to prevent scientists and artists from collectively pooling their creative energies. This, at least, was the thinking behind what would become perhaps the most ambitious art and technology project of the 1960s, Bell scientist Billy Klüver's Experiments in Art and Technology.

While American art certainly did not command the same high status as American science in the 1950s and 1960s, the ascendancy of New York as the center of the global art world and the "triumph" of American art during the postwar period did elevate the self-image of American artists and aligned them with the perceived cutting edge of American innovation.[3] To some degree, then, the desire to forge an alliance of art and technology is an imagined coming together of the great creative forces of the day. Klüver joined the Communication Sciences Division at Bell Labs in 1958, where he worked on backward-wave magnetron amplifiers, linear tubes, and small-signal power-conservation theorems. Klüver was far from the organization man, however, and whether it was Murray Hill's history of interdisciplinary collaboration or the labs' geographical proximity to New York City that encouraged him, Klüver soon found himself deep inside the art world.

Klüver had assisted artists in developing projects since he worked with Jean Tinguely in the construction of *Homage to New York*, his self-destructing sculpture machine, in 1960. It is around this time that Klüver began inviting artists to Murray Hill. "From 1960 on," he later explained, "I brought some 50 to 100 artists through Bell Labs," providing a tour of the site and exposure to advanced technological experiments otherwise inaccessible to outsiders. The artists could see, he noted, "the hands-on process and that one could actually DO things" (Ramljek 1991, 32). By the spring of 1966, Klüver's involvement with artists was notable enough for him to make the cover of the in-house Bell Labs magazine the *Reporter*. In a guest editorial by Klüver's boss John R. Pierce, executive director of the Research Communications Sciences Division, Pierce reminded readers that the collaboration between engineers and artists was nothing new at Bell Labs. In the 1930s, engineer Harvey Fletcher worked with composer Leopold Stokowski on stereophonic sound, and the labs' research on speech, hearing, and visual perception had a hand in the development of sound in films and the beginnings of television. Frequent visitors to the labs, noted Pierce, included the conductor Hermann Scherchen and the composers Ger-

ald Strong, Milton Babbitt, Vladimir Ussachevsky, and Otto Luening, as well as Edgard Varèse, who sought assistance from Bell with the electronic aspects of his *Déserts* (premiered 1954). "We are now," Pierce claimed, "in a period of increasing appreciation of the impact that science and engineering can have on art. We are also becoming aware of the fact that art can have an impact on science and engineering" (Pierce 1966, 1). An effectively designed telephone, he wrote, is not the result of "an occult effort of artistic genius" but of the combined energies of engineers, designers, and psychologists (1). The "intellectual barriers of the compartmentalization of the past" are, according to Pierce, being destroyed by human understanding and knowledge and he imagined a future where the barriers "of ignorance and temperament" that divide science and the arts will be overcome (1).

Pierce's faith in interdisciplinary knowledge exchange reflects the Bell ethos and a recognition of the commercial benefits to be gained by cultivating relations with creative types. A sometime science-fiction writer, Pierce supervised the team that developed the first transistor (and was responsible for naming it) and worked extensively on satellites, including Telstar, the first communications satellite. He was also, as indicated in the name checking of composers, a prominent researcher in computer music, a field he pursued after retirement at Stanford's Center for Computer Research in Music and Acoustics.[4] Klüver's involvement with contemporary art was, then, less unlikely than first appears, and Pierce himself had, around the same time as Klüver, started inviting artists to Bell Labs and welcomed composers such as James Tenney to Murray Hill. Tenney worked at Bell Labs for around two and a half years, from September 1961 to March 1964, collaborating with Pierce, Max Mathews, and others on computer-synthesized sound. At the time, Tenney observed later, "they found it remarkable that anybody in the outside world would be interested in what they were doing" (quoted in Kahn 1999). The same, of course, might be said for much of the art world activity of the early 1960s, which occupied its own insular realm. People like Tenney and his then wife, artist Carolee Schneemann, bounced back and forth between the mutually supportive environments of Murray Hill and New York City, as did Klüver and the Bell Labs engineers.

A third site triangulates Bell Labs and the New York art world and provides an articulation of a generalized sense of shared mission among the scientific and artistic avant-garde. Less than twenty miles south of Bell Labs, the Rutgers University–Douglass College cluster of educators, artists, and students comprised what Claes Oldenburg called the New Jersey School: Allan Kaprow, George Segal, George Brecht, Robert Whitman, Robert Watts, Lucas Samaras, Geoffrey Hendricks, and Roy Lichtenstein (see Marter 1999). Kaprow had

taught art at Rutgers since 1953 (though he was refused tenure and left in 1961), the same year Watts began teaching at Douglass and Brecht settled in New Jersey to work as a chemist at Johnson and Johnson. Hendricks joined the Rutgers staff in 1956, and Samaras was a Rutgers undergraduate. It was while teaching at Rutgers between 1960 and 1964 that Lichtenstein developed his interest in paintings derived from commercial printing processes. And it was Segal, living on a chicken farm in nearby South Brunswick, who introduced the Rutgers crowd to John Cage, whose Black Mountain College experiments in multimedia performance anticipated the environments and performances staged by Kaprow and his New Jersey associates through the late 1950s and early 1960s. Segal, Kaprow, and Watts all attended Cage's experimental composition class at the New School for Social Research in New York City, as did George Maciunas. The emerging Fluxus activity around Maciunas, Brecht, and Kaprow drew heavily on the New Jersey contingent—Klüver and his girlfriend Letty Eisenhauer (who studied with Watts at Douglass and was to become Lichtenstein's girlfriend) both featured in Kaprow events, as did performance artists Schneemann and Olga Adorno (who married Klüver).

Bell Labs, in short, despite its appearance as a suburban, buttoned-up corporate enclave, was a key node in a network of technological and artistic innovation throughout the early part of the 1960s. The current of influence, and admiration, surged both ways, as composers and artists picnicked on the lawns at Murray Hill while Klüver assisted artists with technical matters in Manhattan. The collaborative spirit of the Fluxus projects and the interdisciplinary investigations at Bell Labs, while radically different in many ways, equally drew on the Deweyan ethos of thinking by doing—what Klüver would recall as the "hands-on process." The sense of shared purpose was clear enough to Klüver, who went on to develop his guided tours for artists into a fully fledged network of engineering and artistic collaboration.

**Klüver the Transducer**

For a lecture to be delivered at MIT on April 21, 1967, five months after Experiments in Art and Technology (E.A.T.) was established, Klüver divided his material into four sections. The first was to be a taped introduction accompanied by eighty slides, each shown for ten seconds, beamed from six carousel projectors. The slides would themselves come in four "waves": contemporary art works; Claes Oldenburg "happenings"; black and white shots taken backstage at 9 Evenings: Theatre and Engineering, the series of multimedia events

Klüver hosted, with, among others, Cage and Rauschenberg, at the 69th Regiment Armory in New York in October 1966; and finally, color images of 9 Evenings itself. This compressed audiovisual contextualization of Klüver's project not only demonstrated E.A.T.'s commitment to Bell-style multimedia communications but also acknowledged the inspirational influence, through its distillation in Oldenburg, of the Rutgers contingent's emphasis on process and performance. Most importantly, 9 Evenings provided Klüver with evidence that his organizational chops were sufficiently developed to pull off a complex, high-visibility arts and technology event. It was 9 Evenings that inspired Klüver, his Bell colleague Fred Waldhauer, Robert Rauschenberg, and Robert Whitman to form E.A.T., and it was the Armory events, symbolically performed at the venue responsible for hosting the epochal 1913 International Exhibition of Modern Art (or Armory Show, as it is commonly known) that brought European modernism to the attention of the American public, that captured for Klüver the spirit of experimental overreach and glitch-prone adventurism he wanted E.A.T. to disseminate throughout the networks he aimed to create among engineers, inventors, industrialists, business leaders, and artists of all stripes.

Impossible to summarize, Klüver and his associates hurled everything Bell engineers could supply at the 9 Evenings events. Deploying four dancers (Deborah Hay, Yvonne Rainer, Lucinda Childs, Steve Paxton), two musicians (John Cage, David Tudor), four visual artists (Robert Rauschenberg, Öyvind Fahlström, Alex Hay, Robert Whitman), and over thirty engineers from Bell Labs, 9 Evenings variously used closed-circuit television and television projection, fiber optic and infrared television cameras, a Doppler sonar device, portable wireless FM transmitters and amplifiers, and a multitude of complex video, sound, and light projection systems. Cage repurposed telephones, transistor radios, Geiger counters, contact microphones, and the brain waves of his collaborators to generate a real-time composition from sound siphoned through his numerous receivers into the Armory speakers. Rainer choreographed performers from the balcony using a walkie-talkie, while Rauschenberg staged a tennis match with amplified racquets that were also wired to cut the lights in the auditorium each time a ball was hit.[5] For Klüver, as he would explain to his MIT audience the following spring, this was merely a taste of what a successful orchestration of America's twin art and technology avant-gardes might achieve.

The creative energy Klüver believed E.A.T. was capable of generating was commensurate with the contemporary sense of US cultural ascendancy. Klüver was not shy in admitting that E.A.T. was catching the wave, and his taped

introduction to the MIT presentation, over the surge of the first wave of slides, announced the triumph of American culture:

> Over the last 15 years the best Contemporary Art has been produced in the United States. During this period at least three original schools of painting and sculpture have originated or found their form here. The most interesting development in modern dance is American. The best contemporary writer is an American. A new form of theater has developed and is currently being absorbed by the commercial theater. The most interesting new development in film making comes from New York.[6]

The establishment of New York City as the capital of the art world was, for Klüver, an achieved fact; there are, he pointed out, some one thousand artists working in the city, and around five hundred artists from around the world travel to New York to meet American artists and show their work. "The richness and variety of contemporary American art," Klüver insisted, "far exceeds what was produced in Paris during the Golden Years of the Twenties."

Klüver took Claes Oldenburg as his primary example because Oldenburg seemed to best characterize the contemporary artist's "transgression" of disciplinary boundaries—in the case of Oldenburg, from painter and sculptor to theater writer. Klüver's brief description of Oldenburg's practice in staging the 1962 happenings emphasized the process-led modifications that took place throughout. "Unskilled actors" were used as the artist's "primary material," and the script changed during rehearsals to fit the "character and peculiarity of each particular performer." By the end of the process, Klüver noted, "sometimes every detail in the original script had been changed." The keynote here, for Klüver, is transformation: the artist moves across disciplines and is responsive to the environment while maintaining agency and control. As a prelude to his introduction to 9 Evenings, the happenings establish a precedent and a method that the Armory events radically amplify. On 9 Evenings, Klüver stressed the numbers: ten artists, thirty engineers clocking in 8,500 engineering hours, over thirty technical projects, each developed out of an artist's idea. The event, explained Klüver, was a "deliberate attempt to prove a point"—that "they could talk and work together." Despite difficulties, "everyone seems to agree that the collaboration was a fact." For Klüver, the real lesson of 9 Evenings was not aesthetic but organizational: he had proved the point that collaboration could happen.

The talk for which this thirteen-minute audiovisual section served as an introduction was called, with a deft removal of connectives that gives the title an equation-like efficiency, "Interface: Artist/Engineer," and Klüver's broader

aim was to explain the purpose of E.A.T.[7] Only five months old, the new project had been kick-started with $8,000 from John Hightower at the New York State Council on the Arts that allowed E.A.T. to establish an office on the top floor of 9 East Sixteenth Street, where the organization held a weekly open house on Sundays. The purpose of E.A.T. was not to provide technical services for artists, though Klüver had initially thought along these lines, his own involvement with artists having begun when he lent his expertise to Tinguely and in his subsequent work helping Rauschenberg construct *Oracle*, as well as the technical assistance he gave Jasper Johns with the use of neon and in repairing one of the spinning discs of Marcel Duchamp's *Rotoreliefs* (see Klüver 1994). Instead, at Rauschenberg's insistence, E.A.T. aimed to facilitate genuine collaboration across the arts, sciences, and industry capable of generating unforeseen new forms and ideas (Miller 1998, 28). This ambitious goal was the theme of Klüver's talk at MIT.

He launched the talk on interdisciplinary collaboration with a survey of contemporary art because, Klüver explained, the new relationship between art and technology had "been born out of the direction and the nature of contemporary art itself" (1967b, 2). Historically, argued Klüver, technology had provided new materials, techniques, and imagery for art, but it was rarely inspired by art. After Duchamp, according to Klüver, it was clear that "the vector space that forms the world of the artist must never be experienced as a complete set. The artist must be conscious of the process of being an artist and hence of his own unawareness, of his not-knowing" (3). In other words, art has become a reflexive process of exploration unencumbered by an adherence to traditional tools or methods and unconstrained by an expected outcome. The meaning of art, Klüver insisted, "is not to communicate what we already know but what we don't know, to dislocate our vision, to make us look, to make us aware of our traces and tracks" (3). The contemporary artist "needs access to the contemporary world and he wants to be part of the world of the future"; he "sees the engineer as his collaborator, his material and his inspiration" (7). The ultimate purpose of E.A.T., claimed Klüver, "will be to act as a transducer between the artist and industry, to protect the artist from industry and industry from the artist, to translate the artist's dreams into realistic technical projects. We also hope that we will accumulate enough experience to give help to other institutions who want to set up similar cooperative programs" (15–16).

The evidence of only five months of operations suggested to Klüver that they were on to something. Klüver explained that E.A.T. had received applications from over 250 artists and drawn up a mailing list of over two thousand people. While a number of projects were already underway, what E.A.T.

needed was more engineers. The remainder of the talk addressed practicalities. The basic requirements for the artist/engineer interface must include, Klüver believed, full cooperation from industry, a professional attitude, the protection of artists and engineers in their own environment, short turnarounds for projects, and an emphasis on new technology. It is clear that Klüver's upbeat introduction about the vitality and centrality of art to contemporary American life is, in part, aimed at winning over a skeptical industrial sector. "If industry does not get involved," he makes clear, "the artist/engineer collaboration will go down with a whimper."[8] Allaying concerns that artists would take over the lab or workshop, Klüver told his audience that "the artist and the engineer both need their own environments to be creative." Furthermore, there was no need to worry about aesthetics. "The artist," Klüver explained reassuringly, "likes to deal with his problems in a matter of fact way and not 'esthetically'. Estetic considerations will hinder the development of new art."

Beyond these operational practicalities, there were also clear benefits for industry in encouraging the artist/engineer interface, including the sort of social prestige companies already enjoyed by associating with local causes and education, as well as fostering a collective sense of shared purpose among employees. The presence of artists offered a fresh perspective on problems: "Artists are autonomous," Klüver explained. "They do not 'report' to anyone. As such they form an effective intelligence resource." More attractively, perhaps, there was also potential commercial gain to be had through patents, methods, products, and ideas. Furthermore, artists were likely to identify new applications for technology. Indeed, Klüver suggested that "feedback to industry that the collaboration will lead to is the most important reason why industry should support and sponsor projects." The artist sees the world differently from the engineer, Klüver explained, and it is "not necessary that our environment should always be born out of the engineering mind." Finally, collaboration with artists was likely to foster a greater public understanding of engineering and industry, according to Klüver.

So, what has to be done? Klüver offers a number of items. Professional "engineers in art" groups should be organized as part of existing engineering societies, able to disseminate through journals and conferences the results of their activities. There is also the problem of the different working habits of artists and engineers, and the need to break down misunderstandings about how the other half sees the world. It is important, finally for the engineer to keep focused on the common goal and not get too caught up in "his own contribution." For artists, Klüver suggests that it is important for artists and engineers to meet face to face "under relaxed conditions." Tours of laboratories and in-

dustries are essential so that artists understand working conditions, the nature of materials, processes, and so on. It is also essential that artists learn what they can reasonably expect from an engineer.

Klüver offered troubleshooting tips, or what he called "collaboration handicaps." Difficulties tend to arise, Klüver suggested, when there is a confusion of roles. "When an engineer says 'I am an artist' the collaboration usually breaks down." On the other hand, artists can confuse technical decisions with aesthetic decisions: "Where should the knob sit? What about the color of the batteries—does it matter?" Differences in the pace of work must also be accommodated: artists may work quickly and must understand that engineers require time to tackle problems. Klüver is warming to his subject here and lists "black box syndrome": "When an artist wants a black box that can do all things and does not have time to visit the engineer, you can tell him to forget it. No matter what you do you will never be able to satisfy the artist." Finally, a word of warning about category mistakes: displaying the "products of technology in a gallery will not transform [them] into art." Technology is already beautiful, Klüver explained, "and it does not become more beautiful if it is put up for display."

Rauschenberg and Klüver had drafted a more concise version of E.A.T.'s purpose back in January 1967, where they explained that they wanted to "bring about the adjustment needed for industry to accept its responsibility to actively assume its role in the integration of contemporary technology and the arts" (Rauschenberg and Klüver 1967). The stress here is on industry becoming cognizant of its duties; the integration of technology and the arts is presented as not merely desirable but necessary. In a statement prepared for a well-attended press conference to publicly launch E.A.T. held in Rauschenberg's studio on October 10—reported in the *New York Times* as "enlivened by revolving painted disks, film projections, floating pillows and miniskirted girls in paper smocks" (Lieberman 1967, 49)—E.A.T. announced a "working alliance" with the American Foundation on Automation and Employment (AFAE), a nonprofit organization focused on promoting automation by "solving the labor problems it creates."[9] Here, the notion of industry's responsibility is underscored by stressing the inevitability of the convergence of art and technology: E.A.T., according to the statement, "functions as a catalyst for the inevitable fusing of specializations creating a responsible man operating in the present":

> The mutual objectives are to maintain a constructive climate for the recognition of the new technology and the arts by a civilized collaboration between groups unrealistically developing in isolation. Both organizations [E.A.T. and AFAE] are committed to the elimination of the separation of

the individual from technological change and to expand and enrich technology to give the individual variety, pleasure, exploration and opportunity of self-fulfillment in contemporary life. We will encourage industrial initiative generating original forethought, instead of a compromise in aftermath, and precipitate a mutual agreement in order to avoid the waste of a cultural revolution.

The "adjustment" that needed to be made involved gaining for artists "free access to technology, engineering and the technical processes." Meeting the challenge of achieving this, for E.A.T., "is not only a cultural, educational or aesthetic problem but amounts in fact to an organic social revolution." The vision here is entirely one of mutual transformation: "In their collaboration the artist will stimulate and enlarge technology and its means, and the engineer will significantly transform the arts. This collaboration will be part of a process of accepting and exploring technology as our natural environment." The ultimate aim of E.A.T. is to disappear as a separate organization and to be absorbed into "engineering institutes, universities and industry. This is a nationwide project."

It is striking how much of Rauschenberg's and Klüver's rhetoric draws on the vocabulary of progressive liberalism Dewey made commonplace during the 1920s and 1930s. The emphasis on "adjustment," "responsibility," "integration"; the rejection of the cultural and aesthetic as a separate sphere and instead the call for an "organic" social revolution through the collapsing of boundaries between art and technology; the notion of technology as a "natural" environment rather than as an externalized set of procedures and techniques—all of these positions carry with them the powerful social democratic ethos Rauschenberg brought with him from Black Mountain College and which, as we have seen, Black Mountain derived from its hybrid Dewey-Bauhaus inheritance.

What is also true, however, is that this language of adjustment and adaptation had long since been loosened from its radical democratic moorings and had come to serve corporate liberalism's post-ideological culture of consensus. As a consequence, it is hard to tell from the rhetoric quite what Rauschenberg and Klüver had in mind by an "organic social revolution." There is little doubt, though, that they saw their undertaking as ambitious, with E.A.T. as a means of radically reorienting the way things are done in the arts, sciences, and industry. On a practical level, it was clear that such a project needed to present itself effectively to the business world, and Klüver and Rauschenberg were adept enough to structure the organization more along the lines of a corporation than a revolutionary art movement. Soon, E.A.T. had a president, a board of directors, an advisory council, a small staff, and its own newsletter. Francis S.

Mason Jr., dance critic and former cultural ambassador to London, was appointed president of E.A.T.; art collector John G. Powers was made chairman of the Business Committee; and Theodore W. Kheel, an attorney, labor negotiator, and president of AFAE, served as chairman of the Executive Committee. Klüver and Rauschenberg were, respectively, chairman and vice-chairman of the board. By November 1967 the E.A.T. newsletter could announce that the organization had the formal support of AT&T and the union federation AFL-CIO. Kheel made available to E.A.T. the AFAE's new building, Automation House, on 68th Street.

Kheel was strongly influenced by the view of technological change promoted by Emmanuel Mesthene, director of the Harvard Program on Technology and Society, and stressed the need for adaptability in the face of the transformations technology would inevitably bring to social organization (Wisnioski 2012, 143). Klüver's position tended to broadly follow this line, though at times he would back away from the large social claims made by E.A.T., more pragmatically highlighting the innovations that art and engineering collaboration made possible. Klüver's main objective was to grow the organization and raise funds, and to this extent the language of adjustment and the rhetoric of transformation had to be held in some sort of balance.

Klüver made sure that the fundraising and PR statement drafted in January 1967 carried an endorsement from Bell Labs, in the form of statements from John R. Pierce and Max Mathews, director of Bell's behavioral research laboratory and computer music pioneer. A May 1967 E.A.T. promotional fundraising pack went further, including press cuttings about 9 Evenings (from *Fortune* and *Artforum*) and evidence of the "first technical 'fallout,'" as Klüver described it, of the event: a thermographic phosphor discovered during work with Rauschenberg and Whitman that "is now in daily use in infrared laser research at Bell Laboratories" (E.A.T. 1967a). How many projects could boast of coverage from the business and art worlds as well as the *Institute of Electrical and Electronic Engineers' Journal of Quantum Electronics*? The documentation included in the fundraising pack outlined E.A.T.'s organizational structure, explained how artists and engineers were matched and managed, and provided over seventy samples of artists' technical proposals as well as a list of over two hundred artists wishing to participate. Another list provided the names of around seventy-five "Member Engineers (List Incomplete)." Aside from a number of Bell Labs employees, Klüver had also recruited engineers from other major companies such as Eastman Kodak, Western Electric, Astrosystems, Inc., and RCA, as well as top-drawer universities like MIT, Northwestern, and Cornell. A final three-page list of names and addresses evidenced expressions of interest.

The organic social revolution Rauschenberg and Klüver imagined in January 1967 was fleshed out in the November newsletter. Following the October press conference, the newsletter registers an emboldened tone, imagining that the scope of E.A.T.'s collaborative ethos must extend "further than the individual artist and engineers, and will necessarily involve the cooperation and support of other institutions in society: industry, universities, labor and even politics" (J. Martin 1967, 2–3). There is a sense of urgency to the editorial, which repeatedly stresses the need for an awareness of each "individual's responsibility for the environment he is creating for himself" (3). The artist-engineer relationship should serve as "a catalyst for re-examining and redefining individual responsibilities" (3). As well as its ongoing work with labor, universities, and industrial management, readers are told that E.A.T. must equally be able to "sell its ideas" to middle-management, since they are responsible for formulating company policy (4). A Council of Agents, including John Pierce, Alfred Barr, John Cage, György Kepes, liberal Republican senator Jacob Javits and Harry Van Arsdale Jr., president of the Central Labor Council, are charged with using their influence on behalf of E.A.T. "according to their authority and sympathy" (7).

### The Role of the Engineer

The sense of urgency and the stress on social responsibility in E.A.T.'s public pronouncements are no doubt aimed at providing a broad context within which potential corporate sponsors could situate their understanding of what they were being invited to support. But the emphasis on responsibility also, we think, speaks to a need to address a growing disquiet about technology in American society generally and, more specifically, a longer-standing issue surrounding the status and function of the engineer in American life. While Klüver largely saw the artist as the primary agent in the art/engineering collaboration, it was engineers and corporate sponsors that needed persuading of the value of working with artists. Applications from artists poured into the E.A.T. offices from the start; finding willing engineers was more difficult, and snaring corporate support even more so. Making an appeal for a general sense of social and cultural responsibility was, then, a pitch aimed at the engineering profession and the corporate world. Unlike someone like Kepes, Klüver had from the start avoided considerations of art and science and was more interested in the technical and material processes of making and doing than anything theoretical (Halpern 2015, 96). Even the word "experiment" in the organization's name was problematic for Klüver, who would have preferred "something mundane"

like "Foundation for Artists and Engineers" (1997, 316). The mundane names were already taken, so the group's lawyer registered Experiments in Art and Technology instead, a name he had come up with himself. Despite his advocacy of process, the provisional implications of the word "experiment" seemed to be what troubled Klüver, who later explained that "an artwork is either finished or it isn't, and the public should not be subjected to incomprehensible scientific or technical experiments" (Klüver 1997, 316–317; see also Goodyear 2004, 623). As science had become increasingly specialized, abstract, and abstruse, engineering, at least as Klüver conceived of it in its interaction with artists, retained a pragmatic, problem-solving appeal that made it closer to the explorative investigations of contemporary art.

For all its interdisciplinary credentials, Bell Labs nevertheless maintained a strict division between research and development, as Ross Bassett explains: "Bell Labs was a massive effort to control the chaotic and uncertain process of inventing and developing new technology" (2002, 18). While research "consisted mainly of scientists who used their superior knowledge of physical laws to produce novelty," once a new device was created it was quickly turned over to the development group charged with converting it into a product. Development, according to Basset, "was essentially an engineering function—concerned with economic and technological considerations. Managers at Bell Labs believed that if researchers worked on these types of problems they would lose their scientific edge" (18). It is clear from Klüver's investment in the hands-on work of engineers that it was the development end of the R&D process that he favored, rather than the more theoretical (and higher status) research work.

By the mid-1960s however, Klüver's conception of the engineer as maker was already at odds with the reality of an increasingly managed and compartmentalized profession. A Time Life volume titled *The Engineer*, published in 1966, the same year as the 9 Evenings events and the founding of E.A.T., explained that "the great majority of engineers today work in teams—behind desks or in laboratories—tackling mutual problems with slide rules, computers and microscopes." Although the modern engineer sounds versatile and capable ("He is part scientist, part inventor, part technician, part cost accountant"), he is nevertheless "almost always a specialist in a narrow field." A chemical engineer, for example, "may do nothing but study better ways to manufacture quick-drying paints" (quoted in Wisnioski 2012, 16). This popular account of the engineering life includes collaboration and interdisciplinary flexibility, but a dominant narrative of conformity, repetition, and blinkered specialization subsumes these virtues.

In many ways, the status of the engineer suffered from the same oscillation in public perspective that burdened the postwar scientist. The engineer

was either the driver of technologically fueled prosperity and social progress or, conversely, the epitome of hollow technocratic alienation. As with science, the engineering profession prospered during the early postwar period, and by 1960 engineering was the most common white-collar occupation for men in the country, with one in fifty men in the labor force identifying as an engineer, and over 40 percent of engineers, directly or indirectly, employed by the government (Wisnioski 2012, 23). The compromised position of the scientist—at once the creative soul of the technological revolution and the sold-out functionary of the military-industrial state—was also true for the engineer. Klüver's ambition to grow E.A.T. into an integral aspect of the technological apparatus was, we think, an attempt to realign the role of the engineer according to the perceived creative freedom enjoyed in the arts in the face of a creeping corporatism. Such a move would free engineers from the subordinate position they frequently occupied in relation to scientists and establish engineering alongside art as the proper place for the creative deployment of technological innovation. The debates circulating in the pages of professional engineering journals over the status and role of the engineer during the 1960s are echoed in E.A.T.'s desire to appeal to industry and, at the same time, to maintain its artistic credibility and articulate a vision of engineering as a creative profession (see, e.g., Wisnioski 2012, 31).

The relations between artists and engineers on E.A.T. projects were, given this situation, mixed at best. Artists often felt that engineers relegated their collaborative input to their free time, while engineers tended to feel subordinated to the role of technical support. The engineers, inevitably, had to hold down jobs, and even John R. Pierce, despite his support for Klüver and his own involvement in music and computation, saw E.A.T. as "strictly comparable to golf, skiing, politics, public service, and other spare-time avocations" (quoted in Wisnioski 2012, 146). More problematic for Klüver was the difficulty of securing financial support. Despite the impressive listing of big corporations as sponsors in E.A.T. promotional literature, and Klüver's tireless campaign to enlist more substantial support, most donated only the $1,000 required to receive recognition.

**The Pepsi Generation**

At its peak in 1969, E.A.T. could claim around six thousand members, including approximately two thousand engineers and two thousand artists, and had made about five hundred collaborative matchings. There were over thirty US-based E.A.T. groups, along with overseas activity in South America, Europe, and Australia, while regional offices operated out of Los Angeles and Tokyo (Lind-

gren 1969b, 53). The *E.A.T. Operations and Information* bulletin of April 24, 1969 claimed that matchings were being made at the rate of forty per month, though a shortage of engineer and scientist members persisted in a number of fields. Never an organization to shy away from aggressive inventorial display, however, the list of technical areas in which matching had been made was provided in full, taking up almost a whole page. As a typical example of E.A.T.'s audacity and penchant for Whitmanesque volumetric posturing, the list operates as an exuberant psychedelic hymn to tech potentiality that is best captured by excessive citation:

> electrical and mechanical engineering, computer-generated films, mathematics—computers, printing electromagnetically on irregular surfaces, fiberglass manufacturing, environmental mobile/electric construction involving light/sound, mechanics for inflatables, intermedia, plastic forming and optics, holography, lasers, electro-dynamics, oceanography, geology, space, crystal growth, translucent and luminous aqueous colors, floating houseboats on foam, light machinery, projectors and projection systems, kinetic art, electric engineering/plastics, reorganizing language, effects of technology upon body physiology, earth/global simulation projection, light projectors—color organ, light projection, color organ, flashing lights, holography, use of light for robot [sic], electronics information display devices, flying and floating inflatable forms, vacuum molding, plastics, photoelasticity, rotating scrolls to which paper is attached, aerial projections, cinegraphics, chemical engineering, polyester sculpture, laser technology, computerized lighting, photographic collages, poetry and mathematics, high voltage coronas, random movement and sound, plastics, making use of computers for multisensory and dynamic pies, aquarium environmental simulation lasers, light box, holography, optical simulation—electrical engineering, video tape, projection of intense light, holography, light, mechanics, projection, holography, computers, plastics, liquid sculpture, retro recorder, electronic data processing systems, remote control, sound translations, films, etc., photocell-activated light show, electroluminescence, electric circuit layouts, painted aluminum for outdoor use, electronic music synthesizers, electrical/mechanical engineering, plastic forms filled with incandescent gases, chemical light sources—holography, structural engineering, computer programming and poetry, multi media use of computers, plastics, cultured rotating forms, fiber optics, antigravity machine, mechanical clock containing recordings, relief photography, experimenting with light/electronics, video-tape,

selling and working with vinyl, neurology, plastic lamination, opaque and translucent art works, glass, light, mechanical engineer to assist in three-dimensional projections, electronic constructions with special lights, glass mirrors, computer-electronic music analyzer and synthesizer, computer graphics, audio-visual conversion, electrical mechanical engineering, mechanical engineering, outdoor constructions with electric lighting, earth grading, asphalt construction, electrical engineering, planar image assembling painting and film, mathematical formulae for sculpture, electronic media-music, optical and mechanical engineering, motorized steel panels, heating device for plastic fabrication box, castings and coding techniques, electronic music computer, plastic lamination, illuminated fluid moving in relation to lenses and mirrors, plastic objects flailing in liquid, computers and TV, computer-controlled light array, light effects from linear polarization, electroplating non-metallic material, computer-controlled audio-visual conversion, construction of plexiglas-neon/vacuum form, planted sheet metal constructions, moving holograms, traveling circus. (E.A.T. 1969, 2)

This is a catalog of potentiality, despite (or perhaps because of) some repetition, that is designed, presumably, to appeal to those who spend their spare time perusing the classified ads in *Popular Mechanics*. But it also revels in the rhythms, internal rhymes and barely suppressed erotics of the long list ("floating houseboats on foam," "plastic lamination, illuminated fluid," "flailing in liquid"). Klüver's catalog is a printed incantatory strobe effect designed to bewitch engineers.

Drumming up business was hard, but as far as sponsorship went, the final edition of the E.A.T. newsletter (which was replaced with the short-lived newspaper *Techne*) in April 1968 was able to list seventy-eight sponsors contributing $1,000 a year, an odd but representative mix of art-world patrons like John and Dominique de Ménil and gallery owners such as Virginia Dwan, and corporations including IBM, Schlumberger, and Xerox. Probably only E.A.T. could list as sponsors both the American Flange Company and Max's Kansas City.

The core aspect of the E.A.T. agenda was the Technical Service Program, founded in 1966, which sought to pair artists with engineers using information supplied by applicants on a simple form. Organized tours of Bell Labs and other industrial sites continued for artists as a means of opening dialog, providing a sense of what materials and resources might be available, and to instruct artists in the limits of what they might expect. In addition, E.A.T. also ran a weekly open house, offered rental equipment, and organized numerous

conferences and lectures. In conjunction with a 1968 MoMA exhibition called *The Machine as Seen at the End of the Mechanical Age*, E.A.T. ran a competition for art-tech collaborations. The following year, 140 proposals were exhibited at the Brooklyn Museum in an exhibition called *Some More Beginnings: An Exhibition of Submitted Works Involving Technical Materials and Processes*.

Despite the ongoing funding issues, E.A.T. projects became more ambitious and international. In 1968, E.A.T. was enlisted by PepsiCo to design the American pavilion for the Osaka World's Fair, Expo '70. Coordinated by Klüver and filmmaker Robert Breer, the pavilion was envisaged as a rolling program of artist-led immersive environments. The stress on atmosphere and environment was rendered literal outside the pavilion as artist Fujiko Nakaya and research scientist Thomas R. Mee swathed the building in a manufactured fog. Inside, E.A.T. constructed an inflated spherical Mylar mirror and built an audiovisual system with a krypton laser. The cost of the pavilion came to over $1 million, twice the agreed-upon budget. Despite numerous technical and organizational problems, the pavilion opened on schedule, though E.A.T.'s proposed operating budget for keeping the site running for six months effectively ended Klüver's involvement after Pepsi refused to pay. The E.A.T. program prepared for inside the pavilion was replaced with a cobbled together, Pepsi-approved replacement, and the E.A.T. team returned to New York.[10]

In an essay on E.A.T.'s adventures in Osaka published in the *New Yorker*, art critic Calvin Tomkins was curious about the business side of the project and mentions, at the outset, what is often left unspoken in discussions of art-and-tech projects: who pays and why. A "surprising number" of big corporations have recently shown themselves willing to fund art-and-tech, wrote Tomkins, though the "businessman's motives in sponsoring projects of this sort are seldom entirely clear to anyone" and the "relationship between the new art and its potential patron remains somewhat confused and confusing" (1972, 105). Pepsi got involved with E.A.T. seemingly "inadvertently," according to Tomkins, through a "series of productive confusions that never quite reached the level of corporate decisions" (105). The initial contact between the corporation and E.A.T. came about because David Thomas, vice president for international marketing coordination at the company, asked Breer, a neighbor, if he knew any artists interested in working on the expo. Breer called Klüver, who put together a team after Pepsi agreed to finance a pitch. The competition was the East Village discotheque the Electric Circus, whose proposal was unapologetically well over budget; E.A.T. by default slid into position, though no contract was signed until a week before the event opened in November 1970. According to Tomkins, most of the information about E.A.T.'s plans received by Pepsi was

judiciously mediated through Thomas, while Klüver made full use of the corporation's funding, with E.A.T. personnel making over one hundred trips to Japan and E.A.T. setting up shop in new premises on Park Avenue (128–129). Pepsi, for its part, was more interested in gaining a foothold in the Japanese market than in what form its expo presence would take, and it secured its site before having much of an idea what would go inside. No doubt Pepsi's resolute pursuit of the youth market—the "Pepsi generation" campaign had been running since the early 1960s but the drink was still being outsold by Coca Cola eight-to-one—influenced the company's willingness to take on the artists, but E.A.T.'s endless experimentation and undetermined end product, not to mention the rising cost, eventually proved too much for the company.

Aside from 9 Evenings, the Osaka pavilion at Expo '70 was the most ambitious project E.A.T. had undertaken, and Klüver had high hopes that it would serve to launch his organization on a new phase of ambitious, socially conscious activities "outside art." The withdrawal of Pepsi's financial support and the outstanding costs E.A.T. still had to pay all but put an end to such plans. The defeat, however, did not stop Klüver from shaping the pavilion project into a compelling narrative of organizational experiment through the 1972 publication of a detailed book edited by himself, E.A.T. newsletter editor Julie Martin, and art critic Barbara Rose (Klüver, Martin, and Rose 1972). Titled *Pavilion*, the book included a section on "hardware," with accounts by artists and engineers on the innovations they developed during the process, a detailed exploration of the planned "Live Programming," along with proposals received from an impressive array of composers and musicians—including Allan Kaprow, Alvin Lucier, Pauline Oliveros and Lynn Lonidier, Terry Riley, and La Monte Young. Accompanied by a technical as well as an E.A.T. bibliography, extensive black-and-white photographs and a sequence of color plates, and fortified by three narrative accounts of every detail of the project from the perspective of a technology writer (Nilo Lindgren) and two art critics (Rose and Calvin Tomkins, whose *New Yorker* essay is reprinted in full), *Pavilion* is at once an archive of E.A.T.'s energy, ambition, and outlook, and an exhaustive prospectus. The book, it is fair to say, has one eye on posterity and the other on possible future sponsors. Most importantly, perhaps, the book delivers a sustained examination of Klüver's vision of E.A.T. as an experiment in organization, since the expo pavilion project relied on an extensive network of (mostly) willing collaborators working across disciplines, languages, and nations.

The fullest account of Klüver's collaborative ethos is Lindgren's essay, which opens by recognizing that there is little original about the component parts of the pavilion; what is "new and impressive," though, he claims, and what

makes the work significant, is the "in-depth" and "invisible" collaboration "of men and women from so many different professions, trades, and cultural backgrounds" (Lindgren 1972, 3). Although things did not go smoothly, he admits, it was the "*process* by which the Pavilion was realized" that was the "key ingredient" (3, original emphasis). The purpose of Lindgren's narrative, and indeed of the book as a whole, is to provide evidence of how a collaborative project works by detailing the practical, theoretical, and interpersonal negotiations underwent in order to complete the project. Much as Klüver had stressed from the outset, the real experiment in bringing art and technology together was organizational. The stress E.A.T. placed on open-ended inquiry meant that there was little in the way of a defined outcome, and every aspect of the project, including the delegation of tasks and the relation between individual expertise and interests and group objectives, had to be worked out collectively.

Getting artists and engineers to work together posed its own challenges, but Lindgren's initial discussion of collaboration focuses on the ostensibly more straightforward task of facilitating collaboration among artists. In the first meetings between the lead artists on the expo project, Klüver's organizational strategy was to employ the Delphi method developed at RAND by Olaf Helmer, Norman Dalkey, and Nicholas Rescher. The purpose of the Delphi method is to generate pathways toward unknowable outcomes by soliciting the judgment of an assortment of experts, which is then circulated and modified through what Dalkey called "iteration with controlled feedback" (Dalkey 1969, 15). In the context of the E.A.T. project, Klüver tasked the artists to concentrate on the design of the whole pavilion rather than their preferred approach, which was to each concentrate on their own area. The intention, Lindgren explains, was to "enrich the possibilities in the final convergence" (1972, 16). However, the Delphi method ("an ancient method for modern consensus" is how Lindgren subtitles this section of his account) did not work very well, according to Lindgren, in part because it rubbed hard against "our modern artistic traditions in the West" (17), which privilege the unique contribution of the individual rather than the routinely critiqued collective effort. Exposing artists to RAND-style groupthink challenged, in Lindgren's account, some deeply held notions about artistic labor and resulted in some revealing strategies for protecting professional integrity. The best and most inventive ideas an artist might produce could easily be dismissed or compromised by others, so it might be best to hold back and offer less good ideas in order to maximize the chance of the best work being accepted. This self-interested strategizing, though Lindgren does not say so, sounds like a version of the prisoner's dilemma, that other RAND-generated theory of decision-making, but what it reveals decisively for

Lindgren is that "collaboration between artists is a direct attack on tradition" (17). It is here, we are asked to consider, rather than in what the project finally produces, that the key to E.A.T.'s radicalism is situated. "For those who are on the threshold of such a culture change," writes Lindgren, "there is also the anxiety connected with a sweeping aside of established ground. To a certain extent, one is left floating anxiously" (17).

The assault on individual authorship, in Lindgren's telling, is more than a local organizational strategy and part of a broader reorientation of the culture away from individual self-interest and toward collective problem-solving. The Delphi method may not have been very effective at yielding results, but as a means of exposing the conventional thinking of the participants it appeared to work very well. As such, by peeling back the protective skin insulating the traditional notions of creativity and ownership harbored by the artists, Klüver, in Lindgren's terms, was able to sweep away hidebound expectations and open up a less comfortable—but presumably, as a consequence, more dynamic—imaginative space for collective practice.

The experimental dimension of Klüver's organizational strategies comes across in Lindgren's, at times, almost sociological or anthropological tone, as if he is reporting the results of a field observation. "In talking with the artists," he writes, "it becomes obvious that each in his own way was struggling to wrap his own conceptions around what was already given, or supposedly given. Following this process, we get insights into how these artists thought of themselves and of their functions" (Lindgren 1972, 17). Certainly, the focus of the account positions the development of the pavilion as a test case for Klüver's E.A.T. experimental R&D ambitions. After a few weeks of discussion, Lindgren writes, something begins to happen: the participants discover "how to work with one another" (19). At this point, when it seems that "perhaps the Delphi Method worked better" than Klüver initially thought, he introduces "a new ingredient" (19) in the form of architect John Pearce, who soon concludes that the artists have achieved nothing since they "didn't even seem to realize they were really building a building" (Pearce, quoted in Lindgren 1972, 19).

Klüver emerges from the narrative as a mixture of social engineer and project manager, at once impatient that progress is not being made while encouraging, and even adding new elements to, a swirl of open-ended dialog. The work does eventually begin to cohere, however, and Lindgren claims that by "thrashing out their ideas, the artists became increasingly committed to true, noncompetitive collaboration, discarding ideas, triggering new ideas in each other, and acting as catalysts for each other" (20). As they learn to adapt to the new working conditions, "the artists began to feel that they were onto a beauti-

ful thing" (21), and Pearce, while keeping his involvement "relaxed," acted as a kind of reality check by assessing design features for architectural plausibility and managing the schedule. Though the Japanese were expecting delivery of a completed project, the expo pavilion was, writes Lindgren, "simultaneously a research project, a development project, and a construction project" (22), the outcome of which would not be fully known until it was finished.

From a collaborative point of view, the pavilion at Expo '70 yielded mixed results. Two of the main aspects of the design, a large inflatable mirror and a fog sculpture, were effectively delivered through the successful collaboration among a range of artists, scientists, and engineers able to resolve a number of logistical and aesthetic issues. Composer David Tudor (on the Black Mountain faculty from 1951 to 1953) and musician Gordon Mumma's plans for creating a distinctive sound environment for the pavilion, however, fared less well, with the engineer charged with facilitating the complex plans, Bell Labs' Larry Owens, having to make a series of what, to Tudor, were unacceptable compromises regarding Tudor's design in order for it to work on budget and on schedule. Owens found it a "real learning process," according to Lindgren. What Owens learned was that artists did not want to make up their minds months in advance, even though the use of technology might require such decisions to be made (57). He also learned that, when working with artists, "you are not making decisions based on facts. Sometimes you are making decisions based on the absence of facts!" (57). Faced with this situation, the engineer has "to invent facts, make a decision, implement the decision, and then come back to the artist and say 'Is this what you meant?'" (58). Owens concluded that artists did not know what engineering was, while Tudor, for his part, found the engineering solution to problems unable to accommodate nonengineering interventions, which were considered "meddling" (58). Smoothing things over, Lindgren remarks that "one should not lose sight of the fact that this was an ongoing experiment in a process that is attempting to bring together long-separated areas of endeavor" (59). He also, importantly, recognizes that the pavilion was more than a collaboration between artists and engineers, but also demanded collaboration between an art-and-tech group and a corporation, and between the US-based E.A.T. and Pepsi and Japanese business, art, and industry. Scaling up in this way illustrates for Lindgren not only the possibilities implicit in E.A.T.'s attempt to yoke together art and tech research, but also reveals the complexity of negotiating not only across disciplines but across sectors, nations, languages, and economic and cultural differences. From this perspective, the problems, mishaps, and deflated expectations appear minor setbacks in such an ambitious experiment in restructuring the way creative thinking-as-doing happens.

Calvin Tomkins notes that some of Klüver's art-world friends had urged him not to get involved with Pepsi, which, Tomkins observes skeptically, "they somehow seemed to regard as part of the military-industrial complex" (1972, 111). Though there is certainly an element of paranoid countercultural suspicion in such warnings, it was, after all, Pepsi-Cola that Nixon invited Khrushchev to drink at the first American trade exhibition ever held in the Soviet Union in 1959, and the scene of the famous "kitchen debate," a publicity coup engineered by the company's international head, Donald Kendall. However, E.A.T. had very little to say about politics, American foreign policy, or the Cold War in general. Whether or not this was a strategic decision intended to keep the lines of communication clear between E.A.T. and potential sponsors or a function of a deeper acceptance of the post-ideological rhetoric of American consensus culture is hard to say. Even in Barbara Rose's art historical contextualization of E.A.T. in *Pavilion*, a survey that sought to position E.A.T. as the inheritor of centuries of art and technology collaboration in the public interest that reaches back to antiquity, there was a resolute avoidance of the political ramifications of art or technology (Rose 1972). Noting the divorce of art and life brought about by industrial modernity and the rise of social fragmentation and disciplinary specialization, Rose had remarkably little to say of the political struggles driving the dissenters she named, from Mary Shelley, William Morris, and John Ruskin through the Futurists, Constructivists, Dadaists and Surrealists. The line Rose traced from the historical avant-garde through the Bauhaus, Black Mountain, and on to Kaprow and Cage is clear and accurate yet devoid of the strife and conflict that might render the narrative meaningful. Instead, Rose's art history, like Alfred Barr's torpedo diagram, implied the structural necessity of the present delivering an achieved synthesis of what has come before, in this case, "a new system of values" (61), embodied by E.A.T.'s collaborative process, based on "social interaction, control of technology toward fulfilling human needs, respect for the natural environment and its potentials and limitations, and a belief in the ability of individuals to take responsibility in democratic, noncoercive, nonhierarchical situations" (61).

By now we should be able to recognize this as art-and-technology boilerplate, and though Rose was right to note E.A.T.'s internationalism—in contrast to "the growing chauvinism of the New York School" (96)—its untypical willingness to employ women in "high-level positions" (98), and its ability to introduce the "values and goals" of art to executives, technicians and scientists (98), it must have been hard for many to see the PepsiCo pavilion, as Rose did, as the "realization of the vision of generations of modern artists" (98). The grand claims Rose made for the pavilion—for instance, that the mirrored dome is the modern

equivalent of one of the ancient Seven Wonders—are underpinned, as they often were in Klüver's own purple passages, by a sense that the American present represents a historic turning point. "The collaborative process by which the Pavilion was realized," she wrote, "was a specifically American experiment in democratic interchange. The process by which it was created..., of people taking responsibility without an authoritarian chain of command, acting within the area of their own competence as the need arose, learning new techniques of communicating with each other and with members of a culture vastly different from their own, may be a model for social interaction" (102). Rose insisted that the pavilion was designed for social and aesthetic, rather than commercial, purposes, and, in confident consensus fashion, that the participating artists and engineers "served no given political ideology" (99). For these reasons, the result should not be seen as a "simple 'bread and circuses' experience for a passive, bored public" (99). Instead, Rose insisted, the pavilion is a work of art that "makes an important statement about the future of society as a cooperative enterprise" (99). Forget Pepsi-Cola and the Cold War, the pavilion is utopia in action, part of "the tradition of the *Gesamtkunstwerk* or Total work of art" that will in the future be recognized as "the American equivalent of Tatlin's Monument to the Third International, the great ambitious project, which met with similar hostility and misunderstanding" (101). The pavilion, for Rose, therefore stands as a compromised but heroically utopian monument to "values American society and the corporate structure that manages it are as unwilling to embrace as the bureaucrats who brought Tatlin's project to a halt were unable to understand his meaning" (101).

It is a wonderful piece of temporal legerdemain to position the PepsiCo pavilion proleptically as the Tatlin *Monument* of the future, and Rose did an effective job situating the structure, which was even then "a gradually deteriorating wreck on a desolate ruin outside of Osaka, Japan" (102), as tragic evidence of a utopian vision too virtuous to withstand the indifference of the instrumentalized society into which it was placed. The pavilion may not have turned out to be, she wrote, the "monument to American enterprise and advertising the Pepsi-Cola company bargained for," but the attempt here to position the corporation as the author of the pavilion's ruin overlooks the fact that without Pepsi funding there would be no ruin at all. Klüver's insistence that the pavilion was a work of art, a claim he did not make at the outset but increasingly pursued as the project unraveled, is an attempt to save the reputation of the Osaka project from the compromises enforced upon it by its sponsors. As a work of art, Pepsi's rejigged promotional program becomes more than a commercial enterprise salvaging something from its investment and starts to look like philistine desecration. On this point, Tomkins is more proportionate in

his assessment of Pepsi's position, which he explains in terms of a mixture of concerns regarding finance and public relations. PepsiCo was only willing to spend so much and bend so far in terms of what it thought its audience would accept. In each case, the corporation decided E.A.T. had overreached.

Given that, according to Tomkins's account, the entire enterprise hinged on keeping Pepsi, with the willing involvement of insider David Thomas as go-between, at arm's length, it is remarkable that the pavilion ever got built at all. It is convenient, after the fact, to position PepsiCo as the shortsighted commercial interest resisting the "new system of values" Rose imagined the pavilion represented, but, aside from the warnings Tomkins claimed Klüver received about getting into bed with corporations, there is little sense that Klüver or others gave much thought to the implications of working on a project that would be meaningless to its sponsor if it was not promoting Pepsi-Cola and the broader values of American capitalism the company represented.

In her essay, Rose dismissed the pessimism of critics of technology like Jacques Ellul and the "nihilism" of Conceptual Art in favor of the optimism of Cage, Fuller, and McLuhan. In the face of an institutionalized avant-garde and the "establishment of a world art market for rare decorative objects" that converts "risk or critique" into "commercial investments" (98), Rose's defense of E.A.T. ideals—"group effort, collaboration, integration of the various spheres of artistic and scientific thought, submersion of the individual ego in the service of a common goal, and art as an active agent of social change" (97)—powerfully captures the progressive legacy that the 1960s art-and-tech projects embodied. Yet the expo pavilion was not the outcome of a Works Progress Administration project; it was (albeit by default) the winning bid in a corporate sponsorship deal. As such, the maneuvers that made the Expo '70 Pavilion possible reveal the fundamental disjunction between projects like E.A.T. and the corporate world they sought to win over. If Tomkins is right, the only time E.A.T. received serious money for a project, it was by accident.

### E.A.T. outside Art

While the Expo '70 pavilion survived, the compromised E.A.T. project did little to enhance the organization's fortunes. It did, however, lead E.A.T. to explore bold non-art avenues, under the banner Projects Outside Art, in areas such as education and the environment, and in the developing world, though proper funding was never forthcoming.

Projects Outside Art developed some fairly modest projects, such as Children and Communication, which introduced children to communica-

tions technology; City Agriculture, featuring a hydroponic roof garden at E.A.T. HQ; and Recreation and Play, a Los Angeles-based investigation. A symposium and instructional exhibition were held at the AFAE's Automation House in New York. With funds from the John D. Rockefeller Foundation, E.A.T. organized a cultural exchange called American Artists in India during 1970 and 1971, which allowed artists to travel and work for a month. Participants included dancers and choreographers (Trisha Brown, Steve Paxton, Yvonne Rainer), composers (Lowell Cross, Terry Riley, La Monte Young) and visual artists (Jared Bark, Jeffrey Lew, Kate Redicker, Marian Zazeela).

More ambitious was a plan to broadcast Indian-made educational television programming to rural India by satellite, a project developed in 1969 by Klüver, Robert Whitman, and Vikram Sarabhai of the Nehru Foundation for Development (Delhi, India). In December of that year, the group traveled to the Anand Dairy Cooperative and set up educational assistance programs for female dairy farmers. The Nehru Foundation and E.A.T. proposed using half-inch video equipment to collect on-site visuals to be shown in educational television shows. In 1971, another E.A.T. telecommunications system (Telex: Q&A) was set up in Stockholm at an exhibition themed around the Paris Commune called *Utopier et Visioner 1871–1981*. Teleprinters connected New York City, Stockholm, Ahmedabad, and Tokyo and participants in each city were asked to comment on what they thought the world in 1981 would be like. Also in 1971, E.A.T. worked with Bell Labs psychologists to conduct comparative studies on advanced technologies used in statistical analysis, a project called Multi-Dimensional Scaling, and coordinated the cable broadcast of artists' videos in New York. Further explorations of possible satellite television projects during the early 1970s, with the El Salvador education department and with the United Nations, and a Klüver design for a giant-screen video projection system for the facade of the Centre Georges Pompidou in Paris, remained at the design stage.

For all the optimism about new modes of creativity being generated through a collaboration between artists and engineers, Klüver's model remained an individualistic one: the lone inventor and the solitary artist rather than the emerging mega-teams running Big Science projects. The Bell Labs Murray Park notion of the industrial lab as campus masked the increasingly managerial and hierarchical aspect of Cold War scientific and technological research. The popularity among American artists for new materials and processes rarely developed beyond innovative ways of fabricating objects, and the performative, improvisational, and politically radical directions of the Fluxus-oriented wing of the New York art world had little interest in support from corporate sponsors. The bigger, often unrealized or incomplete E.A.T. projects geared, in

keeping with Great Society ambitions, to social issues tended to move away from the emphasis on art as such and toward a more sociological intervention that they were nevertheless financially and organizationally ill-equipped to support. In one way, Klüver's conception of an expanded E.A.T. shares Black Mountain's exploratory progressivism, yet Klüver's desire and need to court corporate sponsorship, not to mention his tendency, despite the rhetoric of collaboration, to elevate the status of the artist as creator, left E.A.T. awkwardly placed between the corporate administrative model and the patron-dependent entrepreneurial economy of the art world. The sharp decline in E.A.T. activity after 1971 was part of a broader shift in attitudes toward technology that, as will become abundantly clear in the context of LACMA's Art & Technology Program, effectively cut off the oxygen from art-and-tech collaborations.

# 04

**Feedback**
Expertise, LACMA, and the Think Tank

The most interesting and creative art of our time is *not* open to the generally educated; it demands special effort; it speaks a specialized language.
—Susan Sontag, "One Culture and the New Sensibility"

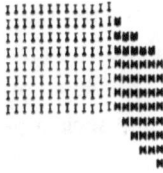

Edward Kienholz, the Los Angeles–based artist famous for his found-object assemblages, used to drive a truck with the legend "ED KIENHOLZ—EXPERT" painted on the door. Kienholz worked as a handyman to pay the bills, suggesting something of the resourcefulness and entrepreneurial spirit that made the Ferus Gallery, which he opened in 1957 with Walter Hopps, the hub of the emerging LA avant-garde. As a form of self-promotion, Kienholz's claim to be an "expert" is both a joke and a statement of fact. It pokes fun at the notional value of an expertise that can stand as a proclamation of superior knowledge or skill without anywhere announcing the area of specialism to which it refers. The idea of a generic expert makes little sense, yet it does speak to the expanded domain of the post-medium artist, where expertise in art as such is not bound to specific materials, skills, traditions, or content. The Duchampian spirit animating much of the LA scene (Hopps would go on to curate the influential, and first, museum retrospective of Duchamp's work at the Pasadena Art Museum in 1963) is there on Kienholz's truck door: expertise is what the expert says it is.

The idea of the expert, though, has a broader valence in 1950s US culture. The defense of science that developed in the early postwar period by Vannevar Bush and others was intended to shape a public perception of specialized expertise as a necessary and desirable condition for the full realization of modernity's democratic promise. The emphasis on interdisciplinary collaboration, while in a sense at odds with the increasingly focused research undertaken by scientists and engineers, answered the charge that narrow specialization led to the creation of a cloistered scientific priesthood. If the cultivation of elite expertise was an affront to a more Deweyan notion of scientific democracy, collaboration among experts allowed for a different, albeit more exclusive, sense of science as a collective endeavor in the service of the people. With scientific, technological and social scientific expertise increasingly presented as enablers of social efficiency and prosperity, meritocratic Cold War educational and scientific institutions could remain on the side of democracy, charged with recognizing and nurturing the capacities of any citizen willing to learn.[1]

It is here, perhaps, in the democratizing of creativity as the source code for the expert, that the military-industrial articulation of scientific and technological innovation as a creative project undertaken by specialists drawn from a common pool converges with the avant-garde's expanded field of artistic engagement. The rejection of the production of objects, along with the singularity of the artist as individual genius, and the emphasis instead on collective, processual investigations across multiple sites and platforms, made the practice of art an embodied realization of democratic possibility (along Deweyan lines) that broke down barriers between work and audience, participation and spectatorship. At the same time, the capacity to understand such processes and engagements as art required a particular stance toward the work that implied a kind of expertise of the sort Kienholz mobilized in his own self-promotion. In other words, the expanded field of the neo-avant-garde did not so much remove the notion of expert knowledge and skill from art as it repositioned such a notion. The definition of what constitutes art underwent a radical restructuring, yet the notion of art as the domain of a distinctive set of specialists remained, even as the terms of what that specialism amounted to changed. Although there may have been little common ground between research scientists and engineers and artists in terms of background, working practices, and operating assumptions, what art and technology collaboration advocates like Billy Klüver recognized was that the general terms upon which postwar American society was premised—terms like creativity, expertise, and innovation—served, in a broad sense, to describe what scientists, engineers and artists were all about.

It is for this reason, we think, that there is little mention by Klüver, Kepes, and others of the political ramifications of their efforts to align technology and art beyond a general, all-purpose utopianism. Any resistance or suspicion among artists or engineers toward the other camp is massaged away through an appeal to the virtues of collaboration and a stress on finding common ground. There appears to be no forum at projects like E.A.T. within which the challenges of working alongside prominent military-industrial institutions might be addressed beyond formal or technical difficulties. In many ways, the shared technocratic embrace of a generalized notion of expertise made it possible for scientists, engineers, and artists alike to perceive themselves and their work within a context that erased the boundaries between the professionalized sites of laboratory and studio while protecting the distinctiveness and importance of what they thought they were doing. In short, the cultural capital enjoyed by American scientists, engineers, and artists during the 1950s and early 1960s allowed each group to benefit in relatively uncomplicated ways through their association with other fellow experts. Scientists and engineers could indeed be said to be creative since artists sought them out; artists could imagine their work as investigative and experimental by virtue of their proximity to the apparatus and personnel of science.

Despite this broadly welcoming context of mutual professional respect, however, and regardless of the efforts of organizers to downplay clumsy or unsuccessful collaborations, it was often in the friction that the real heat was generated in 1960s art and technology projects: when artists and their hosts and collaborators did not get on; when planned collaborations fizzled out or collapsed; when the results of collaborations were dismissed or challenged. This is most obviously the case with the Los Angeles County Museum of Art's Art and Technology Project, which shared something with both CAVS and E.A.T. in terms of vision and ambition but which, especially in its culminating exhibition, came to mark the moment when the art-and-technology vanguard became, almost overnight, the vilified embodiment of complicity with the American military-industrial state. The project was also, as we shall see, responsible for pushing the art-and-technology brief beyond an investigation of materials and devices and into, intriguingly, the area of corporate thinking itself.

### The Center of a New Civilization

Maurice Tuchman, a twenty-seven-year-old research fellow at the Guggenheim Museum in New York City, became the first curator of twentieth-century art at the Los Angeles County Museum of Art (LACMA) in 1964, a year before the institution moved to its site on Wilshire Boulevard. The three-building museum,

constructed at a cost of $11.5 million, is suggestive of the growing cultural confidence of a city that had experienced nearly two decades of massive population growth and urban development since World War II. Despite the work of Kienholz, Hopps, and others during the 1950s, though, LA art had remained subordinate to the power of the New York art world. Part of Tuchman's mission was to put LA art on the map—the city was set to become, the curator told *Life* magazine, "the center of a new civilization" (Wernick 1966, 116)—and secure LACMA's place as the center of the LA art world. To do this, in 1966 he conceived of a program that explicitly sought to bind the museum into Southern California's booming Cold War technology sector. By hooking up the museum to the financial mainline, Tuchman's proposed Art and Technology Program (A&T) would secure the position of art as an integral part of the Southern California success story.

Tuchman's strategy was to stress the minimal cost involved to sponsors, compared to their contributions to other organizations, and to highlight the benefit to business from "proximity to thriving cultural resources in attracting talented personnel" (Tuchman 1971, 9), as well as the bonus for employees from exposure to creative people. All artworks produced as part of the program would be given to the corporations involved. With the help of Missy Chandler, the wife of the *Los Angeles Times* publisher who had read about the project in a newspaper feature, Tuchman recruited forty corporations, some merely as financial contributors, others hosting artists in factories, labs, and offices. Many of the participating corporations were aerospace companies (Lockheed, Pan American, Jet Propulsion Laboratory), major players in computing (Hewlett-Packard, IBM), entertainment (Universal, 20th Century Fox), and electronics (Ampex, Philco-Ford), as well as construction (Kaiser Steel, American Cement) and think tanks like RAND and Herman Kahn's Hudson Institute—the organizations that built and sustained the Cold War United States.[2]

Unlike E.A.T., which encouraged artists to apply to the organization, Tuchman approached artists directly, resulting in a wide spectrum of activities ranging from unproductive exploratory meetings and stalled plans through to the fourteen completed projects that ended up in the exhibit that concluded the program in 1971. Seventy-six participating artists were listed in the *Report on the Art and Technology Program of the Los Angeles County Museum of Art 1967–1971*, the extensive document published to accompany the LACMA show that attempted to record exhaustively the history of the program from its inception (Tuchman 1971). Most of the artists were well-known; more than half were based in New York; fifteen were European (or working in Europe); eighteen were local LA artists. All of the artists were men. The fourteen who exhibited

in 1971 were largely high-profile stars, including R. B. Kitaj, Roy Lichtenstein, Claes Oldenburg, Robert Rauschenberg, Richard Serra, and Andy Warhol. Only twenty-eight out of the seventy-six were placed in residencies; those who did not make it into the show either had not finished in time, ran out of money, never planned to produce work to exhibit, or had fallen out with their sponsor.

The reception of the LACMA A&T show was not helped by the fact that it ignored female artists, favored established New Yorkers over LA artists (only Frederick Eversley and Newton Harrison, among the exhibited artists, were local, though Tuchman had tried to recruit more), and produced viable work from only a small fraction of the collaborations A&T had organized. The *Los Angeles Free Press* published a challenge to LACMA's white male bias by the recently founded Los Angeles Council of Women Artists (LACWA), who also produced a seven-page report on LACMA (Fallon 2014, 17). Questions of representation, however, were only part of a broader problem faced by A&T and other art and technology initiatives by the end of the 1960s as US public opinion shifted sharply away from the technocratic model of corporate liberalism. Like E.A.T., Tuchman saw international expositions as obvious sites for the presentation of art-and-technology collaboration, and eight A&T artists were shown at the American pavilion at Expo '70 in Osaka. The LA press was happy to promote the "democratic ideals of co-operation and interaction between various levels of the society" (quoted in Goodyear 2008, 170) that A&T displayed at Osaka, but Cold War public relations of this kind were increasingly unfashionable and suspect.[3]

In a context of rapidly changing fortunes for art-and-technology projects, the role of documentation became an important way for organizers to explain and secure the reputation of their activities. The in-house and public-facing stream of bulletins issued by E.A.T. created a sense of momentum and coherence surrounding the aims of the organization, but it is the *Pavilion* book, more than the proceedings and reports, that gives Klüver the chance to demonstrate the depth and complexity of what E.A.T. was trying to accomplish (see Klüver, Martin, and Rose 1972). Similarly, it is the *Report on the Art and Technology Program*, rather than the exhibition, that most effectively captures the spirit of A&T. Tuchman's report is in many ways the most interesting outcome of the LACMA project, a document David Antin was already calling, in his 1971 review of the A&T show, a work of "conceptual art" (Antin 2011, 61). In order to give a full account of what Tuchman describes as "the emotional complexities and the sheer logistical difficulties" of the A&T Program (Tuchman 1971, 29), the report presents the business case, the contracts, the list of companies and their logos, the works completed and, more revealingly, the incomplete, the

impossible, the miscommunication, and the breakdown of relations among artists, engineers, and businesses. It details conversations, phone calls, negotiations, drawings, and diagrams produced in the course of interactions among museum staff, 76 artists, and over 225 corporation employees. Like the various E.A.T. bulletins and press releases or a Fluxus work on steroids, the A&T report positions the program of ongoing art and technology investigations itself as the project's core experimental practice. Tuchman is right to do this inasmuch as he was aware from the outset that the final exhibit would never properly represent the range of explorations that had been undertaken, though as a project supported by a major museum the necessity of a show of completed work was clear enough.

It is in the daily negotiations among participants, then, that the ramifications of collaborative or residential work are most properly tested. This is clearly the case in two of the A&T residencies that are distinctive, both among the A&T projects and more widely among the other art and technology ventures, in that they involved organizations explicitly concerned with Cold War intellectual and theoretical formations rather than corporations, businesses, or institutions engaged in the physical investigation or manipulation of materials. Nowhere is the discourse of expertise more vividly revealed than in the placement of John Chamberlain at the RAND Corporation and James Lee Byars at the Hudson Institute.

Most of the placements arranged for A&T artists had a clear practical dimension and involved consultation with technicians and engineers over the feasibility, cost, management, and delivery of fabricated structures. At RAND and the Hudson Institute, by contrast, the business of the organization was the generation of ideas. As such, A&T introduced a new dimension to the notion of the artist placement, since there was no obvious material assistance that the corporation could supply. The inclusion of think tanks in the category of organizations concerned with technology also recognized the extent to which mathematics, statistical and policy analysis, and planning had become integrated into the industrial system. While there had been think tanks in the US since the Progressive Era, RAND and Hudson represented the new postwar generation of what are often called universities without students: institutions charged with developing strategy and innovative policy programs outside of, but often paid for by, government.

### The Think Tank and the Memo

The first national organizations that would, by the 1960s, become known as think tanks, emerged in the early twentieth century, during the Progressive Era's growing confidence in the application of social scientific expertise to solve social

problems and inform government decision-making. Demand for policy research and analysis intensified during the 1930s (including President Roosevelt's "brain trust" of experts), and by World War II the use of nonprofit advisory organizations to provide expertise to government and the military expanded. Among the first and best known of the post–World War II think tanks was the RAND Corporation, which began as a Douglas Aircraft subsidiary that provided research to the United States Air Force. After the war, RAND became an independent nonprofit think tank based in Santa Monica, California, almost entirely dependent on government contracts. With government intervention in the management of a widening array of social and economic affairs, the think tank became a significant means of developing and planning policy. As James Allen Smith observes, RAND "became the prototype for a method of organizing and financing research, development, and technical evaluation that would be done at the behest of governmental agencies, but carried out by privately run nonprofit research centers" (1991, 116). During the 1950s, RAND was deeply engaged in nuclear strategy and the development of systems analysis, producing its most notorious alumnus in Herman Kahn, whose scenario planning for nuclear conflict provoked disquiet when he published *On Thermonuclear War* in 1960, a book famously described by *Scientific American* as a "moral tract of mass murder: how to plan it, how to commit it, how to get away with it, how to justify it" (quoted in Rich 2004, 45). Because RAND was less than happy with Kahn's growing public profile, he left the organization to form the Hudson Institute in 1961, where again the Department of Defense was his biggest customer.[4]

The rising status of the policy analyst benefited from the general postwar high regard with which science was held, and researchers like those at RAND presented themselves, and were presented in the mainstream media, as experimental scientists of a sort, able to invent and engineer new social and organizational forms (see Smith 1991, 14). The wide range of analytical tools developed at RAND, James Smith argues, were a source "of extraordinary confidence in policy making," and the expert during the 1960s "gained new heights of prestige and political influence" (121).[5] At the same time, the suspicion of ideology prevalent during the early 1950s and early 1960s presupposed an intellectual environment that focused on the technical assessment of means rather than challenging the broader structures within which solutions to problems might be addressed. In other words, the elevation of the expert was framed within an understanding of the role of expertise delimited within the terms of a consensus that saw abstract ideas as politically dangerous.

The New York-based artist John Chamberlain was contacted by LACMA in April 1969, and curator Jane Livingston met him in New York. The possibility

of a film project with Ampex, RCA, or CBS was discussed, and Chamberlain visited Ampex in Los Angeles in May, though nothing came of it. After another project, involving packaged odors, failed to connect with corporate sponsors, Chamberlain was offered the option of a placement with a division of Norris Industries, a manufacturer of porcelain bathroom fixtures, or the RAND Corporation. Chamberlain chose RAND.

Larry Bell had already been placed at RAND earlier in the year by A&T, but despite his initial sense of the "romance" of an organization engaged in all sorts of top secret work, nothing happened and Bell was out of RAND by July. In August, Chamberlain was given an office and some secretarial help, and left to navigate the organization. Chamberlain explained to A&T in September, around three weeks into his residency, that the going had been tough; he "couldn't make any headway at the beginning" and the RAND people had thus far been unresponsive (Tuchman 1971, 71). On the face of it, RAND ought to have been receptive enough: the previous year, the corporation's assistant to the president had written A&T that "RAND has something special to offer the creative artist: an intellectual atmosphere and the stimulation of being amid creative individuals working in many disciplines" (71). This promise of interdisciplinary creativity was what Chamberlain hoped to find, and what he had come to expect given RAND's reputation. "I'm not really against the concept of RAND," he explained, "its uniqueness since 1946, through '56, even until 1960" (71). Since those early days, though, the corporation, in Chamberlain's assessment, had become "somewhat stodgy and constricting" and instead of intellectual brilliance he found mostly "sort of dumb fifth grade attitudes about everything" (74).

It is telling that the sense of disappointed belatedness in Chamberlain's remarks, that he had somehow missed the golden age of RAND, is explained by an awareness that there had been something unique about the corporation until 1960—around the time Herman Kahn left to found the Hudson Institute. Chamberlain does not mention Kahn but it is Kahn and his freewheeling intellectual audacity that had come to define RAND during the 1950s. It was also in response to the artist that A&T had placed at the Hudson Institute, James Lee Byars, that Chamberlain came up with the notion of sending RAND employees memos asking for "answers." Byars had begun his involvement with the Hudson Institute in May 1969 and continued to work there through mid-July, returning periodically after that until the end of the year.

What Byars was mainly interested in was "questions": the key aspect of his four-pronged investigation was to gather the "one hundred most in-

teresting questions in America at this time" (Tuchman 1971, 58), which he planned to glean by telephoning influential people from what he called the World Question Center. The other three points he intended to pursue suggest a somewhat awestruck Byars: "the exultation of being in the proximity of extraordinary people," "the next step after $E = MC^2$," and "one thousand superlatives about the Hudson Institute" (58). Byars communicated with Hudson staff mainly through internal memos and questionnaires, the first being a request from Byars for "one hundred superlatives on Herman Kahn." Answering his own question, Byars's top superlative was: "I-fell-in-love-with-Herman-Kahn-because-I-knew-in-advance-that-he-could-speak-four-hundred-words-a-minute" (60).

Like Chamberlain, Byars knew in advance that Kahn was extraordinary—the myth of the genius "defense intellectual" framed his expectations. Unlike Chamberlain, though, Byars got to play in Kahn's sandpit, and Byars was clearly electric with excitement in the presence of greatness while Chamberlain was deflated because he believed he had missed the boat. Chamberlain's memo requesting "answers" at RAND had to acknowledge a prior question he did not get to ask, and there is a certain testiness to the memo that exceeds the feigned bureaucratic mode Chamberlain adopts:

```
TO: Everyone at RAND
FROM: John Chamberlain, Artist in Residence
SUBJECT: ANSWERS

I'm searching for ANSWERS. Not questions!

If you have any, will you please fill in below
and send them to me in Room 1138.

_____
_____
_____

THANXS
CHAMBERLAIN
```
[written in black ink]
(Chamberlain 1969)[6]

Whether the impatient tone here (the emphatic "ANSWERS," and the curt, exclamatory dismissal of questions) is a measure of Chamberlain's frustration with RAND or an attempt to engage with (and outflank) Byars is unclear. The A&T report explained that the two artists did not coordinate their projects, even though Chamberlain "felt in the beginning that the answers might correspond to Byars' questions, and perhaps even be used in conjunction with them as an art work" (Tuchman 1971, 74). What the report did concede, though, is that, despite Byars's awestruck pronouncements about Kahn and the Hudson Institute, things did not go smoothly for either think tank-based artist: "Both were to some degree unsuccessful in drawing enough interesting material from their 'subjects' to constitute a satisfactory artistic product," and had to rely on "their own inventions" to complete their respective projects (74).

The kind of projects Byars and Chamberlain sought to initiate at the think tanks and the difficulties they faced reveal a fascination with the notion of an intellectual hothouse environment, and also with the modes of communication they took to be the common practice within them. The Hudson Institute and RAND represent at once a deep establishment commitment to the protocols and hierarchies of the bureaucratic state and a new model of creative inquiry plugged into the mechanisms of policy-making. The think tank, at least as it is reflected in Byars and Chamberlain through their respective exulted and dejected responses to their placement within one, is where ideas become actions, where creativity has leverage, and where the exceptional and visionary are cultivated. According to this conception, which the popular media nurtured throughout the 1950s and which Kahn's celebrity status seemed to confirm, RAND and the Hudson Institute represented the triumphant fusion of the studio, the laboratory, and the country club: they were creative, experimental, and exclusive, full of "extraordinary people," as Byars imagined them, making the future happen. The problem, as both artists found, was that the extraordinary people were less than impressed by the presence of the artists.

The think tank is among the institutions to develop out of, and to crucially shape, the emergent information society of the postwar period. John Guillory defines information "as any given (datum) of our cognitive experience that can be materially encoded for the purpose of transmission or storage" (2004, 110). Guillory argues that information is more than fact but less than knowledge; fact becomes information, he suggests, "when it is, so to speak, value-added" (110)—when the fact comes to be known in a certain context. Information is less than knowledge because it has not yet been organized into a structure of intelligibility. What is distinctive about information, then, is that its value lies in transmission: "Information demands to be transmitted because

it has a shelf life, a momentary value" that, if missed, requires that the information "be stored to await its next opportunity" (111). The storage of information is a key aspect of what Michel de Certeau (1984, 131–153) calls the "scriptural economy," since the management of written documents is at the heart of modern bureaucracy and its rules for the administration of the files containing the drafts, letters, memos, and reports that comprise the record of the business of the office (see Weber 1978, 957–958).

Guillory's notion of information as fact valued in transmission provides a strong indication of the function of the think thank, where ideas and theories are produced and circulated out of a perceived need to answer specific questions. Unlike scholarly or scientific research, think tanks like RAND are not tasked with the disinterested production of knowledge; they are precisely concerned with the delivery of information or data that can be applied to address particular issues. For Guillory, the quintessential information genre is the memorandum, a document that is "both *ephemeral* and *permanent*" (2004, 113, original emphasis): the memo "might have an audience of one, or none; it might be read once, or never. But however vanishingly ephemeral its interest, it must nonetheless be preserved, that is, *filed*" (113, original emphasis).[7] The memo "gives directions, makes recommendations, but, above all, it is a means of transmitting information within the large bureaucratic structures organizing virtually all work in modernity" (112). Memos are often regulated according to the dictates of standardized forms, and as such their content may be marked by the expectations and practices required by an organization. The memo, in this sense, represents a management of expression according to the shape imposed by the rules and procedures of a business. The circulation of memos is commonly restricted to communications within an organization, suggesting that they constitute an ongoing transcription of its communicational culture—what JoAnne Yates calls "organizational memory" (Yates 1990).

For Guillory, the memo, as a genre of writing that emerges during the late nineteenth and early twentieth centuries, along with the emergence of modern large-scale business organizations, coincides with the demise of the rhetorical tradition associated with oral communication, eloquence, and persuasion. In contrast, the memo reduces scope for persuasion—due to the demands of what Guillory calls an "economy of attention" (2004, 125)—"in favor of permitting a certain instruction to speak for itself" (120). This does not necessarily mean that there is not desire to persuade, only that "persuasion is implicit . . . in simply transmitting information" (120). A memo, when it "*directs* others to act," is received "*as information*, as the answer to the subaltern's question, What should I do?" (121, original emphasis). Where action "is *recommended* to equals

or superiors and argument is supplied, the weight of the argument must be carried by information, and contestation occurs around the question of what course of action the information actually implies" (121, original emphasis). Informational writing is, then, an expression of control where individuals within large organizations with complex communicative networks are "dependent, whatever their rank, on the transmission of information possessed by others and where all functionaries are equally compelled, whenever they write, to submit their writing to certain generic constraints" (122). Chamberlain's interest in the memo as a mode of information generation and dissemination shares something with aspects of Conceptual Art, namely a focus on constraint, procedure, and seriality. These same concerns are pursued exhaustively by Fluxus.

Chamberlain's call for answers through the use of memos came after his initial failed attempts to engage RAND personnel. He suggested dissolving the corporation, cutting off the phones for one day, and taking photos of staff on the patios. Then he decided to screen his film *The Secret Life of Hernando Cortez*, a typically late 1960s art film featuring stalwarts from Warhol's Factory and hallucinatory soft porn, in the cafeteria.[8] *Cortez* was shown once a day for three days before the screenings were canceled due to complaints. This is the point at which Chamberlain dispatched his first memo.

Some responses were measured, if gnomic ("A cautious balance between cataclysmic optimism and discerning myopia"), others facetious ("$2+2=4$"; "pi to the twenty-forth digit"), dismissive ("quit wasting RAND paper + time") and downright hostile ("the answer is to terminate Chamberlain"). More than one respondent displayed expert math chops by scratching out a complex equation, while another stayed resolutely on message by reflecting on the ratio of actual to estimated costs of weapons systems and the speed of computer runs before and after "debugging." One carefully wrote out a very long word ("pneumonoultramicroscopicsilicovolcanoconiosis") with a condescending parenthesis ("in any dictionary"), while another provided a short essay on the current "sex revolution." Many betrayed confusion ("no comprende!") and uncertainty about what question exactly they were being asked to answer, leading a number of respondents to provide an assessment of the *Cortez* film ("stop making movies—stick to sculpture") or make suggestions about how RAND decor could be improved. One of the more lengthy replies provided a review of the film *and* requested more color and some pictures in the hall (as well as correcting the spelling of "thanxs" in red ink).

What Chamberlain expected to receive beyond this mixture of pointy-headed bureaucracy, literal-mindedness, philistinism, and snark is unclear, but he was dissatisfied enough with the responses of RAND staff to issue a clari-

fying (and somewhat admonitory) bulletin, sent on his behalf by his RAND contact Brownlee Haydon:

```
TO: Everyone at RAND
FROM: Brownlee Haydon
SUBJECT: JOHN CHAMBERLAIN'S MEMO (ATTACHED)

Before he left for the East, John Chamberlain gave me the
attached memo for distribution.

Because of some of the responses to his earlier memo asking for
"answers," I think everyone should understand:

1. John has nothing to do with the experimental redecoration of
RAND's halls and offices (see Roger Levien).

2. John is a guest artist-in-residence, sponsored by and paid
for by the Los Angeles County Museum of Art.

3. His question about answers was not intended to elicit reviews
of or comments about his film.
```

In a further memo, with the subject heading "MORE ANSWERS," Chamberlain thanked the previous respondents and explained that he would now "like to be more explicit." Unfortunately, the explanation he provided of what he was after is far from clear: "I had hoped for a more specific poetic imagery to induce, or suggest, an alternative to thinking if or when asked to pair with it, a question or statement. The altruistic answer is nice, but less interesting… the challenging being from without rather than within." One respondent to this memo underlined the word "explicit" and wrote in the margin "Aw, come on!" Another provided a dictionary definition of the word ("characterized by full clear expression") and, in a typed note, instructed Chamberlain that "one of the functions of the artist is to *communicate*. I can't find one person who understood either your first communication or your second. We would be happy to share our spiritual experiences with you if we knew what you are trying to express. Could you please rephrase paragraph #2 (Ernest Hemingway you ain't!) so we can understand what the hell you are driving at—or do you

know yourself?" This is a fair criticism—it is hard to tell from Chamberlain's explanation what he is after.

Despite his disappointment with the pedantic, and sometimes puerile, responses to his memos, a fair number of RAND staff did attempt to genuinely engage in Chamberlain's exercise, even if they could not fathom the purpose. One response, for example, managed to provide a sharp sketch of the RAND experience from the inside:

> RAND atmosphere = above average intellectual honesty + personal isolation in white cubicles = a bright bunch of non-communicative neurotics— Now you come up with a question.

There is a combination of openness and guardedness here, as well as a willingness to identify the tension between collective labor and compartmentalization. This respondent understands the function of the memo as a mode of combat at one remove—employees screened off from one another but accustomed to receiving (and returning) hurled challenges. What Chamberlain's RAND experiment begins to explore, whether deliberately or not, is the bureaucratic mode of communication as a manager, as well as the medium, of information exchange. The memo encourages, and is the condition for, a certain kind of terse exchange, but responses are of necessity delayed. This delay provides an opportunity for reflection but not for the effective correction of misunderstandings. As Chamberlain's limited success in communicating clearly with RAND staff suggests, the memo as a form of communication is just as effective at blocking exchange as it is at enabling it. For Chamberlain, the memo was also presumably an unfamiliar mode of address, and no small part of the cause of his inability to explain what he wanted to do at RAND was down to a failure to communicate using the preferred professional form and idiom.

In an A&T questionnaire Chamberlain completed at the end of the project, he explained that the first person he met at RAND told him that the corporation made "no product except paper." This, Chamberlain goes on, "proved to be incorrect as it took me four weeks to figure that their product was response or feedback."[9] Here, Chamberlain reveals a more sophisticated awareness of the memo culture than is first apparent in his awkward communications with RAND staff. It may have taken a few weeks to work out, but what Chamberlain's memos kick into action is the RAND feedback machine. Processed through and resituated within Chamberlain's art-world context, these irritable scraps collect a form of found poetry that stands as the scratchy transcript of the limits of art-and-technology interaction.

While he clearly was not much of a writer, Chamberlain had spent a year during the mid-1950s at Black Mountain College, where he worked mainly alongside poets, including Charles Olson, Robert Duncan, Robert Creeley, and Fielding Dawson, as well as painters like Joseph Fiore and the musician Stefan Wolpe (see Waldman 1971, 17). He was aware of the benefits of collaboration across disciplines, and the expectations he brought to RAND may well have been colored by his experience at Black Mountain, where exceptional talent was gathered and given free rein. Chamberlain's inability to generate purposeful dialog at RAND was, in his view, a measure of the staff's "constriction," though it is apparent from his memos that part of the problem lay in an opacity all his own. Accustomed to working among the most advanced artistic and literary practitioners in the country, Chamberlain seems unable to recognize his own mode of communication as itself a specialist discourse, and concludes that it is his hosts who are intellectually under par. The notion that RAND staff might have a working knowledge of contemporary art and aesthetics is as optimistic as the prospect that Chamberlain could follow the calculus he received among his "answers." The frustration with RAND employees, then, is due to Chamberlain's sense that, as a member of what Habermas (1987, 397) calls an "expert culture" (the upper echelons of the US art world), he ought to be conversant with and treated on a par with other expert cultures—in this case, RAND. That this patently was not the case not only challenges Chamberlain's personal sense of professional status and competence but also, more seriously, puts in question the operating assumptions of the interdisciplinary collaboration underpinning art-and-technology projects like LACMA's.

### What Was the Question?

Someone who might have been able to follow Chamberlain's cryptic requests was Herman Kahn, whose own unruly oral presentations had to be hammered into coherence for publication by dutiful associates. By 1968 Kahn's performance style had turned the defense intellectual (a category of exotic specialist he came to embody) into a kind of star turn, as admired for his manner of delivery as for what he had to say about thermonuclear war. A *New York Times Sunday Magazine* feature from that year described Kahn as possessing "computerlike capacities" that, in public performance, enable him to "reach into his prodigious repertoire for a series of appropriate 'routines'—explanations, arguments, responses, dramatizations or anecdotes that he has developed in previous lectures and conversations" (quoted in Pickett 1992, 10). Here was the

kind of brain and charisma to match Charles Olson's or Buckminster Fuller's famously unruly and erudite lecture style. Chamberlain may have been right that RAND had lost its maverick spirit after 1960, but on the other side of the continent it was that spirit of which James Lee Byars was so enamored at Kahn's Hudson Institute.

At Hudson, Kahn was beginning to expand the range of think tank activity beyond defense concerns into the new field of future-oriented analysis, a realm of enquiry as abstract and unmanageable—and as reliant, in Kahn's mind, on speculation and outrageous vision—as nuclear deterrence theory. Khan hired on instinct and preferred insight and imagination over academic qualifications. He wanted to shred conventional wisdom and admitted that while his eclectic staff could be "impossible," they were also "extremely interesting" (quoted in Pickett 1992, 7). Here, surely, was the germinal environment within which an artist might work—Byars's effusive early praise for Kahn certainly seemed to suggest as much. Nevertheless, as the A&T report explains, Byars experienced "a general attitude of hostility" to his presence from the institute's staff, who thought what he was doing was a waste of their, and his, time (Tuchman 1971, 60). After the first few weeks, there was little interaction between Byars and the staff, and he spent much of his time "wandering about in the halls, chatting to people at random" (60). Byars was able to spend around twenty hours in total with Kahn during his time at the Hudson Institute, though when asked by A&T curator Jane Livingston about the value of Byars's presence there, Kahn was circumspect in his appraisal. The World Question Center, for Khan, was "a totally undisciplined and uninformed project." For someone well known for his interest in disruptive intelligence, Kahn was less sure about the purpose of hosting Byars: "Why are we bothering with Jim?" he wondered. "After all, I want the organization to run right. The presence of someone like Jim is theoretically subversive of that goal" (60). Livingston suggests that Kahn left the question of why it was worth bothering with Jim unanswered, though given Khan's propensity for amateur insight as a means to crack open received ideas it is surprising that the potential subversion Byars offered was not more fulsomely embraced. Byars himself seemed to sense the problem, which is that Kahn did not see art "as a category of enormous interest for himself or for the world—he tends to view it as a luxury" (60).

One of the A&T team, the assistant curator Hal Glicksman, was able to make a firsthand assessment of the Byars-Kahn interaction when he attended a policy seminar at Hudson in July. For Glicksman, though Kahn was responsive to Byars, there was an evident grinding of gears when Byars's mode of thinking met the analyst's response: "somehow when a person is that rational and

is asked a nonsensical question, the question and answer just don't jibe" (62). Asked by Byars what the most important question of the twentieth century might be, Kahn's response, according to Glicksman, was to break down the question until it became manageable: "Kahn says, 'Well, this question is on three levels. First of all there are cosmic questions like, How is the world created, does God exist and this sort of thing. We can dismiss those.' Then he goes on to outline the three most important questions of the current day. I forget what they were... Viet Nam and this and that" (62). The sense here is that Kahn handles the unruly nature of the initial question by bracketing off the imponderable, allowing him to reframe the issue as a policy matter. In other words, all questions lead back to the business of the Hudson Institute. It is not so much, perhaps, that the question and answer "don't jibe" but that Kahn appears less interested in addressing a question he can see no purpose in answering and practiced enough to convert an open enquiry back into terms relevant to himself and his business. As Hudson staffer Frank Armbruster explained to Byars, "Most of the world is concerned with problems which they think have imminent solutions" (62). Byars insisted that he was not interested in solutions as such and complained that "no one could get this through his head, including Herman Kahn" (62). The World Question Center would have failed, Byars conceded, if he had restricted himself to Hudson. To keep the project viable he had to step out of the tank.

The sense here is of Hudson as an echo chamber, where unpredictable and left-field ideas are encouraged only inasmuch as they feed the narrative of "thinking about the unthinkable." The point of Kahn's well-known phrase is not so much to articulate, in the faux Zen form popular among the counterculture of the time, a paradox as it is to convert the unthinkable into thinkable terms. In this regard, despite the freewheeling style cultivated by Kahn, the instrumentalization of thought remains paramount: only that which can be made amenable to thinking about policy is worth thinking about. For Kahn, the organization will not run right if it concerns itself with questions without answers or problems without solutions. If there is anything "subversive" about Byars being at Hudson, it is in his desire to break the causal link between question and answer and to fixate on the question itself as the object of enquiry. Chamberlain, despite having no contact with Byars, clearly grasped what Byars was doing at Hudson and pursued the idea from the opposite direction. It is the orphaned term (for Chamberlain, the answer without a question; for Byars, the question without an answer) that spooks the think tankers, disrupting the problem-solving apparatus and resisting resolution. What is surprising is not that the RAND and Hudson employees saw this as a waste of time and resources,

but that Byars and Chamberlain thought it might go the other way. Both Byars and Chamberlain entered the think tanks anticipating high-intensity, high-status intellectual engagement, yet neither of them found it there. Their credibility and reputations as artists counted for little in the policy world, and their interactions with staff rarely moved beyond bemusement and condescension. Strangely, given the anti–Vietnam War movement and the growing radical critique of the military establishment after 1968, there is no sign from Byars or Chamberlain that RAND or the Hudson Institute might be politically toxic. The sabotaging of rationality that their orphaned questions and answers enacts would fit well into a subversive narrative about art infiltrating and undermining the logic of the military-industrial complex. Yet this is a claim neither artist seems interested in making. Neither is the fetishization of expertise that each of them appears to lean toward seriously interrogated or admitted.

When Byars began his Hudson residency in May 1969 he had already been working on the notion of questions for some time. In Antwerp in the spring of 1969, Byars persuaded the Belgian national broadcaster Belgische Radio en Televisie to air a live program devoted to the World Question Center. He lined up a range of people prepared to receive his phone call during the broadcast, where he would ask them for a question. The show was broadcast on November 28, 1969, and filmed at the Wide White Space Gallery in Antwerp. The broadcast opens with a shot of Byars sitting, flanked by two young women on either side, inside a wide circle of thirty people perched on the floor of an empty studio. It is silent and everyone is covered in an immense white swathe of fabric (actually pink silk, but the show was broadcast in black and white). It looks like some sort of religious ceremony, perhaps a coven meeting or a gathering of angels. As the camera slowly pans to reveal the faces of the group, a young woman's affectless voice introduces the program with a series of statements and questions such as: "Do you have an affection for questions?" "What is the speed of an idea?" "Which questions have disappeared?" "Is all speech interrogative?" "Do questions require more energy than other sentences?" "Think yourself awake." Byars, in his signature wide-brimmed hat, announces himself as the "self-appointed World Question Center." The artist asked variations of the same question—"Could you present us a question that you feel is pertinent with regard to the evolution of your own knowledge?"—to a number of intellectuals, artists, and scientists. Some are sitting within the circle, most are speaking over the telephone.[10]

The experts Byars was able to persuade to participate constitute an odd but reasonably representative mix of vogueish late-1960s figures. Among the Belgian contingent are Ferdinand Peeters (the man responsible for developing

the first contraceptive pill outside the US), the writer Georges Adé, and artists Jean Toche and Marcel Broodthaers. Also participating are, among others, John Cage, Luciano Berio, Walter Hopps, Cedric Price, Reyner Banham, Jerzy Kosinski, Arthur C. Clarke, and Robert Jungk. Cage, for his part, spoke by phone, and instead of asking a question used the satellite-echo laden transmission to beseech the audience to follow Buckminster Fuller's plans to create a "comprehensive design science" that would create a world for "living rather than killing."

The World Question Center broadcast fulfilled many of the requirements of McLuhan-era techno-utopian global-village theatrics, but as R. John Williams suggests, it is also marked by the influence of Kahn's and Byars's exposure to the futures-oriented speculation of the Hudson Institute (see Williams 2016, 516). Byars had been in attendance at a Hudson briefing with King Baudouin of Belgium when Kahn asked, "What is the question?" This was a pivotal moment for Byars, by his own account, not least because it reminded him of Gertrude Stein's deathbed query (Byars was fond of announcing that his influences were Stein, Einstein, and Wittgenstein). "What is the answer?" Stein is supposed to have asked. Receiving no reply, she is said to have continued, "in that case, what is the question?"

Byars's attraction to the Stein-Einstein-Wittgenstein triad is revealing not just of the artist's ability to bundle a linguistic accident into the strapline for a career but also because it locates the literary, scientific, and philosophical nexus of his enquiry in the form of the names of celebrated individuals. The names Stein, Einstein, and Wittgenstein stand for expertise in three distinctive domains of intellectual labor, and the network that Byars creates out of them provides a shorthand for complexity and experimentation without having to probe too deeply into what the connections between Stein's Jamesian experiments in literary temporality, Einstein's theory of relativity, and Wittgenstein's explorations of logic and philosophy of mind might actually be. Similarly, the Belgian TV staging of the World Question Center is all about the form and the performance; the discussion itself is fragmented, beset with technical difficulties, and often boring. As a performed instantiation of how technology can bring people together, it is uninspiring. More problematic than the staginess of the enterprise, though, is Byars's need to call on the experts, as if, in true think tank fashion, creating an interdisciplinary space within which great minds can come together will substitute for coherent critical thought.

There is a facetiousness to Chamberlain's request for answers that appears to be entirely absent from Byars's mystically inflected asking for questions. Chamberlain was clearly disappointed that RAND employees did not fire back

in an appropriately sophisticated manner, but he is not in thrall to the culture of expertise in the way that Byars appears to be. What Byars's World Question Center reproduces more than the interdisciplinary collaboration of the think tank, or, in a more utopian register, the collective intelligence of the global village, is the media sound bite, whereby complexity and debate are substituted for celebrity bromides. If Byars could have included Stein, Einstein, and Wittgenstein in his teleconference, what might they have been permitted to say, given the serious limitations of the format? An expert is an expert is an expert.

Stephanie Young is right to conclude that Chamberlain and RAND were each skeptical of the function of the other. Neither Chamberlain nor RAND materially produced anything, notes Young: "The technologists did not work with materials, and the artists did not make objects" (2017, 314). The move, in think tanks and in the art world, toward a technical expertise uncoupled from the material challenges and specificities of physical matter, was supposed to reconstruct the relation between knowledge and action under the conditions of postwar modernity. Defense intellectuals proclaimed the redundancy of conventional military strategy in the face of the nuclear threat; artists rejected medium-specificity and the production of unique objects as outmoded responses to the modern world. The challenge posed to the notion of the artist as skilled craftsperson, which reached its apotheosis in the Conceptual Art produced around the time of Chamberlain's and Byars's think tank residencies, is, of course, driven by a politically, as well as philosophically, motivated institutional critique, but it is also a move that perversely aligns the artist with the expert bureaucrat who never sets foot in the theater of conflict. The failure of think tank solutions to the Vietnam War and to President Johnson's War on Poverty came, soon enough, to be seen as a catastrophic failure of theory to relate to practice, and that experts themselves, in their air-conditioned offices, were in no small part responsible for the outcomes of proposals they could only theoretically imagine. The assault on art-and-technology projects came largely from within the art world, as artists and critics began to identify precisely the failure of participants to factor their complicity with defense-related institutions into their relations with them. The wonder is not that RAND and A&T became the targets of radical challenges to the Cold War status quo but that it took so long for that challenge to manifest itself.

Neither Chamberlain nor Byars seem concerned with the ideological underpinning of RAND or Hudson, and they are prepared to take them at face value as thinking factories, not as ideology factories. The communication office at RAND cited Chamberlain as saying: "RAND's business is information" (quoted in Young 2017, 313), and after he left RAND, Brownlee Haydon said

that "John Chamberlain saw RAND as an answer machine: what else did a research organization do besides provide answers?" (quoted in Young 2017, 313). Among the many questions Chamberlain and Byars failed to ask is the obvious one of what constitutes a question in the first place, not to mention the issue of who is asking, what constitutes information, and what is at stake when information is a business? Chamberlain and Byars largely reproduce the conditions of objectivity, neutrality, and disinterest that validated think tanks as the intellectual equivalent of scientific expertise during the early Cold War. In the wake of constructionist and Foucauldian analyses of how knowledge is produced, their unreflective acceptance of the think tank as little more than the venue for the exercise of expertise appears hopelessly inadequate as a response to the complexity of how cognitive authority is established and disseminated within a hegemonic institution. More than this, however, the work Chamberlain and Byars put in at RAND and the Hudson Institute reveals the extent to which expertise had become a normative category to which even fairly wayward artists could subscribe. The main beef the artists had with the think tanks was that their own specialist knowledge was not adequately respected.

**Corporate Art**

By the time the A&T exhibition opened in 1971, what utopian spirit there might have been in the original ambitions for the project were unable to withstand the Vietnam War, Richard Nixon, and the shooting of students at Kent State University. The idea that US corporations could plausibly collaborate with artists to create new worlds of social progress was now evidence of complicity and corruption—technology was the problem and not the solution. The LACMA exhibition was taken apart in the art press, notably by both Jack Burnham and Max Kozloff in *Artforum* (Burnham 2015b; Kozloff 1971), and David Antin in *ARTnews* (Antin 2011). The reviews by Burnham and Antin both flagged the "corporate" nature of things in their titles, while Kozloff, in a review Burnham would later call "the most vicious, inflammatory, and irrational attack ever written on the art and technology phenomenon" (Burnham 1980, 210), called his response "The Multimillion Dollar Art Boondoggle."

Burnham, for one, was clear that the problem with the A&T exhibition was timing:

> If presented five years ago, A&T would have been difficult to refute as an important event, posing some hard questions about the future of art. Given the effects of a Republican recession, the role of large in-

dustry as an intransigent beneficiary of an even more intractable federal government, and the fatal environmental effects of most of our technologies, few people are going to be seduced by three months of industry-sponsored art—no matter how laudable the initial motivation. (Burnham 2015b, 187)

Although Burnham recognized that there was an element of posturing involved in showing outrage at the idea of artists working with industry ("it is permissible," he noted, "to have your fabrication done by a local sheet-metal shop, but not by Hewlett-Packard" [2015b, 186]), he was nonetheless clear that the political climate made it impossible to justify what was now summarily dismissed as "industry-sponsored art." At this point, the theoretical apparatus of interdisciplinary collaboration had fallen away and art and technology was viewed merely as a case of suspect patronage.

For Kozloff, it was precisely the easy seduction of money and power that was so contemptible about the project: as the country was falling apart, he wrote, "the American artists did not hesitate to freeload at the trough of that techno-fascism that had inspired them" (1971, 72). Even Burnham admitted there was "something grossly immodest" about the amounts of money poured into the project, and was also skeptical of the notion that corporations had any interest in genuine research symbiosis between art and industry—at best, he thought, companies might get a bit of good publicity for appearing "forward looking." Billy Klüver and Maurice Tuchman were more than willing to exploit the public relations benefits available to a company willing to sponsor an art-and-technology initiative, but they also imagined, following Kepes, that the arts could exercise a more thoroughgoing transformation of industry if such collaborations were able to multiply and develop. As Burnham's and Kozloff's unforgiving assessments of A&T show, however, the idea of art and technology as a depoliticized zone was an unsustainable and damaging illusion.

One of the reasons it was damaging was because it meant that awkward, frustrating, or failed collaborations like Chamberlain's at RAND were not given the prominence they might otherwise deserve. While A&T had to maintain a sense of productive symbiosis between art and industry, the interesting or revealing projects that cut out spaces or sat inert and offered only undeliverable outcomes were likely to be marginalized. It is to the credit of Tuchman and the A&T team that they understood this well enough to make the report as deep a reflection on the multiplicity of responses to the project as possible. Indeed, it is precisely when A&T did not run as promised that it genuinely started to do some serious cultural work.

Burnham and Kozloff may have caught the dominant cultural mood by aligning A&T with the enemy, but the challenge of generating collaborations with business was not so straightforward, and far from conspiratorial. Most corporations showed no interest in Tuchman's project, as Burnham suspected, and for A&T, like E.A.T., the main problem was getting their attention. Before Missy Chandler's intervention, Tuchman admitted, just making it through the front door was a challenge; even with Mrs. Chandler's considerable influence, over three hundred corporations declined to take part. Tuchman insisted that the response from senior management was positive once initial contact had been made, though among those companies willing to participate in the program, he conceded that it was rare to find anyone in middle management who understood what was going on with A&T. People could not believe, Tuchman explained in an interview with Pacifica Radio, that they "won't get burned by their higher ups if they co-operate" (Spark 1971). The "special kind of intermingling" between the arts and sciences Tuchman and Klüver wanted to achieve was only really possible, Tuchman acknowledged, with the support of a much more powerful body, such as the federal government, behind it. Despite his best efforts, Tuchman explained that he had received little support from museums, colleagues, and even LACMA's board of trustees. His hope had been to make possible in affluent Southern California the kind of collaborative work that lack of resources had prevented the Russian Constructivists and the Bauhaus from achieving. Like Klüver's staging of 9 Evenings at the same venue as the 1913 Armory Show, Tuchman imagined A&T as the inheritor of a radical tradition; like Klüver, Tuchman believed that America could finally deliver what the Old World squandered.

Tellingly, Tuchman's assessment of A&T at the time of the radio interview, made in early 1971 before the exhibition opened, was already restrained by his awareness of recently changed economic and political circumstances. Business was cautious; antiwar sentiment had hardened public opinion against corporations and technology more generally. Like Burnham, Tuchman reckoned that A&T was too late, in Tuchman's estimation by two years. Billy Klüver and Maurice Tuchman appeared to take seriously the notion that the United States had become the natural home of the artistic avant-garde, and each pursued his vision of art and technology collaboration in a manner that conceived of it as a continuation and an enlargement of projects that had failed in the Old World due to insurmountable political and economic obstacles. While Klüver and Tuchman undoubtedly achieved a not inconsiderable amount in drawing together some of the most influential artists of the time with some of the biggest corporate players in American business, neither E.A.T. or A&T was able

to pick up enough support, finance, or critical momentum to see the project through the economically and politically hostile environment of the late 1960s and early 1970s. What their own understanding of their respective projects reveals, though, is a largely unquestioned assumption that American art should be considered on an equal footing with other professional fields of activity. As such, when businesses seemed uninterested or uncooperative, Tuchman's tetchy complaints about risk aversion in middle management served to account for corporate indifference as an organizational weakness in line with popular notions of American conformism. This is another version of Chamberlain's disappointment with the RAND staff—if only they were not so bourgeois, something brilliant might have happened. To an extent, then, while the national economic and political climate provided a compelling explanation for the deflated ambitions of art-and-technology projects like E.A.T. and A&T, a more painful assessment, and one that Tuchman was unwilling to face, was that business just could not care less about them.

At this point, if the attempt by Klüver and Tuchman to hook their projects up to the remains of the European collectivist avant-garde did not already seem far-fetched, it must by now be seen as, at the very least, willfully decontextualized. What is most peculiar about the Americans' desire to align themselves with aspects of Constructivism and Futurism, though it is quite in keeping with broader US cultural strategies during the Cold War, is the absence of any discussion of the political implications of either the work of European and Russian precursors or the new American art-and-technology projects themselves. During the Pacifica Radio interview, Tuchman is asked directly by interviewer Clare Spark whether he thinks the "lack of political content in modern art" has made it possible to achieve collaborations with government and industry in ways that would not have been previously possible. Tuchman's response is, disappointingly, formalist boilerplate: "Stalin found that there was enormous political content in abstract art and so did Hitler. And they were right. I think there is terrific political content in a Frank Stella painting" (Spark 1971). There is no direct discussion by Tuchman of what the political ramifications of an art-and-technology project might be (or, for that matter, what is political about a Frank Stella painting), but Spark had asked the right question.[11]

In her contribution to the A&T report, curator Jane Livingston also positioned the project as an inheritor to collaborative tendencies among the old-world avant-garde, yet her assessment, like Tuchman's, also remained aloof from politics and instead focused on limitations that seem rooted in their attachment to preindustrial or aristocratic (that is, premodern and therefore pre-American) forms. Constructivism and Futurism, for example, despite their

"attempts to embrace a socialist technology," were not, according to Livingston, able to fully realize the formal implications of machine technology and mass production, and tended to focus on stylistic elements, representing merely the appearance of industrial forms. The Bauhaus emphasis on craft, likewise for Livingston, was a "serious ideological limitation" since it tended to "reduce art to craft" and saw the role of "organized technology" as enabling the elevation of craft to art (Tuchman 1971, 43). In the end, for Livingston, though these precursors continued to exercise an influence, it was one that remained "identified with a European sensibility," which she obliquely associates with the "traditionally aristocratic" stress on the "unique object" that can then be condescendingly "mass-produced for public consumption" (43). Like Alfred Barr's torpedo diagram, modern art for Livingston proceeded by way of geographical displacement, with the Europeans and Russians, saddled with inhibiting residual attachments, giving way to the full-throated modernity of the American scene.

If Tuchman and Livingston (and Klüver) were right and the United States was the proper heir to the European art-and-technology avant-garde, not least by virtue of having never been premodern, why was American industry so indifferent to the promise of such a collaboration? Spark's question invites one way of attempting an answer, but the vocabulary with which a project like A&T might be described that keeps it a viable proposition for American business and, at the same time, a viable political challenge to bourgeois aesthetics does not seem available to Tuchman, if it exists at all. Neither capable of convincing corporate America that working with artists would lead to an as yet unimaginable future of innovation, nor willing to directly acknowledge and cultivate the radical underpinning of the movements they claimed as precursors, projects like A&T and E.A.T. failed to appeal, consistently and persuasively, to enough artists, scientists, or business leaders. There is a whiff of the old New Deal collectivist spirit in Tuchman's passing comment that a bigger organization, like the Federal government, might have made it work, but it is a phantom remark out of step with rising anti-government sentiment on the one hand, and bureaucracy's increasingly defensive crouch on the other.

James Lee Byars's love affair with the charisma of expertise, whether it emanated from Herman Kahn, Stein, Einstein, or Wittgenstein, and his desire to work himself into an equation that included them all, is of a piece, it seems to us, with John Chamberlain's defensive response at not being respected by RAND employees and Maurice Tuchman's frustration with middle management's philistinism. The artists wanted respect; they wanted their world recognized as professionally rigorous; they wanted their contribution to stand equally alongside that of scientists, engineers, and businessmen. Their disappointment

and humiliation, however muted or disguised, is a measure of their own fascination with, and desire to bathe in, the lustrous aura emanating from high-status, high-powered Cold War elites. Burnham and Kozloff may have also overestimated the relevance and influence of art in American life, but they did see clearly how asymmetrical the relationship between art and technology was in projects like A&T.

What is missing from Tuchman's assessment of A&T, and what might have saved it from the mauling the exhibition received, is a sense of irony. It is irony that makes Chamberlain's project interesting; it is lack of irony that renders Byars's World Question Center pompous and absurd. A broader awareness, and an embrace, of limitations, failures, reversals, insufficiencies, and accidents would allow the contradictions and tensions in a project like A&T to breathe and a critical space to develop within which they might be interrogated and explored. The A&T report saves A&T from itself, in a sense, because it undermines the bland affirmations of the A&T brand and addresses, to an extent, Tuchman's inability, or unwillingness, to think directly about the political ramifications of the project. The cover of the report, with its grid of hairy artists and clean-cut organization men, provides a compressed signal of the contradictions contained within that is either the smartest summative statement of the project available or among the most supremely oblivious designs ever to adorn the front of an exhibition catalog. With A&T, a disappointing lack of self-awareness makes it difficult to hold out in favor of the former. At the same time, the unflinchingly extensive documentation of all aspects of the project in the report indicates that the notion of the enterprise as an experiment has been preserved, even if the deadpan delivery offered by Kienholz's promise of expertise is, unfortunately, beyond detection.

# 05

## How to Make the World Work

EARTH PIECE
Listen to the sound of the earth turning.
1963 spring
—Yoko Ono, "Earth Piece"

I now see the Earth realistically as a sphere and think of it as a spaceship.
—Buckminster Fuller, *Operating Manual for Spaceship Earth*

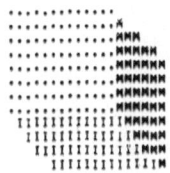

Those scientists who ushered in the Atomic Age felt responsible to humanity. Whether they worked on the Manhattan Project or not, and even if they helped the war effort in socially justifiable ways, they felt responsible. The dawn of a new postwar world had left behind the Great Depression and created a country with a clear leadership mandate on the global stage but without a clear strategy to articulate the mandate. It was also a nation that found the bottle of technology and science empty and the genie nowhere to be seen. That which had enabled victory in the war partially hobbled the future in peacetime. Most scientists had carried out a given task and had plowed a narrow furrow in the larger research field, head down and duty tasked, but once successful as a collective, the individual felt a need to save civilization, perhaps again, without the specter of war driving the agenda—even as the Cold War darkened the new US horizon. These scientists knew they could do better.

It was with such determination and muted optimism that the Macy conferences got underway again in the postwar period. The participants had been keen to pursue ideas raised during meetings before the war and did so during the conflict through letters while stationed around the globe fighting and contributing to the war effort as asked. They knew when they assembled again after the conflagration had ceased that they would face new demands with regard to civilization that needed to be addressed through their collective, interdisciplinary scientific, technological, and aesthetic experimentation. Such concerns had long been the purview of the token anthropologists, Gregory Bateson and Margaret Mead, who indeed spent their entire lives pursuing such experimentation. As exemplified by the Macy conferences and their principled pursuit of cybernetics as a kind of unified science model, they prioritized research that helped us understand how the world worked. Bateson and Mead explored how humans worked in relation to larger environmental and ecological systems while also developing increasingly experimental means of representing to other academicians and the interested general public these systemic relations in their glorified diversity and fundamental unity. Bateson's photographic and film work, though predating the Macy conferences, influenced a new set of experimental ethnographic filmmakers as well as artists seeking to address a war-damaged society. Stan VanDerBeek and Gene Youngblood, as well as Buckminster Fuller, took inspiration from this work, and Bateson and Mead both spoke eloquently on these practices and their limitations to an eager audience of counterculture, avant-garde, social, and artistic engineers.

In the first paragraph of Norbert Wiener's *The Human Use of Human Beings: Cybernetics and Society* (1950), he claims the changes in historical conditions in the shift from the nineteenth to the twentieth century were responsible for "the marked break" in art, literature, and science between the two centuries. Unlike some aspects of Dewey's occasionally synchronic vision of science as a semi-universal endeavor impervious to the vicissitudes of time and context, Wiener argued for it as being in the mix and driving history as much as being driven by it. Alongside Einstein, who fully supported Wiener's ethical stances in relation to science/technology and its military applications, Wiener perceived science as operating in larger systems than itself, and playing in fields demarcated by aesthetic practice and experience as much as by scientific debate. Steve Heims, writing in the introduction to the second edition of Wiener's application of cybernetics to society and history, argues that Wiener resembled Dewey insofar as he understood technology not so much as applied science but as applied social and moral philosophy (1980, xii). And Heims describes

Wiener's book as one that "might have been made by an artist as readily as by a creative scientist" (xv).

As with many of the other Macy conference participants, Bateson, Mead, and Wiener held that the imperative of the moment was to salvage civilization after World War II through scientific, technological, and aesthetic experimentation and interdisciplinary exploration of the interrelatedness of the human, natural, and machinic worlds. For Bateson, this meant a literally endless engagement with "mind" as an evolving and evolutionary set of systems linking the individual to society and nature in an aggregate of ideas: "an ecology of mind" or "a science of mind and order." Citing the work of Wiener, von Neumann, and Shannon on communications and information problems, Bateson saw a glimmer of hope for a devastating half century of world wars when he states that "cybernetics is, at any rate, a contribution to change—not simply a change in attitude, but a change in the understanding of what an attitude is" (2000, 483). The attitude toward science as an epistemology geared toward teleological autocratic ends was the anti-Deweyan hubris of science in the twentieth century, and cybernetics applied to individuals, societies, and ecosystems offered a way to alter this consistently failed enterprise.

The larger pedagogical impulse that drove the ethical and intellectual interdisciplinary imperatives of cybernetic research and researchers profoundly influenced the multifaceted works produced by the Eames Office, headed by the designers Charles and Ray Eames, and the decades of visionary writings and designs by Buckminster Fuller. Similarly, the experimental ethos of avant-garde techniques and aesthetics, practical engagement with materials and technologies, and a general eschewal of goal-oriented processes shaped the pedagogical enterprises of these three thinkers and designers as they sought, like the Macy conference scientists, to examine how the world worked and how to make the world work—and to share the results of this examination with the general public in as effective and experimental way as possible. New knowledge required new articulations of it.

### The Eames Office as Cold War Design Lab

Through a number of commissions for global fairs and representing US and/or corporate interests, the Eames Office designed visions of a technological and informationally shaped future using avant-garde techniques of the early part of the twentieth century. The Eames Office operated as an IT, media, arts, and design lab *avant la lettre*, not unlike those officially founded around the same time such as E.A.T. and CAVS. The Eames Office, though, held no singular

institutional frame or constituency, while such was not the case for Klüver's project at Bell Labs or Kepes's center at MIT. The Eames Office's ability to work with and for a range of clients across the corporate, university, entertainment, and government sectors echoes the relationships between these sectors emergent in and essential to the new Cold War world, relationships connected by technology, aesthetics, global computing, and geopolitical agendas.

The Eameses stated in 1969 that their "interests have included many aspects of communication—photography, exhibitions, writings and motion pictures. Our work in education has intensified this and has provided a natural overlap with several governmental agencies" (quoted in Lipstadt 2005, 151). This overlap essentially transformed the Eameses into "cultural ambassadors" during and for the Cold War representation of the US because "their design agenda aligned with the political agenda the US government wished to communicate" (Schuldenfrei 2015, 43)—and communication became their new mode of design as well as its content. They were designers of the immaterial world of information and think-tank concerns, partnering with RAND, Metro-Goldwyn-Mayer (MGM), MoMA, and IBM. Many designers as well as occupants of the government expressed surprise that the outwardly "nonideological" and "cutting-edge" design firm/lab would fit with and continue to work for the US federal government for many years (Lipstadt 2005, 151–152). It is difficult to distinguish cause from effect with regard to the Eames Office and its various patrons or commissions and its interests, especially when one considers the Eameses' stated position that they would not work on projects with which they did not ethically agree. The Eames Office served as a singularly well-positioned platform that allowed for deft movement across educational, corporate, governmental, entertainment, and technological collaborations, all of it grounded on a solid fine-arts base. The Eames Office received much high-profile patronage from numerous corporate clients, while maintaining links to many university scientists, heads of major corporations, and public as well as private cultural institutions.

The US Information Agency (USIA), the State Department, the Department of the Interior, the Smithsonian, Pan Am, the Ford Foundation, Columbia Broadcasting System, Cummings Engines, Westinghouse, and Herman Miller Furniture counted among their clients. Long-time collaborators included architect Eero Saarinen, designer and US government exhibition organizer and design theorist George Nelson, film director Billy Wilder, film score writer Elmer Bernstein, and designer Alexander (Sandro) Girard (Lipstadt 2005, 152). Buckminster Fuller housed Eames installations in pavilion settings, and György Kepes provided them influential direction with regard to visual

language, social progress, and education. The RAND Corporation links, in particular, proved pivotal for the Eameses in their work on various US pavilions abroad for exhibitions of technology, urbanism, postwar visions of the future, and US consumer market economy as the exemplification of democratic beliefs during the Cold War.

From their geographically marginal site in Venice, California, the influence of their office marked a larger shift in the US begun during World War II from East Coast control to the West. The war efforts in aerospace industries both in terms of design and manufacture, not to mention the siting of the RAND office, Hollywood, and television production all loosened the hold of East Coast power. In the early days of their marriage during the first years of the 1940s, Charles worked as a set designer for MGM while also experimenting with molding plywood for a range of uses in the war effort, ranging from plane parts to splints for wounded limbs, thus emphasizing design and materials in the service of applications from military technology to field medicine to cinema production and art. The biomorphic shapes afforded by molded plywood made their way into Ray's sculptures before shaping their influential and lucrative chair designs. Some of these sculptures featured on the cover of an issue of *Arts and Architecture* in September 1942. The convoluted and folded wooden structures evoked a Möbius strip of planes that aesthetically bore the same interest in perspective found in Braque's and Picasso's cubist sculptures (Giovanni 2005, 60). The process of molded plywood also found its way on to MGM sets, as well as into furniture and industrial design, so that from the outset the Eameses' work cut across art, architecture, and cinema, and military and industrial production: a materiality that physically links the military-industrial-university-entertainment complex. The plasticity of the material allowed it the potentialities plasticity provides. And plasticity of materials and aesthetics, as well as topics, ideas, and clients, proved central to the Eames Office.

The Eames Office occupied a noninstitutional site that operated chronologically and intellectually between the New Bauhaus and CAVS, with the work, ideals, and spirit of Moholy-Nagy but operating in ways more attuned to the predominant corporate culture. With lab and studio seamlessly merging, the sculpted plywood chairs that populated the 1946 MoMA show "New Furniture Designed by Charles Eames" were tested physically and aesthetically at the Eames Office in laboratory conditions. Photos of the chairs were taken next to works by Alexander Calder to underscore their abstract, sculptural, and biomorphic qualities, as well as to place the Eames Office's design work explicitly in dialog with contemporary art (61). Greatly inspired by information and communications theory in the early 1950s, the Eames Office, led by Charles's

enthusiasm for these research areas, turned from primarily working on furniture design to films, information visualization, and multimedia installations. The 1953 Eames film *A Communications Primer* was essentially an animated version of Claude Shannon's 1949 book, *The Mathematical Theory of Communication*.[1] The films also served as experiments in the filmic medium, as well as its installation, engaging technologies of vision that altered the scale of seeing as well as the scale of projection. At the same time, the films suggested the Eames Office was the embodiment of a creative and experimental lab, delivering information theory in a profit-led model of benign US corporate and Cold War idealism of progress.[2] The Eames Office was a platform of experimentation for the materiality of ideas and the immateriality of thought articulated through objects and images capable of effecting sociopolitical change.

The Eames Office shared with more institutionally formalized art and technology labs a strong and sustained link to some of the larger aesthetic and formal concerns of early twentieth-century avant-garde movements, but markedly in their case without explicitly progressive pedagogy and radical social agendas. As we have seen, in each instantiation of the art-and-technology lab, a dilution of the more adventurous social concerns of the Bauhaus or Dada, for example, appeared in the US versions that drew on their traditions. Charles Eames might have gotten the most credit for the Eames Office's success and been its public face, but it was Ray's background in and knowledge of the syntax found in the avant-garde and experimental art milieu of NYC in the early part of the twentieth century, in which she was deeply involved, that provided much of the visual and technological knowledge they updated, recontextualized, and domesticated. In much the same way that Surrealism became part of the Disney studio and popular culture toolbox, the Eames Office brought this same domesticated syntax to various institutions and spaces. The various forces at play in the emergence of Cold War geopolitical parameters and borders made it difficult to maintain fully any alternative political agendas for the various art and design movements that provided inspiration for the Eames Office and other experimental labs. Nonetheless, the idealistic belief in art's efficacy for social change barely wavered. André Breton, vigilant to the end, devoted his aptly titled final publishing endeavor, *The Breach*, to such larger goals. Running from 1961 to 1965 and offering images and new art by various artists still involved in Surrealism's transformations, the publication also included discussions of Pop Art and film as well as pieces about the increasing political demands and pressures of the Cold War (Gale 1997, 414–415). The Eames Office, various politically charged art movements and art-and-technology labs in

university and corporate settings were clearly not alone. All of these enterprises held varying agendas, though with an oddly singular goal: to make peace perpetual during a nuclear standoff through aesthetic, technological, and information experimentation.

The idealistic (and post-ideological) spirit of the Eames Office remains in the present. Although no longer functioning, the Eames Office still maintains an official website with links to archival material, photographs, films, and historical information about the Eames house and their exhibitions. The site includes the ethos of the Eames Office, which reads: "Charles and Ray's work was a manifestation of one broad, all-encompassing goal: to positively impact people's lives and environments."[3] The site also provides a shop where people can purchase products such as prints, toys, books, furniture, memorabilia, and an Eames app—the singular vision of a collective future made material and consumable.

### *Powers of Ten*: The End of Interiority and the Effect of Adding Another Zero

Public education regarding technological developments that were rapidly shaping the postwar world played an important role in the Eames Office's work in film. *Powers of Ten,* their most famous and still most influential such work, went through three different iterations, starting in 1963, and again in 1968 and 1977.[4] The 1968 version was made at the behest of an MIT physics professor working on the Kepes institutional agenda to update and upgrade visual tools at MIT as a means for more effective pedagogy. When presenting the film at Harvard in 1970, according to Schuldenfrei, Charles Eames framed the film as linking economics and ecology to collective responsibility. The application of cybernetic theory to ecosystems as found in Bateson and Fuller, as well as to society and history as articulated by Wiener, exerted its influence on the Eameses' 1977 revision of their film. Schuldenfrei connects some of the NASA-sourced images to the emergent ecological movements of the time (2015, 137–140). *Powers of Ten* addresses, in Martin Heidegger's phrase, "the age of the world picture" when Spaceship Earth, as Buckminster Fuller called our planet, got its owner's manual (courtesy of his own polymath erudition and certitude) as well as an environmentally driven libertarian catalog for the counterculture from Stewart Brand (1968). The Eameses were in the mix too, and used their platform to reframe and recontextualize their film to raise environmental consciousness. The final version, completed in 1977, sports the subtitle: *A Film*

*Dealing with the Relative Size of Things in the Universe, and the Effect of Adding Another Zero.* Underscoring their ecological concerns, some new lines were added to the voiceover—lines that read like the prophetic insights of Fuller or Brand but intended for the masses. When the film has reached the outer edges of the universe, and the world picture becomes a black screen with the illuminated planet now no longer even a speck, the narrator states: "We pause to start back home. This lonely scene—the galaxies like dust—is what most of space looks like. This emptiness is normal. The richness of our neighborhood is the exception" (quoted in Schuldenfrei 2015, 140). The multitude of images showing our lonely planet in its exposed unique fragility became an important strand of the perspective on rapidly rescaling human vision the Eameses offered in this piece of popular visual pedagogy. Home is the place where we start adding zeros and powers of ten to our corporeal vision; it is a dwelling of singular qualities.

The Eameses' film explicitly moves up into the atmosphere through visual technologies multiplied by powers of ten, and then takes audiences into the deepest reaches of outer space, before plunging us back to Earth and eventually into the nucleus of a carbon atom found in the human body. The macro and the micro, and the astronomical and the nano, that constitute the scopic movements of the film chart a history of Western technoscientific power as primarily visual in source and manifestation. The triumph of the visual in the Western sensorium and its empirical power to overturn received *doxa* (and thus create a new world in which science had sway) meant that seeing not only equals knowing but also that seeing equals power over the seen, as satellite technology and other Cold War tele-technologies of surveillance manifest.

Just as their films exploited the most recent innovations of visual technologies and their explosion of scales, so too were they interested in scales of projection and exhibition. An immediate and influential precursor of *Powers of Ten* can be found in an earlier Eames film called *Glimpses of the USA*, a multiscreen presentation at the 1959 Moscow Exhibition.[5] As the undesignated designers of the Cold War through their numerous films, exhibitions, and multiscreen experimentations, the Eameses helped popularize scientific and technological innovation, consumer culture, and the powers of abstraction operative within complex systems. *Glimpses* provides their first foray into displaying the optic capacities made by satellites, using the zooming-in technique that they display in *Powers of Ten*—in fact, some of the imagery of Earth seen from space found in *Powers of Ten* comes from *Glimpses*. The film tracks from the tele-technological wonders of a satellite vision of Earth down to the

mundane start of the day within "the average" US household, zooming rapidly in increments from the space view down to the quotidian making of breakfast. Both films offer the power of the micro and macro technological amplification and production of vision, with universal computation providing the means to scale rapidly up or down.

In *Powers of Ten*, the midway point of the 1977 version arrives with its return from the outer reaches of space back to the human scale before moving into the body and the atomic formation of it. When the film enters the microlevel of prosthetically enhanced vision, it marks the end of a certain kind of human interiority. The site of moving from the macro to the micro is through the epidermis of the hand, that grand metonym for humans as makers. The human is what gets repositioned in these new technologies of scales of vision. Writing contemporaneously with the production of the film, Jean Baudrillard argues for the slow dissolution of human scale and psychological possibility of interiority. He claims that "with the television image—the television being the ultimate and perfect object for this new era—our own body and the whole surrounding universe become a control screen" (1983, 127). The cybernetic desire of control and homeostasis within an individual, society, ecosystem, or machinic operation becomes a control-room screen. The very liberatory possibilities the Macy conference participants, as well as Fuller and the Eameses, espy in cybernetics as potentially capable of derailing Western scientific epistemological hubris has been hijacked, according to Baudrillard, for the very technoscientific ends these experimentations sought to resist. Baudrillard places televisual technologies and media/information theory within three larger "irreversible" trends of the contemporary moment: "an ever greater formal and operational abstraction of elements and functions and their homogenization in a single virtual process of functionalization; the displacement of bodily movements and efforts into electric or electronic commands, and the miniaturization, in time and space, of processes whose real scene (though it is no longer a scene) is that of infinitesimal memory and the screen with which they are equipped" (128–129). The technicities that Baudrillard charts would be systems that undercut homeostasis or the potential for progress within Western science, turned as they are toward instrumental ends for which the human scale and its potential for interior self-reflexivity is obliterated, much as the human body as pivot for the nano and macro scaled modes of scientific seeing passes right through the power of zero. *Powers of Ten* performed the new scales of vision made possible by intensive military technological research, work that further reframed human existence on the face of Earth.

### Fluxus, Abel Gance, and the Eames Office: Another Bauhaus Moment in the Techno-Avant-Garde

Ken Friedman, regional outpost co-chairman (San Francisco) of Fluxus at the time of the Eames Office in its full glory, called the movement "an international laboratory of *ideas*—a meeting ground and workplace for artists, composers, designers and architects, as well as economists, mathematicians, ballet dancers, chefs, and even a would-be theologian" (2011, 35, original emphasis). The Eames Office as lab experimenting with developing technologies, designs, media, theories, educational aspirations, and collaborative projects finds elective affinities with Fluxus, as well as CAVS, E.A.T., and LACMA, especially when the larger, transcendental or ideological rationale for these endeavors is explored. One strand of Fluxus experimentation draws its genealogy from the Soviet avant-garde loosely bundled under the 1920s Russian journal *LEF* and Constructivism back to Dada (36). Friedman further links Fluxus-as-lab to American pragmatism and American transcendentalism, with its influences on Emerson and Thoreau (37). The heady eclectic mixture of pragmatism, transcendentalism, hermeneutics, and "intermedia" highlighted a desire to uncover larger political and existential truths lurking in the quotidian. The combination also foregrounds the discipline of daily routine and instruction that Fluxus artworks perform.

The social effects of such making were explicitly in play with the Fluxus group, as much as it was in the Eames Office's pedagogical mission. In terms of near contemporary artistic influence, Marcel Duchamp's influence on the Fluxus group proved most important, especially his attempt to "reconcile art and the people," as Apollinaire put it in 1912 (Apollinaire 2002, 183). Referring to Duchamp's then emerging *The Large Glass*, Apollinaire suggests "art such as this could produce works of unimagined power. It might even have a social function" (77). Dada also simultaneously held anarchistic and idealistic beliefs regarding the transformative powers of art and aesthetics confronting failed sociopolitical institutions and values that were articulated through technological change. This schizoid belief held that we could turn the tools of war and violence into sources of liberation and revolution. A repetition of such thinking could be found in the ways in which Fluxus and the Eames Office attempted, in rather different ways, to engage a general public facing a new techno-military moment. If Apollinaire felt the seams of society and culture coming apart on the eve of World War I, and if the Fluxus movement felt a similar technological-aesthetic shift in Cold War America reverberating on a global scale, then György Kepes

saw the same strains from within the heart of US military-technological innovation achieved through university R&D at MIT.

Repetitions and recycling of avant-garde techniques and strategies can be found in the multiscreen immersive experiences used by the Eameses in the 1959 USIA-sponsored pavilion in Moscow, and most intensively in the IBM pavilion at the 1964 New York World's Fair. Especially influential for them was the narrative avant-garde cinematic developments of Abel Gance in the first decades of the twentieth century.[6] The points of comparison between Gance and the Eameses film work are vast, including editing techniques, screen expansion on horizontal and vertical planes, and innovations in projected film and image work. Most importantly for both, these formal experiments served the significantly idealistic, conservative, even melodramatic nature of the content of the works. Both Gance and the Eameses were lauded for their formal innovation while simultaneously derided for their capitulation to genre demands, nationalist cheerleading, and general celebration of bourgeois values. Norman King describes Gance's work as "reactionary innovation" in so far as it wedded melodrama with formal innovation (1984, 3)—both a phrase and a critique applicable to the Eames Office's screen productions as well. The links with Gance proved to be substantial for the Eames Office, and they shared many formal and content-related qualities. Other avant-garde influences made their way into international pavilion displays during the 1950s and likewise influenced the Eameses. Although these experiments operated with significantly different Cold War agendas, they were nonetheless often recycled by the Eames Office for their governmental and corporate clients in pavilion settings.

The multiscreen strategy the Eameses first used in Moscow with *Glimpses*, and again later for *Think* (1964),[7] clearly draw on specific strands of European avant-garde theater and performance, more recent iterations of which they encountered at the 1958 Brussels World's Fair. There, Le Corbusier's multimedia show entitled *Poème électronique* provided an explicit display of Philips technology in the service of social commentary and political critique of twentieth-century injustice.[8] Also at the Brussels fair, installations by the Czech avant-garde theater designer Josef Svoboda, such as *Polyekran*, part of the ongoing multimedia project *Laterna Magika*, arranged screens with unconventional angles, shapes, and sizes for projection, allowing the viewer to be bombarded by projected images in an immersive and disorienting manner. Both Le Corbusier and Svoboda owed a great deal to the projection experiments by the Bauhaus designer Herbert Bayer and the projected theater works from the 1920s by Erwin Piscator in collaboration with Walter Gropius and Moholy-Nagy

in Berlin. Piscator emigrated to the US and continued his projected-image and live-actor stage-set experimentation into the 1940s. Various scholars have traced specific elements of these long-range influences displayed by Le Corbusier and Svoboda, back to early twentieth-century avant-garde experiments in projective technologies. Such display techniques also found their way into the Eameses' installations (though in a much tamer fashion and with a markedly different ideological agenda in 1959, and again, and more explicitly in 1964).[9]

Gloria Sutton astutely observes that although the Eameses' films have often been labeled as experimental, they used very few "untested elements" (2012, 154), and many of these elements operate in Gance's early twentieth-century films. Gance had commercial and critical success with his rapid montage and varied and contrasting rhythms of film, which seemed to point toward areas in which cinema could compete with poetry and music in terms of artistic and aesthetic expression (King 1984, 4). Working from a spot squarely within and contributing to the burgeoning experimental avant-garde of the early twentieth century, Gance's close friends and collaborators included Antonin Artaud, Blaise Cendrars, and Max Honegger, while his experimental works were in conversation with those by Apollinaire, Delaunay, Léger, and Picasso (Abel 1987, 4).[10] Richard Abel calls Gance part of "the narrative surrealists," or the First Avant-Garde (1919 to 1924), along with Louis Delluc, Germaine Dulac, and Marcel L'Herbier. The films by these directors mixed styles and modes, generated complex narrative structures, and used patterns of images for rhetorical purposes (280–281). Gance melded melodrama with "polyvision" (multiple screens), allegorical image superimposition, wild camera movement, montage editing, and color-filter overlays for emotional resonance—techniques that the Eameses deployed in *Glimpses* and *Think* (Kirkham 1995, 328). All of the narrative surrealist filmmakers were interested in image perception and how sensory data provided by technologically generated means could be deployed as a goal in and of itself. Abel argues that the more experimental avant-garde that left narrative behind completely—including iconic later films such as René Clair's *Entre'acte* (1924), Buñuel and Dali's *Un chien andalou* (1929), and Léger's *Ballet mécanique* (1924)—found many of its strategies and tools in this earlier moment (Abel 1987, 281). The poetic or impressionist avant-garde admired Gance for "his work on the sensations constructed by the image" (King 1984, 21). But this later avant-garde also found his output deeply schizophrenic, with Clair, for example, writing a 1923 article on Gance's experimental melodrama *La roue* that offered a very early take on the form and content split that dogged Gance's career. Similar criticisms were leveled against the Eameses' work for IBM and the US government, as well as the projects generated by Kepes in the late 1960s.

At the time of the initial screening of Gance's epic *Napoléon* in the late 1920s, Émile Vuillermoz wrote two articles about the film that praised the director's cinematic vision and formal achievements with editing, superimposition, multiple screens, and general refusal to treat cinema "as a slave to a profitable and demagogic Taylorism" (quoted in King 1984, 43), while at the same time deploring his knuckling under to "the law of genre"—a narrative technology inherited from Hollywood (42). About Gance's use of multiscreen projections and their effects in the film, Vuillermoz at the time wrote: "There is an extremely valuable element of polyphony and plurality of rhythms here which completely transform our traditional conceptualization of visual harmony. The monody of the optical melody is supplemented by the possibility of a notation of music of images on three staves. That is truly revolutionary" (quoted in King 1984, 48). But at the same time, the critic derides the director for not moving cinema away from Hollywood's narrowing of narrative options, as well as for the conservative celebration of France's imperial past. The nostalgic nationalist politics displayed in the film actually received less attention than the apparent aesthetic betrayals. Clearly Gance's formal experimentation served different ends aesthetically and politically than the works of other avant-garde artists.

Gance's experimentation and theorization about cinematic experimentation nonetheless provided a profound base for thinking through the capacity of images to create a new visual syntax. In 1923, Gance wrote: "One has to judge images not on their material quality but also on what they express—the value of cinema is to be found not in the photography *on the surface of* the images, but in the rhythm *between* the images, and in the idea, *behind* the image" (quoted in King 1984, 56, original emphasis). The new art that cinema could represent relied, according to Gance, on montage and superimposition (57), yet these formal elements, and a theoretical interest in the potential of image-generation in the mechanical age, are about all he really shared with the avant-garde. Like the Eameses, but contra the avant-garde he helped form, especially the Dadaists and Surrealists, Gance was deeply committed to the "democratic," "popular" and "universal" possibilities of cinema (57). In a similar fashion, the Eameses' exhibition work on behalf of science and technology also steered a politically suspect terrain geared for the masses: science without destruction, technology without devastation, a brave new frontier led by benevolent governments and corporations working hand-in-glove to deliver Cold War propaganda about a promised, brighter tomorrow.

The montage editing developed fully by Gance emerged most powerfully in the work of Sergei Eisenstein, who acknowledged the debt. Eisenstein's correspondence with Ezra Pound linked montage with Imagism as an explicitly

symbolic and nonnarrative means of juxtaposing images to create meaning in the minds of the audience through spatial proximity. The rapid cutting of images intended to overwhelm and affect the senses not by the logic of argumentation but by an onslaught of information and perceptual input became essential to the Eameses' *Glimpses* and *Think*. The formal editing capacities and opportunities afforded through Gance's innovations resulted in both immersive efficacy and rather frequent befuddlement on the part of pavilion attendees. When Stan VanDerBeek writes about experimental cinematic interests in the mid-1960s, at the same moment that *Think* is up and running, he lists "simultaneous images and compression, abstractions, superimposition, discontinuous information, social surrealism, [and] episodic structure" as being among the most telling concerns of filmmaking of the moment (1966a, 338–339). The list speaks to the past and to VanDerBeek's present, just as it perfectly describes the work of Gance and, to a large extent, that of the Eameses.

While *Think* was flashing away inside the IBM dome on Flushing Meadows, a special issue of *Film Culture* was published that contained an "expanded arts diagram" by George Maciunas.[11] The diagram provided a de facto genealogy of Fluxus. Maciunas turns some of his explanation of the diagram into a thinly veiled shot at E.A.T., but more directly at the whole technology-and-art lab collaborative moment when he writes that "pseudotechnology, or 'engineering' (in quotes) has been derived from the fact that artists at best can acquire technological knowledge or understanding comparable to that of a technician (TV repairman) rather than that of an engineer or a scientist who spends many years studying his specialty (just as artists spend many years producing art)." In this scenario, Maciunas can envision only a dumbing down of techno-scientific knowledge because, "(1) artist's new ideas or concepts will be affected or limited by his own past and recent scientific knowledge rather than the uncommunicated knowledge of the engineer. (2) the collaborating engineer meanwhile cannot very well communicate a sophisticated technical and scientific knowledge to the artist without giving him a four year university course on related subjects." For all of his general dismissiveness of such fashionable endeavors, he found some collaborations of this sort more palatable than others, and in his diagram he offers under "International Exhibitions" a section listing those working on "Expanded Cinema," which he places in bold. Here the Fluxus founder lists Stan VanDerBeek, Harry Smith, and Charles Eames as "artists" capable of holding their own with engineers.

If Charles Eames could keep up with current engineering knowledge, according to Maciunas, then Ray Eames could certainly stay on pace with the neo-avant-garde work of the time, thus positioning the Eames Office at the fe-

cund intersection of the two avant-gardes we are examining in this book. If one were to look for the most influential avant-garde influence on the Eames Office, one would find it in Ray Eames and her artistic career in early twentieth-century New York, and this influence permeates all aspects of the varied areas the Eames Office engaged in. Ray Eames, according Joseph Giovanni, was an integral player in an important moment of US abstraction and its development out of the European avant-garde through the American Abstract Artists movement. This movement, largely populated by students of Hans Hofmann, began meeting in 1936, and sought to explore and combine "Expressionist, biomorphic and geometric elements" with a thorough knowledge of, but ultimately an eschewal of, Realist and Surrealist tendencies (Giovanni 2005, 58). Ray Eames worked with this group for years and was at its core when the 1941 Abstract Expressionism show was held, an exhibition that featured works by Léger and Moholy-Nagy, among others. The group also kept close ties with Willem de Kooning and Arshile Gorky. All of this grew out of Ray Eames's full-spectrum interaction with the early 1930s New York avant-garde and artist-as-activist scene, taking classes with Hofmann and visiting exhibitions by Boccioni, Cezanne, Picasso, Matisse, Miró, Léger, and Calder (45). She also had a profound interest in dance (both modern US and classical Indian), working with form and movement in space as it pertained to bodies and the built environment, which become hallmark attributes of the conceptualization of pavilion experience the Eames Office brought to the US government and major corporations. Studying dance, architecture, design, painting, and music as iterations of the same kinds of impulses, Ray Eames charted a multifaceted and immersive career in the arts prior to meeting Charles and starting up the Eames Office.

Hofmann, for his part, had lived in Paris from 1904 until 1914, conversing with the Fauvist and Cubist movements and circulating with Braque, Delaunay, Picasso, Picabia, and Matisse. After getting his own classes up and running in New York, he counted among his students Gorky and de Kooning, along with Jackson Pollock and Clement Greenberg (56). Giovanni argues that Hofmann provided an integral link between pre–World War I Paris and post–World War II New York (56). Hofmann taught Ray Eames a great deal about space, within the plane of the image but also with ways in which the image can be broken into parts and redistributed to create different senses and sensations of space. Both *Glimpses* and *Think* bear the signature of critically deploying various ways of breaking frames of the image (moving or still) as well as that of the exhibition space. Similarly, the plasticity of molded plywood finds some initial theoretical and formal engagement in Hofmann's classes about the plasticity of the image, the plane, and the frame. These ideas about plasticity

proved especially useful for Ray Eames as Hofmann encouraged students "to test color tensions by moving and pinning small pieces of colored paper on their canvases" (56). This method foreshadows the ways in which the Eameses broke with single-projector filmic images and scattered screens about a space of installation (in Moscow and New York) to alter relationships between spectators, space, and the images being viewed. For Hofmann, perspective presents problems because it is only concerned with "one movement in depth, while plastic experience goes in and comes back to the observer" (quoted in Giovanni 2005, 57).[12] With Ray Eames neatly moving between different genres and kinds of depth, the Eames Office brought the avant-garde past and present to the promotional aid of IBM and the US government, an avant-garde in form and to a certain extent in spirit, but by no means revolutionary. This was an art-and-technology collaboration that corporate America found more palatable, and indeed desirable, unlike LACMA's A&T. The Eames Office unlocked a formula that provided more purchase for their "experimental" pavilions than E.A.T. could ever hope to muster for its contribution in Osaka.

### *Think*: Communicating Comfort with Universal Computation

As the crowds at the New York World's Fair in 1964 flowed around the Unisphere and stared at the future of robotics-as-entertainment provided by Disney for the General Electric exhibition "The Carousel of Progress," they also headed to the IBM pavilion to partake in the last and most extravagant immersive multiscreen event the Eames Office would generate. The Eames Office continued to make films, but *Think*, housed in the "Information Machine," proved to be the last in a pavilion setting. It would also be their last to raid the avant-garde exhibition, projection, and moving image larder for a general spectatorship in a thoroughly designed and controlled environment.

In its attempt to change its image as a corporation primarily producing defense computation for the military to one generating universal computation, IBM knew that it needed to educate the general public (that is, stockholders and taxpayers) about how their new product (computation) would change every aspect of their daily lives. The company unveiled its new look at the World's Fair in their pavilion. The IBM pavilion was largely the product of the Eames Office in cooperation with regular collaborators. From the multimedia experience of *Think* to the robotic puppet display, to the large-scale information boards complete with photos and timelines, to the signage and graphics and down to the furniture that tired fair-goers were able to relax on, the pavilion essentially provided a 3D multisensory display of the Eames Office in

action. The highlight of their offerings was *Think*, a multimedia projection and immersive educational experience that furthered the overall pavilion theme of computing and daily problem-solving. The building's design replicated an IBM Selectric typeball that bore only the letters IBM and not the full alphabet. Those entering the pavilion inhabited the corporation's latest innovation in typewriter technology. The centerpiece, *Think*, used a hydraulic lift called "the people wall" that pushed some 500 spectators 50 feet in the air into the suspended theater. The audience was physically thrust into the theater, itself strung with randomly arranged non-uniformly sized screens (fourteen long and eight smaller ones in the shape of rectangles, circles, squares, and triangles). The Eameses had been experimenting for several years with expanding the cinematic technological format with lenses, throw (the distance between projector and screen), and screen shape, as well as editing and narrative techniques. The effect of the space was like being in a control room or TV studio (Colomina 2001, 7–8), and thus anticipates our dashboard-driven computer navigation. The earlier film *Glimpses* provided a similar, less ambitious attempt at fully immersive high-tech, avant-garde inflected public relations, with the client in Moscow being the State Department.

The Moscow exhibition brought together a number of notable Eames collaborators under the auspices of their old friend George Nelson. The others included Billy Wilder and Buckminster Fuller, whose geodesic domes protected the US missile-siting perimeter and early-warning-system stations, but also projected US construction and engineering prowess in international forums. Fuller constructed a massive golden dome on site in Moscow, a construction project that Khrushchev watched intently. The USIA team was hired to exhibit highlights of US "science, technology and culture," with Nelson receiving the commission from USIA to put together the US exhibition.

Housed near Disney's 360-degree film projection system Circarama—yet another projection experiment—and Edward Steichen's *The Family of Man* photo exhibit, the Eameses' film *Glimpses* was projected onto seven screens (each 20 feet by 30 feet) suspended inside Fuller's geodesic dome. The film showed a "typical work day" in nine minutes, and a "typical weekend day" in three minutes. Schuldenfrei (2015, 71) connects *Glimpses* to the city symphony genre of the 1920s, the early twentieth-century nonfiction genre that loosely includes Dziga Vertov's classic 1929 avant-garde paean to posthuman vision, *Man with a Movie Camera*. George Nelson described the series of images as not so much a film but "a projection of data," rapidly moving and on such a scale as to prevent Soviet criticism that the objects portrayed on the screens were but a *Potemkin* film set (F. Turner 2013, 250). The purpose of the USIA

exhibit was to promote the advantages of consumer goods within the material economy of the US (as the Nixon-Khrushchev kitchen debate displayed). In what amounted to a sustained act of "product placement" with the daily doings of US life being augmented by its massive bounty of gadgets and appliances, the Eameses' multiscreen film contained images of many of the objects on display in the pavilion. Some 2,200 still and moving images with saturated editing were shown on the massive screens by seven interlocked projectors, with each screen showing a different but occasionally synched scene. Still images constitute most of the film, with the majority of the movement resultant from the rapid editing that deployed Gance- and Einstein-inflected montage to create a near hallucinatory kind of audiovisual immersion.[13] *Glimpses* worked with scale and speed, such that the term "glimpses" in the title refers not only to the brevity of the "average day of life" synecdoche approach but also more importantly to the fast-cutting technique deployed for the shifting images. The "high-speed technique" is designed to overwhelm the viewer with detail and rapidity in a deluge of evanescence.

*Glimpses* contains images almost exclusively viewable through the advanced optical technologies of telescopes, zoom lenses, airplanes, night-vision cameras and so on, projecting "a hyperviewing mechanism" (Colomina 2001, 13). The visual technological prostheses perform and display the visualizing power resultant from intensive high-tech research, and the performance of these visual technologies is what is on display as much as the material economic contents. Though the film played with scale and the operations of the quotidian, it did so in an age of viewing technologies of surveillance deployed for the Cold War. Of *Glimpses*, Beatriz Colomina states that "intimate domesticity is suspended within an entirely new spatial system—a system that was the product of esoteric scientific military research that had entered the everyday public imagination with the launching of Sputnik in 1957" (12). Emerging from the Eameses' multimedia events comes a new visual and spatial norm, one in which the vast scales of micro and macro viewing found in Cold War tele-technologies become the basis of ubiquitous screen culture as the source of information and control. The merging of the corporate sphere and the geopolitical agenda deployed in the Moscow and New York pavilions show the Eames Office (and others) as interfaces for the avant-garde of military R&D investment and the artistic avant-garde.

Prior to the Moscow event, the Eames Office had begun to shift increasingly toward experiments with space and the built environment. They concentrated their focus on modeling and imaging work and away from Renaissance architects such as Filippo Brunelleschi in order to address what they believed

to be the pressing demands of twentieth-century architecture: "organization of information." As cybernetics, systems theory, and information theory began to change the intellectual landscape, so the Eames Office responded with a full engagement of how best to visually and spatially convey these developments. *Think* becomes their most direct, and indeed audacious, manifestation of these concerns. In addition to educating the public about problem-solving through universal computation, *Think* intended to make the public feel more "at home" with an increasingly "changing and complex" world (Schuldenfrei 2015, 162–163). Further, it connected information theory and communication theory to larger systems that supposedly allowed for individual choice in spite of their scale and complexity. Their earlier film *A Communications Primer* contains a voice-over ideologically laden with the assertion that "no matter where it occurs, communication means the responsibility of decision all the way down the line" (F. Turner 2013, 255). The strident reinforcement of the individual and choice in a Cold War world of automated weapons systems attempts to rescue democratic ideals clearly in peril. By explaining how universal computation could be used in daily life as well as for military purposes, IBM hoped attendees would come away from the exhibition with an image of the corporation as helping the average citizen attain "the negative capability" (to borrow from John Keats) required to be comfortable in a world guided by information, abstraction, consumer wealth, material gain, and nuclear destructive capability—while conveniently eliding the fact that the same systems and technologies made possible all of these contradictory contemporary phenomena.

······················································

In order to achieve this PR sleight of hand, the Eameses dug deep into the avant-garde aesthetic store of formal experimentation. Beyond reaching back to Svoboda's innovations of screen placement, arrangements, and relationships from the 1950s, they looked to Herbert Bayer's 1935 design sketch "Diagram of 360 Degrees of Vision" (figure 5.1) for their own fully immersive space determined by communication and information (Turner 87–90). As with *Think*, Bayer's 1930 Paris exhibition at the Grand Palais was intended to overwhelm the audience with images and evoke a visual gestalt. This general exhibition ethos was carried forward to his work during the next decade. Bayer's design for MoMA's *Road to Victory* exhibition in 1942, led by Edward Steichen, exploited the potential plasticity of the exhibition space and materials that he had promoted in the previous decade. The opened traditional exhibition space offered a walk-through collage environment with angled images surrounding viewers. Elements of this kind of display remained in effect in Europe in the 1940s and

Figure 5.1. Herbert Bayer, "Diagram of 360 Degrees of Vision" [1935], in *Visual Communication, Architecture, Painting* (New York: Reinhold Publishing, 1967), p. xx.

1950s, including specific postwar pavilions, and then found their way into the Eames Office's own pavilion work for the State Department and IBM. Such display experimentation also caught VanDerBeek's attention, as exemplified by his Movie-Drome. For Bayer and the Eameses, the control of information had intentional, and propagandistic, agendas in contrast to the more liberatory and open-ended desires that marked VanDerBeek's projects. With *Think*, cinematic and anti-cinematic, as well as gallery and anti-gallery, exhibition techniques came together, and the experience proved simultaneously disorienting and comforting for spectators. With Bayer's influence on the Eames installation for IBM, along with the long-established dialog between the Eames Office and Kepes, the spatial imaginary of the Bauhaus as well as the socio-visual imaginary of a post-historical ideology geared toward a techno-future of communication and control permeates the exhibition.

The early part of the twentieth century contained an abundance of experimental forms of exhibiting images (still or moving or both) that found echoes in *Think*. El Lissitzky's 1926 piece *Kabinett der Abstrakten* (*Cabinet of Abstract Art*) and Frederick Kiesler's *Raumbuhne* (*Spatial Theater*) from 1924 offer spectators an exploded spatial relationship between the act of viewing and the displayed works (Sutton 2012, 148–150). *Think* took forward the Bauhaus desire for "total environment" as articulated by Walter Gropius and Bruno Taut in the 1920s, itself a kind of updated kindred aspiration of Wagner's *Gesamtkunstwerke*. The Eames Office control of the exhibition space clearly moves toward the kinds of effects the E.A.T. Pepsi pavilion in Osaka hoped to achieve. Extending this Bauhaus principle of "total environment," Bayer's brief 1939 "fundamentals of exhibition design" booklet provided alternative display strategies for public exhibitions, ones he utilized later for his influential US installations during World War II and immediately after. Bayer's usage for these display techniques included avant-garde attempts to undermine bourgeois assumptions about art engagement. For the Eames Office pavilions, however, such viewing and exhibition strategies actually found form *as* bourgeois infotainment that furthered the shared political and economic horizons articulated by the US government and major corporations.

VanDerBeek, writing in *Film Culture* at the time of *Think*, expressed an ethos for expanded cinema and the new language of vision resultant from the increased speed with which humans, images, and information moved. "Man as mobile-man suddenly discovering tremendous amounts of communications consciousness, communications aesthetics and communications instinct" is his audience, VanDerBeek claims (1966b, 15). This audience would contribute to his expanded cinema projects and benefit from them by fully engaging the

global community wrought by real-time technologies. The issues expressed here pertain explicitly to the future of expanded cinema while also looking back a few decades to Moholy-Nagy's *Vision in Motion* (1946b). VanDerBeek and the Eameses were covering similar aesthetic and technological terrain, using similar strategies, techniques, and technics. Their rhetoric also echoed one another: VanDerBeek called Movie-Drome "an experience machine" and the Eameses called *Think* an "information machine." A residual Deweyan progressive view of experience is evident in both, with VanDerBeek aligning with the techno-liberatory potentialities of Kepes and the Bauhaus, and the Eames Office leaning toward corporate-driven futurist visions. Movie-Drome ran from 1962 to 1965 but also was fired up again for the 1966 NY film festival, and thus operated contemporaneously with *Think*. Just as the Eames Office understood itself as a laboratory for general education of contemporary, cutting-edge scientific theory, at least through their films, VanDerBeek said he wished for the Movie-Drome space to function as "a sight and sound research center" (VanDerBeek 1966a, 339).

VanDerBeek and the Eames Office operated in a larger New York scene of multiscreen experimentation, some for avant-garde artistic purposes and others for the kind of corporate promotions and geopolitical agendas found at the World's Fair. Andy Warhol's experimental multiscreen films from the mid-1960s include *Inner and Outer Space* (1965) and *Chelsea Girls* (1966). Similarly, Smithsonian Folkways collector Harry Smith created a four-screen experimental art piece, *Mahagonny*, which Smith called "a mathematical analysis of Duchamp's *The Bride Stripped Bare*" expressed in terms of "Kurt Weill's score for *Aufsteig und Fall der Stadt Mahagonny* with contrapuntal images (not necessarily in order) derived from Brecht's libretto for the latter work" (quoted in Friedberg 2006, 212). At the New York World's Fair, the Eames Office had other multiscreen competition with Francis Thompson and Alexander Hammid's *To Be Alive!*, for the Johnson Wax pavilion, which used three screens to depict life in Africa, Europe, and the US. The eighteen-minute film won the 1966 Academy Award for Best Documentary Short Subject. Thompson and Hammid provide exquisite examples of turn-of-the-century aesthetic practice co-opted for mainstream ends, having traveled from avant-garde experimental film work to the first IMAX via World's Fair pavilions with their multiscreen work. Prior to these multiscreen extravaganzas for the general public, Thompson directed the city-symphony-inspired film, *N.Y., N.Y.* (1957), which employed refracted images made through Moholy-Nagy techniques, and Hammid codirected with Maya Deren the vastly influential *Meshes of the Afternoon* (1943). Following their Oscar-winning hit in New York, Thompson and Hammid made an epic six-

screen extravaganza for Montreal Expo '67 called *We Are Young*. The projection included a sly sequence that sent up *Think* by featuring shots of the IBM Selectric as a symbol for the boredom created by soulless corporate office work.

Usefully, Colomina likens the Eameses' multiscreen displays to the grid space of a newspaper, "a space where continuities are made through 'cutting'" (2001, 22). Of course Gance's and Eisenstein's montage and nonlinear editing were in visual dialog with the earliest of Picasso's and Braque's collage works, which used the newspaper grid as inspiration, structure, and content. Although the "people wall" for *Think* provided enforced immersion in the media and mediated environment, the rapid editing on the oddly shaped screens flashing contradictory images sometimes overwhelmed the method of explaining complex universal computing in the simple manner that the Eameses wished to convey. In spite of half a century of collage-driven aesthetics in a host of print and visual culture works, the speed of this enclosed environment and the expanded frame of cinematic projection made for an uncanny experience for many who witnessed it. Trained as they were within the single-screen image space of cinema (and TV) and the singular narrative trajectory of popular-culture production, it is no wonder audiences found it all somewhat bewildering.

Colomina argues that the Eameses created a space with their multiscreen images that emerges out of a Cold War mentality in terms of architecture, experience, space, and imagination that has become a norm for us in the present (25). *Think* becomes the model of the control room: the multimedia/multiscreen space of the war room/control room for space flight, situation rooms, tele-governance of the globe, TV studios, avant-garde "happenings" and "expanded cinema" (7–8). The kind of multimedia experience the Eames Office generated in Moscow and New York belong to a larger trajectory of media and ideological formation that Fred Turner calls "the democratic surround" (2013), but which we argue has even larger geopolitical ramifications through the perpetuation of the material and immaterial effects of universal computing and the normative constitution of Cold War systems.

To be thrust up in the air and into *Think* was to enter a sphere of knowledge, influence, and control made possible by universal computation, a sphere of near-future technological controls resultant from military research spending crossing over into the consumer market and presented through domesticated avant-garde techniques. It was to enter a sphere of immaterial processes rendering the world as a sphere, a globe, a self-contained monad of information and screens birthed during, and becoming constitutive of, the Cold War, which has only been exponentially accelerated and amplified ever since.

### Buckminster Fuller: Maker of Domes, Counterculture Visionary, and One-Man Lab

*Utopia or Oblivion: The Prospects for Humanity* is the title Buckminster Fuller gave to his 1969 collection of essays about the fate of our species on the planet. Very much of its moment, the title reflects the Manichaean options generated by the Cold War arms race and the decades of dread that the Macy conferences considered immanent and yet hoped to stave off. The standoff between nuclear powers, though still a cold and not a hot war (except in proxy sites), exerted its influence on the emergence of art-and-science/technology labs, as we have seen, but more importantly the institutions that housed them and the rationale that they had for funding them. In this moment, Fuller, the one-man lab freed from institutional constraints, emerged as what he had always imagined himself as being: a visionary for humanity. Fuller held an understanding of humanity's place within a history driven by a technological development of humanity's own making but without much consideration of its consequences or potentialities. The long historical view Fuller insisted upon helped contextualize present concerns and design plans for the future. In one of the essays in this collection, "A Citizen of the Twenty-First Century Looks Back," Fuller, who was born in the nineteenth century, looks backward and forward from the chronotope of his writing and concentrates on "the world-transforming and world-shrinking developments" of technological change that largely determined geopolitics (1969, 17). From this perspective, "politics is, inherently, only an accessory after the fact of the design-science revolution" (17). The most serious side effect found in geopolitical thinking, he consistently argued, was the *a priori* of the zero-sum game in which the self is pitted against the other in a Malthusian struggle over limited resources. In order for the other to gain, the self must lose and vice versa: in other words, the Cold War struggle of nation-states played out as larger metonymic collectives of the individual and the other. Such assumptions and their destructive, oblivion-creating operations emerge in his late writings with great frequency, guiding his ever-alternative thoughts away from status quo concerns. The large systems of self-destructive global processes he addressed were often generated as much by the unintended consequences of military R&D as they were the intended results of geopolitical policies.

Relying on the work of friends, colleagues, and collaborators at the Macy conferences, he too wished to use their insights for a peaceful and prosperous world for all humanity through the application of global design science. "Norbert Wiener's and Claude Shannon's cybernetic 'feedbacks', which implement their 'information theory,'" Fuller writes, "will swiftly and progressively

correct the decisions and thereby the historical course of world-around citizenry evolution. Very swiftly all humanity will learn to think about total Earth, total humanity, and total accumulated knowledge, total resources, etc. and will begin to make some powerful omnihumanity, omni-Universe-considerate decisions" (1981, 342). Like the Macy conference thinkers, and like the Dada movement before them, Fuller intended to turn the innovations found for warfare into universal betterment through critical reverse engineering and alternative applications. Speaking to the audience he had garnered through Stewart Brand's boosterism—an audience that comprised a kind of counterculture modernist movement desirous to start afresh in communes or individually free of governmental dictates—Fuller highlights how fortunate it is that the "do-more-with-less invention initiative does not derive from political debate, bureaucratic licensing or private economic patronage" (1969, 16). Taking terminology from Big Science, which constitutes the polar opposite of the innovation ethos Fuller espouses, he claims that "the license comes only from the blue sky of the inventor's intellect" (16). "Blue sky research," that is non-instrumental research, may be the ideal of Vannevar Bush and the purview of massive governmental funding and coordinated projects, but for Fuller, the "blue sky research" that really counts depends on nothing but the unfettered imagination of anyone. The do-more-with-less initiative, he claims, has developed independently from and in opposition to the arms race, which was designed to kill the greatest number of people from the farthest away with the greatest accuracy and with the least effort. This is what Big Science and governments have delivered to us in spite of the human evolutionary capacity for boundless innovation. Using his own design work as an example, Fuller explains that he decided, as early as the 1920s, to use his energy and intellect for the common good, in this case to create cheap and effective housing, with the "scientific dwelling-service industry as the preferred means of transferring the scientific do-more-with-less capability from a weaponry to a livingry [*sic*] focus" (17). The opposition between weaponry and "livingry" is one that Fuller liked to toss about in his late lectures and writings—another binary option facing humanity and its goals. And it is in this dynamic that Fuller's potential utopia might emerge through his mantras of designing on micro and macro scales to save Spaceship Earth and those who travel on it.

The other essays in the book lay out this program. The titles of the essays reveal the changes he believes humanity can achieve by redesigning existence at all scales: "Prevailing Conditions in the Arts," "The World Game—How to Make the World Work," "Geosocial Revolution," "How to Maintain Man as a Success in the Universe," and "Curricula and the Design Initiative." If the goals and pedagogical means of realizing them seem familiar, they are. This is the

Deweyan progressive line charted in the Bauhaus transplants in the US, especially that of Moholy-Nagy and Kepes. Fuller ends "A Citizen of the Twenty-First Century Looks Back" with claims that neither he nor any other human is a genius, while simultaneously stating that all children might be born geniuses and become "degeniused" by the world (22). Negroponte's answer to this was to prosthetically outfit the child with digital tools and re-genius youth. The progressive trajectory that Fuller echoes, though no less enthusiastic about technology's potential, is to retrofit the child's view of humanity and its place in a globe of limited but adequate resources. Fuller further claims that the accolades and the recognition of his work that arrived late in his life are due to the "world's youth" seeking "world peace" and understanding that to accomplish this utopian ideal, they must use alternative strategies to those offered by establishment economic, governance, and instrumental teleologies for technological development and innovation (20)—alternatives and steps he had been honing his entire and very active life.

The project Fuller both proposed for Expo '67 in Montreal (see Marchessault 2017, 210–215) and pursued in his ongoing research at Southern Illinois University, a project that exemplified his global design science and its repurposing of systems of control as systems for liberation, is explained at some length in the essay entitled "The World Game—How to Make the World Work."[14] The World Game project was not built for the Expo, but it features Fuller's futurist pedagogical design tendencies on full display. Structured as a game intended to be accessible by anyone—not just the ruling elite who control the earth's resources—the simulation education platform that Fuller envisioned pitted teams in noncompetitive engagement to solve pressing global issues. In a later discussion of the World Game, published in his last book, *Critical Path,* and in the full flush of a few decades of game theory's predominance in geopolitical planning, he calls his game the antithesis of "World War Gaming." The roots for RAND-generated game theory, Fuller argues, lay in the British Empire's use of data and calculations from them devised by Thomas Malthus, the chief statistician for the East India Company. These assumptions concentrated on "the lethal inadequacy of life support on our planet" as the bases for calculation, planning, and action (Fuller 1981, 202–203). Using data visualization, real-time information, and statistics, as well as programs for scenario planning, Fuller's game aimed to "make the world work." Success entailed making "every man a world citizen and able to enjoy the whole earth, going wherever he wants at any time, able to take care of his of needs of his forward days without interference with any other man and never at the cost of another man's equal freedom and advantage" (183). Fuller argues that the goal of the game is not to improve hu-

manity per se, but merely to up its productivity with regard to resource investment and use. Thus, the game deploys secondary data collection by piggybacking on extant technologies engaged in other operations, for example using spy satellites that are "inadvertently telephoning the whereabouts and number of beef cattle around the surface of the entire earth" (184).

In this way, the game anticipates some of the most current cutting edge deployments of multi-scaled remote sensing systems, such as the Planetary Skin Institute. Initiated by NASA and Cisco Systems, the Planetary Skin Institute provides a multi-constituent platform for planetary eco-surveillance (Beck and Bishop 2016, 18–19, 273–288). The site operates as a nonprofit means of gathering real-time information from remote-sensing systems regionally and globally to create replicable and scalable big data information about ecological and environmental conditions. It is the current altruistic avatar of Fuller's World Game, but with a twist. As with all of the technologies deployed for the World Game or the Planetary Skin Institute, unintended consequences arise. Just as Fuller wanted to skim secondary inadvertent information off spy satellites, so too can the information generated by the Planetary Skin Institute be used as the basis for resource futures investment, using the same real-time technologies to track environmental conditions and futures markets.

If military technology can be converted to peaceful and progressive use, as delineated in the essay and game, so could Fuller's "scientific dwelling-service industry" be deployed for military aims in the service of the arms race furthered by Big Science. This was a fact Fuller knew all too well but often chose to repress. We only need to look at some of the various uses and deployments of his signature structure, the geodesic dome, to understand this repression. The geodesic dome moved from housing for antiaircraft and missile defense positions along the Distant Early Warning (DEW) Line to housing State Department expo events (including Brussels in 1958 and Moscow in 1959—both involving the Eames Office) to being the architecture of choice for counterculture, antiestablishment, DIY, *Whole Earth Catalog*–influenced communities. Using some design principles he had developed for his Dymaxion house in the 1920s, the structure sprang from Fuller's time teaching at the Design Institute in Chicago in 1948. At Black Mountain College that same year Fuller brought a large geodesic dome from Chicago to rural North Carolina, literally providing a structural linkage between one Bauhaus institution and another, while fueling immaterial and intellectual links.

The dome received its first public viewing in 1954 at the Milan Triennial, built out of corrugated cardboard. The Italians called it "architecture out of the laboratory" (Krausse and Lichtenstein 1999, 374), but Fuller thought of

this incarnation as "anticipatory rather than actual," despite carrying off the top prize at the exhibition (Marks and Fuller 1973, 61). Commercially, and therefore one must assume "actually," the first dome using Fuller's patents was built by the Ford Motor Company starting in 1952, using it to cover its new headquarters in Dearborn, Michigan. Fuller therefore claimed his first customer was "Mr. Industry himself" (61). What would become in the late 1950s and into the 1960s "official pavilion typology" in architecture (Scott 2007, 155) entered US government use, in the field as well as in the imagination, for Cold War defense and propaganda. Thus the impetus to provide affordable shelter for humankind shifted to commercial and defense uses and then back again in the utopian futurist design plans offered late in Fuller's life.

The US government's deployment of geodesic domes for both propagandistic and defense purposes emerged almost simultaneously in the mid-1950s. In 1956, for a fair in Kabul celebrating the independence of Afghanistan, USIA commissioned (through Jack Massey, who worked often with the Eames Office for similar events) a dome 100 feet in diameter for the US stand. As mentioned, a massive dome housed the US pavilion at the 1959 Moscow World's Fair, which proudly displayed the Eameses' *Glimpses* and Edward Steichen's *The Family of Man* (for which Herbert Bayer provided the original display design). Khrushchev reportedly said, after visiting the pavilion displaying *Glimpses*, that he was more impressed with the dome than anything else in the US pavilion and wanted to have Fuller come to the USSR to teach their engineers his techniques (Marks and Fuller 1973, 63). And again in Montreal in 1967, Fuller's dome, though without the World Game geoscopic display, provided a pivotal moment for US architecture on the international stage. As the Kabul dome was going up, Fuller was providing other parts of the government with domes for use along the DEW line, which operated through surveillance and information. An ad touting the technologies deployed for this system explains, "Basically an early warning radar line is a communications system." Further, the ad, ironically published in *Life* magazine, claims that Western Electric worked with Bell Telephone and Lincoln Laboratories at MIT to develop the system. The inset image of the geodesic dome in situ reads "DEW line radar station in the Arctic." The ad provides a public-directed articulation of the increased roles of information and communication technologies and theories in providing for the military defense of the country. The immaterial and somewhat deterritorialized nature of global surveillance emergent in the mid-1950s became materially manifest in systems like the DEW line.

The Fuller archives indicate that the designer had even grander ideas than simply providing shelter for radar equipment and the personnel required

Figure 5.2. Buckminster Fuller, detail from a plan for the US Department of Defense, M1090 Series 2, Box 90 (1955-56), Fuller Archives, Green Library, Stanford University.

to run these remote sensing stations. Fuller's files include blueprints for the domes to have multipurpose functionality, including rotating rocket bases and launching pads that would fuse detection and response (figure 5.2).

The Department of Defense did not take up this specific usage of Fuller's structures in arctic climes or elsewhere, just as the Soviet Army did not follow through on its interests in his 1920s Dymaxion living quarters, about which much correspondence between the Red Army procurement office and Fuller's own office was exchanged (the Fuller archives). These suggested deployments of his designs clearly fall more on the "weaponry" side of the systems, resources, and economics ledger than the "livingry" that Fuller championed in the 1960s. To be fair, Fuller moved easily between domains with a designer's understanding of the client's needs regardless of ideological consideration, and it was through these work experiences that he constituted a kind of holistic vision of alternative thinking about resources in a more expansive manner, one

outside of the geopolitical and economic systems at play in the Cold War while still holding on to thinking globally and materially. His "do-more-with-less" mantra, though, was at play even in his earliest designs. As we see with the blueprints for the rotating geodesic domes as arctic shelters, however, he took the military mission one step further by combining apperception and defense with corresponding retaliation built into the same structure. This was in step with the development of most weapons systems at the time of the Cold War, and it reveals how Fuller's idealistic reversibility of global military surveillance technologies for human betterment and maximum resource exploitation in the World Game could be flipped the other direction as well: altruism ("livingry") easily converted to killing (weaponry). Fuller knew this because, after all, he had designed them. He wrote about his structures and design principles otherwise, perhaps aware that his audience also understood fully that reversibility obviously goes both directions, no matter what, and in an age of constant weaponization, his domes, as was the World Game, could be used for military aims.

Although Fuller did not get his proposed, fully operational, large-scale, real-time electronic version of his World Game at Expo '67 in Montreal, he did get a Jasper Johns painting of his "Dymaxion Air-Ocean World Map" to hang in the massive geodesic dome erected there. Johns's painting, *Map (Based on Buckminster Fuller's Dymaxion Airocean World)*, was a multipieced and multi-shaped canvas measuring more than 30 feet long and over 15 feet high. As with Fuller's cartographic vision, the icosahedron Dymaxion map created by Johns could be disassembled or assembled at will, a result of it being too large to work on in full in his studio. Fuller's map could be folded together to create a sphere or unfolded, origami-like, to be a flat two-dimensional object. Cocreated with Shoji Sadao, the map provided the model for the interactive, data-driven version used in the World Game. Fuller and Sadao's map moved easily, then, between 3D and 2D representations of the earth's continents. These were represented in size based on population distribution and resource usage instead of the standard cartographic nod to land mass. While Fuller's optimistic vision of the map's pedagogical elements was at odds with Johns's more pessimistic view of the geopolitical agonism that marked the moment, the map mimetically reproduces fully "the age of the world picture," to quote Heidegger (2002). The telecommunications technologies developed to provide constant real-time surveillance of the earth necessary to conduct the Cold War and enforce the Truman Doctrine simultaneously converted the earth into a globe (a bounded sphere visible at all times) as well as into a flattened world without horizon (due to the use of "over the horizon" visualizing technologies and complete surveillance of the entire planet all at the same time). The globe as stage

for Fuller-inflected neighborliness also became a site of contiguous land masses locked in Johns-depicted animus: 3D holistic vision coupled with 2D Cold War strategically generated economic inequities.

Telecommunications technologies, such as satellites, metonymically manifest many of the ways that modern technoscientific culture in the post–World War II moment began to create new visions of the planet and shape the metaphysics of the imaginary in terms of what the earth could and should be. In the first few paragraphs of Heidegger's essay about the world picture (2002), he argues that modernity's essence coalesces around a series of seemingly disparate phenomena including science's most visible manifestation as machine technology, itself using specific forms of mathematics to realize its visibility and power. This situation aligns modern science with modern metaphysics. Further, he argues that within the late modernity of the middle part of the twentieth century, art moves into the domain of aesthetics and thus becomes a means for simultaneously creating and articulating human experience. All of this culminates in human action being understood as culture, which then means that culture articulates the highest point of human achievement and care, with care being converted into "the politics of culture" (57). Heidegger brings mathematics, science, machine technology, art, aesthetics, culture, and metaphysics together in a penetrating view of the legacies of twentieth-century trajectories that bespeak the themes found in Fuller's writings and his map, as well as in Johns's interpretation of the latter. Both Fuller's global design science and Johns's painting responded to the same sets of concerns that Heidegger did: concerns that were advanced by the avant-garde of US military spending.

The cultural politics of Heidegger's interpretation of modernity's generated metaphysics can be charted in the capacity for representation to equate with both experience and the real, for the map to create the territory and the technological means for cartographic representation to become the tools for human crafting of the earth as globe, or as flat observable plane, or as Spaceship. The visualizing tele-technologies on display in *Powers of Ten* and the universal computation of *Think*, as well as in the World Game and Dymaxion map, are just such tools, for they chart a trajectory in which the world traveled from being construed as plane to orb to globe to flat, surveilled entity again. Our capacity to see and render the planet whole erased the horizon of the world and made it capable of being held in our collective tele-technological grasp. The age of the world picture is evoked in these maps made by Fuller and Johns, and it is so in the means by which we have enframed, delineated, and curtailed potential futures, realized or not.

# 06

## Heritage of Our Times

If / we get through 1972, Fuller says, we've / got it made
—John Cage, *A Year from Monday*

 The move away from a monolithic model of federally funded R&D defense labs toward a complex public-private model of symbiotic entrepreneurship has, since the late 1960s, massively redistributed and dispersed relations among science, technology, business, and government to the point where there is often no clear distinction between private tech entrepreneurialism and federal sponsorship. The free-market model of defense R&D, though, is entirely in keeping with the broader reshaping of economic and institutional life along neoliberal lines that has occurred since the 1970s. Here, as Philip Mirowski has made plain, Cold War math and physics and the theoretical models they produced leaked into economics through the influence of cybernetics and interactions between the Cowles Commission at the University of Chicago and RAND (Mirowski 2002, 215–222; see also Christ 1994; Van Horn and Klaes 2011). Among the key participants here was economist and mathematician Kenneth Arrow, who, with Gérard Debreu, developed formal proof of "general equilibrium," a model of the perfect free market (see Amadae 2003, 83–132). As markets came to be seen as too complex to be understood (and thus managed), the notion of the autonomous and self-correcting market not only appealed to the cybernetically inclined but also seemed to confirm suspicions that the New

Deal model of a planned economy was, like its Soviet cousin, not only ideologically dubious but unscientific. Public choice theory, developed by Mont Pelerin Society members James Buchanan and Gordon Tullock, which applied economic tools to the study of political behavior, drew directly on the rational choice models worked out at RAND that concluded that rational individuals do not cooperate to achieve common goals unless coerced.

As we have seen, progressive liberalism delivered a conception of science and technology as coterminous with democracy and creativity that was realigned during and after World War II as a mode of expert technocratic managerialism. The emerging neoliberal conception of the rational individual preserves the Enlightenment virtues of rationality and the free individual that underpinned progressivism but effectively jettisons the notion of the public sphere and its associated attributes (deliberation, cooperation, the idea of a common good) that were taken to underpin the liberal project. Rational choice liberalism delivered a scientific understanding of human interaction as a riposte to the purported scientific theory of Marxism and communism but, as S. M. Amadae notes, it is "not without historical irony that the ideological front of American society's hard-fought war against communism and the Soviet Union may, inadvertently, have eroded the meaningfulness of the term 'American society'" (2003, 4). The restricted neoliberal conception of the state—that it serve largely as the guarantor of free competition—is already there in the late 1960s realignment of the military-industrial complex according to the entrepreneurial model.

One of the effects of growing public challenges to the entwined militarized relation between government and science during the late 1960s and 1970s was the retreat of the direct military funding of university research. The Mansfield Amendment to the Military Procurement Authorization Act of 1970 (Public Law 91-121), for example, required agencies to divest themselves of non-mission-oriented research. Though this led the military to cancel a number of projects that were not obviously related to defense, while allowing directly defense-oriented research to continue, other organizations such as the National Science Foundation (NSF) took over the funding of programs previously supported by the Defense Advanced Research Projects Agency (DARPA). Student protests during the period also led some universities to formally separate themselves from military-funded research units (such as the Stanford Research Institute, and the Draper Laboratory at MIT), which were reconstituted as independent not-for-profit organizations that continued to receive military support (see Weiss 2014, 36). A commercial rerouting of funding streams also occurred in biotechnology. Antiwar sentiment in the US

led President Nixon to ban the development of offensive biological weapons in November 1969, and the UN Biological Weapons Convention, aimed at prohibiting the development, production, and stockpiling of such weapons, was ratified by the US in 1972. Nevertheless, aware that a secretive state like the USSR would have the advantage in any biotech arms race, the US kick-started a commercial dual-use biotech industry, shifting over into the commercial sector the research previously undertaken in government labs (34–35).

This realignment, however, did not solve the growing sense, during the 1970s, that the US government was no longer the dominant force in technological innovation. The most enterprising firms in electronics increasingly preferred the commercial market to the government sector. The economic challenges of the 1970s and the rising technological leadership of Japan, along with recognition by US intelligence in 1977 that the Soviet Union had reached parity with the US in terms of nuclear capability and shrinking government investment in R&D, demanded a new strategy through which the US could recapture its dominant position. Secretary of Defense Harold Brown charged William Perry, deputy director of research and engineering, with implementing what Brown called the Offset Strategy. Focusing on information technology, Perry had to find new ways for the DoD to tap into the advanced technologies no longer generated by big government defense contractors but by commercial tech companies (Weiss 2014, 37). Through the 1980s, programmatic, procurement, and institutional reforms were introduced that were designed to create a more effective fit between defense and commerce. This included two reforms of 1980, signed into law by the outgoing President Carter, that incentivized both the DoD and the commercial sector to work for their mutual benefit. The Bayh–Dole Act allowed small companies and universities to retain ownership over government-sponsored innovations (Crow and Tucker 2001, 7–8), while the Stevenson–Wydler Technology Innovation Act was the first in a series of laws designed to encourage the Department of Energy's National Laboratories to commercialize their research (Mirowski and Sent 2007, 657). From the end of the 1970s, defense research became increasingly conceived as an entrepreneurial activity (Weiss 2014, 40).

Although the emphasis has changed over subsequent decades, with Reagan militarizing technology during the 1980s and Clinton civilianizing technology in the 1990s, the broad effect of each approach recognized the interrelationship of commercial and defense R&D and their combined importance in furthering US strategic dominance. The Reagan administration pushed hard toward commercial innovation as a way to maintain technological leadership through patent, procurement, and organizational reforms, the promotion of

US semiconductor, silicon-based, and software research and development, and by revamping Department of Energy labs as drivers of entrepreneurial and commercial innovation. The trend since the 1980s has been less about finding commercially relevant applications for military technologies, one of the main public justifications for military R&D expenditure during the 1950s and 1960s, and more about the military making greater use of commercial or nontraditional suppliers. By the end of the twentieth century, as Linda Weiss explains, the US military technology enterprise "embraced a vast array of innovation hybrids, national labs, industry, and university contractors" (47).

As the Cold War binary model gave way to perceived multiple threats to national security, including pandemics, environmental crises, terrorism, and cyberattacks, new bureaucracies and new hybrid forms of research innovation have proliferated. Post-9/11, the surge in funding for security and antiterrorism allowed the newly formed Department of Homeland Security, for example, to form its own R&D agency, the Homeland Security Advanced Research Projects Agency (HSARPA), in 2003. Modeled after DARPA, HSARPA was charged with developing transformative innovations in homeland security technology. Other DARPA-like agencies appeared within the intelligence sector, the Department of Energy, and the army. Among the latter's innovative hybrids were a venture capital fund called On Point Technologies and an MIT-based nanotechnology development institute focused on high-tech combat equipment (47–48). As Weiss argues, the national security state's willingness to support and even run venture capital initiatives demonstrates "the critical role of government-backed venture funding for the majority of high-risk startups and early-stage technology enterprise—the very entrepreneurial activities in which the United States reportedly leads" (53).

The rise of the 1960s art-and-technology collaborations is most easily understood as an example of corporate liberalism's faith in the deployment of expertise and public funding to intervene in solving social problems and build an American future according to the benign management of accelerating technological innovation. The fall of the art-and-technology projects can equally be understood as a consequence of the collapse of confidence in that vision of the future. The escalation of the war in Vietnam undermined LBJ's project of a Great Society masterminded by think tank research and science and technology, the main planks of the postwar platform for American (and, through the de-ideologized rhetoric of democratic virtue, global) modernization, came to be seen, as technological pessimists had long feared, as agents of imperial mastery. The turn against the utopian promise of technology as such, and in particular the tendency in the US to conflate technological innovation with the

enlargement of democratic potential, can be seen in, for example, the growing public indifference to the space program and in a general suspicion of expertise and bureaucratic control. For some, such as Stewart Brand, the technocratic model could be preserved through some inventive cross-pollination with the utopianism of the counterculture, but for many by the end of the 1960s, advanced science and technology had come to represent the enemy of democracy. Projects like E.A.T. and A&T were not so much ill-conceived as ill-timed, though the striking absence of critical reflection on the politics of art-and-tech collaboration among the organizers and contributors, at least in the documentation and in much of the work, suggests a troubling blind spot or, worse, indifference toward the broader political ramifications of working with corporations and universities engaged in, and supported by, defense-related research. The Vietnam War made plain for many Americans, including those working in universities and the arts, the extent to which creative and intellectual labor had become entwined with state-sponsored military-industrial enterprise. While government got busy redistributing and reimagining the relation between defense funding and research establishments, the kind of institutional critique that failed to inform the art-and-tech projects, though operating at least in latent form in placements like John Chamberlain's at RAND, came to shape the politics of art in the US through much of the 1970s.

**Timing and the Avant-Garde**

The discourse of failure surrounding the avant-garde has been a persistent feature of critical accounts for many years, and especially since Peter Bürger's influential 1974 (translated into English in 1984) assessment of the historical avant-garde and what he sees as the degraded and redundant repetitions of the neo-avant-garde. Bürger's pessimistic account, as noted by Benjamin Buchloh (1986), Hal Foster (1994), and John Roberts (2015), among others, is an articulation of post-1968 disenchantment that sees only empty, bad faith repetitions of the historical avant-garde's best moves in the art of the 1950s and 1960s. The retrieval of elements of Dada, Futurism, Surrealism, and Constructivism by the neo-avant-garde is, for Bürger, evidence of an exhausted project. For Foster, however, it is precisely the relation between prewar and postwar avant-gardes, not least in terms of the importance of repetition for the neo-avant-garde, that opens up crucial questions regarding "avant-garde causality, temporality, and narrativity" (1994, 10).

As we have recognized here, the ideas, and often the personnel, driving 1960s art-and-tech initiatives shared a lineage with the early twentieth-century

avant-gardes, funneled through the Bauhaus, Black Mountain College, and Fluxus. This avant-garde underpinning brought a commitment to experimental, often process-based collaborative practice, usually uninterested in outcome-oriented productivity; a willingness to move beyond disciplinary boundaries to the point where art and the aesthetic dissolved as distinct spheres; and a utopian spirit in keeping with the techno-optimism characteristic of the early years of the decade. Foster is right to note that, in the US context, awareness of the historical avant-garde often came through the very institutions of art the avant-garde intended to demolish—through increasingly professionalized university education such as MFAs, and, as we have seen in the case of MoMA, through galleries and museums. The recovery of the avant-garde in the US was largely already institutionally mediated and, as such, the repetition of avant-garde strategies was critically and theoretically self-aware. For Foster, the relevance of, say, Marcel Duchamp, to modern art was to a significant degree retroactive inasmuch as it was the retrieval of Duchamp in the 1960s that led to him being anointed the key figure of twentieth-century art. Bürger's tendency to read the avant-garde as an evolutionary tendency, despite his recognition of the historical rupture the avant-garde instantiates, blinds him, according to Foster, to the "deferred temporality of artistic signification" (1994, 11). In other words, Bürger's linear, evolutionary model led him to identify the historical avant-garde as a failure (the category of art was not destroyed) and the neo-avant-garde as a farcical retread of that original failure (13–16).

Foster, by contrast, sees the avant-garde (especially Duchamp) and the neo-avant-garde (including Robert Rauschenberg and Allan Kaprow) as less focused on the negation of art or the romantic reconciliation of art and life and more concerned with the "perpetual testing of the conventions of both" (18). In this way, according to Foster, "rather than false, circular, and otherwise affirmative, avant-garde practice at its best is contradictory, mobile, and dialectical, even rhizomatic" (18). It is in sustaining a tension between art and life, in testing what constitutes aesthetic experience, that Foster locates the neo-avant-garde not as the farcical return of a heroic past but a project enacted "for the first time—a first time that ... is theoretically endless" (20). The historical avant-garde, according to this reading, is effective only when it is worked through by the neo-avant-garde; what Foster calls the "becoming-institutional of the avant-garde" does not "doom all subsequent art to court buffoonery" but prompts a process of ongoing, reflexive critique of "acculturation and/or accommodation" and a "creative analysis" of the limitations of precursor avant-gardes (23).

The 1960s art-and-technology initiatives explored in this book, in their inability or unwillingness to account for, and respond to, the challenges of a

militarized scientific and technological avant-garde to which they sought to align themselves, certainly appear to fit the narrative of failure typical of assessments like Bürger's. The narrative of collaboration that chimed with the avant-garde rejection of the expressive subject soon came to signify a more compliant collaborationist tendency as art's position within the university or corporation appeared to achieve no more than provide a flimsy screen for the technocratic implementation of a US imperial project. Yet, as Foster's proposal for an expanded temporal reading of the avant-garde project and its failures suggests, there are grounds for avoiding Bürger's disenchanted outlook on the thwarted ambitions of once radical projects. An adequately historicized account of the avant-garde project would do better to understand any moment of failure as a marker or an impact crater—as an indication or trace of activity the significance of which remains contested and unresolved. The avant-garde, as John Roberts claims, "is inseparable from the absences and discontinuities that *it carries with it*" (2015, 15, original emphasis).

The complex temporalities at work in the art-and-tech projects of the 1960s therefore require some consideration, not only to avoid the enticing but inadequate temptation to dismiss them out of hand as inevitably complicit with the institutions of power they appeared to court and redeem, but because these very projects have, in recent years, themselves been subject to the processes of retrieval and recuperation. CAVS, E.A.T., and A&T are currently reanimated and have come to represent important precursor projects in a revitalized art-and-technology sector. The ambitions of the 1960s projects, their desire to generate interdisciplinary, collaborative, creative research, is no longer perceived as a relic of the doomed utopianism of their historical moment but as a deferred dream the twenty-first century can finally deliver. In order to understand what is at stake in the recent art-and-tech reboot—beyond the obvious synergies between what the art-and-tech projects stood, and continue to stand, for, and the rise of ubiquitous computation and the financial and social power wielded by contemporary tech giants—we would do well to approach the knotted histories of the artistic avant-garde, American progressive politics, and the military-industrial state that have been partially outlined in these pages in the light of the expanded temporal horizons suggested by Foster and Roberts.

The revival of art-and-tech collaboration as a concern among universities, galleries, museums, and other institutions has been, like the neo-avant-garde, a return that relies upon recognition of predecessors. In 2013, LACMA launched the Art + Technology (A + T) Lab (a plus sign substituted for the ampersand of the 1960s version), intended to provide, as the museum explained, "grants, in-kind support, and facilities at the museum to help artists take purposeful risks

in order to explore new boundaries in both art and science" (quoted in Chang 2013). Sponsored by Hyundai, the program drew on staff and facilities from big tech companies Accenture, Daqri, Nvidia, Gensler, Google, and SpaceX. Artists were promised "access to robotics, EEG, sensors, big data-crunching machines, and even SpaceX flight information" (Savov 2013). In 2015, MIT's Center for Art, Science, and Technology (CAST) received a $1.5 million Mellon Foundation grant to further promote and enable the center's mission to inspire teaching, research, and programming that operate at the experimental intersections of art, science, and engineering. In the official news article about the grant, MIT stressed its fifty years of pioneering work integrating the arts into its engineering and science programs. The news release explicitly links the CAST project of "arts on a civic scale" back to György Kepes's CAVS, which it identifies as the progenitor of CAST's studio/lab ambitions (CAST 2015). In 2016, Nokia Bell Labs marked the fiftieth anniversary of Billy Klüver's art and technology collaboration by introducing the E.A.T. Salon, bringing together a wide range of artists and Bell Labs researchers. In a welcoming address, Marcus Weldon, president of Nokia Bell Labs and chief technology officer of Nokia, said that E.A.T. "has been a little dormant for the past decades, because in many ways the ideas were so 'avant-garde' that they were well ahead of their time." Now, however, with the "rise of smartphones and their canonical apps, cloud based creative software platforms, sophisticated digital image capture devices, and immersive, large scale digital displays or head-mounted VR goggles, art and technology are becoming truly coupled, or perhaps even symbiotic." The "time to E.A.T.," writes Weldon, "has come" (Weldon 2016).

Interest in collaborative arts-and-technology research is higher than it has been since the 1960s, and the LACMA initiative, along with the CAST grant and the E.A.T. Salon, are among many indicators of the trend in the arts toward interdisciplinary collaboration and the notion of art as research. Indeed, there are over one hundred such programs and sites in the US alone at the time of writing (see Shanken 2005; Wisnioski and Zacharias 2014). Reawakened interest in art-and-tech labs is a consequence, on one hand, of the enlargement of art's field of operations post-Conceptual Art, and on the other, of the restructuring of the technology sector in the wake of the digital revolution. For John Roberts, since Conceptual Art, or what he calls, following Rosalind Krauss, "art after art in the expanded field," the collective, reflexive strategies of the avant-garde have become "the grammar of a viable and active art production" (2015, 23). This expansive plurality of forms has emerged as the official art world of global stars, blockbuster exhibits, elite institutions, and dealerships has increasingly rendered itself irrelevant to the concerns and interests of a

critical art practice, even though, as Roberts suggests, there is no clear-cut or complete separation between the art world and the enlarged sector of art workers he designates art's "second economy" (23).

The vigorous growth since the 1990s of participatory and other discursive and pedagogic practice, often foregrounding an avant-garde lineage and explicitly radical aims, cannot be separated from or understood outside the deregulated labor market under neoliberalism that has demanded increased worker flexibility, adaptability, and entrepreneurialism. The model here is, of course, the tech sector, its countercultural bona fides shored up through the 1970s and 1980s by the techno-utopianism of apologists like Stewart Brand and the frontier ethos of what Richard Barbrook and Andy Cameron (1996) called "the Californian ideology," undergirded by the deregulated market and its capacity to create new modes of cultural production and exchange.[1]

The renewed interest in art-and-tech projects, then, may preserve the names and the legacies of earlier iterations, but the historical circumstances within which they have arisen are radically different from the situation in the late 1960s. Foster's purpose in reexamining the temporality of the avant-garde recognized that the "becoming-institutional" aspect of the neo-avant-garde marked a reflexive capacity to undertake a critique of "acculturation and/or accommodation"; it appears that this part of the neo-avant-garde legacy has itself been institutionalized in the form of art-and-tech projects fully capable of absorbing their failed histories back into themselves. Yet there is little mention of failure in the press releases and websites promoting CAST, E.A.T. Salon, or the LACMA A + T program. Not only is the criticism leveled at the 1960s projects underplayed to the point of invisibility, but the prospect that these projects have laid "dormant" is suggested as an indication that they were somehow ahead of their time, cryogenically preserved for the purpose of reheating in the present. It is through this narrative of reanimation that MIT, Nokia, and LACMA are able to position themselves as the guardians of underestimated initiatives that can now be allowed to flower. A more skeptical reading might conclude that it is only through historical amnesia and the erasure of the circumstances through which artists came to service the public relations arm of the defense industry and its government backers that it is possible to retrieve a usable past from the art-and-tech adventures of the 1960s.

A navigation of the significance of the twenty-first-century art-and-tech revivals requires a sense of the complex forces that brought about their 1960s ancestors. What is hopefully clear from our account of CAVS, E.A.T., and A&T is that these ambitious, if flawed, initiatives themselves emerged out of, on the one hand, the historical avant-garde's challenge to bourgeois art and its fixation

on the creativity of the autonomous individual, and, on the other, progressive liberalism's claims for science as a generalized means for realizing a radically democratic community. The particular art-and-tech formations considered here, while forged in the historical circumstances of an ascendant industrial modernity, come to fruition, however, at the point where the social, economic and ideological conditions that might support them were no longer available. The Pax Americana may have sought to naturalize and universalize democracy, but the means through which democracy might be realized were increasingly bureaucratic, technocratic, and hierarchical. Indeed, the Cold War liberalism that developed during the 1950s and 1960s had little room for the definitions of science and democracy, of collectivism and creativity as they had been used during the 1920s and 1930s, and as such art-and-tech projects like CAVS, E.A.T., and A&T, despite their high-grade artistic input and high-tech apparatus, were singularly out of step with the realities of the technological agenda represented by elite institutions and policy-makers.

The two main, interwoven stories we have outlined in this book—the pursuit of an emancipatory fusion of art and technology, and the emergence of a corporate military-industrial machine—are not simply narratives that converge with the triumph of a neoliberalism borne out of RAND theories of strategic self-interest, though that is part of it. They are also stories about misaligned and out-of-kilter temporalities, contested pasts, and struggles over the definition of the future. It may be, as Foster (1994) suggests in terms of the avant-garde project, that it is only through the repetitions of new formations that the first iteration might be comprehended.

**The Art of the Reboot**

The explicit positioning of initiatives like CAVS, A&T, and E.A.T. as the germinal ground for twenty-first-century projects marks not only a recognition of the ways the histories of art and technology share a common, if not untroubled, recent history, but it is also an indication of the ways in which the repositioning of historical legacies can legitimate current practice. This historicizing move is one of the ways that current art-and-tech labs significantly differ from their precursors, where the retrospective shoring up of the archive as evidence of a legitimating precedent is markedly absent. In the Cold War moment of the 1960s art-and-tech labs, the temporal perspective was that of JFK's New Frontier, a world of the future that left behind the traumas of the recent past (the Great Depression and World War II) and cast an unblinking eye on the horizon ahead.

# 173

The current retrospective move, of course, is entirely consistent with the retemporalized history of the avant-garde, where each iteration must reflexively include knowledge of its precursors. What is downplayed in the foregrounding of the 1960s art-and-tech legacy, though, is precisely the extent to which, and the reasons why, those projects were unable to deliver on their utopian collaborative promise. In other words, the claims made now by, respectively, MIT, LACMA, and Nokia for CAVS, A&T, and E.A.T. at once retrieve and construct a prehistory of the art-and-tech lab that resists a full investigation of the complex interplay among art, technology, institutions, and business that shaped and troubled the Cold War–era labs and continues to determine, despite their depoliticized self-presentation, their contemporary descendants. This is akin to a neo-Constructivist avant-garde addressing the history of the Russian avant-garde without accounting for Stalin.

While the A&T program, for example, successfully attracted high-profile artists and paired them with the industrial giants of the Southern California tech sector, many of the collaborations choked or fizzled out, and the resulting exhibition was poorly received and drew heavy fire. The current A+T initiative is shrewd enough to establish some distance from the original model, claiming it is "inspired by the spirit" of A&T but is much less wedded to the reliance on art stars and the climactic exhibit and more committed to facilitating open-ended exploration conducted by artists recruited through competitive open calls. What A+T has preserved of the original project, aside from hooking up with major tech players, is the stress on documentation. It is largely through the report produced by Tuchman's initiative (and which served as the catalog for the 1971 LACMA show) that the original program has gained art historical traction and from which the current A+T project derives much of its inspiration (Tuchman 1971). In locating a significant part of its activity in the archiving of its own operations, A+T almost acknowledges the fact that the 1960s project presented itself best and most fulsomely through its documentation. It would not, indeed, be remarkable if it turned out that A+T is inspired more by Tuchman's report than by Tuchman's project itself. The report has all the seductions of the archive and none of the messiness of the workshop, laboratory, or boardroom. Certainly, no small part of the function of the revived lab is, as we have suggested, to promote and trade on the historical value now ascribed to the original. The new lab has a ready-made prehistory (or, at least, a prehistory in the process of ongoing curation by LACMA), a line-up of (now, if not already at the time) celebrated past contributors, and an in-house archive to draw upon. The new lab, the LACMA website explains, is "inspired by the transparency" of the original program and offers full digital disclosure of all the lab's work.[2]

The appeal to transparency is an oddly preemptive move, as if the museum anticipates accountability to be an issue it must address from the outset. Among the problems encountered by the 1960s labs was growing suspicion of the projects as a means of softening the public face of corporate military-industrial enterprise, especially as opposition to the Vietnam War intensified and became more widespread toward the end of the decade. By flagging "transparency," A+T forecloses on any charge that its intentions might be anything other than in the spirit of open exploration and knowledge exchange. Yet the very claim to transparency calls up questions of opacity and concealment, and draws attention to the regulation of the archive as a primary means through which legitimacy can be instantiated and sustained. While A+T does not address in detail the context of the original A&T program, it does benefit from a prophylactic move that brackets off dissent in order to seal in the critical heat generated by the 1971 exhibit. In this way, LACMA's celebration of A&T's exemplary transparency operates as a firewall in at least two ways. First, it separates the earlier program from the "system" it was charged, at the time, with being part of and beholden to, making A&T safe as a precursor. Second, that original transparency can be presented as part of the legacy on which the new iteration builds, while filtering out the malware of history that might otherwise corrupt the archive.

The proclaimed openness of A+T is part of a broader narrative common among rebooted art and technology projects that has found a way to draw upon the appeal of illustrious countercultural precursors, providing a much desired "edge" while capitalizing on the equally legitimizing heritage dimension of the new initiatives. The E.A.T. Salon v2.0 website is, inevitably, illustrated with Bell Labs' archival images of Klüver and Rauschenberg's 9 Evenings series, and Weldon provides a brief history of Bell's contributions to the expansion of the human senses and perception (including hi-fi stereo recordings, sound for the first talkies, the first singing computer voice, and algorithm developments found in current music and video production).[3] He concludes by moving into direct second-person address in order to state that these artistic achievements and tools will be challenged by "you, as artists and creatives," who will further the aesthetic complexity available through technological interfaces and thus "be able to arrive at the upper levels of Maslow's hierarchy of human needs and achieve 'transcendence'" (Weldon 2016). Clearly, Bell Labs customers have their work cut out for them, even with the assistance of the beneficent company. The goals for the E.A.T. Salon echo some of the more visionary elements of Kepes's proselytizing, combined with Negroponte's consumer-driven amateur-artist aesthetic revolution for the contemporary innovation economy. It is a

deft move, from the vanguardism of Cage and Rauschenberg to the supposedly redistributed creativity of the internet age, that purports to deliver, finally, the promised democratization of expertise and resources once anticipated by the utopian energies of the 1960s projects. Those who push the kind of accountability inadvertently flagged by LACMA's promise of transparency, however, would do well to recognize the vexed relationship between the artistic and military-industrial avant-gardes that rendered the 1960s projects politically untenable despite their often radical underpinning in movements committed to a restructuring of the relation between art and life. Yet this enlarged consideration of what art-and-technology collaboration might look like outside its corporate managerial frame is hardly possible when the twenty-first-century art-and-tech labs are as networked into the military-industrial-entertainment complex as their Cold War predecessors, this time without the residual, and to an extent redemptive, vanguardism.

It is true that from the outset, the 1960s projects, while sharing broadly the same ambitions for the union of art and technology, placed their emphasis on different outcomes. CAVS was intended, to an extent, to redeem the research university through an injection of the arts into the heavily instrumentalized world of Cold War science and technology. In his pitch to the university, Kepes (though clearly writing to university administrators) suggested that art might heal what military-industrial applications of science had wrought asunder, arguing that "a place for the visual arts in a scientific university is imperative for a reunification of Man's outlook on life'" (quoted in Ragain 2012). Klüver, more at home in the corporate world and more sympathetic to the practicalities of collaboration, imagined E.A.T. as an organization that, if successful, would dissolve along with the disciplinary distinctions it set out to challenge. The LACMA program, among the three projects considered here, was perhaps the most obviously interested in courting business and integrating the museum into the broader LA enterprise zone. To varying degrees, though, each of the projects remained wedded to a notion of arts-and-technology collaboration that had little directly to say about politics and relied on a set of (already old-fashioned and often naive) working assumptions about objectivity and disinterested attention in research and artistic practice that left them unable to adequately confront the Cold War contradictions of their respective enterprises. Not only did CAVS, E.A.T., and A&T emerge just as public opinion took a skeptical, and often hostile, turn away from technology, but they arrived too early to benefit from the kind of reflexive contextualization that the social constructionists might have provided. The kind of institutional critique underway in the art world by the late 1960s certainly contributed to Jack Burnham's read-

ing of art-and-technology initiatives, and helped frame the critical reception of projects like the final A&T exhibition, but it is largely lacking on the inside of the projects. The absence of sustained critical friction among participants in the projects is not surprising given that the aim of art-and-tech initiatives was to facilitate collaborative labor among disparate, and often mutually suspicious, constituencies. The search for common ground and a common idiom tended to take precedent over broader conceptual or ideological questions regarding the nature of the enterprise. Yet the baseline assumption that art and technology could be mutually productive nevertheless hampered the pursuit of a more probing investigation of the structural support required for such collaborations. The emerging frustration among artists critical of art-and-tech projects was largely due to this perceived collaborationist tendency, which for those who remained aligned to the more overtly political ramifications of the avant-garde project was untenable if art was to maintain its radically transformative capacity.

**Retemporalizing the Avant-Garde**

Contemporary art-and-technology projects have been able to safely reboot without the opprobrium heaped upon their predecessors in part because of the normalized relations among defense and tech sectors, made possible by the post-1960s distribution of defense contracts more deeply among the private sector. Not only has US military action itself become commonplace and frequent, and the spectacle of military high-tech hardware in action a staple of the news cycle, but the business of military-industrial research and development is also now more integrated into American business culture. The military is more likely to buy in innovation from ambitious private sector firms than to rely on Cold War corporate giants like Lockheed or Boeing. A 2014 Reuters article, for example, reports that "the Pentagon has switched from taking the lead in developing technologies like GPS satellites and now looks to commercial players for innovations like 3D printing" (Shalal 2014). Former Raytheon chief engineer Andy Lowery explains in the article how defense suppliers are adopting virtual-reality technologies to cut costs, and smaller, more commercially oriented firms are quicker to utilize such technologies. Lowery is president of Daqri, a VR-software company currently marketing the "Smart Helmet," promoted as the "World's First Wearable Human Machine Interface," and one of LACMA's A+T sponsors. The example Lowery offers of a lithe new player in the defense business is SpaceX, Elon Musk's company, which in 2015 beat Lockheed and Boeing to win its first defense contract, a US Air Force GPS

satellite (Isadore 2015). SpaceX is another A+T sponsor. Hyundai, the major sponsor of the A+T program, includes the Hyundai WIA Corporation, which produces remote weapons systems for global markets. As part of its deal with LACMA, Hyundai funded the acquisition of works by Robert Irwin and James Turrell, both of whom featured in the original A&T exhibition (Tewksbury 2015). Similarly, Nvidia produces military-grade supercomputer chips; the architecture giant Gensler's client base, needless to say, includes defense and aerospace interests. The links of high-tech to military research is as apparent in the present as it was in the mid-twentieth century, though the shift to fully neoliberal economic markets and the attendant rise of the digital revolution in both sectors has shaped the nature of the relationship.

LACMA's claim of "transparency," then and now, is not much of a claim, though there is often a certain luster to be attained through overt displays of integrity, as in Google's by-now notorious motto, "don't be evil." The marketplace has proved an effective solvent, and the notion of tech R&D simultaneously serving defense and culture is no longer news. A similar convergence of interests has meant that moves toward the interdisciplinary integration of the arts and sciences in universities, galleries, museums, and research institutes across the globe have also been met with broad acceptance. In order to provide cross-institutional support for the explosion in arts-based interdisciplinary programs and centers, two recent North American associations, the Alliance for the Arts in Research Universities (a2ru) and Science, Technology, Engineering, Art, and Mathematics Education (STEAMedu), serve as advocates and facilitators for what a2ru calls "arts-integrative research."[4] Despite the public rhetoric of support for such endeavors, which often echoes the 1960s idiom of creative solutions to global problems, the associations understand full well, as do the universities housing them, the dangers inherent within the innovation economy that demands instrumental results and often very speedy ones—a set of demands that Kepes and others were able to negotiate somewhat more easily than those operative in the present. Over forty US universities, as well as the University of Technology in Sydney, are members of a2ru, with the common purpose of raising the profile of, and justification for, arts-based research. STEAMedu furthers these institutional agendas through conferences and workshops, with the arts often positioned as a kind of public relations medium or visualization platform for abstruse STEM research otherwise beyond the understanding of specialist audiences. With claims often couched in the process-oriented discourse familiar to readers of Dewey or other mid-twentieth-century advocates of "learning by doing," the a2ru website offers an explanation of the STEAM acronym that seeks to demonstrate in common-

sense terms the relation among the parts: "Science and Technology, interpreted through the Arts and Engineering, all based in Mathematical elements."[5] The role of interpretation here conforms to the loose-limbed manner in which science, cybernetics, systems theory, and information theory were put to use by Kepes and others, though while Klüver might have recognized and accepted the way engineering is conceived here as the application of science, he would doubtless have been concerned about the instrumentalized deployment of the arts and of engineering as merely interpretive. The final phrase about the basis of inquiry being grounded in mathematical elements provides a tip of the hat to universal computation as the engine for global change in the current moment, and it is a pedagogical sentiment that would have likely had Norbert Wiener and Charles Eames nodding in agreement, with Gregory Bateson and Margaret Mead probably abstaining.

Current science, engineering, art, and design (SEAD) collaborations and research, as organized by a2ru and STEAMedu, face a number of challenges, including funding and the pressure to deliver outcomes in the form of sponsorship for collaborations, "measurable impact, and reputable research" (Zacharias and Wisnioski 2019). These concerns are compounded by demands for institution-building, spinoffs, interdisciplinary research advancements and profitable outputs that Zacharias and Wisnioski say have been present from the avant-garde origin stories surrounding art and technology movements. The runaway "success" of neoliberal enterprises such as the MIT Media Lab only add to the burden, with researchers and artists battling institutional demands, research ideals, multiple and often contradictory stakeholder demands, and financial pressures. Similarly the conflation of the digital with the technological generally—a conflation made in public discourse for decades but also one in this instance largely resultant from the success of the Media Lab—has led to the inextricable entwining of art and digitally led media research, which lends a specific profit-driven and instrumental justification for the linkage as well as the institutional investment.[6]

From one point of view, the assault on the romantic formation of the artist as a social anomaly gifted with distinctive creative powers conducted by the twentieth-century avant-garde has been successful. Artists are now, as organizations like a2ru are happy to claim, conceived as researchers undertaking project-based work in a collaborative interdisciplinary environment. The problem, however, as the Belgian sociologist Pascal Gielen has argued (2013), is that the very things once championed as putting an end to the myth of the creative genius and the expressive self have effectively come to serve in the reproduction of the neoliberal subject. Notions of the network and collaboration have redistributed

**179**

or erased questions of authorship and signature, and a horizontal definition of creativity as democratically accessible to all has overridden the elitism of a vertical model that placed the artist at the top. Problem-solving rather than problem creation (or favoring Chamberlain's project over Byars's) has become the focus of temporary project-based work reliant on a mobile, interchangeable staff tasked with completing the job. Such a model has tapped in to the artist's or curator's longstanding entrepreneurial capacities and fits comfortably with the competitive, ambitious environment within which arts workers vie for space and attention among museums and galleries, festivals and biennials, and with universities, cities, and nations looking to enhance their cultural capital.

Among the consequences of this new model of artistic production is the idea that the enterprising individual—as opposed to, say, the critical citizen or public servant—has "little use for solidarity," Gielen suggests, which is "only temporarily functional, usually only for the duration of a project" (39–40). Unconnected to a permanent workplace that might provide social solidarity and economic security, not to mention labor protection, and at the mercy of the often trend-driven time-limited project, the free-floating creative individual is in many ways the model neoliberal subject, endlessly—and necessarily—dynamic, flexible, mobile, communicative, and resourceful. Furthermore, the time-limited aspect of the project means that while the project may demand total commitment and focus during its execution, the participants, well aware of its temporary existence, will have to be simultaneously on the lookout for future opportunities. This, for Gielen, produces a creative worker who is "in a permanent state of being alert and doubtful at the same time" (50). Within such a fluid situation, workers are able, on the positive side, to "accumulate specialized, creative and highly personalized knowledge," but the "downside is that it is much harder to embed historically or institutionalize. After all, network relationships do not easily build a memory" (50–51). In other words, the conventional notion of the artist as nomadic bohemian is catered for under the entrepreneurial model, and indeed encouraged, yet the price is any sense of sustained or shared commitment to anything beyond the demands of the project. "In short," writes Gielen, "the de-institutionalization of creativity not only cuts away depth and height, but also durable character building. Put simply, creativity becomes disengaged from faith or conviction" (51).

The stress on fluidity across sectors as a mode of facilitating innovation is often foregrounded as a key attribute of contemporary art-and-technology projects. For example, discussing A + T artist John Craig Freeman's project *EEG AR: Things We Have Lost*, Brian Mullins, founder and CEO of Daqri, enthuses about the ease of the collaboration because "the relationship between technol-

ogist and artist is extremely fluid as both are constantly pushing the limits of what's possible in both of their mediums, which is pretty exciting. It opens up the possibilities for all kinds of interesting innovation."[7] Freeman follows up by stating that such apparently easy collaborations are really a matter of sorting out transactional relations within the innovation economy, and he claims that "although there is an inherent tension between the proprietary, often secret, profit motivation of successful technology companies and the public service mission of large institutions like LACMA, the Art+Technology Lab seems committed to exploring and possibly overcoming this tension." Freeman expresses his belief that the success or otherwise of art and technology collaborations hinges on "how fluid the roles between artists and technologist are, and on how willing each party is to freely share intellectual property."

Despite Freeman's blunt explanation of the real stumbling block in the current collaborative configuration, he brings the short interview around to his own work and its artistic lineage. The role that chance plays in the augmented reality work he produced with Daqri, according to Freeman, connects to Duchamp's *Three Standard Stoppages* (1913/14) and John Cage's experiments with the *I Ching*, thus throwing down the project's avant-garde bona fides while finding a place for the notion of chance in a world in which memories are materialized on screens through brain-wave-visualization technologies. Mullins speculates on the increased interest in the tools on display as potentially leading to cheaper and better quality machines and software. Billy Klüver, for one, was never convinced that engineers should see themselves as artists, any more that he expected artists to be able to become engineers. The point of collaboration was, particularly at E.A.T., to facilitate the realization of the artist's investigation into materials. In the twenty-first century, not only has the artist become fluid enough to find a place within the tech sector, but also, for Mullins, technology is itself conceived of as an artistic "medium" and the technologist can liken himself to Cage or Duchamp.

What is perhaps most striking about Mullins's discussion here, though, is that innovation itself has become an empty signifier of virtue and the role of A+T is to overcome "tension" between private enterprise and social mission. The invocation of *Three Standard Stoppages* in this context is revealing, not only in the way that Duchamp has been recruited by the tech sector, but because the term "stoppage" refers to tailoring and a technique for the invisible repair of garments. The role of the art-and-tech project as a means of stitching up the ragged edge between business and polis ought to register as a veiled allusion to the collaborationist claims made by critics of the 1960s art-and-tech ventures, but here it is delivered, post-ironically, as an achievement.

What are at issue in current art-and-tech initiatives are the same questions that dogged their earlier incarnations, questions surrounding, for example, the nature of experiment and the prospect for a plausible means for artists and technologists to break out of the operating paradigms they usually work within. The institutions of art, as the narrative of failed avant-gardes suggests, are capable of converting challenges into product and absorbing dissent as efficiently as corporate or government institutions. Part of the challenge here—and this accounts to an extent for the delimiting of Dewey's potentially radical conception of an experimental democracy—is the sense that, as philosopher of science Ian Hacking argues, "the boundaries of knowledge are formed by the direction of actual knowledge" (1986, 239). Writing in the context of weapons research, Hacking suggests that "when so much knowledge is created by and for weaponry, it is not only our actual facts, the content of knowledge, that are affected. The possible facts, the nature of the (ideal) world in which we live itself becomes determined" (239). Massive defense spending, in other words, produces knowledge within the context of, and is shaped by, military interests.[8] An awareness that the realm of the possible is constructed within "what is held to be thinkable" (243) at any given time is rarely evident in the 1960s art-and-tech projects, and far from widespread in their twenty-first-century reboots. If collaboration among artists, scientists, and engineers is to amount to anything more than the reproduction of the status quo, where terms such as "innovation" serve as hollowed out references to increased efficiency and new product ranges, the friction, disagreement, distrust, false starts, and failures that collaboration brings with it—the resistance and struggle within and between art and technology—need to be given more space. The desire in the 1960s projects for unity among collaborators understandably derived from the aim of bringing diverse participants together. Art-and-tech projects were, in this way, a version of the postwar ambitions to forge a unity of science. Yet if Hacking is right that such a unity is "an idle pipe-dream" since "the forms of different bits of knowledge are brought into being by unrelated and unreliable chains of events" (246), a more plausible version of collaboration might require a stronger sense of the agonistic and incendiary. A more purposeful goal than ensuring that technologists and artists share a common purpose might be generating heat from their differences. John Chamberlain sensed as much during his time at RAND, and it is the resistance from both sides that produced a work that, while to all intents and purposes a failed collaboration, gnawed a small hole in the largely closed worlds of art and the think tank.

Such an agonistic approach to art-and-tech projects would have little space for invisible repairs since it would be attentive to the tears and rips. Tuch-

man's report on LACMA's A&T program (1971), among the 1960s projects, comes closest to embracing the resistance coming from both artists and businesses, and this is what gives the document weight since it accepts that a failed experiment is still an experiment. The notion of failure, however, in light of our discussion of the avant-garde, ought to be reconsidered or at least repositioned within a broader temporality that might also help to prevent the sense of foreclosure that has attended the rise of neoliberalism as the most recent purported post-ideological ideology. According to this familiar narrative, the failure of twentieth-century collectivist projects has given way to the natural order of the free market as the inadequacy of planning and regulation has become evident. Under the sign of strategic self-interest, any attempt to engineer economic and social problems outside the marketplace is to tinker with the self-regulating order of things. Within such a conception of society as the mere aggregation of self-interested units, references to abstractions such as the "common good" sound not only antiquated but also fatally naive. The diminished status of a thinker such as Dewey during the second half of the twentieth century, despite various attempts to resuscitate his reputation, is indicative of the direction of travel.

The Deweyan model of creativity, as an active, experimental encounter with the world that was broadly synonymous with both democracy and the scientific method as unfinished projects could conceive of project-based labor as more than narrowly instrumental because it retained a conviction in the idea of collective action. The Dewey School's occupation-driven curriculum, while carrying the unfortunate connotation of being merely vocational, was reliant upon a capacious interpretation of what an occupation might mean. The shrinkage that occurred, during the second half of the twentieth century, in the definition of the terms in which Dewey outlined his philosophy—science, method, democracy, art—left his arguments vulnerable to adaptation and dismemberment, first by Cold War liberalism's contraction of what constituted the meaning of science in a democratic society, and then by an increasingly algorithmic understanding of how strategic self-interest operated. The erosion of faith or conviction in democracy as the constitution of a public sphere already, by the 1960s, meant that art-and-technology projects driven by a residual progressivist commitment to the enlargement of collective potentialities were out of step with the broader perception of science and technology as instruments of elite bureaucratic control and coercion. Rebooting "dormant" art-and-tech initiatives in the twenty-first century does not have to involve worrying about such skepticism since expectations of what a society based on the public good might look like have contracted so far as to be insignificant.

It might be argued that the avant-garde and its celebrated capacity for creative destruction has had a hand in creating the environment in which the disruptions of radical innovation promoted by the convergence of art and technology have become normative, as affirmative accounts such as Weldon's suggest. Certainly, Jean-François Lyotard understood as much when he observed "a kind of collusion between capital and the avant-garde" due to the dependency of both on "the force of skepticism and even of destruction," a mistrust of rules (and materials) and destruction of the status quo (1991, 104–105). The capitalist economy relies on and is regulated by "an Idea" of pure wealth or power for which it offers no example from reality as proof. Indeed, through the operations of technologies that have made "science subordinate to itself," Lyotard claims that reality has become "increasingly ungraspable, subject to doubt, unsteady" (105). Lyotard's charge, though, is a familiar one that is consonant with Bürger's melancholy backward glance at the failed promise of the historical avant-garde, and while it is hard to argue that vanguardist moves have not been more effective in the hands of economists and corporations than they were with artists, the one-way street Lyotard outlines leads in the same direction as the collectivism-as-failed-experiment narrative and is something of a dead end.

It is here that we need to return to Foster's expanded temporality of the avant-garde, since Lyotard's foreclosed future presupposes the achieved convergence of capitalist and avant-garde destruction. Foster's enlarged sense of avant-garde temporality, as we have seen, allows for the prospect that the neo-avant-garde may have comprehended the historical avant-garde for the first time (1994, 16). In other words, the idea that an avant-garde can succeed or fail misses the point, which is that there is no completion or conclusion to the avant-garde process: "in art," Foster writes, "creative analysis is *interminable*" (16, original emphasis). It is the sense of interminable inquiry that John Roberts (2015) develops in his consideration of the "revolutionary time" of the avant-garde, which he conceives not merely as a series of historically locatable movements or tendencies but, following Imre Lakatos, as a research program. Broadly, the historical avant-garde outlined a set of propositions that, for Roberts, constitute the ongoing avant-garde research program. These are: that art is not an object or set of objects but an eventual process that may or may not include objects; that art is determined by its social and political conditions of possibility; that art is a theoretically driven process; that art is a collective or collaborative process at all times and therefore comprehensible as a social practice; that notions of the artist and artistic skill are functions of general social practices and therefore interdisciplinary and processual; and finally, that art "sets itself the historical and critical task of incorporating its speculative strategies and

practices into the advanced scientific and technological forms of general social technique; art participates in the advanced relations of production" (3).

As a research program, this might sound like a set of principles that could be adopted without controversy by an art-and-tech project without any of the utopian aspirations toward the transvaluation of art and life more commonly associated with the avant-garde. However, this would be a narrow reading of what Lakatos means by a research program, which, for him, is closer, as Ian Hacking explains, to a form of knowledge than it is to a set of proposals and procedures to be followed (1986, 254). For Lakatos, a research program may last a century or lay forgotten for decades: "we may be frustrated by a long series of 'refutations' before ingenious and lucky content-increasing auxiliary hypotheses turn a chain of defeats—*with hindsight*—into a resounding success story, either by revising some false 'facts' or by adding novel auxiliary hypotheses" (1980, 48, original emphasis). Over time, a series of steps may constitute a "consistently progressive theoretical problem shift [but] we do not demand that each step produce *immediately* an *observed* new fact" (49, original emphasis). It is with this sense of a research program in mind that Roberts can write that "the function of the avant-garde today is inseparable from the absences and discontinuities that *it carries with it*" (2015, 15, original emphasis). The point is that the Lakatos model allows for refutations that may be perceived as failures within the scope of the present but which may later be retrospectively understood differently. In a sense, this is partly what Foster is claiming about Bürger's premature dismissal of the neo-avant-garde. Roberts's adoption of the research program model, however, is especially pertinent given the rise of the art-as-research paradigm and its deployment by the neoliberal university, global art museums, and the tech sector to instrumentalize and appropriate the collectivist capacities made possible by ubiquitous computing but politically uncoupled from a viable definition of the public good.

### Apertures of Hope

On the surface, the art and technology projects of the 1960s appeared to fit comfortably with the techno-utopianism of corporate liberalism. The virtues of creativity and interdisciplinary collaboration institutionalized through the embrace of systems-thinking in the sciences, business, and government did not seem to be out of step with advanced artistic tendencies that likewise sought to slough off the residual romanticism of individual authorship, medium specificity, and the autonomy of the art object. The assessment, by Jack Burnham and others, that the failure of the art-and-tech projects to adequately deliver on

their promise was largely one of timing also seems right. The shift in attitudes toward technology and the institutional models that promoted technocratic solutions to the problems of modernity was rapid and decisive during the last years of the 1960s, and the art-and-technology projects were too closely aligned with the institutions and assumptions of the technocratic project to survive the backlash. The current willingness of artists and institutions to return to the 1960s projects, furthermore, is understandable given the ways that the ubiquity of advanced technology in contemporary life appears to have confirmed some of the claims made by gurus of the previous age such as Marshall McLuhan and Buckminster Fuller. As Nokia boss Marcus Weldon reminds us, E.A.T. was just too darned avant-garde for the 1960s, but finally the rest of us have caught up. Outlined in this way, the story of art and technology is one of the gradual synchronization of technological development and social reality after an awkward period when artists and technologists were too far ahead of the curve. This is presumably, after all, what avant-gardes are good at, but what has come before needs to hang around long enough so that it will eventually be recognized as timely.

What we have wanted to stress here, though, is the limitations of this Whig version of the history of art-and-technology projects, whereby the "failure" of the 1960s projects is merely a function of cultural lag that delays the full integration of creative tech collaboration into the processes of twenty-first-century corporate innovation. At the same time, as tempting as it is to partition off projects like E.A.T. and A&T as naive or opportunistic boomer adventures in the corporate financing of the arts, this would merely plug those projects back into their slots in twentieth-century US art history alongside the rest of the currently fashionable "hippie modernism" doing the international museum circuit.[9] The extent to which the potentially radical or utopian aspects of earlier art-and-tech collaborations have been made safe for viewing is not separate from the revival of some of the key projects by contemporary institutions and corporations. The techno-pastoral patina of old photos of long-haired students building geodesic domes on the grass at Black Mountain College is, after all, catnip for hipsters dreaming of seed funding or internships. The retrieval of the 1960s art-and-tech projects in the twenty-first century must itself also be historicized and understood, not merely as an opportunity to market prior achievements, though there is that, but as another indicator of art's entanglement with advanced technology and its military-industrial backers. The point here is that the stuttering narrative of noble failures and bad timing does not do justice to the complex temporalities across, and through which, art, technology, and politics are woven.

The resistance to the narrative of failure we have noted in relation to Foster and Roberts's account of the avant-garde calls for a different conception

of temporality than one that measures "success" as a progressive shoring up of "developments." It is not surprising, though, that CEOs like Weldon have become adept themselves at retemporalizing the histories they wish to emulate. Nevertheless, the notion that "we" have caught up with the avant-garde itself falls back on a comforting synchronicity that cannot be allowed to stand, for while the apparatus of art-and-tech might currently be in alignment, what the retrieval of the 1960s projects must leave out if they are to function within the disruptively innovative environment of the neoliberal corporation are the elements of the precursor projects that were, in the 1960s, already anachronistic. In other words, what must be expunged are the traces of the radical collectivist avant-garde and their fusion with the socially emancipatory, democratically participatory elements the art-and-tech projects carried with them from their revolutionary, progressive, or pragmatist origins. In order to do justice to the notion of the art and technology project as a plausible model for collaborative interdisciplinary research that is more than R&D for the culture industry, we have to take account of the non-simultaneousness of the simultaneous.

Ernst Bloch developed the idea of the nonsimultaneous in his book *Heritage of Our Times*, first published in 1935.[10] A complex montage of Bloch's Weimar period writings, *Heritage of Our Times* sought to understand the rise of fascism in Germany through, in part, a reading of the experience of time under modernity. Bloch derived his notion of the nonsimultaneous from art historian Wilhelm Pinder's challenge to the convention of dating art works according to style.[11] For Pinder, such a practice did not take into account that at any given historical moment, an artist from one generation might be producing work at the same time as an artist from a much younger generation. The generational difference would, for Pinder, bring with it stylistic differences that historically dating the two works would not explain. The term the "nonsimultaneity of the simultaneous" was Pinder's description of how one historical moment could contain elements that were not consonant with each other. While Pinder's method led him to develop the suspect notion of a generational will or "entelechy," it nevertheless allowed him to challenge notions of art history as unilinear and developmental. It is this notion of historical time as non-unified that Bloch develops in *Heritage of Our Times*.

According to Bloch, capitalist modernity might define the present as the most advanced economy, but it does not account for the entirety of contemporary experience. The present, for Bloch, still contains modes of life that belong to earlier times, such as the peasantry, who continue to exist alongside advanced industrial society yet experience the world in an entirely different way to the modern worker. Similarly, other groups, such as disgruntled white-collar

workers, are also nonsynchronous in that they are ideologically out of sympathy with the current state of affairs. To stay with Bloch's examples for a moment, the peasantry is "objectively" nonsynchronous since its mode of life is out of sync with modernity; the white-collar workers are "subjectively" nonsynchronous because their view of the world is not confirmed in the existing structure. It is precisely out of the nonsynchronous—out of the sections of the population that do not experience the present as synchronized with capitalist modernity—that Bloch claims the Nazi Party was able to draw cultural resources that should rightfully belong to the Left.[12]

In the context of our discussion of the history of the artistic avant-garde, the (bad) timing of 1960s art-and-technology projects, and their twenty-first-century reboots, Bloch's notion of the nonsimultaneity of the simultaneous is a useful means of grasping the complex cultural politics that we have described as the convergence of two avant-gardes, one artistic and one military-industrial. Understood according to Bloch's model, if we take the early 1960s as the moment of the most advanced economy, where technology and corporate liberalism are synchronous with US economic and geopolitical dominance, the historical avant-garde and Deweyan participatory democracy are patently nonsynchronous even though they continue to animate the art world and populate the progressive educational environments that nurture the neo-avant-garde.

While it is therefore easy, as critics like Kozloff and Burnham did in the case of A&T, to identify art and tech projects as "corporate art," since in many ways they can indeed be said to be leaning toward a synchronization with the contemporary moment, this criticism misses the fact that practitioners like Cage, Fuller, and Rauschenberg are never properly synchronized as their politics and their understanding of key terms of the debate such as collaboration, experiment, and creativity, are profoundly nonsimultaneous with the meaning of those terms as used by the corporate liberal institutions within which they are attempting to operate. Indeed, as we have seen, the public, participatory definition of terms like "scientific method" and "democracy" developed by progressives like Dewey in the early decades of the century, terms that resonated with European avant-garde practitioners like the Bauhaus, were already non-synchronized with the times by the end of World War II when the emigrant avant-garde is cultivating its relationship with American artists and institutions. Looked at this way, the inability of the art and technology projects to fully synchronize with the corporate liberalism of the military-industrial complex is not a failure but a measure of how temporally nonsynchronous the meaning of terms like "collaboration" and "creativity" has become.

Not only, then, as Foster and Roberts argue, does the avant-garde not fail if the temporal scale is expanded and the unidirectional "development" of art history rejected, but the art-and-technology projects do not fail either, since a successful synchronization of their mission with mid-1960s American capitalism would have constituted a disturbing fusion of radical aesthetics and corporate politics. As Bloch suggests, those elements that appear to be left behind by history instead contain the cultural materials through which a challenge to the normative synchronicity of the present might be properly staged. In the 1930s, in Bloch's analysis, the catastrophe was that these nonsynchronous cultural resources had been stolen by the Right. As the escalation of the Vietnam War raised profound questions about the legitimacy of corporate government expertise and its deployment of technological solutions to social and political problems, a similar missed opportunity perhaps lies at the heart of the criticism leveled at art-and-technology projects. The nonsynchronous resources they carried through from the 1920s and 1930s, the emancipatory potentialities articulated by Dewey and at the Bauhaus and then at Black Mountain, had indeed already been appropriated by the other side. The stripped down, meritocratic, competitive, hierarchical model of democracy shaped in the postwar period by experts like James Conant and Vannevar Bush often used the same words as their more liberal counterparts, but the meaning was different. The kind of interdisciplinary collaboration undertaken at think tanks like RAND was among elites and not among a more generally distributed set of participants.

The notion of failure, then, is not adequate or accurate since it implies a one-time attempt to further the unidirectional narrative that has been thwarted. The capacity of the forces of reaction to identify and utilize the nonsynchronous is, for Bloch, likewise not a one-off theft but must be countered and challenged. In other words, the resources of the past are not exhausted by their appropriation but remain, in their stubborn non-synchronicity, persistent potential excess and a disruption, a contradiction, and an alternative to the present. Nokia and the other institutions and corporations invested in promoting art-and-technology projects demand synchronization between the past and the present, yet a different reading ought to allow for and embrace the way that past projects, as Bloch puts it, "contradict the Now; very strangely, crookedly, from behind" (1991, 97).

What glares out of the pages of Tuchman's A&T report and the archives of the other 1960s art-and-tech projects is not just the incommensurability of the utopias conceived by the artistic and the corporate avant-gardes of that time, but the flair of a corporate world gripped by its own potentiality. It is not surprising that artists wanted access to some of that—the resources, the confidence,

and the sense of mission, derived from the conquest of a brutal adversary, and, so it seemed, responsible (though self-appointed) for solving the problems of humanity. Despite the cold instrumentality of the bureaucratic approach to planning a world, and regardless of the devastating foreign policy failures that sprang from the slide rules and mainframes of the organization men, there is a capaciousness to the vision that, retrospectively, at least, can be breathtaking in its optimism, however catastrophic the consequences turned out to be. It is this chutzpah that wildcards like Buckminster Fuller and John Cage shared with institutions like RAND and outrageous projects like the Apollo program: a willingness to reach a beyond that, from any other angle, might seem ludicrous.

This is what LACMA, Nokia, MIT and other institutions want from that past, or at least the look of it—the cool, insouciant arrogance of ascendant power. What they do not want is the radical undertow that comes with picking Fuller or Cage or Rauschenberg for your team. The equivalent of a Jack Burnham or a John Chamberlain, with their awkward, contrary relation to the straight world, is unlikely to be welcomed, coming very strangely, crookedly, from behind, into the labs of SpaceX or Nvidia. If there is to be disruption, innovation, or creativity, it must speak and walk in the less strange, less crooked manner of the neoliberal adventurer. If there is to be collaboration, it must be via the frictionless transaction where all differences among art, technology, and business are massaged away by and through the synchronized movements of the market.

It is precisely this sense of synchronization claimed by late capitalism that led Fredric Jameson to draw on Bloch in his discussion of uneven development in his 1980s work on postmodernism. From the point of view of the postmodern present, writes Jameson, "Everything has reached the same hour on the great clock of development or rationalization"; we have reached "a situation in which the survival, the residue, the holdover, the archaic, has finally been swept away without a trace" (1991, 310). That which was incomplete, anachronistic, or anomalous has, finally, been brought into line, just as the "too avant-garde" work of E.A.T. has now found its correct time in the twenty-first century. This is the sense, as Jameson notes, "in which we can affirm, either that modernism is characterized by a situation of incomplete modernization, or that postmodernism is *more* modern than modernism itself" (310, original emphasis). A thoroughgoing synchronization of all elements would, indeed, register the end of history and the flattening of any challenge that might be posed by the concept of the new or innovative, which is now evacuated of context and serves merely to signify technical adjustment or improvement within the dehistoricized present.

When Jameson rightly located this postmodern move outside or beyond history as a function of late capitalism, whereby the "past" is synchronized as

a kaleidoscope of depthless and distracting styles, he follows Bloch in understanding that the contradictory nonsimultaneous elements of a "still living past" are most effectively deployed by capitalism "as a means of separation and combat against the future dialectically giving birth to itself in the capitalist antagonisms" (Bloch 1991, 109). In other words, the real contradictions of capitalism (what Bloch calls the objectively *simultaneous* contradictions) can be used to prevent the elements of an "unrefurbished past . . . not yet resolved in capitalist terms" (108) from posing a direct challenge to the maintenance of the status quo.

There is no straightforward way in which the art-and-technology projects of the 1960s can be revived or reclaimed unless the conflict over the meaning of the temporality of modernity is itself synchronized into the perpetual present of capital. Bloch's assessment in the 1930s that the Right stole the nonsynchronous cultural resources of the Left, challenges to the narrative of the "failure" of the avant-garde, and Jameson's account of the postmodern cancelation of history are attempts to claw back the force of the anachronistic and the anomalous from aspects of cultural production all too easily streamlined into affirmation. To borrow from Bloch, we might say that the terms of what once counted as aspects of an emancipatory collectivist model of inquiry—creativity, collaboration, inter-, post-, or non-disciplinary labor—have been stolen. They have not been stolen by neoliberalism in the first instance, though they have become part of the lexicon of this latest nonideological ideology, but were appropriated, and sometimes gifted, from the avant-garde and put to use by corporate liberalism during the early postwar period as it sought to distance itself from the radical implications of the participatory democracy outlined in Dewey's progressivism. As such, mediated through institutions and individuals (such as the Bauhaus, Albers, Kepes, and others) determined to situate themselves in meaningful opposition to the very real threat of totalitarianism, the radical modalities of terms like "creativity" and "collaboration" are already confiscated and redeployed by the time the 1960s art-and-technology projects seek to utilize them.

Despite the tragedy of belatedness that saturates his own diagnosis, Bloch's assessment of how to move beyond the catastrophe of synchronization is not without purchase here. "The task," writes Bloch, "is to release those elements even of the non-contemporaneous contradiction which are capable of aversion and transformation, namely those hostile to capitalism, homeless in it, and to remount them for functioning in a different connection" (1991, 113). The power of the nonsynchronous resources of the past lies, for Bloch, in the fact that they remain incomplete, unresolved, and "hence lastingly subversive and utopian"; they are the "gold-bearing rubble" (116) of a "prevented future" (110). Jameson, likewise, is not ready to concede capital's victory over historical time. The problem

to be solved, he writes, is "how to jumpstart the sense of history so that it begins again to transmit feeble signals of time, of otherness, of change, of Utopia" (2003, 76). The expansive temporality proposed by Foster and Roberts, a temporality that suspends dismissive decisions surrounding purported failures and endings, and which allows for the conception of an avant-garde research program of undisclosed duration, might be one way to jumpstart history. A retrieval of the gold-bearing rubble from the prevented history of the historical avant-garde and its fusion with American pragmatism at its most socialistic moment in the 1930s is another. The force of the neo-avant-garde's commitment to art and technology may well lie there, in advance of the alignment with Bell, MIT and other institutions of Cold War corporate liberalism, when it was still genetically linked to the emancipatory promise of the original Bauhaus and progressive anti-capitalism.

There may be other apertures through which to conceive of and act upon as yet prevented futures. The neoliberal institution's attempt to synthesize its own nonsynchronous elements into the "great clock of development" is one of them. As we hope is now clear, the legacy of the 1960s art-and-technology projects is far from straightforwardly the prehistory of the present. Even before their fall from favor, projects like CAVS, E.A.T., and A&T already contained the archives of prevented futures, including the thwarted techno-utopias of postrevolutionary Russia, Weimar Germany, and America's Progressive Era. As modes of deformed collectivist utopianism, the 1960s art-and-tech projects marked, not so much moments of compromise or collusion between the avant-garde and the state, but rather moments when the contradictions of capitalist democracy flared with a vividness that has not entirely burned out. It is the brightness of the art-and-tech projects, as well as their incompleteness, that has drawn the corporate sponsors, and the critics, back to stand in the afterglow. The reboots, though, mistake the hearth for the flame. It is, in the end, what is wrong with art-and-technology projects—their inability to square radical modes of inquiry and collaborative labor with the demands and expectations of corporate and military funding, institutional support, and instrumentalized science—that is precisely what is most important about them. What art-and-technology projects of the kind discussed here most powerfully demonstrate, both in their 1960s and twenty-first-century iterations, is the ongoing struggle between the idea of an avant-garde and the appetite capital exhibits in its willingness to feed upon it.

# Notes

## Introduction

1. The importance of Gestalt-era psychology as a means of bringing art and science together during the 1950s and 1960s is noted by Caroline Jones and Peter Galison, who observe that many of the key figures, including Rudolf Arnheim, Anton Ehrenzweig, and Ernst Mach, as recent emigrants, had brought to the US "a Central European *wissenschaftlich* approach to learning, where all fields of inquiry had been unified as one systematic investigation into various products of the human mind" (Jones and Galison 1998, 3–4). The influence of Gestalt therapy on postwar American art, especially through Paul Goodman's synthesis of American pragmatism and Gestalt during his involvement at Black Mountain College, is discussed in Belgrad (1998, 142–156). The extent to which Gestalt psychology directly influenced key members of the Bauhaus is debated in Boudewijnse (2012), while György Kepes's debt to Gestalt theory is explored in Moszkowicz (2011).

2. Mesthene was on the staff at RAND from 1953 to 1964 before joining Harvard as director of the Program on Technology and Society. While Mesthene was aware of technology's negative potentialities and the rising anxiety surrounding rapid technological change, he remained confident in the capacity of experts to sustain a balanced approach that would allow society to fully realize the promise of accelerated technological innovation. See, for example, Mesthene (1965, 1968a, 1969, 1970). The immediate target of McDermott's (2014) response is Mesthene (1968b).

3. On artistic collaboration, see Green (2001), Hobbs (1984), and Kester (2011, 2013).

4. A number of books published in the early 1970s provide useful surveys of art and technology projects of the time. See, for example, Benthall (1972), Davis (1973), and Kranz (1974).

5. For a wide-ranging assessment of mid-twentieth-century humanism and its preoccupation with the "crisis of man," see Greif (2015).

6. For more on the continued cultural legacies of the Cold War, see the essays collected in Beck and Bishop (2016).

**Chapter One: Science, Art, Democracy**

1. Dewey was not uninfluenced by Spencer's application of Darwin to social evolution, but he rejected what he saw as Spencer's notion of evolution's fixed goal and the way biology was used to account for and preserve social inequality. On Dewey and Spencer, see Pearce (2014).

2. On Dewey's experiences in Chicago, the Laboratory School, and Dewey's developing pedagogy, see Westbrook (1991, 84–113). On the history of the Dewey School, see Mayhew and Edwards (1936), and for a more recent assessment, see Tanner (1997).

3. On Dewey and Hegel, see Good (2005, 2006) and Shook and Good (2010). On Dewey and *Bildung* in particular, see Good and Garrison (2010).

4. For a detailed account of Barr's teaching practice at Wellesley that includes a discussion of his time at Dessau, see Meyer (2013, 37–113).

5. On Bauhaus in America, see Borchardt-Hume (2006), Kentgens-Craig (1999), and Saletnik (2009). On Dewey, German exiles, and the Bauhaus, see Füssl (2006).

6. For an early, influential account of Black Mountain College, see Duberman (1972). Important later assessments include Harris (1987), Katz (2003), and, most recently, Díaz (2015).

7. For an account of Rice's tenure at Black Mountain, see Reynolds (1998); on Albers in America, see Díaz (2008).

8. For a useful account of Dewey's aesthetics, see Alexander (1987). See also Melvin (1992).

9. Given the apparent convergence of interests between artists and some scientists and engineers, Jack Burnham imagined in 1968 how the future artist, "as part of a time technological elite, may find himself in the position of some of today's Nobel Prize scientists: rather than being humble experimenters in the laboratory, some are executives manipulating research money and the projects of men under them" (Burnham 2015c, 95).

10. It is revealing that among the six case studies presented on the "collaborative advantage" of what they call "Great Groups," business writers Warren Bennis and Patricia Biederman (1998) include Lockheed's secret military R&D unit Skunk Works, the Manhattan Project, and Black Mountain College. The others are the Disney organization, the Xerox Corporation's Palo Alto Research Center, and the 1992 Clinton presidential campaign.

11. As Jamie Cohen-Cole explains, the future imagined in Harvard University's *General Education in a Free Society* "was a technocracy in which each citizen was educated in how to appreciate, judge, and defer to expertise and in which political questions and even voting became technical problems. This technocratic vision fit with the emerging national security state that James Conant, in his role in aiding the development and deployment of the atomic bomb, helped bring into being" (2014, 33). On the fate of Dewey's educational theory during the Cold War, see Hartman (2008).

12. On Bush and postwar science policy, see Kevles (1977).

13. On the importance of Greenberg's formalism and its links to positivism and Cold War thinking, see Caroline Jones's remarks: "Greenberg's linkage of abstraction to positivism replaced the long tradition of a 'spiritual' discourse in abstract art.... The positivist component was part of formalism's midcentury technocratic appeal" (2005, 99).

14. Smith College was, of course, Friedan's alma mater, where she had edited the college newspaper. Stevenson's address, as Friedan notes, was reprinted in the September 1955 issue of *Women's Home Companion*, with an abridged version titled "A Purpose for Modern Woman." See Friedan (1979, 53–54) and Stevenson (1955b).

15. There is a similar confirmation bias at work in a popular volume from 1960, *The Creative Mind and Method*, compiled from a series of radio broadcasts (Summerfield and Thatcher 1960). Among the experts asked to discuss creativity in their respective fields are Frank Lloyd Wright, Aaron Copland, Ben Shahn, György Kepes, Edward Steichen, Robert Penn Warren, Lee Strasberg, Margaret Mead, and Rudolf Arnheim. As impressive as this roster is, it hardly challenges the notion of creativity as the domain of the exceptional.

16. On the Unity of Science movement in relation to the US, see Galison (1998).

17. The anxiety surrounding scientific specialization and a perceived ever-widening gap between expert scientific knowledge and public understanding, continued to trouble commentators throughout the 1950s. In 1959, for example, anthropologist and Macy Conference participant Margaret Mead warned that the unprecedented growth in scientific knowledge and the rapid pace of change meant that "We are... in danger of developing—as other civilizations before us have developed—special esoteric groups who can communicate only with each other and who can accept as neophytes and apprentices only those individuals whose intellectual abilities, temperamental bents, and motivations are like their own. A schismogenic process is under way that is self-perpetuating and self-aggravating" (Mead 1959, 140).

**Chapter Two: A Laboratory of Form and Movement**

1. Powers of Ten, "sketch" version, directed by Charles and Ray Eames (1968), 8 mins.

2. See Conway and Siegelman (2005), Dupuy (1994), Hayles (1999), Heims (1991), Pias (2016), and Wiener (1961).

3. Poem Field was a series of short animations made by VanDerBeek between 1964 and 1968. Begun at Bell Labs, this work carried over to and influenced VanDerBeek's time at CAVS.

4. *Stan VanDerBeek: The Computer Generation!!*, directed by John Musilli and Stan VanDerBeek (1972), 30 mins.

5. VanDerBeek's Panels for the Walls of the World was large-scale mural, approximately 8 × 20 feet, that changed on a daily basis with images fed from different news sources and faxed to the Smithsonian. As such, it concentrated on process, real-time transmission of images, and an ever-evolving collage.

## Chapter Three: The Hands-On Process

1. For a first-hand account of Bell Labs, see Noll (2015, 2016). For a corporate version of the company's achievements, see Mabon (1975).
2. On the charisma of early nuclear weapons research, see Gusterson (2005, 78).
3. In his 1976 study, Irving Sandler retrospectively proclaimed the "triumph" of American painting (Sandler 1976). See also Dossin (2015).
4. For more on Pierce's work at Stanford, see Mody and Nelson (2013).
5. The documentation of 9 Evenings is extensive. The performances were all photographed and filmed, providing copious material for a 2006 exhibition at MIT's LIST Visual Arts Center, Cambridge, Massachusetts, *9 Evenings Reconsidered: Art, Theatre and Engineering, 1966*, curated by Catherine Morris. See Morris (2006). For further information on the individual performances, see the documentation collected on the website of the Daniel Langlois Foundation for Art, Science, and Technology (http://www.fondation-langlois.org).
6. Klüver (1967a, n.p.). All quotes in this and the next paragraph are taken from this source.
7. The talk, without the outline of the introductory audiovisual section, was published as Klüver (1967b).
8. Klüver (1967b, n.p.). Klüver's article contains seventeen paginated and fifteen unnumbered pages. All quotes in this and the following three paragraphs are taken from the unpaginated section.
9. E.A.T. (1967b). All subsequent quotes in this paragraph are taken from this source. For a discussion of E.A.T. and automation, see F. Turner (2008).
10. On E.A.T. and the Pepsi pavilion, see F. Turner (2014).

## Chapter Four: Feedback

1. For a discussion of the tangled relationship among expertise, democracy, and militarization during the Cold War, see Rohde (2013).
2. "Nowhere else in the country," according to Mike Davis, "did there develop such a seamless continuum between the corporation, laboratory and classroom as in Los Angeles, where Cal Tech via continuous cloning and spinoff became the hub of a vast wheel of public-private research and development that eventually included the Jet Propulsion Laboratory, Hughes Aircraft (the world center of airborne electronics), the Air Force's Space Technology Laboratory, Aerojet General (a spinoff of the latter), TRW, the Rand Institute, and so on" (1990, 57).
3. On the impact of the protest movement against the Vietnam War on art and technology projects, with specific reference to Tuchman's initiative, see Kahn (2012) and Goodyear (2008).
4. On the RAND Corporation, see Abella (2008), Collins (2002), and Hounshell (1997, 2000). For an early, mainstream view of the organization, see McDonald (1951). On the Hudson Institute, see Pickett (1992). For a critical biography of Kahn, see Ghamari-Tabrizi (2005).

5. For *Life* magazine's view of RAND as an "odd little company" playing a "big role in US defense," see McCombe (1959), a picture story that emphasizes the energetic, Southern California lifestyle fueling RAND creativity. A similar claim for the dynamism of the think tankers is made in Theodore White's (1967) later article, again for *Life*, on so-called action intellectuals, though the photographs illustrating the piece predominantly feature seated men pensively staring into the middle distance. For further discussion of how think tanks were represented, see Erickson et al. (2013, 10–16), the description of RAND in Ghamari-Tabrizi (2005, 46–60), Lee (2011), and the account of the early days of the Harvard Center for Cognitive Studies in Cohen-Cole (2007).

6. Further citations of Chamberlain's RAND memoranda refer to this source.

7. On the memo, see also Yates (1989a, 1989b). On the "papereality" of bureaucracies, see Dery (1998).

8. *The Secret Life of Hernando Cortez*, directed by John Chamberlain (1969), 69 mins.

9. The questionnaire is a two-page, undated and untitled typescript. Chamberlain, John. Folder 2 of 5, MOD.001.001 2(2). Modern Art Department Art and Technology Records, 1967–2007, bulk 1967–1971, Los Angeles County Museum of Art, Los Angeles.

10. An unofficial recording of the broadcast can be viewed on Youtube. For more on the World Question Center, see Byars (2014, 69–85).

11. The discussion of politics is so muted or absent altogether in the documentation surrounding 1960s art and technology projects that the directness of Spark's question is quite breathtaking. Tuchman's tepid response, less so.

### Chapter Five: How to Make the World Work

1. *A Communications Primer*, directed by Charles Eames (1953), 22 mins.

2. For more on the Eames Office displays, see F. Turner (2013) and Schuldenfrei (2015).

3. Eames Office. Accessed April 30, 2019. http://www.eamesoffice.com/eames-office/who-we-are/.

4. *Powers of Ten*, "trunk version" directed by Charles and Ray Eames (1963); *Powers of Ten*, directed by Charles and Ray Eames (1968); *Powers of Ten: A Film Dealing with the Relative Size of Things in the Universe and the Effect of Adding Another Zero*, directed by Charles and Ray Eames (1977), 9 mins.

5. *Glimpses of the USA*, directed by Charles and Ray Eames (1959), 13 mins.

6. This influence is noted by Colomina (2001), Kirkham (1995), and others.

7. *Think*, directed by Charles and Ray Eames (1964), 30 mins.

8. All of these elements combined with a veiled suggestion that humanity's rifts might be healed by and through Le Corbusier's architectural designs.

9. For more on these influences, see Colomina (2001), Kirkham (1995), and Schuldenfrei (2015).

10. Gance's 1919 critique of technology and war, *J'accuse*, includes a zombie moment in which the war-dead rise from their graves to admonish the society that

has sent them to the trenches. Gance deployed wounded soldiers as well as those on leave from Verdun to play these roles, which means they were essentially playing proleptically their own ghosts. (In fact within a few weeks of shooting, 80 percent of these extras had died.) In a self-reflexive moment that merged filmmaking and battle preparation, for the opening credits Gance also uses troops to spell out the title of the film in a field. Made with collaboration from the cinematographic service of the French army, the film featured tinted scenes, furious cross-cutting, split screens, and allegorical layering of images through which Gance explored the technologies of perception that made possible his art as well as the worldwide destruction it evoked.

11. See Maciunas (1966). The piece was originally published in the winter 1966 issue of *Film Culture*. All quotes in this paragraph are from this source.

12. The quote is itself taken from Ray Eames's notes on a Hofmann lecture in August 1936.

13. Soviet audiences would have been more familiar with Eisensteinian montage than the audiences who entered *Think*, and thus the Moscow exhibition proved both effective and affective in ways that the New York installation did not manage.

14. The design department at Southern Illinois was led by Harold Cohen, who had been at the New Bauhaus in Chicago, where he met Fuller. Cohen not only led the department but he also brought Charles Eames, Moholy-Nagy, Marshall McLuhan, and other leading thinkers to the somewhat remote land-grant university that gave Fuller his first full-time university post in 1959.

**Chapter Six: Heritage of Our Times**

1. The key figure here is Stewart Brand. The fluid transition from social to market emancipation is deftly explored in F. Turner (2006). The relationship between participatory, pedagogic, and other discursive modes of art and new technologies is clear in Nicolas Bourriaud's influential notion of "relational aesthetics," where the DIY, interactive promise of the internet is transferred to the production and reception of art: "Nowadays, modernity extends into the practices of cultural do-it-yourself and recycling, into the invention of the everyday and the development of time lived, which are not objects less deserving of attention and examination than Messianistic utopias and the formal 'novelties' that typified modernity yesterday" (2002, 14). For the critical response to Bourriaud, see, e.g., Bishop (2004) and Martin (2007).

2. LACMA "Art + Tech Lab Archive." https://www.lacma.org/lab/archive. An earlier iteration of the A + T webpage promised that it would make available all relevant code, data, and legal documents as well as images and video. A pdf version of the 1971 report was, until recently, also available from the LACMA website. The most recent A + T webpages are less expansive.

3. Nokia Bell Labs E.A.T. Salon. https://www.bell-labs.com/eat-july/

4. All quotes and information on a2ru are taken from the website of the Alliance for the Arts in Research Universities. Accessed April 30, 2019. http://a2ru.org/about/who-we-are/.

5. It is worth noting that the phrase "learning by doing," like many of the other loose terms Dewey preferred, migrated from the domain of progressive education to that of economics over the course of the twentieth century. As used by Kenneth Arrow (1962), for example, "learning by doing" referred to the way productivity can be increased through modifications made in practice and without increasing costs through adding workers or further investment. Needless to say, there is no reference to Dewey in Arrow's article.

6. A current project entitled "What Is a Media Lab?" is being conducted by Lori Emerson, Jussi Parikka, and Darren Wershler and addresses the state of play with current media labs globally. It also examines the Cold War influences on these labs. See Emerson, Parikka, and Wershler (forthcoming).

7. Quoted from a conversation between Freeman and Mullins (LACMA 2015). All quotes in this paragraph are taken from this source.

8. The relation among defense spending and the invention of new industries and areas of economic activity is noted by Markusen: "Whole new sectors of the economy have flourished under the government's research largesse and steady stream of procurement contracts—aerospace, communications, computing, and electronics owe their initial successes and much of their continued competitiveness to this closet industrial policy.... These sectors in turn have produced technologies, which have radically altered the commercial sectors, particularly through the factory-automating counterparts to automated warfare.... The distinctiveness of postwar military missions, particularly the imperatives of cold war competition, is key to this transformation" (1991, 394). She goes on to claim: "the computing industry was wholly a creature of military missions in its infancy.... Not only were many of the essential early developments military led, but so were more recent innovations: minicomputers, software, time-sharing, data-communications protocols, and supercomputers. The explosion in business applications was a technology-push phenomenon—the military paid for companies to pioneer capabilities whose possibilities were simply laid in the path of potential users. Electronics advances, too, such as the semiconductor, valued for their military capabilities, were overwhelmingly dependent upon military markets in their crucial infant industry stages. In the late 1950s, the government accounted for about 70% of the semiconductor market" (394).

9. The phrase "hippie modernism" is from Blauvelt (2015). For more on the combination of the 1960s counterculture and science, see Kaiser (2011) and Kaiser and McCray (2016).

10. The term used by Bloch, *Ungleichzeitigkeit*, has been variously translated as "nonsynchronous" (Bloch 1977), "non-contemporaneity" (Bloch 1991), and "nonsimultaneity" (Schwartz 2001).

11. On Pinder, see Schwartz (2001, esp. 60–64).

12. Bloch gives examples of appropriation such as the swastika imposed upon the red flag, the words "worker" and "worker's party," the street and the procession, and so on (Bloch 1991, 64–67; see also Schwartz 2001, 78–79).

# References

Abel, Richard. 1987. *French Cinema: The First Wave, 1915–1927*. Princeton, NJ: Princeton University Press.
Abella, Alex. 2008. *Soldiers of Reason: The RAND Corporation and the Rise of the American Empire*. New York: Houghton Mifflin Harcourt.
Adamic, Louis. 1936. "Education on a Mountain." *Harper's Monthly Magazine* 172: 516–530.
Adorno, Theodor W., Else Frenkel-Brunswik, Daniel J. Levinson, and R. Nevitt Sanford. 1950. *The Authoritarian Personality*. New York: Harper.
Albers, Josef. 1935. "Art as Experience." *Progressive Education* 12 (October): 391–393.
Albers, Josef. 1938. "Concerning Fundamental Design." In *Bauhaus: 1919–1928*, edited by Herbert Bayer, Walter Gropius, and Ise Gropius, 114–121. New York: Museum of Modern Art.
Alexander, Thomas M. 1987. *John Dewey's Theory of Art, Experience, and Nature: The Horizons of Feeling*. Albany: State University of New York Press.
Allen, Michael Thad, and Gabrielle Hecht, eds. 2001. *Technologies of Power: Essays in Honor of Thomas Parke Hughes and Agatha Chipley Hughes*. Cambridge, MA: MIT Press.
Amadae, S. M. 2003. *Rationalizing Capitalist Democracy: The Cold War Origins of Rational Choice Liberalism*. Chicago: University of Chicago Press.
Amadae, S. M. 2015. *Prisoners of Reason: Game Theory and Neoliberal Political Economy*. Cambridge: Cambridge University Press.
Anon. 1944. "Modern Laboratory." *Life*, September 18, 79, 81, 82.
Anon. 1967. "Art and Science: Two Worlds Merge". *Bell Telephone Magazine*, November/December, 13–19.
Antin, David. 2011. "Art and the Corporations." In *Radical Coherency: Selected Essays on Art and Literature 1966 to 2005*, 61–77. Chicago: University of Chicago Press.
Apollinaire, Guillaume. 2002. *The Cubist Painters*. Translated by Peter Read. Forest Row, UK: Artists Bookworks.
Arrow, Kenneth J. 1962. "The Economic Implications of Learning by Doing." *Review of Economic Studies* 29.3: 155–173.
ASC (American Society for Cybernetics). n.d. "History of Cybernetics, Chapter 2: The Coalescence of Cybernetics." Accessed April 30, 2019. http://www.asc-cybernetics.org/foundations/history2.htm.
Barbrook, Richard, and Andy Cameron. 1996. "The Californian Ideology." *Science as Culture* 6.1: 44–72.

Bassett, Ross Knox. 2002. *To the Digital Age: Research Labs, Start-Up Companies, and the Rise of MOS Technology.* Baltimore: Johns Hopkins University Press.

Bateson, Gregory. 2000 [1972]. *Steps to an Ecology of Mind.* Chicago: University of Chicago Press.

Baudrillard, Jean. 1983. "The Ecstasy of Communication." In *The Anti-Aesthetic*, edited by Hal Foster, 126–133. London: Pluto Press.

Bayer, Herbert. 1939. "Fundamentals of Exhibition Design." New York Public Library. https://digitalcollections.nypl.org/items/90f27111-9714-4fc1-e040-e00a18064ba4.

Beck, John, and Ryan Bishop. 2016. "Introduction: The Long Cold War." In John Beck and Ryan Bishop *Cold War Legacies: Systems, Theory, Aesthetics*, 1-35. Edinburgh: Edinburgh University Press.

Beckett, Samuel. 2001. "Dante ... Bruno . Vico ... Joyce." In *Disjecta: Miscellaneous Writings and a Dramatic Fragment*, edited by Ruby Cohn, 19–34. London: John Calder.

Belgrad, Daniel. 1998. *The Culture of Spontaneity: Improvisation and the Arts in Postwar America.* Chicago: University of Chicago Press.

Bello, Francis. 1958. "The World's Greatest Industrial Laboratory." *Fortune*, November, 148–157, 208, 212, 214, 219–220.

Bennis, Warren, and Patricia Ward Biederman. 1998. *Organizing Genius: The Secrets of Creative Collaboration*, rev. ed. New York: Basic Books.

Benthall, Jonathan. 1972. *Science and Technology in Art Today.* London: Thames and Hudson.

Berube, Maurice R. 1998. "John Dewey and the Abstract Expressionists." *Educational Theory* 38.2: 211–227.

Bijvoet, Marga. 1997. *Art as Inquiry: Towards New Collaborations Between Art, Science, and Technology.* Bern: Peter Lang.

Bishop, Claire. 2004. "Antagonism and Relational Aesthetics." *October* 110 (fall): 51–79.

Bishop, Ryan. 2016. "Smart Dust and Remote Sensing Systems: The Political Subject in Autonomous Systems." In John Beck and Ryan Bishop *Cold War Legacies: Systems, Theory, Aesthetics*, 273–288. Edinburgh: Edinburgh University Press.

Bishop, Ryan, and John Phillips. 2010. *Modernist Avant-Garde Aesthetics and Contemporary Military Technology: Technicities of Perception.* Edinburgh: Edinburgh University Press.

Blakinger, John R. 2016. "The Aesthetics of Collaboration: Complicity and Conversion at MIT's Center for Advanced Visual Studies." *Tate Papers* 25 (spring). http://www.tate.org.uk/research/publications/tate-papers/25/aesthetics-of-collaboration.

Blauvelt, Andrew, ed. 2015. *Hippie Modernism: The Struggle for Utopia.* Minneapolis, MN: Walker Art Centre.

Bloch, Ernst. 1977. "Nonsynchronism and the Obligation to Its Dialectics." Translated by Mark Ritter. *New German Critique* 11 (spring): 22–38.

Bloch, Ernst. 1991. *Heritage of Our Times.* Translated by Neville and Stephen Plaice. Cambridge: Polity Press.

Borchardt-Hume, Achim, ed. 2006. *Albers and Moholy-Nagy: From the Bauhaus to the New World*. London: Tate Publishing.

Boudewijnse, Geert-Jan. 2012. "Gestalt Theory and Bauhaus—A Correspondence." *Gestalt Theory* 34.1: 81–98.

Bourriaud, Nicolas. 2002. *Relational Aesthetics*. Translated by Simon Pleasance and Fronza Woods. Dijon: Les Presses du Réel.

Boyer, Paul S. 1985. *By the Bomb's Early Light: American Thought and Culture at the Dawn of the Atomic Age*. New York: Pantheon.

Brand, Stewart. 1968. *The Whole Earth Catalog*. Menlo Park, CA: Whole Earth.

Brand, Stewart. 1987. *The Media Lab: Inventing the Future at MIT*. New York: Viking Penguin Press.

Brinkley, Alan. 1994. "The Problem of American Conservatism." *American Historical Review* 99.2: 409–429.

Buchloh, Benjamin. 1986. "The Primary Colors for the Second Time: A Paradigm Repetition of the Neo-Avant-Garde." *October* 37 (summer): 41–52.

Buettner, Stuart. 1975. "John Dewey and the Visual Arts in America." *Journal of Aesthetics and Art Criticism* 33.4: 383–391.

Bürger, Peter. 1984. *Theory of the Avant-Garde*. Translated by Michael Shaw. Minneapolis: University of Minnesota Press.

Burnham, Jack. 1968. *Beyond Modern Sculpture*. New York: George Braziller.

Burnham, Jack. 1980. "Art and Technology: The Panacea That Failed." In *The Myths of Information: Technology and Postindustrial Culture*, edited by Kathleen Woodward, 200–215. Madison, WI: Coda Press.

Burnham, Jack. 2015a. *Dissolve into Comprehension: Writings and Interviews 1964–2004*, edited by Melissa Ragain. Cambridge, MA: MIT Press.

Burnham, Jack. 2015b [1971]. "Corporate Art." In *Dissolve into Comprehension: Writing and Interviews, 1964–2004*, edited by Melissa Ragain, 184–191. Cambridge, MA: MIT Press.

Burnham, Jack. 2015c [1968]. "The Future of Responsive Systems in Art." In *Dissolve into Comprehension: Writing and Interviews, 1964–2004*, edited by Melissa Ragain, 89–98. Cambridge, MA: MIT Press.

Burnham, Jack. 2015d. "System Aesthetics" In *Dissolve into Comprehension: Writing and Interviews, 1964–2004*, edited by Melissa Ragain, 115-125. Cambridge, MA: MIT Press.

Bush, Vannevar. 1949. *Modern Arms and Free Men: A Discussion of the Role of Science in Preserving Democracy*. New York: Simon and Schuster.

Bush, Vannevar. 1960 [1945]. *Science—The Endless Frontier: A Report to the President on a Program for Postwar Scientific Research*. Washington, DC: National Science Foundation.

Byars, James Lee, Magali Arriola, Peter Eleey. 2014. *1/2 an Autobiography: Sourcebook*. London: Koenig Books.

Cage, John. 1968. *A Year From Monday: Lectures and Writings*. London: Calder and Boyars.

CAST. 2015. "MIT Center for Art, Science and Technology Receives $1.5 Million Grant from the Andrew W. Mellon Foundation," MIT News. April 22.

http://news.mit.edu/2015/center-art-science-technology-receives-andrew-mellon-foundation-grant-0448.

Century, Michael. 1999. "Pathways to Innovation in Digital Culture." Montreal: Centre for Research on Canadian Cultural Industries and Institutions, McGill University. http://www.nextcentury.ca/PathwaysToInnovationInDigitalCulture.pdf.

Chamberlain, John. 1969. "Memorandum, Chamberlain, John," MOD.001.001 2(9), folder 4 of 5, Modern Art Department Art and Technology Records, 1967–2007, bulk 1967–1971, Los Angeles County Museum of Art, Los Angeles.

Chang, Andrea. 2013. "LACMA Announces Art + Technology Lab, with Support from Google, Space X." *Los Angeles Times*, December 10. https://www.latimes.com/business/la-xpm-2013-dec-10-la-fi-tn-lacma-art-technology-lab-google-20131210-story.html.

Chomsky, Noam. 1997. *The Cold War and the University: Toward an Intellectual History of the Postwar Years*. New York: New Press.

Christ, Carl F. 1994. "The Cowles Commission's Contributions to Econometrics at Chicago, 1939–1955." *Journal of Economic Literature* 32 (March): 30–59.

Cohen-Cole, Jamie. 2007. "Instituting the Science of Mind: Intellectual Economies and Disciplinary Exchange at Harvard's Center for Cognitive Studies." *British Journal for the History of Science* 40: 567–597.

Cohen-Cole, Jamie. 2009. "The Creative American: Cold War Salons, Social Science, and the Cure for Modern Society." *Isis* 100.2: 219–262.

Cohen-Cole, Jamie. 2014. *The Open Mind: Cold War Politics and the Sciences of Human Nature*. Chicago: University of Chicago Press.

Collins, Martin J. 2002. *Cold War Laboratory: RAND, the Air Force, and the American State, 1945–1950*. Washington, DC: Smithsonian Institution Scholarly Press.

Colomina, Beatriz. 2001. "Enclosed by Images: The Eameses Multimedia Architecture." *Grey Room* 2 (winter): 6–29.

Conway, Flo, and Jim Siegelman. 2005. *Dark Hero of the Information Age: In Search of Norbert Wiener, the Father of Cybernetics*. New York: Basic Books.

Crow, Michael M., and Christopher Tucker. 2001. "The American Research University System as America's *de facto* Technology Policy." *Science and Public Policy* 28.1: 2–10.

Dalkey, Norman C. 1969. "The Delphi Method: An Experimental Study of Group Opinion" (Report RM5888-PR). Santa Monica, CA: The RAND Corporation.

Danilowitz, Brenda. 2006. "Josef Albers: 'Open Eyes.'" *Chinati*. https://chinati.org/programs/josef-albers-open-eyes-by-brenda-danilowitz#fn-4105-5.

Davis, Douglas. 1973. *Art and the Future: A History-Prophecy of the Collaboration between Science, Technology and Art*. London: Thames and Hudson.

Davis, Mike. 1990. *City of Quartz: Excavating the Future in Los Angeles*. London: Verso.

De Certeau, Michel. 1984. *The Practice of Everyday Life*. Translated by Steven Rendall. Berkeley: University of California Press.

Dery, David. 1998. "'Papereality' and Learning in Bureaucratic Organisations." *Administration and Society* 29.6: 677–689.

Dewey, John. 1910a. *How We Think*. Boston: D.C. Heath.

Dewey, John. 1910b. *The Influence of Darwin on Philosophy and Other Essays in Contemporary Thought*. New York: Henry Holt.

Dewey, John. 1916. *Democracy and Education: An Introduction to the Philosophy of Education*. New York: Macmillan.

Dewey, John. 1980 [1934]. *Art as Experience*. New York: Perigee.

Dewey, John. 1983 [1899]. "The School and Society." In *The Middle Works of John Dewey, 1899–1924, Vol. 1: Essays on School and Society, 1899–1901*, edited by Jo Ann Boydston, 2–109. Carbondale: Southern Illinois University Press.

Dewey, John. 2016 [1927]. *The Public and Its Problems: An Essay in Political Inquiry*, edited by Melvin L. Rogers. Athens, OH: Swallow Press.

Díaz, Eva. 2008. "The Ethics of Perception: Josef Albers in the United States." *Art Bulletin* 90.2: 260–285.

Díaz, Eva. 2015. *The Experimenters: Chance and Design at Black Mountain College*. Chicago: University of Chicago Press.

Dossin, Catherine. 2015. *The Rise and Fall of American Art, 1940s–1980s: A Geopolitics of Western Art Worlds*. Farnham, UK: Ashgate.

Duberman, Martin. 1972. *Black Mountain: An Exploration in Community*. New York: E. P. Dutton.

Dupuy, Jean-Pierre. 1994. *The Mechanization of the Mind: On the Origins of Cognitive Science*. Cambridge, MA: MIT Press.

Dutta, Arindam, ed. 2013. *A Second Modernism: MIT, Architecture, and the "Techno-Social" Moment*. Cambridge, MA: MIT Press.

E.A.T. 1967a. "Fundraising Package," May 1, box 145, folder 4, Experiments in Art and Technology Records, 1966–1997, Getty Research Institute, Los Angeles.

E.A.T. 1967b. "Press Release," October 10, box 145, folder 4, Experiments in Art and Technology Records, 1966–1997, Getty Research Institute, Los Angeles.

E.A.T. 1969. "A.2. Matchings." *E.A.T. Operations and Information* 2 (April 24): 1–2, box 138, folder 6, Experiments in Art and Technology Records, 1966–1997, Getty Research Institute, Los Angeles.

Edwards, Paul N. 1996. *The Closed World: Computers and the Politics of Discourse in Cold War America*. Cambridge, MA: MIT Press.

Emerson, Lori, Jussi Parikka, and Darren Wershler. Forthcoming. *The Lab Book: On Situated Practices in Media Studies*. Minneapolis: University of Minnesota Press.

Engerman, David C. 2003. "Rethinking Cold War Universities: Some Recent Histories." *Journal of Cold War Studies* 5: 80–95.

Ensmenger, Nathan. 2010. *The Computer Boys Take Over: Computers, Programmers, and the Politics of Technical Expertise*. Cambridge, MA: MIT Press.

Erickson, Paul, Judy Klein, Lorraine Daston, Rebecca Lemov, Thomas Sturm, and Michael Gordin. 2013. *How Reason Almost Lost its Mind: The Strange Career of Cold War Rationality*. Chicago: University of Chicago Press.

Fallon, Michael. 2014. *Creating the Future: Art and Los Angeles in the 1970s*. Berkeley, CA: Counterpoint.

Finch, Elizabeth. n.d. "CAVS history." Accessed April 30, 2019. http://act.mit.edu/collections/cavs/history/.

Flam, Jack, ed. 1996. *Robert Smithson: The Collected Writings*. Berkeley: University of California Press.

Ford, Simon. 2012. "Three Early Texts by Gustav Metzger on Computer Art." In *Mainframe Experimentalism: Early Computing and the Foundations of Digital Art*, edited by Hannah B. Higgins and Douglas Kahn, 209–228. Berkeley: University of California Press.

Foster, Hal. 1994. "What's Neo About the Neo-Avant-Garde?" *October* 70 (autumn): 5–32.

Friedan, Betty. 1979 [1963]. *The Feminine Mystique*. New York: Dell.

Friedberg, Anne. 2006. *The Virtual Window: From Alberti to Microsoft*. Cambridge, MA: MIT Press.

Friedman, Ken. 2011. "Fluxus: A Laboratory of Ideas." In *Fluxus and the Essential Questions of Life*, edited by Jacquelynn Baas, 34–44. Hanover: Hood Museum of Art, Dartmouth College.

Fuller, R. Buckminster. 1969. *Utopia or Oblivion: The Prospects for Humanity*. London: Penguin.

Fuller, R. Buckminster. 1970. "Introduction." In Gene Youngblood, *Expanded Cinema*, 15-37. New York: E. P. Dutton.

Fuller, R. Buckminster. 1981. *Critical Path*. New York: St. Martin's Press.

Fuller, R. Buckminster. 2008 [1969]. *Operating Manual for Spaceship Earth*. Zurich: Lars Muller Publishers.

Füssl, Karl-Heinz. 2006. "Pestalozzi in Dewey's Realm? Bauhaus Master Josef Albers among the German-Speaking Emigreés' Colony at Black Mountain College (1933-1949)." *Paedagogica Historica* 42.1/2: 77–92.

Gale, Matthew. 1997. *Dadaism and Surrealism*. London: Phaidon.

Galison, Peter. 1992. "The Many Faces of Big Science." In Peter Galison and Bruce Hevly *Big Science: The Growth of Large Scale Research*, 1–17. Stanford, CA: Stanford University Press.

Galison, Peter. 1994. "The Ontology of the Enemy: Norbert Wiener and the Cybernetic Vision." *Critical Inquiry* 21: 228–266.

Galison, Peter. 1998. "The Americanization of Unity." *Daedalus* 127: 45–71.

Galison, Peter, and Bruce Hevly, eds. 1992. *Big Science: The Growth of Large Scale Research*. Stanford, CA: Stanford University Press.

Gardner, John W. 1965. *Self Renewal: The Individual and the Innovative Society*. New York: Harper and Row.

Gerard, Ralph W. 1956. "Design and Function in the Living." In György Kepes, *The New Landscape in Art and Science*, 277–279. Chicago: Paul Theobald and Co.

Gertner, Jon. 2013. *The Idea Factory: Bell Labs and the Great Age of American Innovation*. London: Penguin.

Ghamari-Tabrizi, Sharon. 2005. *The Worlds of Herman Kahn: The Intuitive Science of Thermonuclear War*. Cambridge, MA: Harvard University Press.

Gielen, Pascal. 2013. *Creativity and Other Fundamentalisms*. Amsterdam: Mondriaan Fund.

Gilkeson, John S., Jr. 1995. "American Social Scientists and the Domestication of 'Class' 1929–1955." *Journal of the History of the Behavioral Sciences* 31: 331–346.

Gilman, Nils. 2003. *Mandarins of the Future: Modernization Theory in Cold War America*. Baltimore: Johns Hopkins University Press.

Giovanni, Joseph. 2005. "The Office of Charles Eames and Ray Kaiser: The Material Trail." In *The Work of Charles and Ray Eames: A Legacy of Invention*, edited by Donald Albrecht et al., 45–71. New York: Abrams.

Gitre, Edward J. K. 2010. "Importing Freud: First-Wave Psychoanalysis, Interwar Social Sciences, and the Interdisciplinary Foundations of an American Social Theory." *Journal of the History of the Behavioral Sciences* 46: 239–262.

Good, James A. 2005. *A Search for Unity in Diversity: The "Permanent Hegelian Deposit" in the Philosophy of John Dewey*. New York: Lexington Books.

Good, James A. 2006. "John Dewey's 'Permanent Hegelian Deposit' and the Exigencies of War." *Journal of the History of Philosophy* 44.2: 293–313.

Good, James A., and Jim Garrison. 2010. "Traces of Hegelian *Bildung* in Dewey's Philosophy." In *John Dewey and Continental Philosophy*, edited by Paul Fairfield, 44–68. Carbondale: Southern Illinois University Press.

Goodyear, Anne Collins. 2004. "Gyorgy Kepes, Billy Klüver, and American Art of the 1960s: Defining Attitudes toward Science and Technology." *Science in Context* 17.4: 611–635

Goodyear, Anne Collins. 2008. "From Technophilia to Technophobia: The Impact of the Vietnam War on the Reception of 'Art and Technology.'" *Leonardo* 41.2: 169–173.

Green, Charles. 2001. *The Third Hand: Collaboration in Art From Conceptualism to Postmodernism*. Minneapolis: University of Minnesota Press.

Greif, Mark. 2015. *The Age of the Crisis of Man: Thought and Fiction in America, 1933–1973*. Princeton, NJ: Princeton University Press.

Gropius, Walter. 1938 [1923]. "The Theory and Organization of the Bauhaus." In *Bauhaus 1919–1928*, edited by Herbert Bayer, Walter Gropius, and Ise Gropius, 22-100. New York: Museum of Modern Art.

Guillory, John. 2004. "The Memo and Modernity." *Critical Inquiry* 31.1: 108–132.

Gusterson, Hugh. 2005. "A Pedagogy of Diminishing Returns: Scientific Involution across Three Generations of Nuclear Weapons Science." In *Pedagogy and the Practice of Science: Historical and Contemporary Perspectives*, edited by David Kaiser, 75–107. Cambridge, MA: MIT Press.

Habermas, Jürgen. 1987. *The Theory of Communicative Action, Vol. 2: Lifeworld and System: A Critique of Functionalist Reason*. Translated by Thomas McCarthy. Boston, MA: Beacon Press.

Hacking, Ian. 1986. "Weapons Research and the Form of Scientific Knowledge." *Canadian Journal of Philosophy* 16.S12: 237–260.

Hacking, Ian. 2002. *Historical Ontology*. Cambridge, MA: Harvard University Press,

Halpern, Orit. 2014. *Beautiful Data: A History of Vision and Reason Since 1945*. Durham, NC: Duke University Press.

Haraway, Donna. 2016. *Staying With the Trouble: Making Kin in the Chthulucene*. Durham, NC: Duke University Press.

Harris, Mary Emma. 1987. *The Arts at Black Mountain College*. Cambridge, MA: MIT Press.

Hartman, Andrew. 2008. *Education and the Cold War: The Battle for the American School*. Basingstoke, UK: Palgrave.

Hayakawa, S. I. 1969. "The Revision of Vision." In György Kepes, *Language of Vision*, 8–10. Chicago: Paul Theobald and Company.

Hayles, N. Katherine. 1999. *How We Became Posthuman: Virtual Bodies in Cybernetics, Literature, and Informatics.* Chicago: University of Chicago Press.

Heidegger, Martin. 2002. "The Age of the World Picture." In *Off the Beaten Track*, edited and translated by Julian Young and Kenneth Haynes, 57–72. Cambridge: Cambridge University Press.

Heims, Steve J. 1991. *The Cybernetics Group.* Cambridge, MA: MIT Press.

Herman, E. 1995. *The Romance of American Psychology: Political Culture in the Age of Experts, 1940–1970.* Berkeley: University of California Press.

Higgins, Hannah B., and Douglas Kahn, eds. 2012. *Mainframe Experimentalism: Early Computers and the Foundations of the Digital Arts.* Berkeley: University of California Press.

Hobbs, Robert C. 1984. "Rewriting History: Artistic Collaboration since 1960." In *Artistic Collaboration in the Twentieth Century*, edited by Cynthai Jaffee McCabe, 64–87. Washington, DC: Smithsonian Institution Press.

Hollinger, David A. 1983. "The Defense of Democracy and Robert K. Merton's Formulation of the Scientific Ethos." *Knowledge and Society: Studies in the Sociology of Culture Past and Present* 4: 1–15.

Hollinger, David A. 1990. "Free Enterprise and Free Inquiry: The Emergence of Laissez-Faire Communitarianism in the Ideology of Science in the United States." *New Literary History* 21.4: 897–919.

Hollinger, David A. 1995. "Science as a Weapon in Kulturkampfe in the United States during and after World War II." *Isis* 86.3: 440–454.

Hounshell, David A. 1997. "The Cold War, RAND, and the Generation of Knowledge, 1946–1962." *Historical Studies in the Physical and Biological Sciences* 27: 237–267.

Hounshell, David A. 2000. "The Medium is the Message, or How Context Matters: The RAND Corporation Builds an Economics of Innovation, 1946–1962." In *Systems, Experts, and Computers: The Systems Approach in Management and Engineering, World War II and After*, edited by Agatha C. Hughes and Thomas P. Hughes, 255–310. Cambridge, MA: MIT Press.

HUC (Harvard University Committee on the Objectives of a General Education in a Free Society). 1950 [1945]. *General Education in a Free Society: Report of the Harvard Committee.* Cambridge, MA: Harvard University Press.

Huhtamo, Erkki. 2013. *Illusions in Motion: Media Archaeology of the Moving Panorama and Related Spectacles.* Cambridge, MA: MIT Press.

Isaac, Joel. 2007. "The Human Sciences in Cold War America." *Historical Journal* 50: 725–746.

Isaac, Joel. 2011. "Introduction: The Human Sciences and Cold War America." *Journal of the History of the Behavioral Sciences* 47: 225–231.

Isidore, Chris. 2015. "Elon Musk's SpaceX Set to Get Its First Military Contract." *CNN*, November 19. http://money.cnn.com/2015/11/19/news/companies/elon-musk-spacex-military-launch/.

Jameson, Fredric. 1991. *Postmodernism, or The Cultural Logic of Late Capitalism.* London: Verso.

Jameson, Fredric. 2003. "Future City." *New Left Review* 21 (May/June): 65–79.

Jewett, Andrew. 2012. *Science, Democracy, and the American University: From the Civil War to the Cold War*. Cambridge: Cambridge University Press.

Johnson, James Scott. 2002. "John Dewey and the Role of Scientific Method in Aesthetic Experience." *Studies in Philosophy and Education* 21: 1–15.

Jones, Caroline A. 2005. *Eyesight Alone: Clement Greenberg's Modernism and the Bureaucratization of the Senses*. Chicago: University of Chicago Press.

Jones, Caroline A. 2013. "Artist/System." In *The Second Modernism: MIT, Architecture and the "Techno-Social" Moment*, edited by Arindam Dutta, 506–549. Cambridge, MA: MIT Press.

Jones, Caroline A. 2016. *The Global Work of Art: World's Fairs, Biennials, and the Aesthetics of Experience*. Chicago: University of Chicago Press.

Jones, Caroline A., and Peter Galison, eds. 1998. *Picturing Science Producing Art*. New York: Routledge.

Kahn, Douglas. 1999. "James Tenney Interviewed by Douglas Kahn." *Leonardo*. https://www.leonardo.info/LEA/Tenney2001/tenneyinterview.html.

Kahn, Douglas. 2012. "The Military-Arts Nexus: Two Cases in the United States, c. 1970." *Studies in Material Thinking* 8: 1–8.

Kaiser, David. 2004. "The Postwar Suburbanization of American Physics." *American Quarterly* 56.4: 851–888.

Kaiser, David. 2011. *How the Hippies Saved Physics: Science, Counterculture, and the Quantum Revival*. New York: Norton.

Kaiser, David, and W. Patrick McCray, eds. 2016. *Groovy Science: Knowledge, Innovation, and American Counterculture*. Chicago: University of Chicago Press.

Kantor, Sybil Gordon. 2002. *Alfred H. Barr, Jr. and the Intellectual Origins of the Museum of Modern Art*. Cambridge, MA: MIT Press.

Katz, Vincent, ed. 2003. *Black Mountain College: Experiment in Art*. Cambridge, MA: MIT Press.

Kay, Jane H. 1967. "Art Science on the Charles." *Art in America* 55.5: 62–67.

Kentgens-Craig, Margret. 1999. *The Bauhaus and America: First Contacts 1919–1936*. Translated by Lynette Widder. Cambridge, MA: MIT Press.

Kepes, György. 1956. *The New Landscape in Art and Science*. New York: Paul Theobald and Company.

Kepes, György. 1960. "Introduction to the Issue 'The Visual Arts Today.'" *Daedalus* 81.1: 3–13.

Kepes, György. 1965. "The Visual Arts and the Sciences: A Proposal for Collaboration." *Daedalus* 94.1: 117–134.

Kepes, György. 1969 [1944]. *Language of Vision*, 2nd ed. Chicago: Paul Theobald and Company.

Kepes, György. 1971. "Toward Civic Art." *Leonardo* 4: 69–73.

Kester, Grant H. 2011. *The One and the Many: Contemporary Collaborative Art in a Global Context*. Durham, NC: Duke University Press.

Kevles, Daniel J. 1977. "The National Science Foundation and the Debate over Postwar Research Policy, 1942–1945: A Political Interpretation of Science—The Endless Frontier." *Isis* 68: 5–26.

King, Norman. 1984. *Abel Gance*. London: BFI.

Kirkham, Pat. 1995. *Charles and Ray Eames: Designers of the Twentieth Century*. Cambridge, MA: MIT Press.

Kleinman, Daniel Lee. 1995. *Politics on the Endless Frontier: Postwar Research Policy in the United States*. Durham, NC: Duke University Press.

Kline, Ronald R. 2015. *The Cybernetics Movement, or Why We Call Our Age the Information Age*. Baltimore: Johns Hopkins University Press.

Kloppenberg, James T. 1986. *Uncertain Victory: Social Democracy and Progressivism in European and American Thought, 1870–1920*. Oxford: Oxford University Press.

Klüver, Billy. 1967a. "Interface: Artist/Engineer," April 21, box 145, folder 3, Experiments in Art and Technology Records, 1966–1997, Getty Research Institute, Los Angeles.

Klüver, Billy. 1967b. "Interface: Artist/Engineer." *E.A.T. Proceedings* 1 (April 21): 1–17 + 15 n.p.

Klüver, Billy. 1972. "The Pavilion." In *Pavilion: Experiments in Art and Technology*, edited by Billy Klüver, Julie Martin, and Barbara Rose, ix–xvi. New York: E. P. Dutton.

Klüver, Billy. 1994. "Artists, Engineers, and Collaboration." In *Culture on the Brink: Ideologies of Technology*, edited by Gretchen Bender and Timothy Druckery, 207–219. Seattle: Bay Press.

Klüver, Billy. 1996 [1967]. "Theatre and Engineering—An Experiment: Notes by an Engineer." In *Theories and Documents of Contemporary Art: A Sourcebook of Artists' Writings*, edited by Kristine Stiles and Peter Selz, 412–415. Berkeley: University of California Press.

Klüver, Billy, with Julie Martin. 1997. "Working with Rauschenberg." In *Robert Rauschenberg: A Retrospective*, edited by Walter Hopps and Susan Davidson, 310-327. New York: Guggenheim Museum.

Klüver, Billy, Julie Martin, and Barbara Rose. 1972. *Pavilion by Experiments in Art and Technology*. New York: E. P. Dutton.

Knowles, Scott G., and Stuart W. Leslie. 2001. "'Industrial Versailles': Eero Saarinen's Corporate Campuses for GM, IBM, and AT&T." *Isis* 92: 1–33.

Kostelanetz, Richard. 1968. *The Theatre of Mixed Means: An Introduction to Happenings, Kinetic Environments, and Other Mixed-Means Performances*. New York: Dial Press.

Kozloff, Max. 1971. "The Multimillion Dollar Art Boondoggle." *Artforum* 10.2: 72–76.

Kranz, Stewart. 1974. *Science and Technology in the Arts: A Tour through the Realm of Science + Art*. New York: Van Nostrand Reinholt.

Krausse, Joachim, and Claude Lichtenstein. 1999. *Your Private Sky: R. Buckminster Fuller—the Art of Design Science*. Baden, Switzerland: Lars Müller Publishers

LACMA. 2015. "Art, Technology, and Collaboration". LACMA Unframed, July 8. https://unframed.lacma.org/2015/07/08/art-technology-and-collaboration.

LACMA. 2019. "Art + Tech Lab Archive." https://www.lacma.org/lab/archive.

Lakatos, Imre. 1980. *The Methodology of Scientific Research Programmes, Vol. 1: Philosophical Papers*. Cambridge: Cambridge University Press.

Lambert, Nick. 2013. "Artists Engaging with Technology—for Better or Worse." *Synesis: A Journal of Science, Technology, Ethics, and Policy* 4: 37–43.

Lee, Pamela M. 2004. *Chronophobia: On Time in the Art of the 1960s*. Cambridge, MA: MIT Press.

Lee, Pamela M. 2011. "Aesthetic Strategist: Albert Wohlstetter, the Cold War, and a Theory of Mid-Century Modernism." *October* 138: 15–36.

Leslie, Stuart W. 1993. *The Cold War and American Science: The Military-Industrial-Academic Complex at MIT and Stanford*. New York: Columbia University Press.

Leupnitz, Deborah A., and Steven Tulkin. 1980. "The Cybernetic Epistemology of Gestalt Therapy." *Psychotherapy: Theory, Research and Practice* 17.2: 153–157.

Lieberman, Henry R. 1967. "Art and Science Proclaim Alliance in Avant-Garde Loft." *New York Times*, October 11, 49.

Lindgren, Nilo. 1969a. "Art and Technology I: Steps Toward a New Synergism." *IEEE Spectrum* 6.4: 59–68.

Lindgren, Nilo. 1969b. "Art and Technology II: A Call for Collaboration." *IEEE Spectrum* 6.5: 46–56.

Lindgren, Nilo. 1972. "Into the Collaboration." In *Pavilion: Experiments in Art and Technology*, edited by Billy Klüver, Julie Martin, and Barbara Rose, 3–59. New York: E. P. Dutton.

Lippard, Lucy R. 1967. "Total Theater?" *Art International* 11.1: 39–43.

Lippard, Lucy R., and John Chandler. 1967. "Visible Art and the Invisible World." *Art International* 11.5: 27–30.

Lipstadt, Helene. 2005. "'Natural Overlap,' Charles and Ray Eames and the Federal Government." In *The Work of Charles and Ray Eames: A Legacy of Invention*, edited by Donald Albrecht et al., 150–177. New York: Abrams.

Lowen, Rebecca S. 1997. *Creating the Cold War University: The Transformation of Stanford*. Berkeley: University of California Press.

Lyotard, Jean-François. 1991. *The Inhuman: Reflections on Time*. Translated by Geoffrey Bennington and Rachel Bowlby. Cambridge: Polity Press.

Mabon, Prescott C. 1975. *Mission Communication: The Story of Bell Laboratories*. Murray Hill, NJ: Bell Telephone Laboratories.

Maciunas, George. 1966. "Expanded Arts Diagram." Accessed June 29, 2018. http://georgemaciunas.com/wp-content/uploads/2011/03/p1162-1.jpg.

Mandler, P. 2009a. "Margaret Mead amongst the Natives of Great Britain." *Past and Present* 204: 195–233.

Mandler, P. 2009b. "One World, Many Cultures: Margaret Mead and the Limits to Cold War Anthropology." *History Workshop Journal* 68: 149–172.

Marchessault, Janine. 2017. *Ecstatic Worlds: Media, Utopia, Ecologies*. Cambridge, MA: MIT Press.

Marks, Robert, and R. Buckminster Fuller. 1973. *The Dymaxion World of Buckminster Fuller*. Garden City, NY: Anchor Press.

Markusen, Ann. 1991. "The Military-Industrial Divide." *Environment and Planning D: Society and Space* 9: 391–416.

Marter, Joan, ed. 1999. *Off Limits: Rutgers University and the Avant-Garde, 1957–1963*. New Brunswick, NJ: Rutgers University Press.

Martin, Julie, ed. 1967. "E.A.T. News 1.3," November 1, box 138, folder 6, Experiments in Art and Technology Records, 1966–1997, Getty Research Institute, Los Angeles.

Martin, Reinhold. 2003. *The Organizational Complex: Architecture, Media, and Corporate Space*. Cambridge, MA: MIT Press.

Martin, Stewart. 2007. "Critique of Relational Aesthetics." *Third Text* 21.4: 369–386.

Mayhew, Katherine Camp, and Anna Camp Edwards. 1936. *The Dewey School: The Laboratory School of the University of Chicago, 1896–1903*. New York: D. Appleton-Century.

McCombe, Leonard. 1959. "Valuable Batch of Brains", *Life*, May 11, 101–107.

McDermott, John. 2014 [1969]. "Technology: The Opiate of the Intellectuals." In *Philosophy of Technology: The Technological Condition—An Anthology*, 2nd ed., edited by Robert C. Scharff and Val Dusek, 693–704. New York: Wiley.

McGrath, Patrick J. 2002. *Scientists, Business, and the State, 1890–1960*. Chapel Hill: University of North Carolina Press.

Mead, Margaret. 1959. "Closing the Gap between the Scientists and the Others." *Daedalus* 88 (winter): 139–146.

Melman, Seymour. 1970. *Pentagon Capitalism: The Political Economy of War*. New York: McGraw-Hill.

Melvin, Georgina. 1992 [1937]. "The Social Philosophy Underlying Dewey's Theory of Art." In *John Dewey: Critical Assessments, Vol. 3: Value, Conduct and Art*, edited by J. E. Tiles, 302–311. London: Routledge.

Merton, Robert K. 1973 [1942]. "The Normative Structure of Science." In *The Sociology of Science: Theoretical and Empirical Investigations*, edited by Norman W. Storer, 267–278. Chicago: University of Chicago Press.

Mesthene, Emmanuel G. 1965. "On Understanding Change: The Harvard University Program on Technology and Society." *Technology and Culture* 6.2: 222–235.

Mesthene, Emmanuel G. 1968a. "How Technology Will Shape the Future." *Science* 161. 3837 (July 12): 135–143.

Mesthene, Emmanuel G. 1968b. "The Role of Technology in Society: Some General Implications of the Program's Research." In Harvard University Program on Technology and Society, *Fourth Annual Report 1967–1968*, 41–74. Cambridge, MA: Harvard University Press.

Mesthene, Emmanuel G. 1969. "Some General Implications of the Research of the Harvard University Program on Technology and Society." *Technology and Culture* 10.4: 489–513.

Mesthene, Emmanuel G. 1970. *Technological Change: Its Impact on Man and Society*. Cambridge, MA: Harvard University Press.

Mesthene, Emmanuel G. 2014 [1967]. "Technology and Wisdom." In *Philosophy of Technology: The Technological Condition—An Anthology*, 2nd ed., edited by Robert C. Scharff and Val Dusek, 680–685. New York: Wiley.

Metz, Joseph G. 1969. "Democracy and the Scientific Method in the Philosophy of John Dewey." *Review of Politics* 31.2: 242–262.

Meyer, Richard. 2013. *What Was Contemporary Art?* Cambridge, MA: MIT Press.

Miller, Paul. 1998. "The Engineer as Catalyst: Billy Klüver on Working with Artists." *IEEE Spectrum* 35.7: 20–29.

Mills, C. Wright. 1951. *White Collar: The American Middle Classes.* New York: Oxford University Press.

Mirowski, Philip. 1989. *More Heat than Light: Economics as Social Physics, Physics as Nature's Economics.* Cambridge: Cambridge University Press.

Mirowski, Philip. 2002. *Machine Dreams: Economics Becomes a Cyborg Science.* Cambridge: Cambridge University Press.

Mirowski, Philip. 2004. "The Scientific Dimensions of Social Knowledge and their Distant Echoes in 20th-Century American Philosophy of Science." *Studies in History and Philosophy of Science* 35: 283–326.

Mirowski, Philip. 2011. *ScienceMart™: Privatizing American Science.* Cambridge, MA: Harvard University Press.

Mirowski, Philip. 2013. *Never Let a Serious Crisis Go to Waste: How Neoliberalism Survived the Financial Meltdown.* London: Verso.

Mirowski, Philip, and Dieter Plehwe, eds. 2015. *The Road to Mont Pelerin: The Making of the Neoliberal Thought Collective.* Cambridge, MA: Harvard University Press.

Mirowski, Philip, and Esther-Mirjam Sent. 2007. "The Commercialization of Science and the Response of STS." In *Handbook of Science, Technology and Society Studies*, edited by Edward J. Hackett, Olga Amsterdamska, and Michael Lynch, 635–689. Cambridge, MA: MIT Press.

MIT. 2011. "Arts at MIT White Paper." MIT, June. http://orgchart.mit.edu/sites/default/files/reports/20110628_Provost_ArtsatMITFinal6-20-2011.pdf.

Mody, Cyrus C. M., and Andrew J. Nelson. 2013. "'A Towering Virtue of Necessity': Interdisciplinarity and the Rise of Computer Music at Vietnam-Era Stanford." *Osiris* 28: 254–277.

Moholy-Nagy, László. 1946a [1928]. *The New Vision.* New York: Wittenborn and Company.

Moholy-Nagy, László. 1946b. *Vision in Motion.* Chicago: Paul Theobald and Company.

Moholy-Nagy, Sibyl. 1950. *Moholy-Nagy: Experiment in Totality.* New York: Harper Brothers.

Moholy-Nagy, Sibyl. 1969. *Moholy-Nagy: Experiment in Totality*, 2nd edn. Cambridge, MA: MIT Press.

Morris, Catherine, ed. 2006. *9 Evenings Reconsidered: Art, Theatre, and Engineering, 1966.* Cambridge, MA: MIT List Visual Arts Center.

Moszkowicz, Julia. 2011. "Gestalt and Graphic Design: An Exploration of the Humanistic and Therapeutic Effects of Visual Organization." *Design Issues* 27.4: 56–67.

Mozingo, Louise A. 2011. *Pastoral Capitalism: A History of Suburban Corporate Landscapes.* Cambridge, MA: MIT Press.

Murray, Janet H. 2003. "Inventing the Medium." In *The New Media Reader*, edited by Noah Wardrip-Fruin and Nick Montfort, 3–11. Cambridge, MA: MIT Press.

Negroponte, Nicholas, and Molly Wright Steenson. 2013. "We Were Bricoleurs." In *The Second Modernism: MIT, Architecture and the "Techno-Social" Moment*, edited by Arindam Dutta, 794–809. Cambridge, MA: MIT Press.

Nelson, George. 1957. *Problems of Design*. New York: Whitney Publications.

Nieland, Justus. 2014. "Midcentury Futurisms: Expanded Cinema, Design, and the Modernist Sensorium." *Affirmations: Of the Modern* 2.1: 46–84.

Noll, A. Michael. 2015. "Memories: A Personal History of Bell Telephone Laboratories." Working Paper. East Lansing: Quello Centre, Michigan State University. http://quello.msu.edu/wp-content/uploads/2015/08/Memories-Noll.pdf.

Noll, A. Michael. 2016. "Early Digital Computer Art at Bell Telephone Laboratories, Incorporated." *Leonardo* 49.1: 55–65.

Ogata, Amy F. 2013. *Designing the Creative Child: Playthings and Places in Midcentury America*. Minneapolis: University of Minnesota Press.

Oreskes, Naomi. 2014. "Science in the Origins of the Cold War." In *Science and Technology in the Global Cold War*, edited by Naomi Oreskes and J. Krige, 11–29. Cambridge, MA: MIT Press.

Patterson, Zabet. 2010. "POEMFIELDS and the Materiality of the Computational Screen." *Animation* 5.2: 243–262.

Pearce, Trevor. 2014. "The Dialectical Biologist, circa 1890: John Dewey and the Oxford Hegelians." *Journal of the History of Philosophy* 52.4: 747–777.

Pias, Claus, ed. 2016. *The Macy Conferences 1946–1953: The Complete Transactions*. Chicago: University of Chicago Press.

Pickett, Neil. 1992. *A History of the Hudson Institute*. Indianapolis, IN: Hudson Institute.

Piene, Otto, and Matthew Wisnioski. 2013. "Arts/Science/Technology: Otto Piene in Interview with Matthew Wisnioski." In *A Second Modernism: MIT, Architecture and the "Techno-Social" Moment*, edited by Arindam Dutta, 770–793. Cambridge, MA: MIT Press.

Pierce, John R. 1966. "Science and Art: Some Mutual Implications." *The Reporter* 15.2: 1.

Pinnington, Mike. 2015. "John R. Blakinger on 'Design Thinker' György Kepes." Tate, April 10. http://www.tate.org.uk/context-comment/articles/design-thinker-György-Kepes.

Ragain, Melissa. 2012. "From Organization to Network: MIT's Center for Advanced Visual Studies." *X-Tra Online* 14.3. http://x-traonline.org/article/from-organization-to-network-mits-center-for-advanced-visual-studies/.

Ramljek, Suzanne. 1991. "Interview: Billy Klüver." *Sculpture* 10.3: 32–35.

Rauschenberg, Robert, and Billy Klüver. 1967. "Statements of E.A.T.'s Purpose for Fund-Raising and P.R.," box 145, folder 3, Experiments in Art and Technology Records, 1966–1997, Getty Research Institute, Los Angeles.

Reynolds, Katherine Chaddock. 1998. *Visions and Vanities: John Andrew Rice of Black Mountain College*. Baton Rouge: Louisiana State University Press.

Rice, John Andrew. 1942. *I Came Out of the Eighteenth Century*. New York: Harper.
Rich, Andrew. 2004. *Think Tanks, Public Policy, and the Politics of Expertise*. Cambridge: Cambridge University Press.
Riesman, David, with Nathan Glazer and Reuel Denney. 1950. *The Lonely Crowd: A Study of the Changing American Character*. New Haven, CT: Yale University Press.
Roberts, John. 2015. *Revolutionary Time and the Avant-Garde*. London: Verso.
Robin, Ron. 2001. *The Making of the Cold War Enemy: Culture and Politics in the Military-Intellectual Complex*. Princeton, NJ: Princeton University Press.
Rohde, Joy. 2013. *Armed with Expertise: The Militarization of American Social Research during the Cold War*. Ithaca, NY: Cornell University Press.
Rose, Barbara. 1972. "Art as Experience, Environment, Process." In *Pavilion: Experiments in Art and Technology*, edited by Billy Klüver, Julie Martin, and Barbara Rose, 60–104. New York: E. P. Dutton.
Saletnik, Jeffrey. 2009. "Pedagogic Objects: Josef Albers, Greenbergian Modernism, and the Bauhaus in America." In *Bauhaus Construct: Fashioning Identity, Discourse and Modernism*, edited by Jeffrey Saletnik and Robin Schuldenfrei, 83–102. New York: Routledge.
Sandler, Irving. 1976. *The Triumph of American Painting: A History of Abstract Expressionism*. New York: Harper and Row.
Savov, Vlad. 2013. "Google and Space X Revive the Search for Impractical Inventions." *The Verge*. December 17. https://www.theverge.com/2013/12/17/5219324/lacma-art-and-tech-lab.
Sawyer, R. Keith. 2006. *Explaining Creativity: The Science of Human Innovation*. New York: Oxford University Press.
Schuldenfrei, Eric. 2015. *The Films of Charles and Ray Eames*. New York: Routledge.
Schwartz, Frederic J. 2001. "Ernst Bloch and Wilhelm Pinder: Out of Sync." *Grey Room* 3 (spring): 54–89.
Schwerber, S. S. 1992. "Big Science in Context: Cornell and MIT." In Peter Galison, and Bruce Hevly, *Big Science: The Growth of Large Scale Research*, 149–183. Stanford, CA: Stanford University Press.
Scott, Felicity. 2007. *Architecture or Techno-Utopia: Politics after Modernism*. Cambridge, MA: MIT Press
Serra, Richard, and Clara Weyergraf-Serra. 1980. *Richard Serra: Interviews, Etc., 1970–1980*. Yonkers, NY: Hudson River Museum.
Shalal, Andrea. 2014. "Pentagon, Suppliers Must Change to Survive: Report." *Reuters*, July 6. http://www.reuters.com/article/us-usa-industry-arms-idUSKBN0EH2CC20140606.
Shanken, Edward A. 1998. "Gemini Rising, Moon in Apollo: Attitudes on the Relationship Between Art and Technology in the US, 1966–71." In *ISEA97: Proceedings of the Eighth International Symposium on Electronic Art*. Chicago: ISEA97. http://heavysideindustries.com/wp-content/uploads/2011/01/Gemini-Rising-Moon-in-Apollo-Attitudes-on-the-Relationship-Between-Art-and-Technology-in-the-US-1966-1971%E2%80%9D.pdf.

Shanken, Edward A. 2005. "Artists in Industry and the Academy: Collaborative Research, Interdisciplinary Scholarship and the Creation and Interpretation of Hybrid Forms." *Leonardo* 38.5: 415–418.

Shanken, Edward. 2013. "Reprogramming Systems Aesthetics: A Strategic Historiography." In *Relive: Media Art Histories*, edited by Sean Cubitt and Paul Thomas, 83–96. Cambridge, MA: MIT Press.

Shannon, Claude E., and Warren Weaver. 1949. *The Mathematical Theory of Communication*. Urbana: University of Illinois Press.

Sholette, Gregory. 2011. *Dark Matter: Art and Politics in the Age of Enterprise Culture*. London: Pluto Press.

Shook, John R., and James A. Good, eds. 2010. *John Dewey's Philosophy of Spirit, with the 1897 Lecture on Hegel*. New York: Fordham University Press.

Sloterdijk, Peter. 2014. *Globes*. Translated by Wieland Hoban. South Pasadena, CA: Semiotext(e).

Smith, Bruce L. R. 1966. *The RAND Corporation: Case Study of a Nonprofit Advisory Corporation*. Cambridge, MA: Harvard University Press.

Smith, James Allen. 1991. *The Idea Brokers: Think Tanks and the Rise of the New Policy Elite*. New York: Free Press.

Smith, T'ai. 2014. *Bauhaus Weaving Theory: From Feminine Craft to Mode of Design*. Minneapolis: University of Minnesota Press.

Snow, C. P. 1965. *The Two Cultures; and A Second Look*. Cambridge: Cambridge University Press.

Solovey, Mark, and Hamilton Cravens, eds. 2012. *Cold War Social Science: Knowledge Production, Liberal Democracy, and Human Nature*. New York: Palgrave Macmillan.

Sontag, Susan. 1969 [1965]. "One Culture and the New Sensibility." In *Against Interpretation and Other Essays*, 294–304. New York: Dell.

Spark, Clare. 1971. "Maurice Tuchman on Art and Technology." Part of the series *Art and Technology*, radio broadcast, KPFA, February 7 to July 19, 1971. https://www.pacificaradioarchives.org/recording/bb445801-13.

Stevenson, Adlai Ewing. 1955a. "Women in a Free Society (The Commencement Address)." *Smith Alumnae Quarterly* 46.4: 195–198.

Stevenson, Adlai E. 1955b. "A Purpose for Modern Woman." *Women's Home Companion*, September, 30–31.

Summerfield, Jack D., and Lorlyn Thatcher, eds. 1960. *The Creative Mind and Method: Exploring the Nature of Creativeness in American Arts, Sciences, and Professions*. Austin: University of Texas Press.

Sutton, Gloria. 2012. "Stan VanDerBeek's *Poemfields*: The Interstice of Cinema and Computing." In *Mainframe Experimentalism: Early Computing and the Foundations of Digital Art*, edited by Hannah B. Higgins and Douglas Kahn, 311–333. Berkeley: University of California Press.

Sutton, Gloria. 2015. *The Experience Machine: Stan VanDerBeek's Movie-Drome and Expanded Cinema*. Cambridge, MA: MIT Press.

Tanner, Laurel N. 1997. *Dewey's Laboratory School: Lessons for Today*. New York: Teachers College Press.

Tewksbury, Drew. 2015. "LACMA Acquires James Turrell and Robert Irwin Works and Announces Korean Exhibitions." KCET, March 27. https://www.kcet.org/shows/artbound/lacma-acquires-james-turrell-and-robert-irwin-works-and-announces-korean-exhibitions.

Tomkins, Calvin. 1972. "Outside Art." In *Pavilion: Experiments in Art and Technology*, edited by Billy Klüver, Julie Martin, and Barbara Rose, 105–165. New York: Dutton.

Tuchman, Maurice, ed. 1971. *A Report on the Art and Technology Program of the Los Angeles County Museum of Art, 1967–1971*. New York: Viking.

Turner, Fred. 2006. *From Counterculture to Cyberculture: Stewart Brand, the Whole Earth Network and the Rise of Digital Utopianism*. Chicago: University of Chicago Press.

Turner, Fred. 2008. "Romantic Automatism: Art, Technology, and Collaborative Labor in Cold War America." *Journal of Visual Culture* 7.1: 5–26.

Turner, Fred. 2013. *The Democratic Surround: Multimedia and American Liberalism from World War II to the Psychedelic Sixties*. Chicago: University of Chicago Press.

Turner, Fred. 2014 "The Corporation and the Counterculture: Revisiting the Pepsi Pavilion and the Politics of Cold War Multimedia." *Velvet Light Trap* 73 (summer): 66–78.

Vallye, Anna. 2011. "Design and the Politics of Knowledge in America, 1937–1967: Walter Gropius, György Kepes." PhD thesis. New York: Columbia University.

Vallye, Anna. 2013. "The Middleman: Kepes' Instruments." In *A Second Modernism: MIT, Architecture and the "Techno-Social" Moment*, edited by Arindam Dutta, 144–187. Cambridge, MA: MIT Press.

VanDerBeek, Stan. 1966a. "Re:Vision." *American Scholar* 35.2: 335–340.

VanDerBeek, Stan. 1966b. "'Culture Intercom' and Expanded Cinema: A Proposal and Manifesto." *Film Culture*. 40: 15-18.

Van Horn, Robert, and Matthias Klaes. 2011. "Chicago Neoliberalism versus Cowles Planning: Perspectives on Patents and Public Goods in Cold War Economic Thought." *Journal of the History of the Behavioral Sciences* 47.3: 302–321.

Veblen, Thorstein. 1918. *The Higher Learning in America: A Memorandum on the Conduct of Universities by Business Men*. New York: Viking Press.

Von Bertalanffy, Ludwig. 1950. "An Outline of General Systems Theory." *The British Journal for the Philosophy of Science* 1:2: 134–165.

Waldman, Diane. 1971. *John Chamberlain: A Retrospective*. New York: Solomon R. Guggenheim Foundation.

Wang, Jessica. 1999a. *American Science in an Age of Anxiety: Scientists, Anticommunism, and the Cold War*. Chapel Hill: University of North Carolina Press.

Wang, Jessica. 1999b. "Merton's Shadow: Perspectives on Science and Democracy." *Historical Studies in the Physical and Biological Sciences* 30: 279–306.

Wang, Jessica. 2002. "Scientists and the Problem of the Public in Cold War America, 1945–1960." *Osiris* 17: 323–347.

Weber, Max. 1978 [1922]. *Economy and Society: An Outline of Interpretive Sociology*, edited by Guenther Roth and Claus Wittich. Berkeley: University of California Press.

Weiss, Linda. 2014. *America Inc.? Innovation and Enterprise in the National Security State*. Ithaca, NY: Cornell University Press.

Weldon, Marcus. 2016. "Welcome Address." Nokia Bell Labs, Experiments in Art and Technology, July 27. https://media-bell-labs-com.s3.amazonaws.com/pages/20160726_2207/EAT_booklet_webv25_July_FINAL.pdf.

Wernick, Robert. 1966. "Wars of the Instant Medicis." *Life*, October 28, 102, 105–108, 111–112, 114, 116.

Westbrook, Robert. 1991. *John Dewey and American Democracy*. Ithaca, NY: Cornell University Press.

White, Theodore H. 1967. "The Action Intellectuals." *Life*, June 9, 3, 44, 64.

Whitman, Robert. 2008. "Material Witness: A Tribute to Robert Rauschenberg (1925–2008)." *Artforum*, September, 430–431.

Whyte, William H., Jr. 1956. *The Organization Man*. New York: Simon and Schuster.

Wiener, Norbert. 1950. *The Human Use of Human Beings*. Boston: Houghton Mifflin.

Wiener, Norbert. 1956. "Pure Patterns in a Natural World." In György Kepes, *The New Landscape in Art and Science*, 274–276. Chicago: Paul Theobald and Co.

Wiener, Norbert. 1961 [1948]. *Cybernetics: or Control and Communication in the Animal and the Machine*, 2nd ed. Cambridge, MA: MIT Press.

Williams, R. John. 2016. "World Futures." *Critical Inquiry* 42 (spring): 473–546.

Wilson, Sloan. 1955. *The Man in the Gray Flannel Suit*. New York: Simon & Schuster.

Wilson, Stephen. 2002. *Information Arts: Intersections of Art, Science, and Technology*. Cambridge, MA: MIT Press.

Wisnioski, Matthew. 2012. *Engineers for Change: Competing Visions of Technology in 1960s America*. Cambridge, MA: MIT Press.

Wisnioski, Matthew. 2013a. "Centerbeam: Art of the Environment." In *A Second Modernism: MIT, Architecture and the "Techno-Social" Moment*, edited by Arindam Dutta, 188–225. Cambridge, MA: MIT Press.

Wisnioski, Matthew. 2013b. "Why MIT Institutionalized the Avant-Garde: Negotiating Aesthetic Virtue in the Postwar Defense Institute." *Configurations* 21.1: 85–116.

Wisnioski, Matthew, and Kari Zacharias. 2014. "Sandbox Infrastructure: Field Notes from the Arts Research Boom." *ARPA Journal* 1. http://www.arpajournal.net/we-are-test-subjects-2/.

Yates, JoAnne. 1989a. *Control through Communication: The Rise of System in American Management*. Baltimore: Johns Hopkins University Press.

Yates, JoAnne. 1989b. "The Emergence of the Memo as a Managerial Genre." *Management Communication Quarterly* 2.4: 485–510.

Yates, JoAnne. 1990. "For the Record: The Embodiment of Organizational Memory, 1850–1920." *Business and Economic History* 19: 172–182.

Yates, JoAnne, and Wanda J. Orlikowski. 1992. "Genres of Organizational Communication: A Structurational Approach to Studying Communication and Media." *Academy of Management Review* 17.2: 299–326.

Young, Stephanie. 2017. "'Would Your Answers Spoil My Questions?': Art and Technology at the RAND Corporation." In *Where Minds and Matters Meet: Technology in California and the West*, edited by Volker Janssen, 293–320. Berkeley: University of California Pres.

Youngblood, Gene. 1970. *Expanded Cinema*. New York: E. P. Dutton.

Zacharias, Kari, and Matthew Wisnioski. 2019. "Land-Grant Hybrids: From Art and Technology to SEAD." *Leonardo* 52.3: 261–270.

# Index

Note: Page numbers in *italics* indicate figures.

A&T (LACMA Art & Technology Program), 77–104, 107–132; Chamberlain, 114, 120; exhibition, 7, 127–129; as "hippie modernism," 186; Kahn, 122; Livingston, 130–131; reanimation of, 170, 173–177; report, 116, 132; techno-utopianism, 189–190; Tuchman, 110–112

A+T (LACMA Art + Technology Lab), 8, 170–171, 172, 173–177, 177–185

Abel, Richard, 144

Abstract Expressionism, 28

Abstract Expressionism show (1941), 147

Accenture, 171

Adamic, Louis, 25

Addams, Jane, 19

Adorno, Olga, 84; *The Authoritarian Personality*, 39

Albers, Anni, 25

Albers, Josef, 22, 25, 26–27, 49; "Art as Experience," 28; "Concerning Fundamental Design," 27

Alliance for the Arts in Research Universities (a2ru), 178–179

Amadae, S. M., 165

American Abstract Artists movement, 147

American Artists in India, 105

American Bauhaus, 48

American Foundation on Automation and Employment (AFAE), 89–90

Ampex, 114

anti-dualistic thinking, 14, 25

Antin, David, 111, 127

Apollinaire, Guillaume, 142

Architecture Machine Group, 69, 75, 76

Armbruster, Frank, 123

Arrow, Kenneth, 164, 199n5

*Artforum*, 69, 91, 127

*ARTnews*, 127

*Arts and Architecture*, 137

"authoritarian personality," 39, 42

Barbrook, Richard, 172

Barr, Alfred, 22–25, 48; torpedo, 131

Bassett, Ross, 93

Bateson, Gregory, 61, 134–135, 179

Baudrillard, Jean, 141

Bauhaus: in America, 49–52; Barr, 22–23, 48; Burnham, 69, 71; collaboration, 30; craft and industrial modernity, 44; Dewey, 13, 22, 25, 188, 189; emigre artists, 2; experimentation, 33; Fuller, 65; graphic design, 59; Kepes, 56; Livingston, 131; and MIT, 53; Moholy-Nagy, 49, 62–63; movement, 142–148; Movie-Drome, 154, 159; social responsibility, 46; "tactilism," 67; thinking-by-doing ethos, 6; "total environment," 153

Bayer, Herbert, 143; "Diagram of 360 Degrees of Vision," 151–153, *152*

Bayh-Dole Act (1980), 74, 166

Beckett, Samuel, 17

Belgische Radio en Televisie, 124–125

Bell, Larry, 114

Bell Laboratories, 77–84, *80*; Cold War, 6, 192; and E.A.T., 96; and Fluxus, 45; Billy Klüver, 84–85, 91; Multi-Dimensional Scaling, 105; Murray Park, 105; 9 Evenings, 175; Larry Owens, 101; R&D, 93; VanDerBeek, 68. *See also* Nokia Bell Labs

Bennis, Warren, 194n10

Berkeley, 42–43

Biederman, Patricia, 194n10

Bigelow, Julian, 60

Big Science, 54, 105, 157, 159

*Bildung*, 20

Black Mountain College, 6; Josef Albers and, 49; American progressive liberalism, 44; Cage, 84; Chamberlain, 121; Dewey, 25, 26, 29, 30–31, 189; Fuller, 159; Gestalt therapy, 193n1; Greenberg, 33; "hippie modernism," 186; Motherwell, 28; progressivism, 106; Rauschenberg, 90; VanDerBeek, 68

Bloch, Ernst, 190–192; *Heritage of Our Times*, 187–189

"blue sky research," 157

Bourriaud, Nicolas, 198n1

Brand, Stewart: Fuller, 157; markets, 198n1; MIT Media Lab, 8, 74; Negroponte, 76; *Powers of Ten* (1968), 139; techno-utopianism, 168, 172; *Whole Earth Catalog*, 63

Braque, Georges, 155

Brecht, George, 83–84

Breer, Robert, 97

Breton, André: *The Breach*, 138

Brooklyn Museum: *Some More Beginnings: An Exhibition of Submitted Works Involving Technical Materials and Processes*, 97

Brown, Harold, 166

Brunelleschi, Filippo, 150–151

Brussels World's Fair (1958), 143

Buchanan, James, 165

Buchloch, Benjamin, 168

Bürger, Peter, 168, 169–170

Burnham, Jack: A&T, 127–129, 132, 176–177, 185–186; "The Aesthetics of Intelligent Systems," 69; arts and science, 194n9; *Beyond Modern Sculpture*, 67, 69; CAVS, 67–68, 69;

"The Future of Responsive Systems in Art," 69–72, 70; "Systems Esthetics," 69, 70, 72

Bush, Vannevar: "blue sky research," 157; *Modern Arms and Free Men*, 35–36; postwar science, 79, 108, 189; science and the public, 31; *Science—The Endless Frontier*, 32–33, 52; World War II, 53

*Business Week*, 78, 79, 81

Byars, James Lee, 112, 114–116, 122–126, 131, 132

Cage, John: Bauhaus, 51; Dewey, 29; experimentation, 26–27, 56; *I Ching*, 181; neo-avant-garde, 1–2; 9 Evenings, 85; Rutgers University, 84; VanDerBeek, 68; as wildcard, 190; *A Year from Monday*, 164

Cahill, Holger, 28

Calder, Alexander, 137

"Californian ideology," 172

Cal Tech, 196n2

Cameron, Andy, 172

Carnegie Corporation of New York, 41, 42

Carter, Jimmy, 166

Center for Advanced Visual Studies (CAVS): A&T, 172–173; "Arts at MIT White Paper," 74; Bauhaus, 6; Burnham, 69–72; CAST, 171; *Explorations* exhibition, 72–73; Kepes, 47, 48–49, 54–55, 66–68; Piene, 73–74; reanimation of, 170, 173–177; VanDerBeek, 68; Vision+Value, 56, 59

Center for Art, Science, and Technology (CAST), 8–9, 171

Chamberlain, John, 112, 113–127, 131, 132, 182; *The Secret Life of Hernando Cortez*, 118

Chandler, Missy, 110, 129

Chicago Bauhaus, 51, 52

Clair, Rene, 144

Cohen, Harold, 198n14

Cohen-Cole, Jamie, 39, 43, 194n11

Cold War: A&T, 112, 132; Bauhaus, 24; CAVS, 176; *A Communications Primer*, 151; corporate liberalism, 13, 14–15, 48, 192; Dewey, 29, 30–31; Eames Office, 140, 145, 155; European avant-garde, 130; Fluxus, 142; Fuller, 64, 160; *Glimpses of the USA*, 150; Greenberg, 195n13; interdisciplinarity, 5; liberalism, 173, 183; militarism,

9–10; Mirowski, 164; MIT, 53; Osaka World's Fair, Expo '70, 111; research, 11–12, 105; "scientific community," 36; scientific democracy, 108; scientist as creator, 81–82; security, 167; techno-futurism, 35; think tanks, 127; Truman Doctrine, 162–163; *Utopia or Oblivion: The Prospects for Humanity*, 156; VanDerBeek, 73

collaboration, 18, 43–45, 188; advantage, 194n10; handicaps, 89

collectivism, 13, 19; enterprise, 30–31; experimentation, 133–163; practice, 2

Colomina, Beatriz, 150, 155

Compton, Karl Taylor, 53

Conant, James, 10, 31, 37, 40–41, 43, 189, 194n11

Conceptual Art, 118, 126, 171–172

Constructivists, 71, 130–131, 142, 168

corporate art, 127–132, 188

Council for Conscious Existence, 73–74

Cowles Commission, University of Chicago, 164

*Creative Mind and Method, The* (Summerfield and Thatcher), 195n15

creativity, 18, 188; contra conformity, 38–43

Cunningham, Merce, 68

cybernetics: Eames Office, 151; ecosystems, 139; "feedbacks," 156–157; Gestalt theory, 4; Macy conferences, 60, 134, 141; markets, 164–165; systems theory, 60–61; Norbert Wiener, 66, 76, 134–135

Dada, 44, 56, 142, 157, 168

*Daedalus* (journal), 46–47

Dalkey, Norman C., 99

Daqri, 171, 177–178, 180–181

Darwinism, 19, 21, 27, 194n1

Davis, Mike, 196n2

Debreu, Gérard, 164

de Certeau, Michel, 117

Defense Advanced Research Projects Agency (DARPA), 165, 167

de Kooning, Willem, 33, 147

Delphi method, 99–101

dematerialization, 67

democracy: and education, 19–22; experimental, 182–183; participatory, 188, 189, 191; scientific, 13, 18–19, 28–33, 108

Department of Energy's National Laboratories, 166–167

Deren, Maya: *Meshes of the Afternoon*, 154

Design Institute, Chicago, 159

Dewey, John: anti-dualistic thinking, 14, 25; *Art and Experience*, 33; *Art as Experience*, 27–28, 77; Burnham, 69; Darwinism, 194n1; democracy, 188; democracy and education, 19–22; *Democracy and Education*, 26; experimental democracy, 182–183; experimentation, 26–28; "learning by doing," 49–50, 178–179, 199n5; Moholy-Nagy, 48; participatory democracy, 189, 191; progressive liberalism, 90; *The School and Society*, 19; scientific democracy, 13, 18–19, 28–33; Wiener, 134

Dewey School, 19

Díaz, Eva, 22, 26

Douglass College, New Jersey, 45, 83–84

Dreier, Theodore, 25

Duchamp, Marcel, 169; *The Bride Stripped Bare*, 154; *The Large Glass*, 142; *Rotoreliefs*, 87; *Three Standard Stoppages*, 181

Dymaxion house, 159, 161

Eames, Charles, 139, 146, 179

Eames, Charles and Ray, 135–139; *A Communications Primer*, 138; *Powers of Ten* (1968), 57

Eames, Ray, 146–148

Eames Office, 66, 135, 142–148, 160; as Cold War design lab, 135–139; *A Communications Primer*, 151; *A Film Dealing with the Relative Size of Things in the Universe, and the Effect of Adding Another Zero*, 139–140; *Glimpses of the USA*, 140–141, 143, 144, 146, 147, 149–150, 160; *Powers of Ten* (1968), 139–141; *Think*, 143, 144, 146, 147, 148–155

E.A.T., 6–7; avant-garde, 172–173, 190; corporate art, 186; documentation, 111; engineering collaboration at, 77–106; Maciunas, 146; 9 Evenings, 9; *Operations and Information*, 95–96; outside Art, 104–106; reanimation of, 170, 173–177; Salon, 9, 171, 172, 175–176; Technical Service Program, 96

Edgerton, Harold: "cybernetic sculptures," 72

Eisenhauer, Letty, 84

Eisenhower, Dwight D., 34–36
Eisenstein, Sergei, 145–146, 155, 198n13
Emerson, Ralph Waldo, 142
*Engineer, The* (Time Life volume), 93
engineering, 92–94, 146; collaboration at E.A.T., 77–106
European avant-garde, 24
European modernism, 85
experimentation, 18, 26–28, 135–139, 145
Experiments in Art and Technology (E.A.T.). See E.A.T.
expertise, 107–132; and freedom, 28–33

Federal Arts Project, 28
federally funded research and development centers (FFRDCs), 36
Ferus Gallery, 107
*Film Culture*, 146, 153–154
First Avant-Garde, 144
Fletcher, Harvey, 82
Fluxus, 44–45, 71, 84, 105, 118, 142–148, 169
Fogg Art Museum, 23
Ford Motor Company, 160
*Fortune*, 77, 91
Foster, Hal, 168–170, 172, 173, 184, 186–187, 189, 192
Freeman, John Craig: EEG AR: *Things We Have Lost*, 180–181
Fremont-Smith, Frank, 44
Friedan, Betty, 195n14; *The Feminine Mystique*, 40
Friedman, Ken, 142
Fuller, Buckminster, 156–163; "A Citizen of the Twenty-First Century Looks Back," 156, 158; *Critical Path*, 158; cybernetics, 134–135, 139, 141; "design science," 63–65, 72; "Dymaxion Air-Ocean World Map," 162–163; Eames Office, 136; geodesic dome, 149; *Operating Manual for Spaceship Earth*, 64–65, 133; techno-futurism, 8; techno-utopianism, 26, 76; *Utopia or Oblivion: The Prospects for Humanity*, 156–158; VanDerBeek, 68, 73; as wildcard, 190; "The World Game—How to Make the World Work," 158–159
Futurism, 130–131, 168

Galison, Peter, 54
Gance, Abel, 142–148; *J'accuse*, 197–198n10; *La roue*, 144; montage, 155; *Napoleon*, 145
Gardner, John W., 41–42
Gensler, 171, 178
geodesic dome, 158–62, *161*
Gerard, Ralph W., 51, 62
Gertner, Jon, 78
Gestalt psychology, 4, 29, 51, 56, 193n1
Giedion, Sigfried, 54
Gielen, Pascal, 179–180
Giovanni, Joseph, 147
Glicksman, Hal, 122–123
Goodman, Paul, 193n1
Google, 171, 178
Gorky, Arshile, 147
graphic design, 59
"Great Groups," 194n10
Great Society, 106, 167
Greenberg, Clement, 33, 195n13
Gropius, Walter, 49, 50, 143, 153; "The Theory and Organization of the Bauhaus," 22
Group Zero, 72
Guilford, J. P., 42
Guillory, John, 116–118

Habermas, Jürgen, 121
Hacking, Ian, 182, 185
Hammid, Alexander: *Meshes of the Afternoon*, 154; *To Be Alive!*, 154; *We Are Young*, 154–155
"hands-on-process," 77–106
Haraway, Donna, 54
Harvard University, 23, 27, 49, 193n2; *General Education in a Free Society*, 40–41, 194n11; Program on Technology and Society, 7, 91
Hayakawa, S. I., 54
Haydon, Brownlee, 119, 126–127
Hegel, Georg Wilhelm Friedrich, 20–21
Heidegger, Martin, 139, 162, 163
Heims, Steve, 134–135
Hendricks, Geoffrey, 83–84
Hightower, John, 87
Hoffman Committee: *Creative Renewal in a Time of Crisis*, 59
Hofmann, Hans, 147–148

Hollinger, David, 32
Homeland Security Advanced Research Projects Agency (HSARPA), 167
Hopps, Walter, 107
Hudson Institute, 112, 113, 114, 115–116, 122–124, 127
Hull House, 19
Huxley, Julian, 48
Hyundai, 171, 178

IBM, 77–104, 143, 144, 146, 148–155
Institute of Design, Chicago, 51–52
*Institute of Electrical and Electronic Engineers' Journal of Quantum Electronics*, 91
Institute of Personality Assessment and Research (IPAR), 42–43
interdisciplinarity, 4–5, 44, 49, 54, 60, 82–83, 108
Irwin, Robert, 178

Jameson, Fredric, 190–192
Jewett, Andrew, 31
Jewett, Frank Baldwin, 77
John D. Rockefeller Foundation, 105
Johns, Jasper, 87; *Map (Based on Buckminster Fuller's Dymaxion Airocean World)*, 162–163
Johnson, Lyndon B., 36–38, 41–42, 167
Jones, Caroline A., 60–61, 66, 71
Josiah Macy Jr. Foundation, 60

Kabul fair (1956), 160
Kahn, Herman, 114, 115–116, 121–123, 125, 131; *On Thermonuclear War*, 113
Kaiser, David, 81
Kaprow, Allan, 83–84; "happenings," 68
Kelly, Mervin J., 78
Kendall, Donald, 102
Kennedy, John F., 173
Kepes, György, 52–59, 61–63; CAST, 171; CAVS, 6, 49, 59, 66–68; collaboration, 128; Eames Office, 136–137, 153; E.A.T. Salon, 175–176; "expanded cinema university," 65; *Explorations* exhibition, 72–73; Gance, 144; *Language of Vision*, 46, 52, 52–59, 68; "learning by doing," 49–50; militarism, 142–143;

Moholy-Nagy, 48; *The New Landscape in Art and Science*, 50, 51, 55, 57–59, 58, 61–62; Piene, 72; *Powers of Ten* (1968), 139; progressivism, 70; social responsibility, 46–47; STEAMedu, 178–179; systems theory, 60–61; *Toward Civic Art*, 73; VanDerBeek, 154
Kerschensteiner, Georg, 22
Kheel, Theodore W., 91
Khrushchev, Nikita, 102
Kienholz, Edward, 107–108, 132
Kiesler, Frederick: *Raumbuhne*, 153
King, Norman, 143
Klüver, Billy: 84–94; Bell Laboratories, 82–83; collaboration, 98–101, 105–106, 108; E.A.T., 6; E.A.T. Salon, 171; engineering, 179; 9 Evenings, 9, 70, 175; Osaka World's Fair, Expo '70, 96–98; *Pavilion*, 98; PepsiCo, 97, 102–104; Tuchman, 128–130
Korean War, 34, 53
Kozloff, Max, 127–129, 132
Krauss, Rosalind, 171
Kraynik, Ted, 68
Kuhn, Thomas, 72

laboratory of form and movement, 45, 46–76
Laboratory School, University of Chicago, 19
LACMA, 107–132
LACMA's Art & Technology Program (A&T). See A&T
LACMA's Art + Technology Lab (A+T). See A+T
Lakatos, Imre, 184–185
Laura Spelman Rockefeller Memorial, 44
"learning by doing," 22, 49–50, 178–179, 199n5
Le Corbusier: *Poème électronique*, 143–144
*LEF* (journal), 142
Leslie, Stuart, 36
Lewis, Sid, 73–74
liberalism: American, 10; Cold War, 173, 183; corporate, 13, 14–15, 48, 192; neoliberalism, 173; progressive, 44, 90, 165; rational choice, 165; social, 18
Lichtenstein, Roy, 83–84
*Life*, 79, 80, 110, 160, 197n5
Lincoln Laboratories, MIT, 69
Lindgren, Nilo, 98–101

Lippard, Lucy, 67
Lissitzky, El: *Kabinett der Abstrakten*, 153
"livingry," 157, 161–162
Livingston, Jane, 113–14, 122, 130–131
*Look* (magazine), 43
Los Angeles Council of Women Artists (LACWA), 111
*Los Angeles Free Press*, 111
*Los Angeles Times*, 110
Lowery, Andy, 177–178
Lyotard, Jean-François, 184

Maciunas, George, 44–45, 71, 84, 146
Macy conferences, 44, 134–135; cybernetics, 60, 61, 141; Fuller, 156–157; Gerard, 62; Kepes, 56, 66–67, 68; Vision+Value, 55; Wiesner, 74
Macy Foundation, 44
Malthus, Thomas, 158
Manhattan Project, 15, 31, 40
Mansfield Amendment, 165
Markusen, Ann, 199n8
Martin, Julie: *Pavilion*, 98
Martin, Reinhold, 55, 59
Mason, Francis S., Jr., 90–91
Massey, Jack, 160
Mathews, Max, 91
McCulloch, Warren, 60
McDermott, John, 164–192
Mead, Margaret, 61, 134–135, 179, 195n17
Mee, Thomas R., 97
Mellon Foundation, 9, 171
Merton, Robert, 31
Mesthene, Emmanuel, 7, 91, 193n2
Milan Triennial (1954), 159–160
Military Procurement Authorization Act of 1970, 165
Minsky, Marvin, 69
Mirowski, Philip, 9, 26, 30, 36, 164
MIT, 46–76; Architectural Machine, 68–69; CAST, 171; Cold War, 6, 192; Media Lab, 8, 69, 74–76, 179; nanotechnology, 167; *Powers of Ten* (1968), 139; R&D, 143; reanimation of, 172, 173–177; "White Paper," 66, 74
Moholy-Nagy, László: Bauhaus, 49–52, 69; "expanded cinema university," 65; "experience with the material," 67; graphic design, 59; Negroponte, 75; *The New Vision*, 46, 48, 49, 50, 51; projection experiments, 143; School of Design, Chicago, 47–48; Soviet Constructivists, 71; *Vision in Motion*, 51, 57, 154
Moholy-Nagy, Sibyl, 51–52, 59, 62–63
montage, 145–146, 150, 155, 198n13
Mont Pelerin Society, 165
Montreal Expo '67, 155, 158, 160, 162
Morris, Charles W., 51
Moscow Exhibition (1959), 140, 143, 149, 160
Motherwell, Robert, 28
Movie-Drome, 68, 73, 153, 154
Mozingo, Louise, 78
Mullins, Brian, 180–181
Mumma, Gordon, 101
Murray Hill, 77–84, *80*, 105
Museum of Modern Art (MoMA), 22–24, 25, 48; *The Machine as Seen at the End of the Mechanical Age*, 97; "New Furniture Designed by Charles Eames," 137; *Road to Victory*, 151
Musk, Elon, 177–178

Nakaya, Fujiko, 97
National Endowment for the Arts (NEA), 37
National Endowment for the Humanities (NEH), 37
National Foundation of the Arts and the Humanities Act (1965), 37
National Military Establishment, 34
National Security Act (1947), 34
National Security Agency (NSA), 34
"National Security Council Report 68" (NSC-68), 34
Negroponte, Nicholas, 69, 74, 75–76, 158, 175–176
Nehru Foundation for Development, 105
Nelson, George, 66, 149; *Problems of Design*, 66
neo-avant-garde, 1, 5, 168–169, 172
Neurath, Otto, 44
New Bauhaus, 47, 49
New Deal, 3, 29–30, 32, 48, 131, 164–165
New Frontier, 173
New Jersey School, 83
*New Masses*, 23

New School for Social Research, New York City, 84
*New Yorker*, 23, 97, 98
New York film festival (1966), 154
*New York Review of Books* (1969), 7
New York School, 102
New York State Council on the Arts, 87
*New York Times*, 89
*New York Times Sunday Magazine*, 121
New York World's Fair (1964), 143, 148–155, 154
9/11, 167
9 Evenings: Theatre and Engineering, 9, 70, 84–87, 91, 93, 175, 196n5
Nixon, Richard, 102, 166
Nokia Bell Labs, 9, 171, 172, 173–177, 186, 189. *See also* Bell Laboratories
Northrop, Filmer S. C., 61
Norton, W. W., 48
Nvidia, 171, 178

Office of Scientific Research and Development (OSRD), 32
Oldenburg, Claes, 83, 86; "happenings," 84–85
Ono, Yoko: "Earth Piece," 133
On Point Technologies, 167
organization man, 79, 82
Osaka World's Fair, Expo '70, 97–98, 101, 103–104, 111
Owens, Larry, 101

Pacifica Radio, 129, 130, 131
"Paleocybernetic Age," 65, 68
Paris exhibition (1930), 151
*Pavilion*, 102–103
pavilions, 97–104, 111, 136–137, 143
Pearce, John, 100–101
PepsiCo, 94–104
Perry, William, 166
Picasso, Pablo, 155
Piene, Otto, 68, 72, 75, 76; "cybernetic sculptures," 72; "sky art," 72, 73–74
Pierce, John R., 82–83, 91, 94
Pinder, Wilhelm, 187
Piscator, Erwin, 143–144
Planetary Skin Institute, 159

Poem Field, 68
Pop Art, 138
positivism, 195n13
post-Conceptual Art, 171–172
Pound, Ezra, 145–146
Powers, John G., 91
Progressive Era, 18, 112–113
Projects Outside Art, 104–106

R&D: Cold War, 17; defense, 7–8, 11, 34–35, 36, 164, 166, 167; E.A.T., 100; interdisciplinarity, 187; MIT, 6, 52, 74, 143; organization man, 79; tech, 12, 178
Ragain, Melissa, 67
Rainer, Yvonne, 85
RAND Corporation: Chamberlain, 112, 118–121, 131, 182; Chamberlain and Byars, 116, 124, 125–127; Cold War, 164–165; Delphi method, 99; Eames Office, 136–137; *Life*, 197n5; Mesthene, 193n2; neoliberalism, 173; think tank, 113–114; wildcards at, 190
Rauschenberg, Robert, 1–2, 6, 70, 85, 89–92, 175; *Oracle*, 87
Red Book, 40–41
*Reporter* (Bell Labs magazine), 82
*Report on the Art and Technology Program of the Los Angeles County Museum of Art 1967–1971*, 110–112
Reuters, 177
Rice, John Andrew, 25, 26
Roberts, John, 44, 168, 170–172, 184, 186–187, 189, 192
Rockefeller Foundation, 42
Rogers, Carl, 43
Rollins College, Florida, 25
Roosevelt, Franklin D., 32
Rose, Barbara, 102–104; *Pavilion*, 98
Rosenblueth, Arturo, 60
Russian Constructivism, 44, 45, 71
Russian Productivism, 45
Rutgers University, New Jersey, 45, 83–84, 85

Sachs, Paul J., 23
Sadao, Shoji, 162
Saletnik, Jeffrey, 33

Samaras, Lucas, 83–84
Sarabhai, Vikram, 105
Schneemann, Carolee, 84
School of Design, Chicago, 47–48, 51–52
Schuldenfrei, Eric, 139–140, 149
Science, Technology, Engineering, Art, and Mathematics Education (STEAMedu), 178–179
*Scientific American*, 113
scientific democracy, 13, 19, 28–33, 108
Segal, George, 83–84
Serra, Richard, 7
Shannon, Claude, 61, 135, 156–157; *The Mathematical Theory of Communication*, 138
Sholette, Gregory: *Dark Matter*, 10–11
Silicon Valley, 8, 11
Smith, Harry, 146; *Mahagonny*, 154
Smith, James Allen, 113
Smith College, 39–40, 41, 195n14
Snow, C. P., 38
Sontag, Susan: "One Culture and the New Sensibility," 107
Southern Illinois University, 158, 198n14
Soviet Constructivism, 44, 45, 71
Soviet Union, 34, 38, 102, 165–166
Spaceship Earth, 139
SpaceX, 171, 177–178
Spark, Clare, 130, 131
Spencer, Herbert, 19, 194n1
*Stan VanDerBeek: The Computer Generation!!*, 68
STEAMedu, 178–179
Steichen, Edward, 151; *The Family of Man*, 149, 160
Stein-Einstein-Wittgenstein triad, 125–126, 131
Stevenson, Adlai, 39–41, 43
Stevenson-Wydler Technology Innovation Act, 166
Stokowski, Leopold, 82
Surrealism, 44, 56, 138, 144–146, 168; "narrative surrealists," 144
Sutton, Gloria, 68, 144
Svoboda, Josef, 143–144; *Polyekran*, 143
synchronicity, 189–191
systems theory, 60–61, 63–64

Takis, Vassilakis, 68
Tatlin, Vladimir: *Monument*, 103
Taut, Bruno, 153
techno-avant-garde, 142–148
techno-futurist pioneer-consultancy, 8
techno-optimism, 7, 37–38
techno-utopianism, 14, 29, 49, 172, 192
television, 69, 77, 82, 85, 105, 137, 141
Tenney, James, 83
think tanks, 107–132, 167
Thomas, David, 97–98, 104
Thompson, Francis: *N.Y., N.Y.*, 154; *To Be Alive!*, 154; *We Are Young*, 154–155
Thoreau, Henry David, 142
Tinguely, Jean, 82, 87
Tomkins, Calvin, 97–98, 102, 103–104
Torrance, E. Paul, 42–43
Torrance Tests of Creative Thinking, 42–43
totality of patterns, 59–65
Tovish, Harold, 68
Truman, Harry S., 34
Truman Doctrine, 162
Tsai, Wen-Ying, 68, 69
Tuchman, Maurice, 6, 109–112, 128–132, 174, 182–183, 189–190
Tudor, David, 101
Tullock, Gordon, 165
Turner, Fred, 155, 198n1
Turrell, James, 178

unity of science movement, 44, 48, 51
University of Technology, Sydney, 178
USIA, 143, 149–150, 160
*Utopier et Visioner 1871–1981*, 105

Vallye, Anna, 52, 55–56
VanDerBeek, Stan, 68–70; Macy conferences, 134; Movie-Drome, 68, 153–154; *Panels for the Walls of the World*, 73, 195n5; *Think*, 146
*Vanity Fair*, 23
Varèse, Edgard: *Deserts*, 83
Veblen, Thorstein, 30
Vertov, Dziga: *Man with a Movie Camera*, 149

Vietnam War: A+T, 175; expertise, 189; MIT, 59; techno-optimism, 37; techno-utopianism, 14; think tanks, 167–168; VanDerBeek, 73
Vision+Value, 49, 55, 56, 58, 59, 66
von Bertalanffy, Ludwig, 61
von Neumann, Johann, 60, 135
Vuillermoz, Émile, 145

Waldhauer, Fred, 85
Warhol, Andy: *Chelsea Girls*, 154; Factory, 118; *Inner and Outer Space*, 154
Watts, Robert, 83–84
Weaver, Warren, 61
Weiss, Linda, 34, 167
Weldon, Marcus, 171, 175, 186, 187
Wellesley College, 23
White, Theodore H., 197n5
Whitman, Robert, 85, 91, 105
Whyte, William H., 79
Wide White Space Gallery, Antwerp, 124
Wiener, Norbert: Jack Burnham, 70; cybernetic "feedbacks," 156–157; cybernetics, 60–61, 66, 76; *Cybernetics*, 66; engineering, 179; *The Human Use of Human Beings: Cybernetics and Society*, 134–135; "Pure Patterns in a Natural World," 61–62; Wiesner, 74
Wiesner, Jerome, 74–75, 76
Williams, R. John, 125
Wisnioski, Matthew, 37–38, 179
Works Progress Administration (WPA), 28
World Game, 158–159, 160, 162
World Question Center, 115–116, 122, 123, 124–126, 132
World War II: Black Mountain College, 30; Bush, 35; corporatism, 48; creativity, 42; education, 13; Kepes, 46–47; MIT, 53, 60; Piene, 72; RAND Corporation, 113, 137

Yates, JoAnne, 117
Young, Stephanie, 126
Youngblood, Gene, 68, 72, 134; *Expanded Cinema*, 64–65

Zacharias, Kari, 179

www.ingramcontent.com/pod-product-compliance
Lightning Source LLC
Chambersburg PA
CBHW021547200526
45163CB00016B/2572